A

GENERAL HISTORY

of

QUADRUPEDS

THE FIGURES ENGRAVED ON WOOD BY

THOMAS BEWICK

WITH A NEW FOREWORD BY
YANN MARTEL

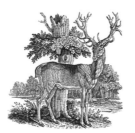

THE UNIVERSITY OF CHICAGO PRESS
Chicago & London

PUBLISHER'S NOTE:

With the exception of a new title page and a new foreword on
pages [iii]–[vi], this volume is a facsimile edition of volume 3 of the 1885
Memorial Edition of the works of Thomas Bewick. It was selected, from many
editions of Bewick's *Quadrupeds*, because it includes the most complete
and most carefully reproduced collection of wood engravings.

We would like to acknowledge the help of the University of Chicago
Libraries, Department of Special Collections, in researching this edition. They
have a remarkable collection of works by Thomas Bewick. We are grateful, too,
to Mr. David Gray of the Bewick Society, both for his advice on which
edition to reproduce and for the use of his rare copy of the book.

———

The University of Chicago Press, Chicago, 60637
The University of Chicago Press, London
Foreword © 2009 by Yann Martel
All rights reserved.
University of Chicago Press edition 2009

Printed in the United States of America

18 17 16 15 14 13 12 11 10 09 1 2 3 4 5

ISBN-13: 978-0-226-04481-1 (cloth)
ISBN-13: 978-0-226-04480-4 (paper)
ISBN-10: 0-226-04481-5 (cloth)
ISBN-10: 0-226-04480-7 (paper)

Library of Congress Cataloging-in-Publication Data

Bewick, Thomas, 1753–1828.
A general history of quadrupeds : with figures engraved on wood /
Thomas Bewick; with a new foreword by Yann Martel.
p. cm.
"Facsimile edition of volume 3 of the 1885 Memorial Edition
of the works of Thomas Bewick"—T.p. verso.
ISBN-13: 978-0-226-04481-1 (cloth : alk. paper)
ISBN-13: 978-0-226-04480-4 (pbk. : alk. paper)
ISBN-10: 0-226-04481-5 (cloth : alk. paper)
ISBN-10: 0-226-04480-7 (pbk. : alk. paper) 1. Mammals—Early works
to 1800. 2. Mammals—Pictorial works. I. Martel, Yann. II. Title.
QL706.B55 2009
599—DC22

2008056049

♾ The paper used in this publication meets the minimum requirements of
the American National Standard for Information Sciences—Permanence
of Paper for Printed Library Materials, ANSI Z39.48-1992.

Foreword

BY YANN MARTEL

A zoo is an embassy and within each enclosure lives an animal representing its species. If we did not have these varied animal ambassadors, what would we have? It's simple: we would have no relations with the natural world. We would live in our concrete jungles, oblivious of all other creatures, with the exception of those two reliable, permanently infantilized, tame animals, the cat and the dog, and a handful of other wildish species such as the pigeon and the squirrel. Otherwise, we would live—we do live—in a self-obsessed bubble paying attention to only one species, our own. The danger in this phylogenetic narcissism, besides existential dullness, is that if we have no regard for other species, then we will likely treat them with disregard. Since we humans have a unique capacity for destruction, disregard often leads to destruction. And in this sad syllogism, destruction of other species will come round to destroy us, for we live on a ship—it might be called an ark—whose cargo has been carefully balanced, and such unholy throwing overboard of precious cargo will throw the ship off balance and make it capsize and sink.

Thus the importance of maintaining relations with animals, to keep the ship aright and afloat. Nature shows on TV are a good start. They make us feel powerfully the marvel and fragility of nature. But if animals exist only as represented on television, then one can love them only as much as one can love any television series. Worse: being on television confers to animals, thanks to reruns, an immortality that is delusional.

No, no, no: it is in the flesh, there before you, staring at you quietly and guardedly, that an animal begins to connect with you and you with it. That is the reason citizens should rise up to the defense of good zoos, or work to improve the others: so that we might see and feel beyond our own species.

If zoos are embassies and their residents ambassadors, if there are nations of animals and a nation of humans, then one of the animal world's pioneering diplomats was one Thomas Bewick (pronounced Buick, as in the car) of England. He was born in 1753 and died in 1828, and he lived most of his life in Newcastle upon Tyne. He was by trade an engraver, not a scientist, but he had a deep affection and a sharp eye for the natural world. In that, he was in tune with his age. The eighteenth and nineteenth centuries saw an explosion of interest in the animal world, the result of a great number of European explorers discovering that the world was a bigger, wilder, and more varied place than Christian Europe had imagined. This interest culminated, of course, in the shattering theories of Charles Darwin. Suddenly, the gulf between humans and animals, between Us and Them, became vertiginously narrow. But I'm jumping ahead here. *The Origin of Species*, which made Darwin the Talleyrand of animal diplomacy, came later, in 1859 to be exact.

Bewick appeared earlier, and his mission was more humble. He sought to illustrate and show, not to explain. His *A General History of Quadrupeds* was first published in 1790. In it he set out to describe the appearance and behavior of all four-legged animals then known to humankind. He started with an animal that he and his compatriots knew well: the horse. Then he moved outward to describe quadrupeds utterly alien to him whose existence had nonetheless been attested to by reliable others, and whose duty he took it upon himself to portray as faithfully as he could, basing himself on all the material evidence he could find.

The resulting book was wildly successful in its time. It was

reprinted and expanded several times, and it made Bewick a famous man. There is a Bewick Street in Newcastle, an active Bewick Society in the virtual world, and there are two birds named after him, Bewick's wren and Bewick's swan.

A General History of Quadrupeds deserves yet another printing now for two reasons. The first and most obvious is the quality of the woodcut engravings. Until Bewick's time, if an animal had been portrayed in an illustration or painting, it was the result of coincidence rather than genuine interest. For example, a realistic horse appearing under an important nobleman in a Renaissance painting. Or from the same period, an accurately portrayed dove radiating strobes of divine light before transfixed believers. The animals are not there for their own sake, but are rather playing supporting roles. With Thomas Bewick we have, from the hands of a master engraver, an attempt to portray an animal with rigorous biological accuracy. That's nothing so ground shaking when speaking of a sheep or a cow, with whom every person in England would have been familiar, but, yes, quite ground shaking when speaking of the camelopard, as the giraffe was then called, or the tapir or the anteater. Could such strange creatures truly exist? astonished readers surely asked. Yes, Bewick's book authoritatively asserted, yes, they do. Behold.

The engravings—over two hundred of them—are lively, precise, detailed, unsentimental, and luminous. Each animal is set in a parcel of natural environment. Also to be enjoyed are a good number of vignettes, smaller illustrations scattered throughout the text, many of them amusing, some of them baffling. I especially like the one of the monkey standing in front of a mirror, a razor in one hand. They seem to be there to reassure readers that animals could still be comforting figments of their imagination, if the upsetting newness of all the real animals got to be too much.

Accompanying the illustrations, and of no less interest, are the textual descriptions. The approach is at first heav-

ily anthropocentric. Take, for example, the very first paragraph of the book, concerning the horse:

The various excellencies of this noble animal, the grandeur of his nature, the elegance and proportion of his parts, the beautiful smoothness of his skin, the variety and gracefulness of his motions, and, above all, his utility, entitle him to a precedence in the history of the brute creation.

The terms "noble," "grandeur," "elegance," "gracefulness," "utility," the pronoun "his"—the human sensibility is so closely bound to the description of the animal that one can hardly imagine it but at the end of a halter rope, being guided in a circle around its lord, master and self-professed center of the universe.

The distance *A General History of Quadrupeds* travels intellectually from this smug beginning is revealed by the very last animal Bewick describes, one so little known to him as not yet to bear a name—he simply calls it "an amphibious animal"—a bizarre, egg-laying, category-defying mammal. The platypus, as it came to be known, made its first appearance in print in Bewick's book. Gone is the smothering familiarity that attended the horse. The platypus is an "it" and no moral character is assigned to it, neither nobility, gracefulness, nor utility. The animal is rather described in purely factual language: "it chiefly frequents the banks of the lakes; its bill is very similar to that of a duck," and so on.

From the horse to the platypus, from the tame and misconstrued to the wild and unknown—such is the stupendous journey that Thomas Bewick bears witness to in his seminal book. In it he ventured from the human into the animal unknown, from the self-centered and arrogant to the humble and curious.

May you, reader, make a similar journey.

A

GENERAL HISTORY

OF

QUADRUPEDS.

THE FIGURES ENGRAVED ON WOOD

BY

THOMAS BEWICK.

VOL. III.

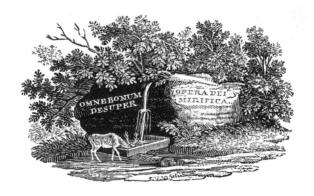

NEWCASTLE-UPON-TYNE:

PRINTED BY R. WARD AND SONS, FOR

BERNARD QUARITCH, 15 .PICCADILLY,
LONDON.

1885.

PREFACE.

In disposing the order of the following work, we have not thought it necessary to confine ourselves strictly within the rules prescribed by systematic writers on this part of Natural History; as it was not so much the object of our plan to lay down a methodical arrangement of the various tribes of four-footed animals, as to give a clear and concise account of the nature, habits, and disposition of each, accompanied with more accurate representations than have hitherto appeared in any work of this kind. Our disregard of system, however, has not prevented us from attending to the great divisions of Quadrupeds, so obviously marked out by the hand of Nature and so clearly distinguished that the most careless observer cannot avoid being forcibly struck with an agreement of parts in the outward appearance of the different individuals of which it consists.

The intermediate stations, however, have not been always so clearly defined; these are frequently occupied by characters so dubious that naturalists have not always agreed in ascribing to each its proper place: of this kind are the Elephant, the Hippopotamus, the Rhinoceros, the Cameleopard, the Beaver, the Hedge-Hog, the Sloth, the Jerboa, &c., which bear in themselves characteristics so peculiar that they might seem to constitute distinct genera.

We have endeavoured to lay before our readers a particular account of the animals with which our own country is abundantly stored, especially of those which so materially contribute to the strength, the wealth, and the happiness of this kingdom; of these the Horse, the Cow, and the Sheep, claim the first place; and in treating of these, we have no-

ticed the improvements which an enlarged system of agricul-
ture, supported by a noble spirit of emulation, has introduced
into all parts of the country. To these we may add that
most useful animal the Dog, the account of which forms a
conspicuous part of our history, and we trust will afford
some entertainment to those who are pleased with contem-
plating the various talents of that trusty servant and humble
companion of man. We have selected the most remarkable
of the different kinds, and have given faithful portraits of
them, drawn from the life. There are still others, not un-
worthy of attention, which might have been added; but to
have noticed all the variations and shades of difference ob-
servable in the canine race would have swelled our account,
already large, to an immoderate length, and have left us too
little room for others of equal importance, in a comprehen-
sive view of this part of the animal creation.

Our attention has been directed in a particular manner to
the various instinctive powers of animals—that hidden prin-
ciple, which actuates and impels every living creature to
procure its subsistence, provide for its safety, and propagate
its kind. To discover more and more of this unerring guide,
directing the brute creation to their highest good, by the
simplest and most certain methods, is a pursuit worthy of the
most refined understanding, and leads us to contemplate the
wisdom and goodness of the adorable Author of Nature, who
" openeth His hand, and all things are filled with good."

It may perhaps be thought necessary to offer some apo-
logy for the evident want of proportion observable in the size
of the different animals—a defect to which every work of
this kind must, in some measure, be liable. In adverting to
this, we found, that at whatever point, between the Elephant
and the Mouse, the scale were to be fixed, a great and un-
avoidable deficiency would be the consequence; we were
therefore obliged to relinquish a plan, which, so far from
being practicable, would have been the means of throwing
the whole into irregularity and confusion.

CONTENTS OF THE THIRD VOLUME.

b

CONTENTS.

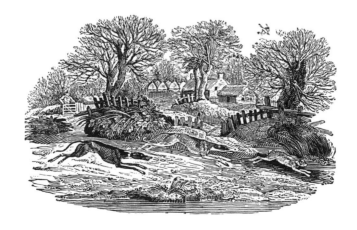

A

GENERAL HISTORY

OF

QUADRUPEDS.

THE HORSE.

(Equus Caballus, Linnæus.—*Le Cheval*, Buffon.)

THE various excellencies of this noble animal, the
grandeur of his stature, the elegance and propor-
tion of his parts, the beautiful smoothness of his
skin, the variety and gracefulness of his motions,
and, above all, his utility, entitle him to a pre-
cedence in the history of the brute creation.

The Horse, in his domestic state, is generous,
docile, spirited, and yet obedient; adapted to the
various purposes of pleasure and convenience, he
is equally serviceable in the draught, the field, or
the race.

There are few parts of the known world where
the Horse is not produced; but if we would see
him in the enjoyment of his native freedom, unsub-
dued by the restraints man has imposed upon him,
we must look for him in the wild and extensive
plains of Africa and Arabia, where he ranges with-
out control in a state of entire independency. In
those immense tracts, the wild Horses may be seen
feeding together, in droves of four or five hundred;
one of them always acting as sentinel, to give
notice of approaching danger: this he does by a
kind of snorting noise, upon which they all run off

with astonishing rapidity. The wild Horses of
Arabia are esteemed the most beautiful in the
world: they are of a brown colour, their mane and
tail of black tufted hair, very short; they are
smaller than the tame ones, are very active, and of
great swiftness. The most usual method of taking
them is by snares or pits formed in the sand. It is
probable there were once wild Horses in Europe,
which have long since been brought under subjec-
tion. Those found in America were originally of
the Spanish breed, sent thither upon its first dis-
covery, which have since become wild, and spread
themselves over various parts of that vast con-
tinent. They are generally small, not exceeding
fourteen hands high, with thick heads and clumsy
joints; their ears and necks are longer than those
of the English Horses. They are easily tamed;
and if by accident they should regain their liberty,
they seldom become wild again, but know their
master, and may be easily caught by him.

At the age of two years,* the Horse is in a con-
dition to propagate. The mare is generally in
season from the latter end of March till the

* There are various ways of judging of the age of a Horse. The
following are the most general:—The eye-pits of old Horses are com-
monly hollow; but that mark is equivocal, young Horses, begot by
old stallions, having them also hollow. The teeth afford the best
criterion of the age of Horses. The Horse has, in all, forty teeth;
viz., twenty-four grinders, four canine teeth or tusks, and twelve fore
teeth. Mares have either no tusks, or very short ones. Five days
after birth, the four teeth in front begin to shoot: these are called
nippers, and are cast at the age of two years and a half: they are
soon renewed: and the next year, he again casts two above, and two
below,—one on each side of the nippers. At four years and a half,
other four fall out, next those last placed: these last four foal teeth
are succeeded by other four, which grow much more slowly than the

beginning of June; but her chief ardour for the Horse continues only fifteen or twenty days. She goes with young eleven months and some days; continues to breed till the age of sixteen or eighteen years; and lives, on an average, between twenty and thirty years.

Although the Horse is endowed with vast strength and powers, he seldom exerts either to the prejudice of his master: on the contrary, he shares with him in his labours, and seems to participate in his pleasures: generous and persevering, he gives up his whole powers to the service of his master; though bold and intrepid, he represses the natural vivacity and fire of his temper, and not only yields to the hand, but seems to consult the inclination of his rider.

But it must continue to be matter of regret to every feeling mind, that these excellent qualities should be often shamefully abused in the most unnecessary exertions; and the honest labours of this noble animal thrown away in the ungrateful task of accomplishing the purposes of unfeeling folly, or lavished in gratifying the expectations of an intemperate moment.

first eight: and it is from these last four corner teeth, that the age of a Horse is distinguished: they are somewhat hollow in the middle, and have a black mark in the cavities. At five years, these teeth scarcely rise above the gums; at six their cavities begin to fill up, and turn to a brownish spot, like the eye of a garden bean; and before eight years, the mark generally disappears. The tusks also indicate the age of a Horse. Those in the under jaw generally shoot at the age of three years and a half; and the two in the upper jaw at four: till six, they continue sharp at the points; but at ten they appear long and blunted. These are the general rules for ascertaining the age of a Horse; but there are frequent exceptions, as some Horses retain the mark two or three years longer.

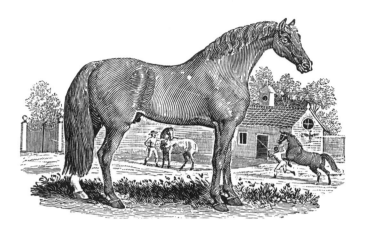

THE ARABIAN HORSE.

THERE is scarcely an Arabian, how poor soever in other respects, but is possessed of his Horse, which he considers as an invaluable treasure. Having no other dwelling but a tent, the Arabian and his Horse live upon the most equal terms: his wife and family, his mare and her foal, generally lie indiscriminately together; whilst the little children frequently climb without fear upon the body of the inoffensive animal, which permits them to play with and caress it without injury. The Arabs never beat their Horses; they speak to, and seem to hold friendly intercourse with them: they never whip them, and seldom, but in cases of necessity, make use of the spur. Their agility in leaping is wonderful; and if the rider happen to fall, they are so tractable as to stand still in the midst of the most rapid career. The Arabian Horses, in general, are less than the Race Horses of this

country; they are easy and graceful in their motions, and rather inclined to leanness. It is worthy of remark, that, instead of crossing the breed, the Arabs take every precaution to keep it pure and unmixed: they preserve, with the greatest care, and for an amazing length of time, the genealogies of their Horses: those of the first kind are called Nobles, being "of a pure and ancient race, purer than milk." They have likewise two other kinds, which, having been degraded by common alliances, sell at inferior prices.

From Arabia, the race of Horses has probably extended into Barbary and other parts of Africa; those being considered as next to the Arabian Horses in swiftness and beauty, though they are somewhat smaller.

The *Spanish Genette* is held in great estimation: like the former, it is small, but beautiful, and extremely swift.

The Horses of India and China are of a much less size and more vicious than those of this country, and many of them very small. One of these was some years ago brought into this country as a present to the Queen, measuring only nine hands in height.

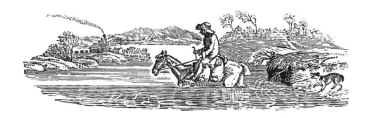

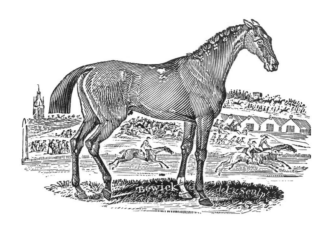

THE RACE HORSE.

IN Great Britain, the breed of Horses seems to be as mixed as that of its inhabitants. By great attention to the improvement of this noble animal, by a judicious mixture of several kinds, and by superior skill in management, the English Race Horse* is allowed to excel those of the rest of

* The following account of the prizes won by some of our capital Race Horses, will shew the importance of that breed in England, where such vast sums frequently depend on the issue of their contests :—

BAY MALTON (by Sampson), the property of the late Marquis of Rockingham, in seven prizes, won the amazing sum of 5,900*l*. At York he ran four miles in seven minutes and forty-three and an half seconds, which was seven and an half seconds less time than it was ever done in before over the same course.

CHILDERS (well known by the name of Flying Childers) the property of the Duke of Devonshire, was allowed by sportsmen to be the fleetest Horse that was ever bred in the world: he started repeatedly at Newmarket against the best Horses of his time, and was never beaten: he won, in different prizes, to the amount of nearly 2,000*l*.; and was afterwards reserved as a stallion. The sire of Childers was an Arabian, sent by a gentleman as a present to his brother in England.

DORIMANT, a famous Horse belonging to Lord Ossory, won prizes to the great amount of 13,363*l*.

Europe, or perhaps the whole world. For supporting a continuance of violent exertion (or what is called, in the language of the turf, *bottom*), they are superior to the Arabian, the Barb, or the Persian; and for swiftness, they will yield the palm to none. An ordinary Racer is known to go at the rate of a mile in less than two minutes; but there have been instances of much greater rapidity; the famous Horse, Childers, has been known to move eighty-two feet and a half in a second, or nearly a mile in a minute; he has run round the course at Newmarket, which is little less than four miles, in six minutes and forty seconds.

ECLIPSE was allowed to be the fleetest Horse that ever ran in England since the time of Childers. After winning king's plates and other prizes to a great amount, he covered, by subscription, forty mares, at thirty guineas each, besides those of his owner.

HIGHFLYER was accounted the best Horse of his time in England. The sums he won and received amounted to near 9,000*l.*, though he never started after five years old. He was never beaten, nor ever paid a forfeit.

MATCHEM, a Horse belonging to the late W. Fenwick, Esq. of Bywell, besides being a capital Racer, was particularly remarkable as a stallion, and may be truly said to have earned more money than any other Horse in the world. He was engaged, during nine years of his life, to cover twenty-five mares, at fifty guineas a mare, and was uncommonly successful in the celebrity of his progeny, having been sire to many of our most famous running Horses. He was remarkable for being the quietest stallion that ever was known; to which, perhaps, may be attributed his great age, being in his thirty-third year when he died.

SHARK won, besides a cup value 120 guineas, and eleven hogsheads of claret, the astonishing sum of 15,507 guineas, in plates, matches, and forfeits.

On the 25th March, 1799, a match for 3000 guineas was run at Newmarket, by Sir H. Vane Tempest's HAMBLETONIAN, and Mr. Cookson's DIAMOND, and won by the former. It was supposed that wagers to the amount of nearly *two hundred thousand pounds* were betted on the event of this severe race.

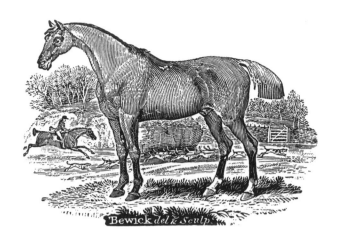

THE HUNTER.

Is a happy combination of the Race Horse with others of superior strength, but inferior in swiftness; and may be considered as the most useful breed of Horses in Europe. Their spirit and activity in the field are well known, and can only be equalled by the perseverance with which they endure the much more severe labour of posting on the road, which is now carried on by this active and hardy race, with a celerity unknown at any former period.

Geldings of this kind are sent over to the continent in great numbers: their superior worth is universally acknowledged abroad; and they are sold at very high prices, to foreigners of the first distinction.

The mixture of this with others of inferior rank, forms an endless variety, the different gradations becoming too minute to be discriminated.

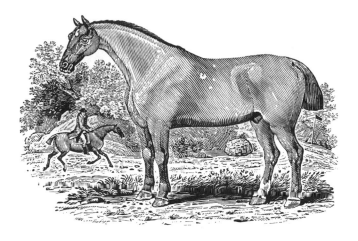

THE OLD ENGLISH ROAD HORSE.

IS a strong, vigorous, and active kind, capable of enduring great hardship; its stature rather low, seldom exceeding fifteen hands; the body round and compact, its limbs strong, and its head thick.

Although this breed has of late years been neglected, and almost totally superseded by Horses of another kind, more nearly related to the Race Horse, where the fashion of figure seems to have been preferred to utility, we cannot help congratulating our associated countrymen* on their spirited exertions towards public improvement, in which nothing of excellency in the various kinds of domestic animals is suffered to escape their vigilance, and this kind is again likely to be brought into notice. A mare of this breed, in the possession of Arthur Mowbray, Esq., of Sherburn, appears to us to possess all the valuable properties attributed to the old Road Horse.

* Agricultural societies.

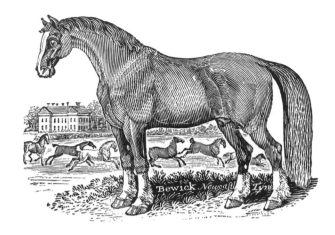

THE BLACK HORSE.

No other country has produced a breed of Horses equal in size and strength to the larger kind of our draught Horses. The cavalry of England formerly consisted of this class of Horses; but their inutility being experienced in most situations, others of a lighter and more active kind have been generally substituted, except in a few regiments. In the fens of Lincolnshire a larger breed of Horses is produced than in any other part of this kingdom. In London, there have been instances where a single Horse of that kind, has drawn, for a small space, the enormous weight of three tons, half of which is known to be their ordinary draught.

Considerable improvements have of late years been made in this kind of Horses, by Mr. Bakewell, of Dishley, and others; who, by great ingenuity and attention, have acquired such celebrity, that they frequently sell stallions of their

respective breeds for two hundred guineas; or, what is a more general practice, let them to hire by the season, for forty, eighty, or perhaps an hundred guineas; and some of them cover at five guineas a mare. The form of the black Lincoln-shire Horse has, by their management, been materially altered: the long fore-end, long back, and long thick hairy legs, have been gradually contracted into a short thick carcase, a short but upright fore-end, and shorter and cleaner legs; ex-perience having at length proved, that strength and activity, rather than height and weight, are the more essential properties of farm Horses.

Another advantage possessed by this improved breed, is its hardiness, or thriving quality: its being able to carry flesh, or stand hard work, with comparatively little provender. This hardiness of constitution, or natural propensity to thriving, the Leicestershire breeders assert is hereditary in par-ticular individual breeds or lines of Horses. If this observation be just, and that the feeding quality can be obtained with any degree of cer-tainty by management in breeding, in this as well as other kinds of live stock, it is a most interesting circumstance in the nature of domestic animals.

A strong, bony, and active kind of Horse is now used in our carriages, instead of the old black Coach Horse, which is almost universally laid aside. The docked tail, offensive both to humanity and decency, is rarely to be seen: propriety and good sense have at length prevailed over a custom replete with absurdity; and our Horses are per-mitted to retain a member both useful and ornamental. But we have still to regret, that the

cruel practice of forming the tail, by cutting and nicking it on the under side, is yet continued.

Although it would be impossible to trace out the kind of Horses with which our British ancestors opposed themselves to the legions of Julius Cæsar, on his landing in this country, yet that celebrated warrior himself bears testimony to their activity and discipline.

———

The *Ponies* of Wales, and those that are bred in the Highlands of Scotland, seem to be original and unmixed. They are both much esteemed for the neatness and beauty of their forms, for the nimbleness of their motions, and, above all, for being remarkably sure-footed on the most difficult roads, which renders them extremely valuable in the mountainous tracts to which they originally belong. Those of Shetland are the smallest of the genus, being in general much less than the Ass.

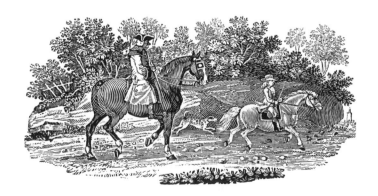

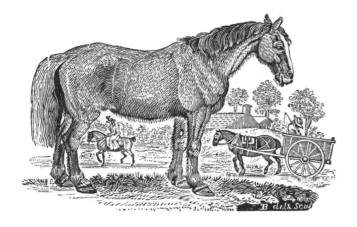

THE COMMON CART HORSE.

Is inferior to the Black Horse both in size and strength: his form is heavy, his motions slow, and his aspect without sprightliness: he is nevertheless extremely useful, and is employed in the business of agriculture and other domestic concerns.

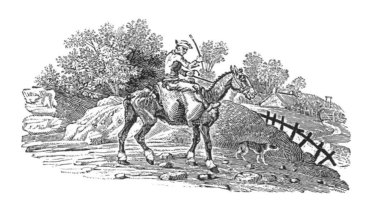

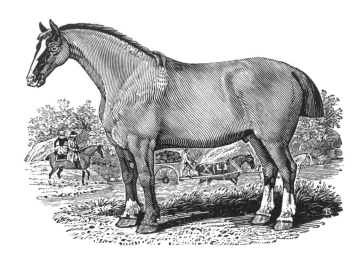

THE IMPROVED CART HORSE.

It will be gratifying to most of our readers to know that the spirit of improvement has extended itself greatly to this useful breed; and to the advantages of strength and docility, has added those of form, activity, and vigour. George, Baker, Esq. of Elemore, in the county of Durham, has a remarkably fine Horse of this kind, from which this figure was drawn.

Till of late years, *Pack Horses* were employed, in the northern counties of England, to carry the different manufactures and articles of traffic from one part of the kingdom to another; but the improved state of our roads has caused that mode of conveyance to be almost entirely laid aside. In their journies over trackless moors, they strictly adhered to the line of order and regularity custom

had taught them to observe: the leading Horse, which was always chosen for his sagacity and steadiness, being furnished with bells, gave notice to the rest, which followed the sound, and generally without much deviation, though sometimes at a considerable distance. The following anecdote will shew with what obstinate perseverance they have been known to observe the line of their order:— Some years ago, one of these Horses, which had been long accustomed to follow his leader, by accident or fatigue, was thrown into an inferior rank: the poor animal, as if sensible of his disgrace, by the most strenuous exertions, at length recovered his usual station, which he maintained during the remainder of the journey; but on his arrival at the inn-yard, he dropped down dead upon the spot, his life falling a sacrifice to his ambition,— a species of heroism we must admire even in the brute creation.

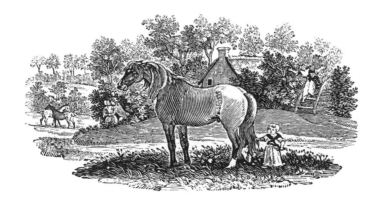

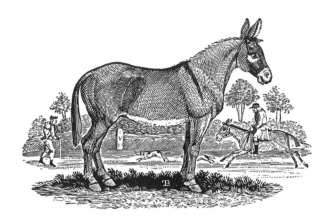

THE MULE.

THIS useful and hardy animal is the offspring of the Horse and the Ass, and being generally barren, furnishes an indisputable proof that the two species are perfectly distinct. Nature has providently stopped the further propagation of these heterogeneous productions, to preserve, uncontaminated, the form of each animal; without which regulation, the races would in a short time be mixed with each other, and every creature, losing its original perfection, would rapidly degenerate.

Mules have not unfrequently been known to bring forth young, especially in hot countries; and instances have not been wanting, though they are rare, both in England and Scotland. But it would require a succession of experiments to prove that Mules will breed with each other, and produce an offspring equally capable of continuing the race.

The common Mule is very healthy, and will live above thirty years. It is found very serviceable in

carrying burdens, particularly in mountainous and stony places, where horses are not so sure-footed. The size and strength of our breed have lately been much improved by the importation of Spanish male Asses; and it were much to be wished, that the useful qualities of this animal were more attended to: for, by proper care in its breaking, its natural obstinacy would in a great measure be corrected; and it might be formed with success for the saddle, the draught, or the burden.

People of the first quality in Spain are drawn by Mules, where fifty or sixty guineas is no uncommon price for one of them; nor is it surprising, when we consider how far they excel the Horse in travelling in a mountainous country, the Mule being able to tread securely where the former can hardly stand. Their manner of going down the precipices of the Alps, the Andes, &c., is very extraordinary; and with it we will conclude their history. In these passages, on one side, are steep eminences, and, on the other, frightful abysses; and as they generally follow the direction of the mountain, the road, instead of lying on a level, forms, at every little distance, deep declivities, of several hundred yards downward. These can be descended only by Mules; and the animal itself seems sensible of the danger, and the caution that is to be used in such descents. When they come to the edge of one of these precipices, they stop without being checked by the rider; and if he inadvertently attempt to spur them on, they continue immoveable. They seem all this time ruminating on the danger that lies before them, and preparing themselves for the encounter. They not only at-

tentively view the road, but tremble and snort at
the danger. Having prepared for the descent, they
place their fore feet in a posture as if they were
stopping themselves; they then also put their hind
feet together, but a little forward, as if they were
going to lie down. In this attitude, having taken
as it were a survey of the road, they slide down
with the swiftness of a meteor. In the mean time,
all the rider has to do is to keep himself fast on
the saddle, without checking the rein, for the least
motion is sufficient to disorder the equilibrium of the
Mule; in which case they both unavoidably perish.
But their address in this rapid descent is truly won-
derful; for in their swiftest motion, when they seem
to have lost all government of themselves, they fol-
low exactly the different windings of the road, as
if they had previously settled in their minds the
route they were to follow, and taken every precau-
tion for their safety. In this journey, the natives
place themselves along the sides of the mountains;
and, holding by the roots of the trees, animate the
beasts with shouts, and encourage them to per-
severe. Some Mules, after being long used to these
journies, acquire a kind of reputation for their safe-
ty and skill; and their value rises in proportion to
their fame.

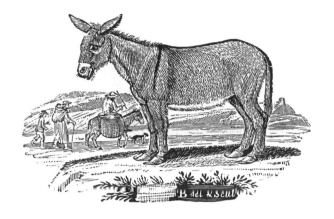

THE ASS.

(Equus Asinus, Linn.—L'Ane, Buff.)

THE Ass, it is probable, was originally a native of Arabia and other parts of the East: the deserts of Lybia and Numidia, and many parts of the Archipelago, contain vast herds of wild Asses, which run with such amazing swiftness, that even the fleetest Horses of the country can hardly over-take them. They are caught by the natives chiefly on account of their flesh, which is eaten by them, and considered as a delicious repast. The flesh of the common or tame Ass is, however, drier, and more tough and disagreeable than that of the Horse; Galen says, it is even unwholesome: its milk, on the contrary, is an approved remedy for certain disorders.

The Ass, like the Horse, was originally imported into America by the Spaniards, where it has run wild, and become extremely numerous. Ulloa informs us, that in the kingdom of Quito, they hunt them in the following manner:—A number of

persons on horseback, attended by Indians on foot, form a large circle, in order to drive them into a narrow compass, where at full speed they throw a noose over them, and having secured them with fetters, leave them till the chase is over, which frequently lasts for several days.

A warm climate is most favourable to the growth of this animal: the Ass produced in this country is much inferior in size and beauty to those of Spain and other warm countries: in Guinea, they are larger and more beautiful than even their Horses: in Persia, they have two kinds,—the one slow and heavy, which is made use of for carrying burdens; the other nimble, smooth, and stately, used chiefly for the saddle.

Holingshed informs us that in the reign of queen Elizabeth, there were no Asses in this country: how soon after they might be introduced, is uncertain. However, they are at present naturalized in this kingdom, where their utility becomes daily more universally experienced.

The qualities of this animal are so well known, as to need no description: his gentleness, patience, and perseverance, are without example: he is temperate with regard to food, and eats contentedly the coarsest and most neglected herbage: if he give the preference to any vegetable, it is to the plantain, for which he will neglect every other herb in the pasture. In his water he is singularly nice, drinking only from the clearest brooks. He is so much afraid of wetting his feet, that, even when loaden, he will turn aside, to avoid the dirty parts of the road.

He is stronger, in proportion to his size, than the Horse; but more sluggish, stubborn, and untract-

able. He is hardier than the Horse; and of all other quadrupeds, is least infested with lice or other vermin; probably owing to the extreme hardness and dryness of his skin. For the same reason, perhaps, he is less sensitive of the lashes of the whip, or the stinging of flies.

He is three or four years in coming to perfection; and lives to the age of twenty, or sometimes twenty-five years. He sleeps much less than the Horse, and seldom lies down for that purpose but when he is much fatigued. The She-Ass goes eleven months with young, and seldom produces more than one at a time.

The services of this useful creature are too often repaid by hard fare and cruel usage; and being generally the property of the poor, it partakes of their wants and their distresses: whereas, by due cultivation and care in its education, the Ass might be usefully and profitably employed in a variety of domestic purposes, and in many cases supply the place of the Horse, to which only it is second, though generally degraded into the most useless and neglected of domestic quadrupeds.

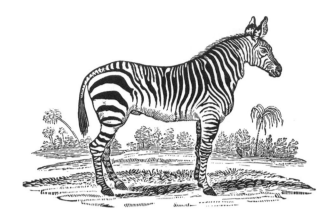

THE ZEBRA.

(Equus Zebra, Linn.—*Le Zebre*, Buff.)

MANY authors have mistaken the Zebra for a
wild Ass: it is one of the most beautiful, and also
one of the wildest and most untameable animals in
nature. It is larger than the Ass, and rather
resembles the Mule in shape: its head is large; its
ears long; its legs beautifully small, and well
placed; and its body well formed, round, and
fleshy: but the beauty of its shape is greatly
heightened by the glossy smoothness of its skin,
and the amazing regularity and elegance of its
colours, which in some are white and brown, and
in others white and black, ranged in alternate
stripes over the whole body, in a style so beautiful
and ornamental, that it would at first sight seem
rather the effect of art, than the genuine production
of nature: the head is striped with fine bands of
black and white, which form a centre in the fore-
head; the neck is adorned with stripes of the same
colour running round it; the body is beautifully

variegated with bands running across the back, and ending in points at the belly; its thighs, its legs, its ears, and even its tail, are all beautifully streaked in the same manner.

The Zebra inhabits the southern parts of Africa, where whole herds are seen feeding on those extensive plains that lie towards the Cape of Good Hope. However, their watchfulness is such, that they will suffer nothing to come near them; and their swiftness so great, that they easily leave their pursuers far behind.

Such is the beauty of this creature, that it seems by nature fitted to gratify the pride, and formed for the service of man; and it is most probable, that time and assiduity alone are wanting to bring it under subjection. As it resembles the Horse in regard to its form, as well as manner of living, there can be little doubt but it possesses a similitude of nature, and only requires the efforts of an industrious and skilful nation, to be added to the number of our useful dependents. Nevertheless, its liberty has hitherto remained uncontroled, and its natural fierceness has as yet resisted every attempt to subdue it: those that have been brought to this country, have discovered a degree of viciousness which rendered it unsafe to approach them too familiarly; but it is by no means to be concluded from hence, that they are untameable. They have continued to be wild, because they are natives of a country where the wretched inhabitants have no other idea of advantage from the animal creation than as they are good for food, paying more regard to that which affords the most delicious repast, than to delicacy of colouring, or beauty of conformation.

RUMINATING ANIMALS.

THE various animals of this kind are entirely
confined to grain and herbage for their nourish-
ment and support; it is therefore necessary that
they should be enabled to receive a large quantity
into the stomach, as well as to retain it a consider-
able time before it be reduced to proper chyle: for
this purpose, their intestines are remarkably long
and capacious, and formed into a variety of fold-
ings. They are furnished with no less than four
stomachs. The food, after mastication, is thrown
into the first stomach, where it remains for some
time; after which it is forced up again into the
mouth, and undergoes a second chewing: it is then
sent directly into the second stomach, and gradu-
ally passes into the third and fourth; from whence
it is transmitted through the convolutions of the
intestines. By this conformation, ruminating ani-
mals are enabled to devour large quantities of
vegetable aliment, to retain it long in their bowels,
and consequently extract from it a quantity of nu-
tritious matter sufficient for their growth and sup-
port.

The great obligations we are under to those of
this class, render them objects of the highest im-
portance to us. We are nourished with their milk,
we are supported by their flesh, and we are clothed
and warmed with their fleeces: their harmlessness
and innocence endear them to us, and claim from
us that protection which their natures seem to re-
quire: and, in return, they supply us with the
necessaries and comforts of life.

THE OX KIND.

(Bos Taurus, Linn.—*Le Taureau*, Buff.)

OF all quadrupeds, the Cow seems most exten-
sively propagated: it is equally capable of enduring
the rigours of heat and cold; and is an inhabitant
of the frozen, as well as the most scorching cli-
mates. Other animals preserve their nature or
their form with inflexible perseverance; but these,
in every respect, suit themselves to the wants and
conveniences of mankind. In no animal is there
to be met with a greater variety of kinds; and in
none, a more humble and pliant disposition.

The climate and pastures of Great Britain are
well adapted to the nature of this animal; and we
are indebted to the variety and abundance of our
wholesome vegetables, for the number and excel-
lence of our cattle, which range over our hills, and
enliven our plains—a source of inexhaustible wealth
—the pride and boast of this happy country.

Being destitute of the upper fore teeth, the Cow
prefers the high and rich grass in pastures, to the
short and more delicate herbage generally selected
by the Horse. For this reason, in our English
pastures, where the grass is rather high and flour-
ishing, than succulent and nutritious, the Cow
thrives admirably; and there is no part of Europe
in which this animal grows larger, yields more
milk, or fattens sooner.

It has often been remarked, that the Horse and
Sheep impoverish the soil on which they graze;
whilst the pasture where the Cow is fed acquires a

finer surface, and every year becomes more level and beautiful: the Horse selects the grass that is most delicate and tender; and being furnished with fore teeth on each jaw, nips it close, and frequently pulls it up by the roots, thereby preventing its future growth and propagation: the Sheep also, though formed like the Cow with respect to its teeth, only bites the most succulent parts of the herbage.

The age of a Cow is known by its horns: at the age of four years, a ring is formed at their roots; and every succeeding year another ring is added. Thus, by allowing three years before their appearance, and then reckoning the number of rings, the creature's age may be exactly known.

The quantity of milk given by Cows is very various: some will yield only about six quarts in one day; while others give from ten to fifteen, and sometimes even twenty. The richness of the pasture contributes not a little to its increase. There have been instances of Cows giving upwards of thirty quarts of milk in one day. In such cases there is a necessity for milking them thrice. From the milk of some Cows, twelve or fourteen pounds of butter are made in a week.

It has been advanced by some naturalists, as a general principle, that neither animals nor parts of animals, appear to be primarily intended for the use of man, but are only capable of a secondary application to his purposes: yet it must be allowed that, in many instances, what they term the secondary use, is so manifest and important, that it cannot, with propriety, be supposed to be excluded from the original design of the all-wise Creator: and it

must be allowed that the Cow, in its faculty of
giving, in such abundance and with so much
ease, its milk, which forms so rich and nutritive an
aliment for the human species, is a striking ex-
ample of this subordination to the interests of
mankind: for this animal differs, in some parts of
its organization, from most others, having a larger
and more capacious udder, and longer and thicker
teats, than the largest animal we know of: it has
likewise four teats, whilst all other animals of the
same nature have but two: it also yields the milk
freely to the hand, whilst most animals, at least
those that do not ruminate in the same manner,
refuse it, except their own young, or some adopted
animal, be allowed to partake.

The Cow having four teats is a striking peculiar-
ity; the number in all other animals bearing some
proportion to the number of young ones they bring
forth at a time; as in the Bitch, the Cat, the
Sow, &c.

The Cow will yield her milk as freely, and will
continue to give it as long, without the aid of the
calf, as if it were permitted to suck her constantly.
This is not the case with the Ass; which, it is well
known, will soon grow dry, if her foal be not per-
mitted to suck part of her milk every day.

Upon the whole, it appears that the property of
yielding milk, without the young one, is confined
to those kinds of ruminating horned animals which
have cloven hoofs, four stomachs, long intestines,
are furnished with suet, and have no fore teeth
in the upper jaw; that Cows, Sheep, Goats, and
Deer, are of this kind, and no other; and that
the Cow has this property in a more eminent

degree than others, owing to the capaciousness
of her udder, and the size and form of her teats.

The Cow goes nine months with young, and
seldom produces more than one at a time.

It is a curious fact, that when a Cow happens to
bring forth two calves,—one of them a male, the
other a female,—the former is a perfect animal, but
the latter is incapable of propagation, and is well
known to farmers under the denomination of a *Free
Martin*. It resembles the Ox, or spayed Heifer, in
figure; and is considerably larger than the Cow. It
is sometimes preserved by the farmer, for the pur-
pose of yoking with the Oxen, or fattening for the
table. Mr. Hunter observes, that the flesh of the
Free Martin, like that of the Ox, is much finer in
the fibre than either the Bull or Cow. It is sup-
posed to exceed that of the Heifer in delicacy of
flavour, and bears a higher price at market.

By great industry and attention to their breed,
and by judicious mixtures with those of other coun-
tries, our horned cattle are universally allowed to
be the finest in Europe; although such as are
purely British are inferior in size to those on many
parts of the continent.

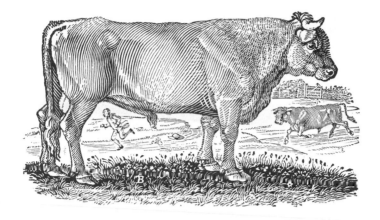

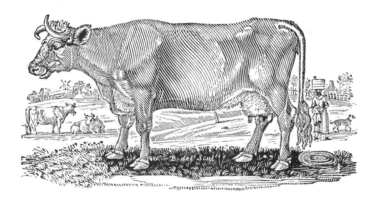

THE HOLSTEIN, OR DUTCH BREED.

HAS been introduced with great success, and is
now the prevailing stock in all the counties on the
eastern coast of this kingdom. In good pastures,
cattle of this kind grow to a great size;* and the
cows yield a greater abundance of milk than those
of almost any other kind.

* An Ox, fed by Mr. Edward Hall, of Whitley, in Northumber-
land, and killed in March, 1789, when seven years old, measured,
from the head to the rump, nine feet eight inches and a half; the

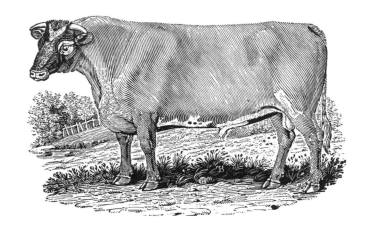

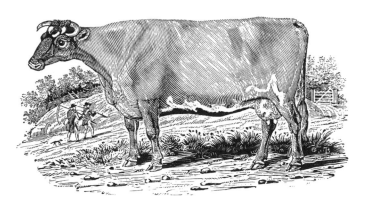

THE IMPROVED HOLSTEIN, OR DUTCH BREED.

THE rapid improvements which have taken place in this and other kinds, form an interesting subject of enquiry, of which the limits of our work will only allow us to give the outlines. We shall, however, notice the general principles which have

height at the shoulder, was five feet ten inches; and it weighed, without the offal, one hundred and eighty-seven stones five pounds— fourteen pounds to the stone.

been laid down, and steadily adhered to, in the improvement of the several breeds of cattle; and which have been so successfully brought into practice. The first, and most obvious, is beauty of form, a principle which has been in common applied to every species of domestic cattle, and, with great seeming propriety, was supposed to form the basis of every kind of improvement, under an idea, that beauty of form and utility were inseparable. But at present a distinction is made, by men who have been long conversant in practice, between a useful sort and a sort that is merely handsome. Utility of form is therefore the next general principle, and may be considered as arising from a larger proportion of those parts which are the most useful: thus, for instance, all those parts which are deemed *offal*, or which bear an inferior price, should be small in proportion to the better parts. A third principle of improvement, laid down by breeders, consists in the fineness of the muscular parts, or what is termed *flesh*. But the great object which engrosses the attention of breeders at present, is the *fattening quality*, or a natural propensity in cattle to arrive at a state of fatness at an early age, and in a short space of time: and it appears, from observation, that beauty and utility of form, the quality of the flesh, and a propensity to fatness, are principles consistent with each other, are frequently found united in the same individual, and hereditary in particular lines or families of cattle. In regard to the means of improvement, it has long been an established maxim, that, to improve the breed, it is necessary to cross it with others of an alien stock, under an opinion, that continuing to breed

from the same line, weakens the stock. This idea,
however rooted it may have been in the minds of
former practitioners, is now entirely set aside by
the modern practice of breeding, not from the same
line only, but from the same family: the sire and
the daughter, the son and the mother, the brother
and sister, are now permitted to improve their own
kind. This practice is well known under the term
of breeding *in-and-in;* and, in this way, the im-
provement of the several breeds have advanced
rapidly to a height unknown before in any age or
nation.

The practice of letting out Bulls by the season
has contributed very materially towards the im-
provement of this valuable breed; as by this
means, one Bull, instead of being useful to his
proprietor only, may, in a few years, extend the
benefits of his stock through a whole district; and
so fully are the stock-masters convinced of its
advantages, that eighty guineas have been given
for the use of a Bull for one season. Some Bulls
are in such estimation, as to leap at the extra-
ordinary price of five guineas a Cow: and it is
perhaps a circumstance worth mentioning, that Mr
Fowler, of Rollright, in Oxfordshire, in 1789, for
ten Bull calves, refused five hundred guineas.*

* This valuable stock was sold off in March, 1791, at the following
enormous prices, viz. :—

Garrick, a five-years old Bull,	205	guineas.
Sultan, two years old,	210	,,
Washington, two years old	205	,,
Young Sultan, a yearling Bull,	200	,,
Two yearling Bulls,	245	,,
Brindled Beauty, a Cow,	260	,,
Washington's Mother, in calf,	185	,,
Some of the Rams sold as high as	60	,,

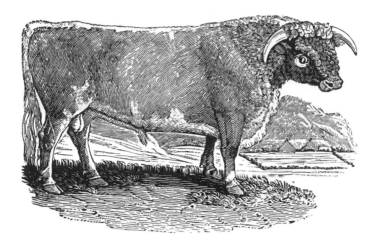

THE LONG-HORNED, OR LANCASHIRE BREED.

Is common in Lancashire, Westmorland, and Cumberland, and some of the neighbouring counties; and, notwithstanding the changes which have taken place by the introduction of foreign kinds, there is reason to believe that this, for a considerable time at least, has been the prevailing stock of the kingdom at large.

Mr. Marshall, in his excellent treatise on the "Economy of the Midland Counties," observes, that from this kind the present improved breed of cattle in Leicestershire is traceable, by the most indisputable evidence. From Bulls brought out of Westmorland and Lancashire, and Cows from the banks of the Trent, the celebrated *Canley breed*, the property of Mr. Webster, derived its origin; and about fifty years ago it was esteemed the most

valuable at that time in the kingdom. From this
breed, the late Mr. Bakewell obtained the source
of his superior stock of cattle; and several other
eminent breeders are also indebted to the same
origin for the celebrity they have since obtained.

Great improvements have of late years been
made in the *old Lancashire kind*, both in size and
beauty. Craven, in Yorkshire, has long been cele-
brated for a superior variety of the long-horned
kind; and from thence the graziers of Westmorland
and Lancashire purchased the flower of their
Heifers; which, by crossing with the original stock
of those counties, have produced a breed, which is
now had recourse to, for the improvement of this
kind of cattle, in every part of the kingdom.
Some of the Bulls are extremely large. Their
horns are not long, but beautifully turned; their
hair short and smooth; their crests rise extremely
high; their chests are let down to their knees;
their bodies are long and in the form of a perfect
cylinder.

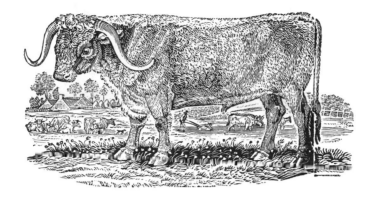

THE LANCASHIRE OX.

THE Cows and Oxen are smaller. Their horns are long and small, very smooth; and their colour, in general, approaches to yellow: their hair is beautifully curled; and their whole form extremely handsome. The Oxen frequently grow to a considerable size, are very active, and consequently useful in the draught. They are well suited to a cold climate, and grow fat on indifferent pastures.

In Scotland there are two kinds, which differ greatly from each other, as well as from all those in the southern part of this island.

Those of the county of Galloway are without horns, and generally of a reddish-brown colour, mixed with black. Large droves of these are yearly brought into the southern parts of the kingdom, where they soon greatly improve.

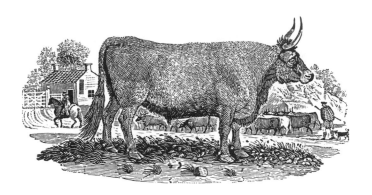

THE KYLOE OX.

THE Highland Cattle, and those bred in the Western Islands, are very small, and partake much of the wildness of the country of which they are natives. They are mostly black, with fine white horns, very sharp, and black at the points; their hair is thick and furry. Great numbers of them are annually sold into England at the great northern fairs. They are greatly esteemed for the fineness and sweetness of their beef, as well as for the facility with which they acquire a considerable degree of fatness, even with moderate feeding.

Although the Oxen of this breed, when fed in the ordinary way, do not exceed forty stones the four quarters, one of them, fed by Mr. Spearman, of Rothley Park, in Northumberland, weighed, when killed in 1790, at the age of six years, eighty-one stones.

In Great Britain, the Ox is the only horned animal that will apply his strength to the service of mankind; and, in general, is more profitable

than the Horse for the plough or the draught. There is scarcely any part of this animal without its use: the skin is made into various kinds of leather; the hair is mixed with lime for plastering; the bones are made use of as a substitute for ivory, and, being calcined, are used by the refiner as an absorbent to carry off the baser metals in refining silver, &c.; combs, and many other articles are made of the horns; we are supplied with candles from the tallow; and from the feet is procured an oil, of great use in preparing and softening leather; besides the well-known benefits derived from butter, milk, and cheese; its blood, gall, liver and urine, have their respective uses in manufactures and medicine.

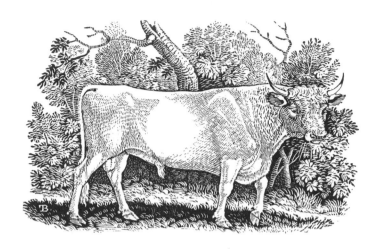

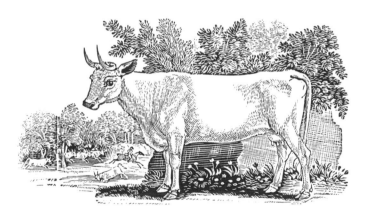

WILD CATTLE.

THERE was formerly a very singular species of
Wild Cattle in this country, which is now nearly
extinct. Numerous herds of them were kept in
several parks in England and Scotland; but they
have been destroyed by various means: and the
only breeds now remaining in the kingdom, are
in the park at Chillingham Castle, in Northumber-
land; at Wollaton, in Nottinghamshire, the seat of

Lord Middleton; at Gisburne, in Craven, York-shire; at Lime Hall, in Cheshire; and at Chartley, in Staffordshire.

The principal external appearances which dis-tinguish this breed of cattle from all others, are the following: Their colour is invariably white; muzzles black; the whole of the inside of the ear, and about one-third of the outside, from the tip downwards, red*; horns white, with black tips, very fine, and bent upwards: some of the Bulls have a thin upright mane, about an inch and a half or two inches long.

At the first appearance of any person, they set off in full galop, and at the distance of two or three hundred yards, make a wheel round, and come boldly up again, tossing their heads in a menacing manner: on a sudden they make a full stop, at the distance of forty or fifty yards, looking wildly at the object of their surprise; but upon the least motion being made, they all again turn round, and run off with equal speed, but not to the same distance: forming a shorter circle, and again returning with a bolder and more threatening aspect than before, they approach much nearer, probably within thirty yards; when they make another stand, and again run off: this they do several times, shortening their distance, and ad-

* About twenty years since, there were a few, at Chillingham, with BLACK EARS, but the present park-keeper destroyed them; since which period there has not been one with black ears. The ears and noses of all those at Wollaton, are BLACK. At Gisburne there are some perfectly WHITE, except the inside of their ears, which are BROWN. They are without horns, very strong boned, but not high. They are said to have been originally brought from Whalley-abbey, in Lancashire, upon its dissolution in the thirty-third of Henry the Eighth. Tradition says, they were drawn to Gisburne by the 'power of music.'

vancing nearer, till they come within ten yards;
when most people think it prudent to leave them,
not chusing to provoke them further; for there is
little doubt but in two or three turns more they
would make an attack.

The mode of killing them was, perhaps, the only
modern remains of the grandeur of ancient hunting.
On notice being given that a Wild Bull would be
killed on a certain day, the inhabitants of the
neighbourhood came mounted, and armed with
guns, &c., sometimes to the amount of an hundred
horse, and four or five hundred foot, who stood
upon walls, or got into trees, while the horsemen
rode off the Bull from the rest of the herd, until he
stood at bay: when a marksman dismounted and
shot. At some of these huntings twenty or thirty
shots have been fired before he was subdued. On
such occasions, the bleeding victim grew desperate-
ly furious, from the smarting of his wounds, and
the shouts of savage joy that were echoing from
every side; but, from the number of accidents that
happened, this dangerous mode has been little prac-
tised of late years; the park-keeper alone generally
shooting them with a rifled gun, at one shot.

When the Cows calve, they hide their calves for
a week or ten days in some sequestered situation,
and go and suckle them two or three times a day.
If any person come near the calves, they clap their
heads close to the ground, and lie like a hare in
form, to hide themselves: this is a proof of their
native wildness, and is corroborated by the follow-
ing circumstance that happened to the writer of
this narrative, who found a hidden calf, two days
old, very lean and very weak:—On stroking its
head, it got up, pawed two or three times like an

old Bull, bellowed very loud, stepped back a few steps, and bolted at his legs with all its force; it then began to paw again, bellowed, stepped back, and bolted as before; but knowing its intention, he stepped aside, and it missed him, fell, and was so very weak that it could not rise, though it made several efforts: but it had done enough; the whole herd were alarmed, and coming to its rescue, obliged him to retire; for the dams will allow no person to touch their calves, without attacking them with impetuous ferocity.*

When any one happens to be wounded, or is grown weak and feeble through age or sickness, the rest of the herd set upon it and gore it to death.

The weight of the Oxen is generally from forty to fifty stones the four quarters: of the Cows about thirty. The beef is finely marbled, and of excellent flavour.

Those at Burton-Constable, in the county of York, were all destroyed by a distemper a few years since. They varied slightly from those at Chillingham, having black ears and muzzles, and the tips of their tails of the same colour: they were also much larger, many of them weighing sixty stones; probably owing to the richness of the pasturage in Holderness, but generally attributed to the difference of kind between those with black and with red ears, the former of which they studiously endeavour to preserve. The breed which was at Drumlanrig, in Scotland, had also black ears.

* Tame Cows, in season, are frequently turned out amongst the Wild Cattle at Chillingham, and admit the Bull. It is somewhat extraordinary, that the calves produced by this mode are invariably of the same colour with the wild breed (white with red ears), and retain a good deal of the fierceness of their sire.

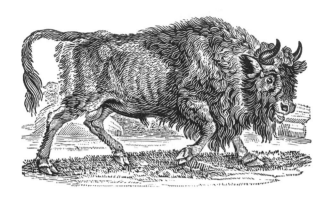

THE URUS, OR WILD BULL.

Is chiefly to be met with in the extensive forests of Lithuania. It grows to a size almost equal to the Elephant, and is quite black; the eyes are red and fiery, the horns thick and short, and the forehead covered with a quantity of curled hair; the neck is short and strong, and the skin has an odour of musk. The female, though not so big as the male, exceeds the largest of our Bulls in size; nevertheless, her udder is extremely small. Upon the whole, however, this animal, which greatly resembles those of the tame kind, probably owes its variety to its natural wildness, and the richness of the pastures where it is produced.

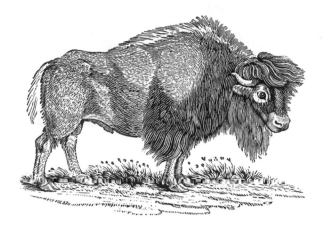

THE BISON.

(Bos Bison, Linn.*—Le Bison Amerique,* Buff.)

DIFFERS from the rest of the Ox kind, in having
a large lump between its shoulders, almost as high
as that of a Camel. He has a long shaggy mane,
which forms a kind of beard under his chin; his
eyes are fierce, his forehead large, and his horns
extremely wide. It is dangerous to pursue him,
except in forests abounding with trees large enough
to conceal the hunters. He is generally taken in
pits covered with branches of trees and grass, on
the opposite side of which the hunters tempt the
animal to pursue them; and the enraged creature
running towards them, falls into the trap prepared
for it, and is then overpowered and slain.

The Bison, or the animal with the hump, is found
in all the southern parts of the world, though
greatly differing from each other in size and form.

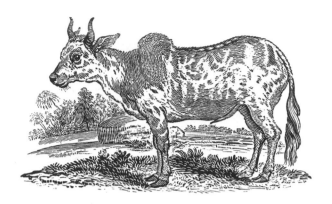

THE ZEBU.

THEY are all equally docile and gentle, when tamed; and are in general covered with fine glossy hair, softer and more beautiful than that of the common Cow. Their humps are of different sizes, in some weighing from forty to fifty pounds, but in others less. That part is in general considered as a great delicacy; and, when dressed, has much the appearance and taste of udder.

The Bisons of Madagascar and Malabar are of the great kind; those of Arabia Petrea, and most parts of Africa, are of the Zebu or small kind.

In America, especially towards the North, the Bison is well known. They herd together, in droves of from one to two hundred, on the banks of the Mississippi, where the inhabitants hunt them: their flesh is esteemed good eating.

They all breed with the tame Cow. The hump, which is only an accidental characteristic, gradually declines; and in a few generations, no vestiges of it remain. Thus we see, whether it be the wild

or the tame Ox, the Bonasus or the Urus, the Bison or the Zebu, by whatever name they are distinguished, or however variously classed by naturalists, in reality they are the same; and, though diversified in their appearance and properties, are descendants of one common stock; of which the most unequivocal proof is, that they all mix and breed with each other.

The *Oxen* of India are of different sizes, and are made use of in travelling, as substitutes for Horses. Instead of a bit, a small cord is passed through the cartilage of the nostrils, which is tied to a larger cord, and serves as a bridle. They are saddled like Horses; and, when pushed, move very briskly. They are likewise used in drawing chariots and carts. For the former purpose, white Oxen are in great esteem, and much admired. They will perform journies of sixty days, at the rate of from twelve to fifteen leagues a day; and their travelling pace is generally a trot.

In Persia, there are many *Oxen* entirely white, with small blunt horns, and humps on their backs. They are very strong, and carry heavy burdens. When about to be loaded, they drop down on their knees like the Camel, and rise when their burdens are properly fastened.

THE GRUNTING OX.

(Bos Grunniens, Linn.—*La Vache de Tartarie*, Buff.)

THE Sarluc, or Grunting-Cow of Tartary, from its resemblance to the Bison, may be considered as belonging to the same species: its horns are short, upright, slender, and very sharp; the hair on its body is black, except the mane and the ridge of the back, where it is white; its whole body is covered with very long hair, which hangs down below its knees, and makes its legs appear short: it has a hump on its back; its tail resembles that of a Horse, is white, and very bushy; it strikes with its head like a goat, and is very unruly: its distinguishing peculiarity is, that it makes a grunting noise like a Hog, instead of lowing like the Ox, which in every other instance it greatly resembles. It abounds in the kingdom of Thibet, where it is domesticated.

The wild breed, called *Bucha*, is extremely fierce. When wounded, it will sometimes turn upon its assailant, and attack him with great fury. It copulates with the tame Cow. Their produce is employed in domestic purposes.

Its tail is very valuable, and is sold at a great price in Thibet. When mounted on a silver handle, it is used, by the principal men in India, as a brush to chase away the flies. It is sometimes fastened, as an ornament, to the ear of the Elephant. The Chinese dye the hair red, and form it into tufts to adorn their bonnets.

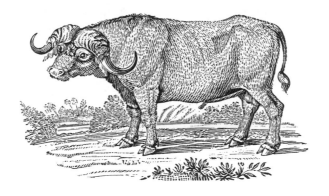

THE BUFFALO.

(Bos Bubalus, Linn.—*Le Buffle*, Buff.)

THERE is the most striking general resemblance between the Buffalo and the common Ox; their habits and propensities are nearly similar; they are both equally submissive to the yoke, and may be employed in the same domestic services; yet it is certain, from experience, that no two animals of the same genus can, in reality, be more distinct: the Cow refuses to breed with the Buffalo, while it is known to propagate with the Bison, to which it bears, in point of form, a much more distant similitude.

The Buffalo is found, in a wild state, in many parts of Africa, and India, and is common in the countries near the Cape of Good Hope, where he is described, by Sparrman, as a fierce, cruel, and treacherous animal. He frequently rushes from behind a thicket upon some unwary passenger; and, having thrown him down, tramples him to death with his feet and knees, tearing him with his horns and teeth, and licking him with his rough tongue, till the skin is nearly stripped

from the body. The following accurate descrip-
tion we owe to the same author:—The length
of the Buffalo, from head to tail, is eight feet;
the height five and a half; and the fore legs
two feet and a half long: from the tip of the
muzzle to the horns, twenty-two inches; his limbs,
in proportion to his size, are much stouter than
those of the Ox; his fetlocks likewise hang near
the ground: the horns are singular, both in their
form and position; the bases of them are thirteen
inches broad, and only an inch distant from each
other, having a narrow channel or furrow between
them; from this furrow the horns assume a spheri-
cal form, extending over a great part of the head:
the distance between the points is often above five
feet: the ears are a foot long, somewhat pendulous,
and in a great measure covered and defended by
the lower edges of the horns, which bend down on
each side, and form a curve upwards with the
points: their hair is of a dark brown colour, about
an inch long, harsh, and, upon those males that are
advanced in years, straggling and thin, especially
on each side of the belly, which gives them the ap-
pearance of being girt with a belt; the tail is short,
and tufted at the end: the eyes are large, and
somewhat sunk within their prominent orbits,
which are almost covered with the bases of the
horns overhanging its dangling ears; this, with a
peculiar inclination of the head to one side, pro-
duces an aspect at once fierce, cunning, and tre-
mendous: the flesh is coarse, rather lean, but full
of juice of a high but not unpleasant flavour: the
hide is thick and tough, and of great use in making
thongs and harness; it is so hard, as not to be

penetrated by a common musket-ball; those made use of for shooting the Buffalo are mixed with tin; and even these are frequently flattened by the concussion.

In Italy the Buffalo is domesticated, and constitutes the riches and food of the poor, who employ them for the purposes of agriculture, and make butter and cheese from their milk.

The female produces but one at a time, and continues pregnant twelve months; another striking characteristic difference between the Buffalo and the common Cow.

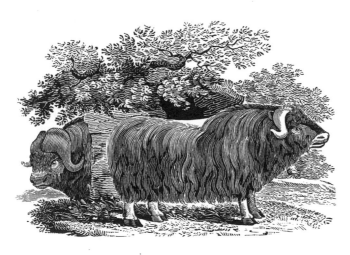

THE MUSK-BULL.

INHABITS the interior parts of North America, on the west side of Hudson's Bay, between Churchill and Seal rivers. They are very numerous in those parts, and live in herds of twenty or thirty. The Indians eat the flesh, and make coverings of their skins. They are brought down in sledges, to supply the forts during the winter. Notwithstanding

the flesh is said to have a strong flavour of musk, it is reckoned very good and wholesome.

The Musk-Bull is somewhat lower than a Deer, but more bulky. Its legs are short; and it has a small hump on its shoulder: its hair is of a dusky-red colour, very fine, and so long as to reach to the ground: beneath the hair, its body is covered with wool of an ash colour, which is exquisitely fine, and might be converted into various articles of useful manufacture: Mr. Jeremie says, that stockings made of it are finer than silk. Its tail is only three inches long, and is covered with long hairs, of which the Esquimaux Indians make caps, which are so contrived, that the long hair, falling round their faces, defends them from the bites of the musquitos: its horns are close at the base, they bend downwards, and turn out at the points; they are two feet long, and two feet round at the base; some of them will weigh 6olbs.

These animals delight chiefly in rocky and mountainous countries: they run nimbly, and are very active in climbing steep ascents.

———

THE SHEEP.

(Ovis Aries, Linn.—*La Brebis*, Buff.)

THE Sheep, in its present domestic state, seems so far removed from a state of nature, that it may be deemed a difficult matter to point out its origin. Climate, food, and above all, the unwearied arts of cultivation, contribute to render this animal, in a peculiar manner, the creature of man; to whom it is obliged to trust entirely for its protection, and to whose necessities it largely contributes. Though

singularly inoffensive, and harmless even to a pro-
verb, it does not appear to be that stupid, inanimate
creature, described by Buffon, "devoid of every
art of self-preservation, without courage, and even
deprived of every instinctive faculty, we are led
to conclude that the Sheep, of all other animals,
is the most contemptible and stupid:" but amidst
those numerous flocks which range without control
on extensive mountains, where they seldom depend
upon tho aid of the shepherd, it will be found to
assume a very different character: in those situa-
tions, a Ram or a Wedder will boldly attack a
single Dog, and often come off victorious; but
when the danger is more alarming, they have re-
course to the collected strength of the whole flock.
On such occasions they draw up into a compact
body, placing the young and the females in the
centre; while the males take the foremost ranks,
keeping close by each other. Thus an armed front
is presented to all quarters, and cannot easily be
attacked without danger or destruction to the as-
sailant. In this manner they wait with firmness
the approach of the enemy; nor does their courage
fail them in the moment of attack: for when the
aggressor advances within a few yards of the line,
the Rams dart upon him with such impetuosity, as
to lay him dead at their feet, unless he save him-
self by flight. Against the attacks of single Dogs
or Foxes, when in this situation, they are perfectly
secure. A Ram, regardless of danger, will some-
times engage a Bull; and, as his forehead is much
harder than that of any other animal, he seldom
fails to conquer: for the Bull, by lowering his
head, receives the stroke of the Ram between his
eyes, which usually brings him to the ground.

In the selection of their food, few animals dis-
cover greater sagacity than the Sheep: nor does
any domestic animal shew more dexterity and
cunning in its attempts to elude the vigilance of
the shepherd, in order to steal such delicacies as
are agreeable to its palate.

Besides its hardiness in enduring great severi-
ties of weather, the natural instinct of the Sheep,
in foreseeing the approach of a storm, is no less
remarkable: in their endeavours to secure them-
selves under the shelter of some hill, whole flocks
have frequently been buried for many days under
a covering of snow, and have afterwards been
taken out without any material injury. Thus
beautifully described by Thomson :—

> " Oft the whirlwind's wing
> " Sweeps up the burthen of whole wintry plains
> " At one wide waft; and o'er the hapless flocks,
> " Hid in the hollow of two neighbouring hills,
> " The billowy tempest whelms."

There have been instances where Sheep, at the
approach of a storm, have fled for shelter to a
neighbouring cottage, and taken refuge with their
shepherd.

The variety in this creature is so great, that scarce-
ly any two countries produce Sheep of the same kind:
there is found a manifest difference in all, either in
the size, the covering, the shape, or the horns.

The *woolly Sheep* is found only in Europe, and in
the temperate provinces of Asia. When transported
into warmer climates, it loses its wool, and becomes
hairy and rough; it is likewise less fertile; and its
flesh no longer retains the same flavour.

No country produces finer Sheep than Great
Britain: their fleeces are large, and well adapted
to the various purposes of clothing. The Spanish

fleeces are indeed finer, but stand in no degree of comparison with those of Lincolnshire or Warwickshire for weight or utility. In Edward the Third's time, when wool was allowed to be exported, it brought 150,000*l.* per annum, at 2*l.* 10*s.* a pack, which was a great sum in those days. At this time, when our woollen manufactory stands unrivalled by any nation in the world, and every method is taken to prevent this valuable commodity from being sent out of the kingdom, the annual value of wool, shorn in England, is supposed to be about five millions sterling; and when manufactured conjointly with the Spanish wool imported, amounting to about six hundred thousand pounds, must be above twenty millions.

Like other ruminating animals, the Sheep wants the upper fore teeth: it has eight in the lower jaw; two of which drop out, and are replaced at two years old; four of them are renewed at three years, and the remainder at the age of four.

The Ewe produces one or two lambs at a time, and sometimes, though rarely, three or four. She bears her young five months, and brings forth in the spring. The Ram lives to the age of about fifteen years, and begins to procreate at one. When castrated, they are called Wedders: they then grow sooner fat, and the flesh becomes finer and better flavoured.

There is hardly any part of this animal that is not serviceable to man: of the fleece we make our clothes; the skin produces leather, of which are made gloves, parchment, and covers for books; the entrails are formed into strings for fiddles and other musical instruments, likewise coverings for whips; its milk affords both butter and cheese; and its flesh is delicate and wholesome food.

The following remarks, taken from Mr. Culley's "Observations on Live Stock," will not be unacceptable to many of our readers, as they convey a just idea of some of the most noted kinds of Sheep at this time in the island. He begins with those of Lincolnshire, which are of a large size, big-boned, and afford a greater quantity of wool than any other kind, owing to the rich, fat marshes on which they feed; but their flesh is coarse, leaner, and not so finely flavoured as that of smaller Sheep. The same breed extends, with some variations, through most of the midland counties of England. The Dorsetshire breed is likewise remarkably prolific, the Ewes being capable of bringing forth twice a year. It is from these that the tables of our nobility and gentry are supplied with early lamb at Christmas, or sooner, if required. Great numbers of those early victims to luxury are yearly sent to the London markets, where they are sold at the enormous price of 10s. 6d. or perhaps 15s. per quarter. The manner of rearing the lambs is curious: they are imprisoned in little dark cabins; the Ewes are fed with oil-cakes, hay, corn, turnips, cabbages, or any other food which the season of the year affords; these are given them in a field contiguous to the apartments where the lambs are kept; and, at proper intervals, the nurses are brought in to give suck to their young ones; while the attendants, at the same time, make their lodgings perfectly clean, and litter them with fresh straw. Great attention is paid to this, as much of the success of rearing these unseasonable productions depends upon warmth and cleanliness.

The Dorsetshire Sheep are mostly white-faced;

their legs are long and small; and great numbers
of them have no wool upon their bellies, which
gives them an uncouth appearance. They produce
a small quantity of wool, but of a good quality;
from which our fine Wiltshire cloths are made.
The mutton of these Sheep is very sweet and well
flavoured. The variations of this breed are spread
through most of the southern counties; but the
true kind is to be found only in Dorsetshire and
Wiltshire. There is a breed, not unlike this, in
Norfolk and Suffolk; but they are all grey or
black-faced.

The South Down Sheep are of the same hardy
nature as the Cheviot breed, and like them, can
live and thrive on the barest heaths; their wool is
also fine, and their mutton well flavoured.

The Sheep in the low parts of Northumberland
are of a mixed breed, between the long kind, the
Tees water, and the Lincolnshire. The Mug or
Muff kind was formerly common in that county.
They were so called, from their wool growing
round their heads into their very eyes, so as almost
to prevent them from seeing. This breed is now
nearly exploded, being considered by every breeder
of experience, as unprofitable, from their thriving
slowly, and being very tender.

In the northern districts of Scotland, and in
many of the islands, there is a breed of Sheep,
which differs from the others, in the smallness of
their size, many of them, when fed, weighing no
more than six, seven, or eight pounds per quarter.
They have dun faces, without horns; and their
wool, which is very fine, is variously mixed and
streaked with black, brown, and red.

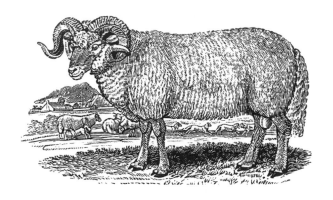

THE BLACK-FACED, OR HEATH RAM.

The north-west part of Yorkshire, with all that mountainous tract of country running towards Lancashire southward, and to Fort William northward, is occupied by a hardy, black-faced, wild-looking tribe, generally called *short Sheep*, which differ from our other breeds, not only in the darkness of their complexions and horns, but principally in the coarse shaggy wool which they produce. Their eyes have a fiery, sharp, and wild cast. They run with great agility, and seem quite adapted to the heathy mountains they inhabit. Their flesh is peculiarly fine and high-flavoured. The three great fairs for these sheep (where amazing numbers of them are sold every year) are, Stagshaw-bank, in Northumberland; Brough, in Westmorland; and Linton, in Scotland. There is likewise a breed of Sheep inhabiting the same country as the former; but peculiarly distinguished from them by long, thin bodies, white legs, white faces, and by having no horns. Their wool is fine and thickly planted.

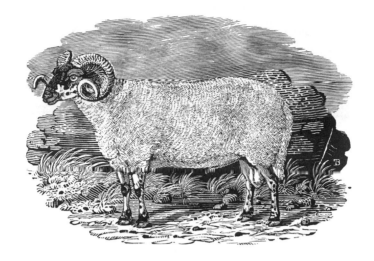

HEATH RAM OF THE IMPROVED BREED.

THE Ram from which we took this drawing, in July, 1798, belonged to the Bishop of Durham. It obtained the premium given for the best Tup, shewn for that purpose, at Blanchland, on the southern border of Northumberland, in 1797. Exclusive of the symmetry of proportions, and beauty of its form, a more important object has been obtained in the quality of the wool. They are also as hardy as the unimproved breed, and can equally endure the severity of the cold and wet to which they are exposed on the bleak heaths which they are doomed to inhabit.

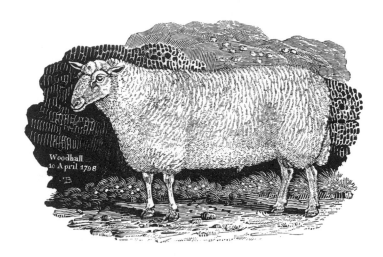

THE CHEVIOT RAM.

THE Cheviot breed have a fine open countenance,
lively prominent eyes, have no horns, and are
mostly white-faced and white-legged; the body
long, with fine, clean, small-boned legs: weight of
the carcase from 12 to 18lbs. per quarter; and the
mutton is highly esteemed for its flavour.

The best breeds of these Sheep are to be found
in the north-west parts of the county of Northum-
berland, and on the range of hills adjoining them
in Scotland, and are maintained (except when pre-
vented by snow) solely from the natural produce of
the grounds on which they depasture, which, in
general, are very mountainous, and consist of ling,
moss, heather, deer-hair, and wire-bent, with a mix-
ture of green sward. We can find no account from
whence this valuable breed originally sprung,
which, as mountain Sheep, are unrivalled, as well
on account of their carcases and hardiness, as from
the superior value of their wool, which is in the
highest estimation for clothing, and sells from 2d.

to 2½d. per pound higher than the best in the district. The great demand that has been made for this wool, added to the encouragement given by Sir John Sinclair (who, for a few years, bought considerable numbers of these Sheep, which he took to the Highlands of Scotland, and now breeds them upon the same kind of heathy mountains as the original stock were taken from) caused an emulation amongst the breeders, which has been productive of considerable improvement in their flocks, both in the wool and fore-quarter, in which they were generally deficient. But as improvements in stock can only be effected by slow gradations, and as this improved breed is but of a few years standing, it will probably be advantageous, not only to individuals, but to the public at large, to encourage exertions which, if fortunately successful, might place these Sheep upon a level with those produced upon well-cultivated grounds, which might be otherwise more advantageously employed for the use of the public.

Thus the difficulty of producing an improved breed for heath pastures has, in a great measure, been removed by the skill and attention of the Northumberland farmers, to whom we think the community much indebted; and we doubt not that, in the course of a few years, this breed will become the parent stock of all the Sheep bred for grazing on heathy, and what are called waste grounds. They thrive on the most sterile heaths, their wool is of the most desirable texture, they are easily fattened, and their whole conformation is so properly suited to mountainous pasture, that we are surprised the breed has not already been more generally diffused.

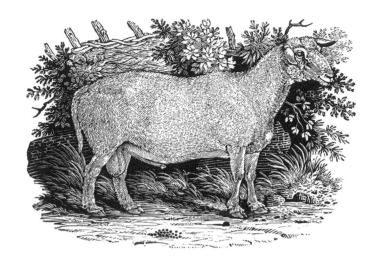

TEES-WATER OLD OR UNIMPROVED BREED.

THE largest breed of Sheep in this island is to be met with on the banks of the Tees, which runs through a rich and fertile country, dividing the two counties of Yorkshire and Durham. This kind differs from the Lincolnshire Sheep, in their wool not being so long and heavy; their legs are longer, but finer boned, and support a thicker, firmer carcase; their flesh is likewise much fatter, and finer grained.

Our figure was taken in July, 1798, from a Ram which had been purchased for the purpose of shewing its uncouth and uncultivated appearance, in contrast to those of the improved kind.

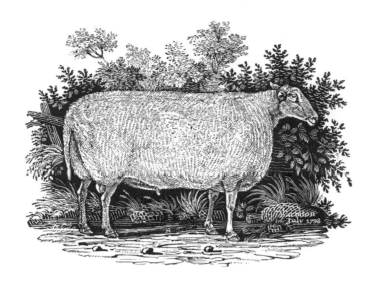

TEES-WATER IMPROVED BREED.

BY persevering in the same laudable plan of improvement so successfully begun by the late Mr. Bakewell, the stock-farmers or graziers of Tees-water have produced a kind which is looked upon by judges as nearly approaching to perfection. Many of their Sheep possess the thriving or fattening quality of the Dishley breed, and are fit for the butcher at as early an age.

These Sheep weigh from twenty-five to forty-five pounds per quarter; some have been fed to fifty pounds; and one in particular was killed, which weighed sixty-two pounds ten ounces per quarter, avoirdupoise; a circumstance never before heard of in this island. The Ewes of this breed generally bring forth two Lambs each season: sometimes three, four, and even five. As an instance of

extraordinary fecundity, it deserves to be men-
tioned, that one of these Ewes, at the age of two
years, brought forth four Lambs at one time;
the next season five; both within eleven months.

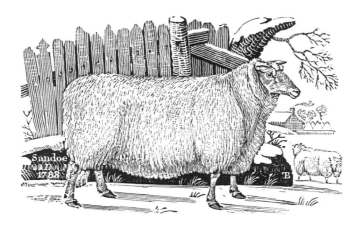

THE LEICESTERSHIRE IMPROVED BREED.

To these various and numerous tribes of this useful animal, we must add, that, by the persevering industry and attention of Mr. Bakewell, of Dishley, in Leicestershire, our breed of Sheep has been greatly improved; and he has been followed by many eminent breeders with nearly equal success.

It seems to be generally agreed, that in Sheep, as well as in all other animals, there is a certain symmetry or proportion of parts, which is best adapted to the size of each particular animal: all those of each kind that exceed or fall short of this pitch, are more or less disproportioned, according to the size they attain; and in the degree they are advanced beyond this line of perfection, we find them less active, weaker, and always less able to endure hardship. Thus, by selecting the handsomest and best proportioned of their kinds, the judicious breeder has gradually arrived at a degree of perfection in

improving this animal, unknown at any former period.

The superior qualities of the Leicestershire breed are, that they will feed quickly fat at almost any age, even on indifferent pastures, and carry the greatest quantity of mutton upon the smallest bone. Their carcases are round, have remarkably broad backs, and short legs; and to shew the immense weight to which they may be fed, we give the measurement of a Ram of Mr. Bakewell's, mentioned by Young in his "Eastern Tour."—At three years old, his girt was five feet ten inches; height, two feet five inches; breadth over his shoulders, one foot eleven inches and a half; breadth over his ribs, one foot ten inches and a half; breadth over his hips, one foot nine inches and a half.

The great importance of this breed of Sheep will best be shewn, by stating the following facts respecting the modern practice of letting out Rams for hire by the season; which, from very small beginnings, has already risen to an astonishing height; and is likely, for some time, to prove a copious source of wealth to the country at large. About forty years ago, Mr. Bakewell let out Rams at sixteen and seventeen shillings a-piece; and from that time, the prices kept gradually rising from one guinea to ten. But the most rapid increase has taken place since the year 1780. Four hundred guineas have been repeatedly given. Mr. Bakewell, in the year 1789, made twelve hundred guineas by three Rams; two thousand of seven; and, of his whole stock, three thousand guineas. Astonishing as this may appear, it is nevertheless an undoubted fact. But it ought to be observed that these great prices are not given by graziers,

for the purpose of improving their grazing stock; but by principal breeders, in order to procure a stock of Rams of the improved breed, which they let out again to breeders of an inferior class. The prices given by graziers, for the sole purpose of getting grazing stock, seldom exceed ten guineas, which is considered as an extraordinary price, five or six guineas being most frequently given.

This valuable breed has likewise found its way into Northumberland. Messrs. Culley, of Fenton; Mr. Thompson, of Lilburn; and Messrs. Donkin and Co., of Hexham brewery, with great spirit, and at considerable expence, have greatly improved their respective breeds of Sheep, by an admission of the Dishley blood.

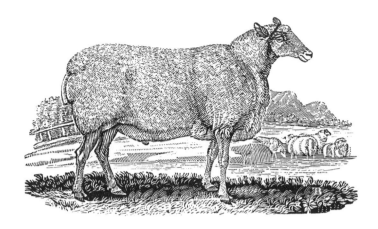

A WEDDER OF MR. CULLEY'S BREED.

WE are favoured, by Mr. Culley, with the follow-
ing account of a Wedder of his breed, fed at Fenton,
in Northumberland, and killed at Alnwick, in Octo-
ber, 1787, when four years old: his dimensions
were as follow: Girt, four feet eight inches and a
half; breadth over his shoulders, one foot three
inches; over his middle, one foot seven inches and
a quarter; across the breast, from the inside of one
fore leg to the inside of the other, nine inches. At
the dividing of the quarters, through the ribs, it
measured seven inches and one-eighth of solid fat,
cut straight through without any slope; and his
mutton was of the most beautiful bright colour.
But in nothing was he so remarkable as in the
smallness of his bones. The proprietor of this
Sheep laments that he had not the offals exactly
weighed (by offals, we would be understood to mean
not only the tallow, but the head, pluck, and pelt,
with the blood and entrails); because it is now well

known, that this breed of Sheep have a greater quantity of mutton, in proportion to the offal, than any other kind we know of, and is consequently cheaper to the consumer.

[The drawing from which the preceding cut was taken, was made by Mr. Bailey, of Chillingham, soon after the Sheep had been shorn.]

Before we quit this article, we must take notice of a breed of Sheep which have hitherto been but little known or attended to; although, it is probable, they possess advantages of equal importance with those we have just mentioned; and, in all likelihood, they might have continued still longer in the same neglected state, but for the endeavours of a set of men, who actuated by a truly patriotic zeal, are labouring to draw out the natural resources of their country, and secure, to the most distant and long-neglected parts of this kingdom, those permanent advantages to which they are by their situation entitled. In pursuing these important objects, the *Highland Society of Scotland* have discovered, that the Shetland Islands, and some parts of the Highlands of Scotland, are in possession of a breed of Sheep, which produces wool infinitely superior to that of any other in the kingdom, and equal to Spanish wool in fineness and texture. By order of the society, specimens of these Sheep have been obtained, for the purpose of a fair investigation into the nature and quality of their wool, which, upon examination, proves much finer than was at first imagined. We are favoured, by Dr. James Anderson, with the following particulars:—

THE SHETLAND SHEEP.

ARE handsome, small, and in general hornless; and are peculiarly distinguished by the unusual shortness and smallness of their tails. They weigh, when fat, from eight to ten pounds per quarter. Their fleeces are, on an average, about two pounds weight. The wool, when properly dressed, is of a pure and glossy white: some small specimens of it, compared with Vigognia wool, were allowed, by good judges, to be fully as fine, and, in softness, equal to that of which the Indian shawls are made. The Sheep producing this fine wool, are said to be of the hardiest nature: they are never housed, and, in the winter season, are often so pinched for food, that they are obliged to feed upon the sea-ware driven upon the shore. Besides the wool with which they are covered, they have long hairs growing amongst it, which serve to shelter it.

It is a singular circumstance, that the Shetland Sheep are never shorn; but, about the beginning of June, the wool is pulled off, without the smallest pain or injury to the animal, leaving the long hairs already mentioned, which contribute to keep the creature warm and comfortable, at a season of the year when cold and piercing winds may be expected, in so northern a latitude.

From the spirited measures which are now taken to preserve this valuable breed,* we are led to hope, that British wool may in time regain that great

* See the Report of the Committee of the Highland Society, on the subject of wool, 1789.

superiority for which it was once so famous; and
that, by perseverance and attention to this im-
portant object, we may in time be enabled to
produce not only as fine wool as can be obtained
from any other country, but may also, in the same
breed, be able to conjoin with it every other de-
sirable quality,—such as closeness of fleece, beauty
and utility of form, hardiness, a capability of being
easily fattened, largeness of size, and other valuable
properties, adapted to every peculiarity of situation
in these islands.

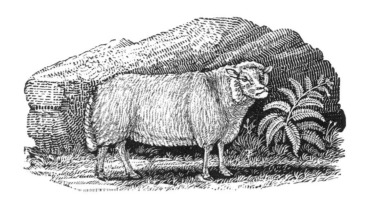

THE DUNKEY, OR DWARF SHEEP.

ANOTHER variety of the Sheep kind; deserves
to be noticed for the singular and grotesque forma-
tion of its features. The wool growing round its
head, forms a kind of hood or ruff, before which
stand its short erect ears : the uncommon protru-
sion of its under jaw considerably before the upper,
by which the fore teeth are left exposed, and the
shortness of the nose, which lies under its high-
projecting forehead, altogether give it the appear-
ance of deformity, and make a striking contrast to
most animals of the Sheep kind. A Ram, from
which the drawing was made, came from abroad,
with two Ewes, as a present to a gentleman in the
county of Northumberland. They are very small,
and have no horns. In Lincolnshire there is a
small kind, mentioned by Mr. Culley under the
name of *Dunkies*, which we suppose to be the same
with this.

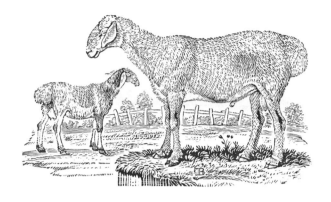

THE TARTARIAN SHEEP.

THE Sheep of which the annexed cut is an accurate representation, seem to be the same with those described by Mr. Pennant, under the name of the *Fat-rumped Sheep*. A pair of them was brought to this country, by way of Russia, from the borders of Tartary. They are rather larger than the English Sheep. The colour of the male is roan, or light brown mixed with white; that of the female, black and white; their ears are pendulous; and, instead of a tail, they have a large protuberance of fat behind, which covers the rump. When the drawing was made, they had just been shorn; at other times, the wool is so long and thick, that their form cannot well be distinguished.

The African or *Guinea Sheep* are found in most of the tropical climates. They are large, strong, and swift; with coarse hairy fleeces, short horns, pendulous ears; have a kind of dew-lap under the chin; and though domesticated, seem to approach nearest to a state of nature.

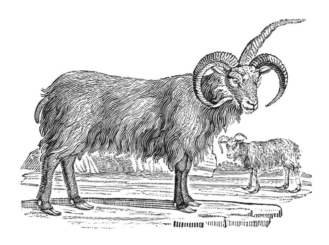

THE MANY-HORNED SHEEP.

THE Iceland Sheep, as well as those of Muscovy
and the coldest climates of the north, resemble our
own in the form of the body, but differ in the num-
ber of their horns, having generally four, and some-
times eight, growing from the forehead. Their
wool is long, smooth, and hairy: they are of a dark
brown colour; and, under the outward coat of hair,
which drops off at stated periods, there is an inter-
nal covering resembling fur, which is fine, short,
and soft; the quantity produced by each Sheep is
about four pounds.

The Broad-tailed Sheep, common in Persia, Bar-
bary, Syria, and Egypt, are remarkable chiefly for
their large and heavy tails, which grow a foot
broad, and, so long, that the shepherds are obliged
to put boards with small wheels under them, to
keep them from galling. The flesh of these tails
is esteemed a great delicacy: it is of a substance
between fat and marrow, and eaten with the lean

of the mutton: they generally weigh from twenty to fifty pounds each.

The *Sheep* bred on the mountains of Thibet, produce wool of extraordinary length and fineness, of which is made the Indian shawl, frequently sold in this country for fifty pounds or upwards.

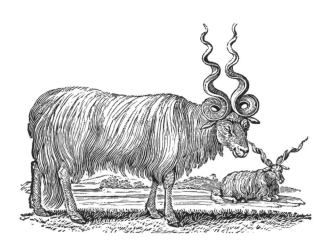

THE WALLACHIAN SHEEP.

(Ovis Strepsiceros, Linn.—*La Chevre de Crete,* Buff.)

IN Wallachia, they have Sheep with curious spiral horns, standing upright, in the form of a screw; long shaggy fleeces; and, in size and form, nearly resembling ours. They are also found in the island of Crete, and in many of the islands of the Archipelago. This is said to be the *Strepsiceros* of the ancients.

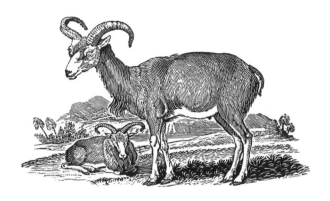

THE MOUFLON, OR MUSMON.

(Capra Ammon, Linn.—*Le Mouflon,* Buff.)

HAS been classed both with the Sheep and the
Goat kind, and may be considered as standing in a
middle place, and forming the link between each;
for it is curious to observe, that Nature, in all her
variations, proceeds by slow and almost insensible
degrees, scarcely drawing a firm and distinguishing
line between any two races of animals that are
essentially different, and yet, in many respects,
nearly allied to each other. In all transitions from
one kind to the other, there is to be found a middle
race, that seems to partake of the nature of both,
and that can precisely be referred to neither. Thus
it is hard to discover where the Sheep kind ends,
or the Goat begins. The Musmon, therefore, which
is neither Sheep nor Goat, has a strong affinity to
both. Though covered with hair, it bears a strong
similitude to the Ram: its eyes are placed near the
horns; and its ears are shorter than those of the
Goat: its horns resemble those of the Ram, in

being of a yellow colour and a triangular shape; they likewise bend backward behind the ears: in some they grow to an amazing size, and measure above two yards long. The general colour of the hair is reddish brown; the inside of the thighs and belly white, tinctured with yellow; the muzzle and inside of the ears are of a whitish colour; the other parts of the face are of a brownish grey.

The Musmon is found in the wild and uncultivated parts of Greece, Sardinia, Corsica, and in the deserts of Tartary.

The form of this animal is strong and muscular, and it runs with great agility. It is very timorous, and, when old, is seldom taken alive. It frequents the highest summits of the mountains, and treads securely on the most dangerous precipices. The old Rams have often furious battles with each other, in which one of the contending parties will sometimes be thrown down from the heights on which they stand, and dashed in pieces at the bottom. If their horns should by accident entangle, they have been known to fall and perish together.

The chase of the Musmon is attended with great danger. At the sight of a man, they fly to the highest parts of the rocks, where they cannot easily be followed: they are sometimes taken in pit-falls. The Tartars pursue them with horses and dogs, and, surrounding a pretty large tract of land, drive them towards the centre where they are caught.

The Kamschatkans pass the latter part of the summer, with all their families, among the mountains, in pursuit of these animals. The flesh and fat of the young Musmons are esteemed, by the natives, as most delicious eating. The skins serve

them for warm raiment and coverings: the horns
are made use of for a variety of domestic purposes.

The Mouflon has been known to breed with the
Sheep; and from that circumstance, is supposed by
M. Buffon and others, to be the primitive race.

The female of this species is rather less than the
male; and her horns never grow to that prodigious
size.

Those of Kamschatka are so strong, that ten men
can scarcely hold one; and the horns so large, that
young Foxes often shelter themselves in the hollow
of such as fall off by accident. They grow to the
size of a young Stag, copulate in autumn, and
bring forth one young at a time, though sometimes
two.

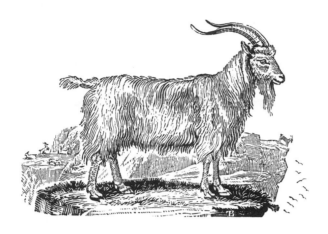

THE COMMON GOAT.

(Capra Hircus, Linn.—*Le Bouc, La Chevre,* Buff.)

THIS lively, playful, and capricious creature oc-
cupies the next step in the great scale of Nature;
and though inferior to the Sheep in value, in
various instances bears a strong affinity to that
useful animal. It is said that the Goat and the
Sheep will propagate together: the He-Goat copu-
lates with the Ewe, and the Ram with the She-
Goat; the offspring likewise is prolific.

The Goat is much more hardy than the Sheep,
and is, in every respect, more fitted for a life of
liberty. It is not easily confined to a flock, but
chuses its own pasture, straying wherever its appe-
tite or inclination leads. It chiefly delights in wild
and mountainous regions, climbing the loftiest
rocks, and standing secure on the verge of inac-
cessible and dangerous precipices: although, as

Ray observes, one would hardly suppose that their
feet were adapted to such perilous achievements;
yet, upon a nearer inspection, we find that Nature
has provided them with hoofs well calculated for
the purpose of climbing; they are hollow under-
neath, with sharp edges, like the inside of a spoon,
which prevent them from sliding off the rocky
eminences they frequent.

The Goat is an animal easily sustained, and is
chiefly therefore the property of those who inhabit
wild and uncultivated regions, where it finds an
ample supply of food from the spontaneous produc-
tions of Nature, in situations inaccessible to other
quadrupeds. It delights in the heathy mountain,
or the shrubby rock, rather than the fields culti-
vated by human industry. Its favourite food is the
tops of the boughs, or the tender bark of the young
trees. It bears a warm climate better than the
Sheep, and frequently sleeps exposed to the hottest
rays of the sun.

The milk of the Goat is sweet, nourishing, and
medicinal, and is found highly beneficial in con-
sumptive cases: it is not so apt to curdle upon the
stomach as that of the Cow. From the shrubs and
heath on which it feeds, the milk of the Goat ac-
quires a flavour and wildness of taste very different
from that of either the Sheep or Cow, and is highly
pleasing to such as have accustomed themselves to
its use: it is made into whey for those whose diges-
tion is too weak to bear it in its primitive state.
Several places in the north of England and the
mountainous parts of Scotland are much resorted
to for the purpose of drinking the milk of the Goat;
and its effects have been often salutary in vitiated
and debilitated habits.

In many parts of Ireland, and in the Highlands
of Scotland, their Goats form the chief possessions
of the inhabitants; and, in most of the mountainous
parts of Europe, supply the natives with many of
the necessaries of life: they lie upon beds made of
their skins, which are soft, clean, and wholesome;
they live upon their milk, and oat bread; they con-
vert part of it into butter, and some into cheese.
The flesh of the Kid is considered as a great deli-
cacy: and, when properly prepared, is esteemed by
some as little inferior to venison.

The Goat produces generally two young at a
time, sometimes three, rarely four: in warmer cli-
mates, it is more prolific, and produces four or five
at once; though the breed is found to degenerate.
The male is capable of propagating at one year
old, and the female at seven months; but the fruits
of a generation so premature are generally weak
and defective: their best time is at the age of two
years, or eighteen months at least.

The Goat is a short-lived animal, full of ardour,
but soon enervated. His appetite for the female is
excessive, so that one Buck is sufficient for one
hundred and fifty females.

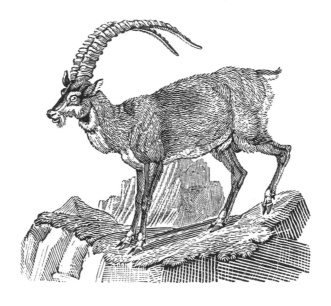

THE IBEX.

(Capra Ibex, Linn.*—Le Bouquetin,* Buff.)

IF we believe M. Buffon, is the stock from which our domestic Goat is descended; it is larger, but resembles it much in the shape of its body: its horns are much larger; they are bent backward, and are full of rings: every year of its life, it is asserted, one is added to the number of them. Some of these horns have been found at least two yards long. The head of the Ibex is small, adorned with a dusky beard, and has a thick coat of hair of a deep brown colour, mixed with ash: a streak of black runs along the top of its back: the belly and thighs are of a delicate fawn colour. The female is one-third less than the male; her horns are very small, and not above eight inches long.

The Ibex inhabits the highest Alps of the Grisons country and the Valais, and is also found in Crete : they are very wild, and difficult to be shot; and as they always keep on the highest points of the rocks, the chase of them is attended with great danger : they are very strong, and often turn upon the incautious huntsman, and tumble him down the precipice, unless he have time to lie down, and let the animal pass over him. They bring forth one young at a time, seldom two; and are said not to be long-lived.

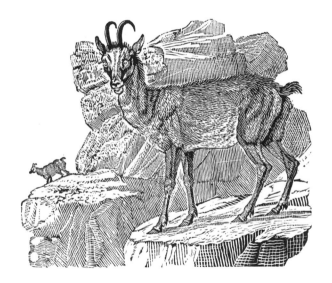

THE CHAMOIS GOAT.

(Capra Rupicapra, Linn.—*Ysarus ou Sarris,* Buff.)

THE Chamois, though a wild animal, is very easily made tame and docile. It is to be found only in rocky and mountainous places; is about the size of the domestic Goat, and resembles it in many re-

spects. It is most agreeably lively, and active be-
yond expression. The hair is short like that of the
Doe: in spring, it is of an ash colour; in autumn,
dun, inclining to black; and in winter, of a blackish
brown.

This animal is found, in great plenty, in the
mountains of Dauphiny, Piedmont, Savoy, Switzer-
land, and Germany. They are very gentle, and live
in society with each other. They are found in flocks
from four to fourscore, and even an hundred, dis-
persed upon the crags of the mountains. The large
males are seen feeding detached from the rest,
except in rutting time, when they approach the fe-
males, and drive away the young. The time of their
coupling is from the beginning of October to the end
of November; and they bring forth in March and
April. The young keep with the dam for about five
months, and sometimes longer, if the hunters and
the Wolves do not separate them. It is asserted,
that they live between twenty and thirty years.
Their flesh is good to eat; and they yield ten or
twelve pounds of suet, which far surpasses that of
the Goat in hardness and goodness.

The Chamois has scarcely any cry: it has a kind
of feeble bleat, by which the parent calls its young:
but in cases of danger, and when it is to warn the
rest of the flock, it uses a hissing noise, which is
heard at a great distance: for it is to be observed
that this creature is extremely vigilant, and has an
eye remarkably quick and piercing: its smell also
is not less distinguishing. When it sees its enemy
distinctly, it stops for a moment; and if the person
be near, it flies off in an instant. In the same man-
ner, by its smell, it can discover a man at half a
league distance, and give immediate notice. Upon

the least alarm, the Chamois begins its hissing note
with great force. The first hiss continues as long
as the time of one respiration : in the beginning it
is very sharp, and deeper towards the close. The
animal having, after this first alarm, reposed a mo-
ment, again looks round; and perceiving the reality
of its fears, continues to hiss by intervals, until it has
spread the alarm to a very great distance. During
this time, it seems in the most violent agitation ; it
strikes the ground with one fore foot, and sometimes
with both ; it bounds from rock to rock, turns and
looks round, runs to the edge of the precipice, and,
still perceiving the enemy, flies with all its speed.
The hissing of the male is much louder and sharper
than that of the female: it is performed through the
nose, and is properly no more than a very strong
breath driven violently through a small aperture.

The Chamois feeds upon the best herbage, and
chuses the most delicate parts of the plants, the
flowers, and the tender buds. It is not less delicate
with regard to several aromatic herbs, which grow
upon the sides of the mountains. It drinks very
little whilst it feeds upon the succulent herbage,
and chews the cud in the intervals of feeding.

This animal is greatly admired for the beauty of
its eyes, which are round and sparkling, and mark
the warmth of its constitution. Its head is furnished
with two small horns of about half a foot long, of a
beautiful black, rising from the forehead almost be-
twixt the eyes : these, instead of going backwards
or sideways, stand forward, and bend a little back-
ward at their extremities, ending in a very sharp
point. The ears are placed, in a very elegant man-
ner, near the horns ; there are two stripes of black
on each side of the face, the rest is of a whitish yel-

low. The horns of the female are less, and not so much bent: they are so sharp that the natives have been known to bleed cattle with them.

These animals are so much incommoded by heat, that they are seldom seen in summer, except in the caverns of rocks, amidst fragments of unmelted ice, under the shade of high and spreading trees, or of rough and hanging precipices, that face the North, and keep off entirely the rays of the sun. They go to pasture both morning and evening, and seldom during the heat of the day. They run along the rocks with great ease and seeming indifference, and leap from one to another, so that no Dogs are able to pursue them. Nothing can be more extraordinary than the facility with which they climb and descend precipices, that to most other quadrupeds are in-accessible: they always mount or descend in an oblique direction, and throw themselves down a rock of thirty feet, and light with great security up-on some excrescence or fragment, on the side of the precipice, which is just large enough to place their feet upon: they strike the rock, however, in the de-scent, with their feet, three or four times, to stop the velocity of their motion; and when they have got upon the base below, they at once seem fixed and secure. In fact, to see them jump in this manner, they seem rather to have wings than legs. Certain it is, that their legs are formed for this arduous em-ployment; the hind being rather longer than the fore legs, and bending in such a manner, that when they descend upon them, they break the force of their fall.

During the rigours of winter, the Chamois keeps in the thickest forests, and feeds upon the shrubs and the buds of the pine-tree.

The hunting of the Chamois is very laborious and difficult. The most usual way is to shoot them from behind the clefts of the rocks. Some also pursue them as they do the Stag, by placing proper persons at all the passages of a glade or valley, and then sending in others to rouse the game. Dogs are quite useless in this chase, as they rather alarm than overtake : nor is it without danger to the men ; for it often happens, that when the animal finds itself overpressed, it drives at the hunter with its head, and often tumbles him down an adjoining precipice. The Chamois cannot go upon ice when smooth; but if their be the least inequalities on its surface, it then bounds along in security, and quickly evades all pursuit.

The skin of the Chamois was once famous, when tanned, for its softness and warmth : at present, however, since the art of tanning has been brought to greater perfection, the leather called *shammoy*, is made also from those of the tame Goat, the Sheep, and the Deer.

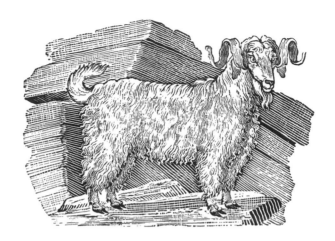

THE GOAT OF ANGORA.

Is well known for its long hair, which is thick, glossy, of a dazzling whiteness, and so fine, that cloths as beautiful as silk, known among us by the name of *camblets*, are made of it. Its ears are long and pendulous. The male is furnished with horns, curiously twisted, which proceed horizontally from each side of the head, forming a screw; those of the female are shorter, and encircle the ear somewhat like those of the common Ram. They inhabit the rocky mountains of Pontus, where they experience a considerable degree of cold: they would probably thrive in Britain as well as in their native country. The same might be said of the *Goat of Thibet*, so famous for the fineness of its wool: it lives in a climate colder than ours in winter, and might probably be transplanted with success.

In Portugal there is a breed of fine large *Goats*, remarkable for yielding a great quantity of milk,—

a gallon and a half per day. These, if introduced into our navy, might be of infinite service in long voyages.

Experiments of this kind would certainly be attended with many great advantages; and it were much to be wished, that the great and opulent would employ some portion of their time and affluence in procuring, from distant countries, such useful animals as would propagate in our island, and are yet unknown in it. By this means many of our lofty mountains might contribute to support a variety of useful creatures, that would, at the same time, beautify the most barren and rugged parts of our country.

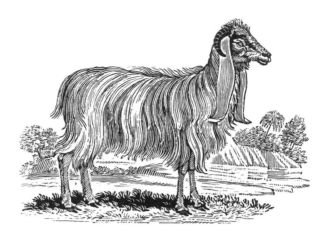

THE SYRIAN GOAT.

M. BUFFON makes this a variety of the Goat of
Angora; it differs from ours in nothing more than
the length of its ears, which are pendulous, and
from one to two feet long: they are often trouble-
some to the creature in feeding; for which reason,
the owners are sometimes obliged to cut one of them
off. Their horns are short and black. They are very
numerous in the neighbourhood of Aleppo, and
supply the inhabitants with milk, which they prefer
to that of the Cow or Buffalo.

These are the principal varieties of the Goat
kind; of which there are others of less note; such
as the *African Goat*, or *Buck of Juda*, which is not
much larger than a Hare; it is extremely fat, and
its flesh is well tasted: the horns are short, smooth,
and turn a little forward. It is common in Guinea,
Angola, and all along the coast of Africa.

In America there are *Goats* of a small kind, not
much larger than a Kid, with long hair: the horns,
which are short and thick, bend downwards so close

to the head, as almost to penetrate the skull. These
are, in every respect, similar to the Dwarf Goat
found in Africa; and, according to Buffon, have
been sent from that country. It is certain that,
before the discovery of America by the Spaniards,
the Goat, and every other domestic animal, were
unknown there.

THE GAZELLES, OR ANTELOPES.

THESE are a numerous and beautiful race of ani-
mals, inhabiting the hottest parts of the globe.
They are classed, by systematic writers, with the
Goat kind; and, like them, have hollow horns,
which they never cast: in other respects they
greatly resemble the Deer, especially in the ele-
gance of their form and the swiftness of their
motions. They are of a restless and timid disposi-
tion, remarkably agile; their boundings are so
light and elastic, as to strike the spectators with
astonishment.

Of all animals, the Gazelle has the most beautiful
eye; to which the eastern poets have made fre-
quent allusions, in describing those of their favourite
beauties.

The distinguishing marks of this tribe of animals,
in which they differ both from the Goat and Deer,
are principally these:—Their horns are different,
being annulated or ringed round, and at the same
time marked with longitudinal depressions or fur-
rows, running from the base to the point: besides
the extreme beauty and meekness of its aspect, the
Gazelle is more delicately and finely limbed than
the Roe-Buck; its hair is finer and more glossy:
its swiftness is so great, that the Greyhound, the
fleetest of Dogs, is unequal to the course; and the

sportsman is obliged to call in the aid of the Falcon, which, being trained to the work, seizes on the animal, and impedes its motion, so as to enable the Dogs to overtake it. In India and Persia, a sort of Leopard, which takes its prey by the greatness of its springs, is sometimes made use of in the chace; but should he fail in his first essay, the game escapes.

Some species of the Antelope form herds of two or three thousand, while others keep in small troops of five or six. They for the most part live in hilly countries. They often browse like the Goat, and feed on the tender shoots of young trees, which give their flesh an excellent flavour.

There are many varieties of this animal; some of them little known or described.

THE BLUE GOAT.

(*Antelope Leucophœa*, Pallas.)

MR. PENNANT considers this as being next to the Goat, from the length of its hair, and the form of its horns.

The colour of this creature is a fine blue, resembling velvet; but when dead, it is said to change to a bluish grey: its belly is white; beneath each eye it has a large white mark: its tail is seven inches in length, with long hairs at the end: its horns incline backward, and form a curve; three-fourths of their length are decorated with twenty-four rings; the uppermost quarter is smooth, and runs tapering to a point. It inhabits the hottest parts of Africa. Sparrman describes one which he saw at the Cape of Good Hope, and calls it a *Blaaw-Bok*.

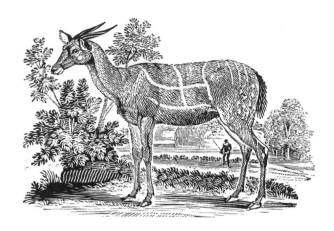

THE PIED GOAT.

THIS animal is likewise an inhabitant of the Cape, as well as the plains and woods of Senegal, where large herds of them are to be seen.

It is remarkable for having a white band running along each of its sides, crossed by two others from the back to the belly, disposed somewhat like a harness, from which it is called the *Harnessed Antelope:* on each side of the rump it has three white lines pointing downwards; its thighs are spotted with white; the colour of the body is a deep tawny; beneath each eye there is a white spot; its horns are straight, nine inches long, pointed backward, with two spiral ribs. Great flocks of them are found in the plains and the woods of the country of Poder, in Africa. It is called by M. Buffon, the *Guib;* and, by Sparrman, the *Bonti-Bok,* or *Spotted Goat.*

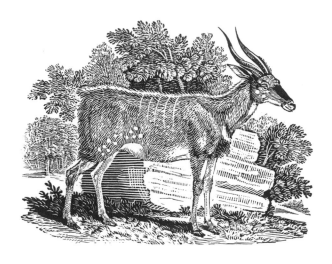

THE WOOD-GOAT.

WE are indebted to the indefatigable labours of
Dr. Sparrman, for an accurate description of this
rare animal, which is found in the country about
the Cape of Good Hope, and lives chiefly in woods
and groves, from whence it derives its name.

Its horns are black, somewhat more than ten
inches long, and have three sides wreathed in a
spiral direction towards the top; at the bottom
they are rough, in consequence of a number of
wavy rings, which, however, are not elevated much
above the surface; at the top they are round, sharp-
pointed, and in that part as smooth as if they had
been polished; their position is almost in the same
line with the forehead, inclining a little forwards,
and by means of the twist they make, they recede
from each other towards the middle, where they
are three inches and a half distant; at the base,
they are only one inch.

The Wood-Goat is somewhat more than two feet and a half high, of a dark brown colour, in some parts bordering upon black: on each cheek-bone there are two large round white spots; another, still larger, occupies the fore part of the neck, somewhat below the top of the windpipe; and several smaller white spots are scattered over the haunches: a narrow line of white hair extends from the neck all along the back and tail, but is not easily distinguished, being hid by tho longth of the dark brown hairs on the top of the back, which are three or four inches long, so as to form a kind of mane: the hair on the head is very short and fine; in other parts of the body it is longer, resembling that of Goats: its tail is not more than a finger's breadth in length, covered with long hairs, which extend down the hind part of the thighs and buttocks; the legs and feet are slender; the fetlock joints are likewise small; the nose and under lip, which are white, are decorated with black whiskers about an inch long.

As this animal runs but slowly, it is sometimes caught with Dogs. When it finds there is no other resource, it boldly puts itself into a posture of defence; and when going to butt, kneels down, and in that position sells its life at a very dear rate, killing and goring some of the best and most spirited Hounds. It carries its head straight forward whilst it runs, laying its horns upon its neck, to prevent their being entangled in the bushes. The female is without horns; and, being lighter than the male, runs more freely through the forests, and is not so easily caught. Her breast is said to be very plump: but the flesh of this animal is not very tender.

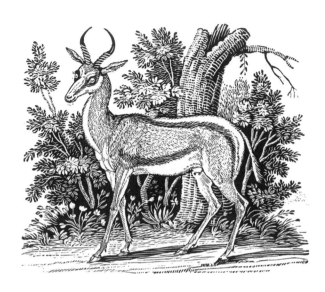

THE SPRINGER.

THE *White Antelope*, which is supposed to be the same with the *Pygarg*, mentioned in the book of Numbers, is an inhabitant of the Cape of Good Hope, where it is called the *Spring-Bok*, and is to be seen in herds of several thousands, covering the plains as far as the eye can reach. Sparrman says, that having shot at a large herd of them, they formed a line, and immediately made a circular movement, as if to surround him; but afterwards flew off in different directions.

The height of this beautiful creature is two feet and a half; it measures from the ears to the tail, somewhat above three feet; the tail is rather less than a foot long: the length of the ears six inches and a half; that of the horns, measuring them along their curvatures, nine inches; their distance

at the base, where they are nearly three inches
thick, is one inch; they gradually widen from
thence to the distance of five inches from each
other, when they turn inwards, so that at the tip
they are not above three inches and a half asunder;
they are of a deep black colour, annulated above
half way up; toward the top they are quite smooth,
and end in a sharp point.

The predominant colour of this animal is brown,
or a light rust colour: the breast, belly, and inside
of the limbs, are white; as is also the head, except-
ing a dark brown list, which passes from each
corner of the mouth, over the eyes, to the base of
the horns: a stripe of the same dark colour extends,
on each side, from the shoulders to the haunches,
forming a boundary between the snowy whiteness
of the belly and the rusty colour of the sides: the
buttocks are white; and from the tail half way up
the back, is a stripe of white, bounded on each side
by a dark brown list: the tail, at least the lower
part of it, is not thicker than a goose quill; the
under side is quite bare; towards the tip there are
a few dark brown hairs, from one to two inches and
a half long: the ears are of an ash colour, tipt on
the edges with fine light grey hairs: the eye-brows
and whiskers are black: the hair in general is fine
and short; but the dark line which borders upon
the white consists of longer hairs, which the animal
is able to expand to the breadth of eight or nine
inches, particularly on taking a high leap. When
pursued, it is no less pleasant than curious to see
the whole herd jumping over each other's heads to
a considerable height: some of them will take
three or four high leaps successively. In this situa-
tion, they seem suspended in the air, looking over

their shoulders at their pursuers, and at the same time shewing the white part of their backs in a most beautiful manner.

The Springers are so extremely swift as to require a good Horse to overtake them; although they are sometimes bold enough to allow a sportsman, either on foot or on horseback, to come within gun-shot of them. Their flesh is very palatable, and has a more juicy and delicate taste than that of the other Gazelles.

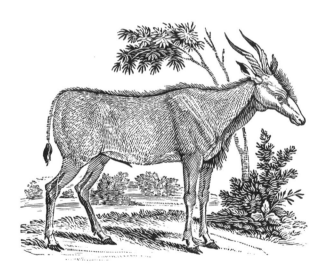

THE ELK-ANTELOPE.

(*Le Coudous*, Buff.)

THIS is an inhabitant of the Cape, as well as of the greater part of India, and is one of the larger kinds of Gazelles. It has straight horns, two feet in length, of a dark brown colour, marked with two prominent spiral ribs running near two-thirds of

their length, but smooth towards the ends, which are turned a little inwards: the forehead is flat, and broad at the top; and has a forelock, standing erect, the whole length of it: its nose is sharp; and its breast is covered with a loose skin.

This animal is of an ash colour, inclining a little towards blue; has a thin upright mane, quite black, which extends from the nape of its neck along the top of the back; it has a tuft of black hair at the end of the tail.

The Elk-Antelopes live chiefly in plains and vallies; and, when hunted, always run, if possible, against the wind: they are not very swift; and being in general fat, especially the males, which are always the largest and fattest in the herd, are soon tired. The hunter generally endeavours to get to windward of the animal, and when he has accomplished this, takes an opportunity of throwing himself from his Horse, and instantly shoots the flying game: at this practice, the Dutch colonists at the Cape are so expert as seldom to fail. Sparrman says, there have been many instances where keen sportsmen, as well for their own pleasure as convenience, have hunted Elk-Antelopes and other Gazelles, for many miles together, from the open plains, and driven them to their own doors, before they thought it worth while to shoot them.

The female has horns like the male, but smaller. They are used by the Hottentots for tobacco-pipes.

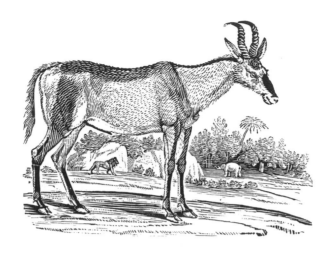

THE HART-BEEST.

(Le Bubale, Buff.)

THIS is the most common of all the larger
Gazelles, known in any part of Africa. The follow-
ing accurate description is taken from Sparrman,
to whom we are indebted for the best accounts of
such of these rare animals as are to be met with
near the Cape. Its height is somewhat above four
feet: the horns are from six to nine inches long,
very strong and black, almost close at the base,
diverging upwards, and at the top bending back-
wards in an horizontal direction almost to the tips,
which turn a little downwards; they are embossed
with about eighteen rings of an irregular form.
The general colour of the Hart-Beest is that of
cinnamon; the front of the head is marked with
black, as is likewise the fore part of the legs; the
hind part of the haunch is covered with a wide

black streak, which reaches down to the knee; a
narrow stripe of black begins behind each ear, and
runs all along the ridge of the neck; a dark brown
oval spot extends over the back, terminating just
above the tail, which is slender, somewhat like that
of an Ass, and is covered with strong black hairs
about six inches long: there is a pore about an inch
below the eye, from which a matter is distilled,
somewhat like ear-wax, which the Hottentots pre-
serve as a rare and excellent medicine.

This animal is supposed to be the *Bubalus* of the
ancients; it is the *Cervine Antelope* of Mr. Pennant.

The hair of the Hart-Beest is very fine; and its
long ears are covered with white hair on the inside:
it has only eight teeth in the lower jaw, none in the
upper: the legs are rather slender, with small fet-
locks and hoofs.

The large head and high forehead, together with
the assinine ears and tail, of the Hart-Beest, render
it one of the least handsome of the whole tribe of
Antelopes. Its pace, when at full speed, appears
like a heavy gallop; notwithstanding which, it
runs as fast as any of the larger Antelopes. When
it has once got a-head of its pursuers, it is very apt
to turn round, and stare them full in the face. Its
flesh is fine, rather dry, but of an agreeably high
flavour.

THE KOEDOE, OR STRIPED ANTELOPE.

(*Le Condoma*, Buff.)

Is a beautiful, tall Gazelle, inhabiting the Cape
of Good Hope; has long, slender legs, and is larger,
though not so clumsy, as the Elk-Antelope: its
horns are smooth, twisted spirally, with a pro-
minent edge or rib following the wreaths; they are
three feet nine inches long, of a pale brown colour,
close at the base, and at the points round and sharp.

The colour of this animal is a rusty brown; along
the ridge of the back there is a white stripe, mixed
with brown; from this are eight or nine white
stripes, pointing downwards; the forehead and the
fore part of the nose are brown; a white stripe runs
from the corner of each eye, and meets just above
the nose; upon each cheek bone, there are two
small white spots; the inner edges of the ears are
covered with white hair, and the upper part of the
neck is adorned with a brown mane, an inch long;
beneath the neck, from the throat to the breast, are
some long hairs hanging down; the breast and
belly are grey; the tail is two feet long, brown
above, white beneath, and black at the end.

The Koedoe, though a tall and slender animal,
is not so swift as many of the Gazelle kind, and is
easily overtaken by the Hounds: on these occa-
sions, the males defend themselves with great spirit
with their horns, and will come to close quarters
with the Dogs; but the females, having no horns,
are obliged to depend on their speed.

THE GEMSE-BOK.

(Capra Gazella, Linn.—*Le Pasan,* Buff.)

IT is called by Mr. Pennant, the *Egyptian Antelope.* The horns are straight, slender, of a black colour, about three feet long, with above twenty rings, reaching half to the points, which are smooth and taper; it is of an ash colour, inclining to red; the belly, legs, and face are white; a black line extends from the neck to the loins; the tail is about two feet long, terminated with black hairs.

This animal is famous for a concretion in its stomach or intestines, called the *oriental bezoar,* which was much esteemed in former times for its great virtue in expelling poison from the human frame, and was sold at enormous prices, its value increasing in proportion to its size. There was a time, when a stone of four ounces sold in Europe for above 200*l.*; at present, however, its estimation and price are greatly decreased. The virtues which ignorance and inexperience attributed to it, are now found no longer to exist; and this once-celebrated medicine is now only consumed in countries where the knowledge of nature has been but little advanced. Similar concretions are likewise found in a variety of animals of the Gazelle and Goat kind: even Apes, Serpents, and Hogs are said to have their bezoars. In short, there is scarcely an animal, except of the carnivorous kind, that does not produce some of these concretions in the stomach, intestines, kidnies, and even the heart.

These are the principal animals of the Gazelle
kind described by Dr. Sparrman, in his voyage to
the Cape of Good Hope. He mentions a variety
of others that are to be met with there, of which he
gives us little but their names.

THE REE-BOK.

Is two feet in height; of a colour somewhat re-
sembling that of a Hare, but a little more inclining
to red: the belly and anus are white: the tail is
short: the horns are black and straight, very similar
to those of the Gemse-Bok, but barely a foot long,
very taper, and sharp-pointed; they are used by
the Hottentots as awls or bodkins, for boring holes
in making their shoes or cloaks.

The flesh of this animal is dry, and accounted
worse to eat than that of any other Gazelle.

THE RIET-REE-BOK.

Is twice as big as the last-mentioned animal; is
monogamous (or keeps in pairs); it generally lies
concealed among the reeds and marshy places, and
resembles the Ree-Bok.

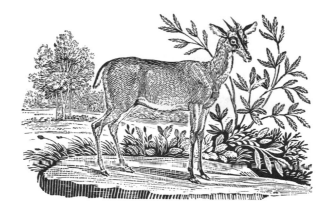

THE GRYS-BOK.

(La Grimme, Buff.)

Is of a greyish or ash colour, with large black ears, and a black ring round the eyes; straight black horns, slender and sharp-pointed, not three inches long, slightly annulated at the base: its height is about eighteen inches; and it is most elegantly formed: beneath each eye is a cavity that contains a strong-scented oily liquor, which smells something like musk, and, when exposed to the air, becomes hard and black. It is the *Guinea Antelope* of Mr. Pennant.

THE KLIP-SPRINGER.

Is of a light red colour, inclining to yellow, intermixed with black streaks; the tips and edges of its ears are black: it runs with great swiftness, and makes large bounds, even on the steepest precipices, and in the most rocky places, where it cannot easily be caught with Hounds.

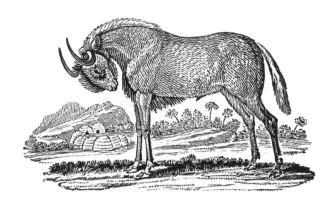

THE GNU.

To these we may add the *Gnu*, the Hottentot name for a singular animal, which, with respect to its form, is between the Horse and the Ox. It is about the size of a common Galloway, the length of it being somewhat above five feet, and the height rather more than four.

This animal is of a dark brown colour; the tail and mane of a light grey; the shag on the chin and breast, and the stiff hairs which stand erect on the forehead and upper part of the face, are black: the curvature of the horns is singular; and the animal is represented in the cut in the attitude of butting, to give an idea of its form and position.

The legs of the Gnu are small; its hair is very fine; and it has a cavity beneath each eye, like most of the Antelope kind.

THE STEEN-BOK.

(*Le Nagor*, Buff.)

Is found in Senegal, and at the Cape of Good Hope. Its whole body is of a pale red colour; it is as large as a Roe-Buck; its horns, which do not exceed six inches in length, are almost smooth, and bend a little forward; its ears are five inches long; and it has a white spot over each eye. It is called, by Mr. Pennant, the *Red Antelope*.

THE SWIFT ANTELOPE.

(*Le Nanguer*, Buff.)

Is likewise a native of Africa, and is found in Senegal. It is three feet and a half in length, and two and a half high; the horns are black and round, eight inches in length, and, what is singular, bend forward at the points ; its general colour is tawny ; belly and thighs white; it has likewise a white spot under the neck, is a very handsome animal, and easily tamed; it swiftness is compared to that of the wind.

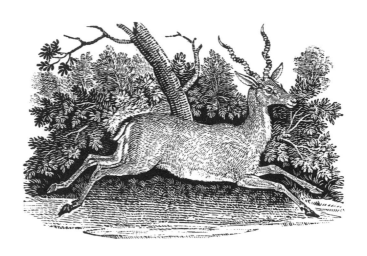

THE COMMON ANTELOPE.

(Capra Cervicapra, Linn.—*L'Antelope*, Buff.)

THE Antelope, properly so called, abounds in
Barbary, and in all the northern parts of Africa.
It is somewhat less than the Fallow-Deer: its horns
are about sixteen inches long, surrounded with
prominent rings almost to the top, where they are
twelve inches distant from point to point. The
horns of the Antelope are remarkable for a beauti-
ful double flexion, which gives them the appearance
of the lyre of the ancients. The colour of the hair
on the back is brown, mixed with red; the belly
and the inside of the thighs are white; the tail
short.

THE BARBARY ANTELOPE.

(*Capra Dorcas*, Linn.—*La Gazelle*, Buff.)

Is likewise common in all the northern parts of
Africa, in Syria, and Mesopotamia; and seems to
be a variety of the last-mentioned animal, which it
strongly resembles; only the two colours on the
back are separated from each other by a strong
dusky line on each side, and on each knee there is
a tuft of hair.

THE KEVEL.

(*Le Kevel*, Buff.)

Is a native of Senegal; and, in colour and marks,
very much resembles the preceding animal. It is
about the size of a small Roe-Buck; and its horns,
instead of being round, are flatted on their sides,
and the rings are more numerous. It lives in great
flocks, may be easily tamed, and is excellent meat.

THE CORIN.

(*Le Corine*, Buff.)

Is still less than the two former animals: its
horns are very slender, only six inches long, and
almost smooth, the annular prominences being
scarcely discernible; each side of its face is marked
with a white line, and beneath that a black one;

the upper part of the body is tawny; the belly and inside of the thighs white; a dark line on each side forms a separation between the two colours on the back and belly; on each knee is a tuft of hair. Some of these animals are irregularly spotted with white.

THE KOBA.

(Le Koba, Buff.)

Is remarkable for the form of its horns, which are almost close at the base, bending out towards the middle, where they form a curve inwards, and again fly off at the points, which bend backward; they are seventeen inches long, surrounded with fifteen rings; the ends are smooth and sharp.

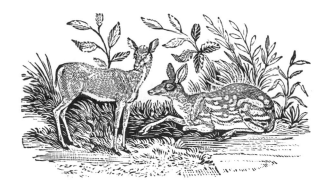

THE CHEVROTAIN AND MEMINNA.

(Le Chevrotain de Guinea, Buff.)

THE Chevrotain, or little Guinea Deer, is the smallest of all the Antelope kind, the least of all cloven-footed quadrupeds, and, we may add, the most beautiful. Its fore legs, at the smallest part, are not much thicker than a tobacco pipe; it is not more than seven inches in height, and about twelve from the point of the nose to the insertion of the tail: its ears are broad; and its horns, which are straight, and scarcely two inches long, are black and shining as jet; the colour of the hair is a reddish brown; in some a beautiful yellow, very short and glossy.

These elegant little creatures are natives of Senegal and the hottest parts of Africa; they are likewise found in India, and in many of the islands adjoining to that vast continent.

In Ceylon, there is an animal of this kind called *Meminna,* which is not larger than a Hare, but perfectly resembling a Fallow-Deer. It is of a grey

colour; the sides and haunches are spotted and barred with white; its ears are long and open; its tail short.

None of these small animals can subsist but in a warm climate. They are so extremely delicate, that it is with the utmost difficulty they can be brought alive into Europe, where they soon perish. They are gentle, familiar, most beautifully formed; and their agility is such, that they will bound over a wall twelve feet high. In Guinea, they are called *Guevei*. The female has no horns.

THE SCYTHIAN ANTELOPE.

(Capra Tartarica, Linn.—*Le Saiga*, Buff.)

THIS is the only one of the species that can be found in Europe. The form of its body resembles the domestic Goat; but its horns are those of an Antelope, being marked by very prominent rings, with furrows between: they are a foot long, the ends smooth, of a pale yellow colour, almost transparent.

The male, during the winter, is covered with long rough hair, like the He-Goat, and has a strong scent; the female is smoother, and without horns. The general colour is grey, mixed with yellow: the under part of the body is white.

These animals inhabit Poland, Moldavia, about Mount Caucasus, the Caspian Sea, and Siberia; are fond of salt, and frequent the places where salt-springs abound. In the rutting season, at the latter end of autumn, great flocks of them, consisting of several thousands, migrate towards the south,

and return in the spring, in smaller flocks, to the great northern deserts; where the females bring forth their young, and rear them.

The males, the females, and their young, generally feed together; and when a part of them are resting, others, by an instinctive kind of caution, are always keeping watch; these again are relieved in due time; and in this manner, they alternately rest and keep watch; frequently preserving themselves by this means, from the attacks of men and wild beasts.

Their common pace is a trot; but, when they exert their speed, they bound like the Roe-Buck, and exceed it in fleetness. They are so timid as to suffer themselves to be taken through fear: if once bitten by a Dog, they instantly fall down, and give themselves up without further effort to escape. When taken young, they are easily tamed; but the old ones are so wild and obstinate, as to refuse all food whilst in a state of captivity. They are hunted for the sake of their flesh, horns, and skins; the latter are excellent for gloves, belts, &c. The huntsman is extremely cautious in approaching a herd of these animals, lest they should discover him by the excellency of their smell. They are either shot, or taken by Dog; and sometimes by the Black Eagle, which is trained for that purpose. In running they seem to incline to one side; and their motion is so rapid, that their feet seem scarcely to touch the ground.

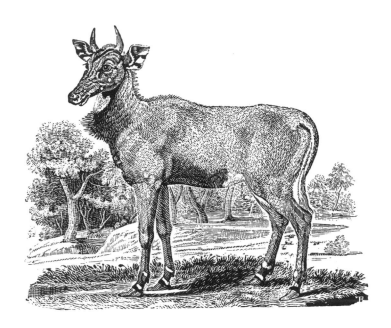

THE NYL-GHAU.

THIS animal is a native of the interior parts of
India. It seems to be of a middle nature, between
the Cow and the Deer, and carries the appearance
of both in its form. In size, it is as much smaller
than the one, as it is larger than the other : its
body, horns, and tail, are not unlike those of a Bull;
and the head, neck, and legs, are similar to those
of a Deer. The colour, in general, is ash or grey,
from a mixture of black hairs and white : all along
the ridge or edge of the neck, the hair is blacker,
longer, and more erect, making a short, thin, and
upright mane, reaching down to the hump : its
horns are seven inches long, six inches round at
the root, tapering by degrees, and terminating in a
blunt point : the ears are large and beautiful, seven

inches in length, and spread to a considerable breadth; they are white on the edge and on the inside, except where two black bands mark the hollow of the ear with a Zebra-like variety. The height of this animal at the shoulder, is four feet one inch; behind the loins it measures only four feet.

The female differs considerably from the male, both in height and thickness; she is much smaller, in shape and colour very much resembling a Deer, and has no horns: she has four nipples, and is supposed to go nine months with young: she has commonly one at a birth, but sometimes two.

Several of this species were brought to this country in the year 1767, which continued to breed annually for some years after. Dr. Hunter, who had one of them in his custody for some time, describes it as a harmless and gentle animal; that it seemed pleased with every kind of familiarity, always licked the hand that either stroked or fed it, and never once attempted to use its horns offensively. It seemed to have much dependance on its organs of smell, and snuffed keenly whenever any person came in sight: it did so likewise, when food or drink was brought to it; and would not taste the bread which was offered, if the hand that presented it happened to smell of turpentine.

Its manner of fighting is very particular, and is thus described:—Two of the males at Lord Clive's, being put into an inclosure, were observed, while they were at some distance from each other, to prepare for the attack, by falling down upon their knees: they then shuffled towards each other, still keeping upon their knees; and, at the distance of a few yards, they made a spring, and darted against each other with great force.

The following anecdote will serve to shew, that
during the rutting season, these animals are fierce
and vicious, and not to be depended upon:—A
labouring man, without knowing that the animal
was near him, went up to the outside of the inclo-
sure: the Nyl-Ghau, with the quickness of lightning,
darted against the woodwork with such violence,
that he dashed it to pieces, and broke off one of his
horns close to the root. The death of the animal,
which happened soon after, was supposed to be
owing to the injury he sustained by the blow.

Bernier says, that it is the favourite amusement
of the Mogul Emperor to hunt the Nyl-Ghau; and
that he kills them in great numbers, and distributes
quarters of them to his omrahs; which shews that
they are esteemed good and delicious food.

The Nyl-Ghau is frequently brought from the
interior parts of Asia, as a rare and valuable pre-
sent to the nabobs and other great men at our
settlements in India.

It remains to be considered, whether this rare
animal might not be propagated with success in
this country. That it will breed here, is evident
from experience; and if it should prove docile
enough to be easily trained to labour, its great
swiftness and considerable strength might be ap-
plied to the most valuable purposes.

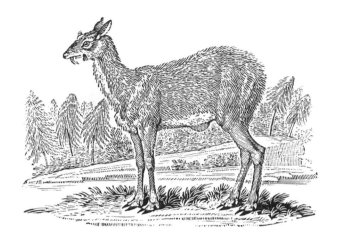

THE MUSK.

(Moschus Moschiferus, Linn.—*Le Musc*, Buff.)

THERE have been various accounts given of this animal by naturalists and travellers; by whom it seems to have been taken notice of more for the perfume which it produces, than for the information of the curious enquirer into its nature and qualities: for we are still at a loss what rank to assign it among the various tribes of quadrupeds.

It has no horns; and whether it ruminates or not, is uncertain: but, by its wanting the fore teeth in the upper jaw, we are led to suppose that it belongs either to the Goat or the Deer kind; and have therefore given it a place after the Gazelles, relying upon those characteristic marks which are known, and leaving it to those naturalists who may be possessed of better means of information, to ascertain its genuine character.

The Musk of Thibet resembles the Roe-Buck in
form. It is somewhat above two feet in height at
the shoulder; the hind legs, which are longer than
the fore legs, are two feet nine inches high at the
haunches; the length is three feet six inches from
the head to the tail; the head is above half a foot
long: its upper jaw is much larger than the lower;
and on each side of it there is a slender tusk, nearly
two inches long, which hangs down, bending in-
wards like a hook, and very sharp on the inner
edge: its lower jaw contains eight small cutting
teeth; and in each jaw there are six grinders: its
ears are long, small, and erect, like those of a
Rabbit: the hair on the whole body is long and
rough, marked with small waves from top to bot-
tom: the colour is a rusty brown; under the belly
and tail it is white: on each side of the lower jaw
there is a tuft of thick hair, about an inch long: its
hoofs are deeply cloven, slender, and black: the
spurious hoofs are likewise very long: its tail is not
more than two inches in length, and hid in the hair.
The use it makes of its tusks is not well known:
the most probable is that of hooking up roots out
of the ground, and catching at small twigs and
branches of trees, upon which it feeds. The female
has no tusks, is less than the male, and has two
small teats.

The Musk is found in the kingdom of Thibet, in
several of the Chinese provinces, about the lake
Baikal, and near the rivers Jenisea and Argun,
from lat. 60 to 45; but seldom so far south, except
driven by great falls of snow to seek for food in
more temperate climates. It is naturally a timid
animal, and endowed with a quick sense of hearing.
Its solitary haunts are usually mountains, covered

with pines; where it avoids mankind, and when pursued, flies to the highest and most inaccessible summits.

The perfume produced by this animal, which is so well known in the fashionable circles, and of late so much used in the practice of physic, needs little description. It is found in a bag or tumour, nearly of the size of a Hen's egg, on the belly of the male only. These bags the hunters cut off, and tie them up for sale; many thousands of them are sent over annually to Europe, besides what are consumed in different parts of the East. To account for this great consumption, it is supposed that the musk is frequently adulterated and mixed with the blood of the animal. It comes to us from China, Tonquin, Bengal, and Muscovy; but that of Thibet is reckoned the best, and sells at a much higher price than the rest.

The flesh of the males, especially in the rutting season, is much infected with the flavour of the musk; but is, nevertheless, eaten by the Russians and Tartars.

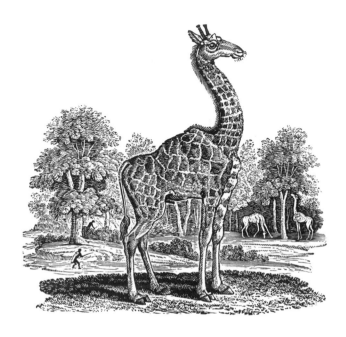

THE CAMELEOPARD.

(Cervus Camelopardalis, Linn.—*La Giraffe,* Buff.)

THIS animal (the existence of which has fre-
quently been called in question) is a native of the
wild and unfrequented deserts of Ethiopia, and
other interior parts of Africa, where it leads a soli-
tary life, far from the habitations of men, for whose
use it is rendered unfit by the enormous dispropor-
tion of its parts. It has hitherto been regarded
chiefly as an object of curiosity, and may lead us to
admire the wonderful productions of that creative
power, which has filled the earth with life in such a
boundless variety of forms.

The height of this extraordinary animal, from the
crown of the head to the ground, is seventeen feet;
while at the rump it measures only nine; the neck
alone is seven feet long; and the length from the
extremity of the tail to the end of the nose, is
twenty-two feet; the fore and hind legs are nearly
of an equal height; but the shoulders rise so high,
that its back inclines like the roof of a house: its
neck is slender and elegant, adorned on the upper
side with a short mane, on the highest part of the
head it has two perpendicular horns, six inches
long, covered with hair, and round at the ends,
where they are encompassed with a circle of short
black hairs:* on the middle of the forehead there is
a protuberance about two inches high: its ears are
long, and its eyes large and beautiful.

The colour of the male is a dark brown, with a
network of light grey over the neck and the whole
body; these lines on the female are of a pale yellow
colour.

It is a timid and gentle creature, but not swift.
From the great length of its fore legs, it is obliged
to divide them to a great distance when it grazes,
which it does with some difficulty; it lives chiefly
by browsing on the leaves and tender branches of
trees; it lies on its belly, and has hard protuber-
ances on its breast and thighs, like the Camel; its
tail is similar to that of an Ox, with strong black
hair at the end; it is cloven-footed, has no teeth in
the upper jaw, and is a ruminating animal. The fe-
male has four teats, and is less than the male. This
animal was known to the Romans in early times.

* M. Vaillant, who shot several of these animals, says, that these
horns differ from those of the Stag or the Ox, in being formed by a
continuation of the bone of the skull.

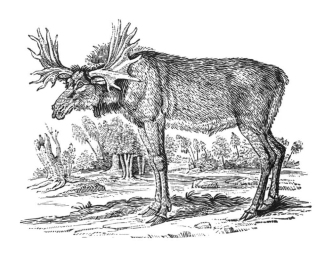

THE ELK.

(Cervus Alces, Linn.—*L'Elan*, Buff.)

Is the largest and most formidable of all the Deer kind. It is a native of both the old and the new continent, being known in Europe by the name of the *Elk*, and in America by that of the *Moose-Deer*. It is sometimes taken in the forests of Russia and Germany; though it is rarely to be seen, on account of its extreme wildness. It likewise inhabits Norway, Sweden, Poland, and Tartary, as far as the North of China. It is common in Canada; and all the northern parts of America.

The Elk has been variously described by naturalists and travellers: by some, it is said to be twelve feet high; while others, with greater appearance of probability, describe it as being not much higher than a Horse. It is, however, a matter of doubt to

which a greater degree of credibility should be given.

From a variety of Elks' horns preserved in the cabinets of the curious, some of which are of a most enormous size, there is every reason to conclude, that the animal which bore them must have been of a proportionable bulk and strength.

Those who speak of the gigantic Moose, say, their horns are six feet long, and measure, from tip to tip, above ten feet: the beams of the horns are short; from which they spread out into large and broad palms, one side of which is plain, but on the outside are several sharp snags or shoots.

The European Elk grows to the height of seven or eight feet; and in length, from the end of the muzzle to the insertion of the tail, measures ten feet: the head is two feet long; the neck, on which is a short upright mane, of a light brown colour, is much shorter: its eye is small; and, from the lower corner of it, there is a deep slit, common to all the Deer kind, as well as most of the Gazelles: the ears are upwards of a foot in length, very broad, and somewhat slouching; the nostrils are wide; and the upper lip, which is square, and has a deep furrow in the middle, hangs greatly over the lower, whence it was imagined by the ancients, that this creature could not graze without going backward: the withers are very high, the hind legs much shorter than the fore legs, and the hoofs deeply cloven: from a small excrescence under the throat, hangs a long tuft of coarse black hair: the tail is very short, dusky above, and white beneath: the hair is long and rough, like that of a Bear, and of a hoary brown colour, not much differing from that of the Ass.

The pace of the Elk is a high, shambling trot; but it goes with great swiftness. Formerly these animals were made use of in Sweden to draw sledges; but as they were frequently accessory to the escape of such as had been guilty of murders or other great crimes, this use of them was prohibited under great penalties.

In passing through thick woods these animals carry their heads horizontally, to prevent their horns being entangled in the branches.

The Elks are timid and inoffensive, except when wounded, or during the rutting season, when the males become very furious, and at that time will swim from isle to isle in pursuit of the females. They strike with both horns and hoofs, and possess such agility and strength of limbs, that, with a single blow of the fore feet, they will kill a Wolf or a Dog.

Their flesh is extremely sweet and nourishing. The Indians say, they can travel farther after eating heartily of the flesh of the Elk, than of any other animal food. Their tongues are excellent; but the nose is esteemed the greatest delicacy in all Canada. The skin makes excellent buff leather, and is strong, soft, and light: the Indians make their snow-shoes, and likewise form their canoes with it. The hair on the neck, withers, and hams, of a full-grown Elk, from its great length and elasticity, is well adapted to the purpose of making mattrasses and saddles.

The methods of hunting these animals in Canada are curious. The first, and most simple, is,—before the lakes or rivers are frozen, multitudes of the natives assemble in their canoes, with which they form a vast crescent, each horn touching the shore;

whilst another party on the shore surrounds an extensive tract: they are attended by Dogs, which they let loose, and press towards the water with loud cries. The animals alarmed by the noise, fly before the hunters, and plunge into the lake, where they are killed by the people in the canoes with lances and clubs. Another method requires a greater degree of preparation and art. The hunters enclose a large space with stakes and branches of trees, forming two sides of a triangle; the bottom opens into a second inclosure, which is fast on all sides: at the opening are hung numbers of snares, made of the slips of raw hides. They assemble as before, in great troops; and, with all kinds of hideous noises, drive into the inclosure not only the Moose, but various other kinds of Deer, with which that country abounds. Some, in forcing their way through the narrow pass, are caught in the snares by the neck or horns; whilst those which escape these, meet their fate from the arrows of the hunters, directed at them from all quarters. They are likewise frequently killed with the gun. When they are first discovered, they squat with their hind parts, and make water; at which instant the sportsman fires; if he miss, the Moose sets off in a most rapid trot, making, like the Rein-Deer, a prodigious rattling with its hoofs, and running twenty or thirty miles before it stops or takes the water. The usual time for this diversion is in winter. The animal can run with ease upon the firm surface of the snow; but the hunters avoid entering on the chase till the heat of the sun is strong enough to melt the frozen crust with which it is covered, and render it so soft as to impede the flight of the Moose, which sinks up to the shoulders, flounders, and gets on with

great difficulty: the sportsman pursues in his broad
rackets, or snow-shoes, and makes a ready prey of
the distressed animal.

"As weak against the mountain-heaps they push
"Their beating breasts in vain, and piteous bray,
"He lays them quiv'ring on th' ensanguin'd snows,
"And with loud shouts rejoicing bears them home."

The female is less than the male, and has no
horns. They are in season in the autumn; and
bring forth in April, sometimes one, but generally
two young ones at a time, which arrive at their full
growth in six years.

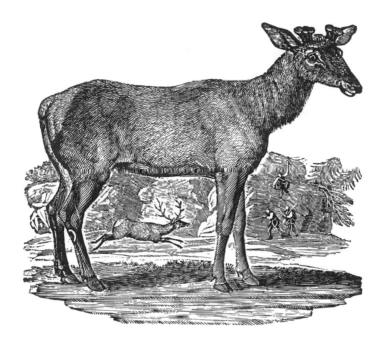

THE AMERICAN ELK.

WE have given a faithful portrait of this animal, from a living one lately brought from the interior parts of America. It seems to be very different from that generally described under the name of the *Elk*, or *Moose-Deer*, to which it has very little resemblance. It seems; indeed, to belong to a distinct species, and is probably the *Elk* or *Orignal* of Canada and the northern parts of America.

At the age of five years, the length of this creature was nine feet, from the end of the muzzle to the insertion of the tail, the head and neck being extended in a line with the body: its height at the shoulder was four feet six inches; length of the

head, one foot six inches; breadth over the forehead, seven inches; length of the fore legs, two feet five inches; length of the neck, two feet six; its ears, nine inches; and tail three. Its horns, which it had just shed, are not palmated, like those of the Moose: they are large; and, when full grown, measure above six feet, from tip to tip. The antlers are round, and pointed at the ends: the lowermost antler forms a curve downward over each eye, to which it appears a defence. Its hair is long, of a dark dun colour on the back and sides; on the head and legs dark brown: its eyes full and lively; and below each there is a deep slit, about two inches in length, the use of which we are unable to discover.

It was very lively and active; of great strength of body and limbs: its hoofs short, and like those of a calf; the division between them is less than in those of the Rein-Deer; and, when the animal is in motion, they do not make a rattling noise. It has no mane; but the hair under its neck is longer than that on any other part of the body.

We were told by the owner of this very rare and beautiful animal, that it does not attain its full growth till twenty years old, and that it sheds its horns every third year.

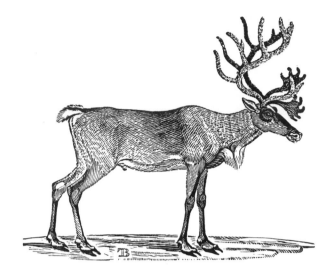

THE REIN-DEER.

(Cervus Tarandus, Linn.—*Le Renne*, Buff.)

THIS extraordinary animal is a native of the icy
regions of the North; where, by a wise and boun-
tiful dispensation, which diffuses the common goods
of nature over every part of the habitable globe, it
is made subservient to the wants of a hardy race of
men inhabiting the countries near the pole, who
would find it impossible to subsist among their
snowy mountains without the aid of this most use-
ful creature.

In more temperate regions, men are indebted to
the unbounded liberality of nature for a great
variety of valuable creatures to serve, to nourish,
and to cloath them. To the poor Laplander, the
Rein-Deer alone supplies the place of the Horse,

the Cow, the Sheep, the Goat, &c.; and from it he derives the only comforts that tend to soften the severity of his situation in that most inhospitable climate.

The Rein-Deer of Lapland are of two kinds,—the wild and the tame: the former are larger, stronger, and more hardy than the latter; for which reason, the tame females, in the proper season, are often sent out into the woods, where they meet with wild males, and return home impregnated by them. The breed from this mixture is stronger, and better adapted for drawing the sledge, to which the Lap-landers accustom them at an early age.

THE SLEDGE.

The Rein-Deer is yoked to this vehicle by a col-lar, from which a trace is brought under the belly between the legs, and fastened to the fore part of the sledge. These carriages are extremely light, and covered at the bottom with the skin of the Rein-Deer. The person who sits in it guides the animal with a cord fastened to its horns; he drives it with a goad, and encourages it with his voice. Those of the wild breed, though by far the strongest,

often prove refractory, and not only refuse to obey their master, but turn against him, and strike so furiously with their feet, that his only resource is to cover himself with his sledge, upon which the enraged creature vents its fury; the tame Deer, on the contrary, is patient, active, and willing. When hard pushed, the Rein-Deer will trot the distance of sixty miles without stopping; but in such exertions, the poor obedient creature fatigues itself so exceedingly, that its master is frequently obliged to kill it immediately, to prevent a lingering death that would ensue. In general they can go about thirty miles without stopping; and that without any great or dangerous effort. This mode of travelling can be performed only in the winter season, when the face of the country is covered with snow; and although the conveyance is speedy, it is inconvenient, dangerous, and troublesome.

As the Rein-Deer constitutes the sole riches of the Laplander, it may well be supposed that a constant attention to preserve and secure it, forms the chief employment of his life. It is not uncommon for one person to possess above five hundred in a single herd.

As soon as summer appears, which forms but a short interval from the most piercing cold, the Laplander, who had fed his Rein-Deer upon the lower grounds during the winter, drives them up to the mountains, leaving the woody country and the low pastures, which at that season are in a state truly deplorable. Myriads of insects, brought to life by the heat of the sun in the woods and fens with which that country abounds, are all upon the wing; the whole atmosphere swarms with life; every place and every creature is infested; the natives

are obliged to cover their faces with a mixture of
pitch and milk, to shield them from these minute
invaders, which are drawn in with the breath, and
enter the nostrils, and even the eyes; but they are
chiefly inimical to the Rein-Deer: the horns of that
animal being then tender, and covered with a skin,
which renders them extremely sensitive, a cloud of
these insects settle upon them, and drive the poor
animal almost to distraction. In this extremity
there is no resource but flight. The herdsmen
drive their flocks from the plains to the summits of
the mountains, whither the foe cannot follow them:
there they will continue the whole day, with little
or no food, rather than venture down into the lower
parts, where they have no defence against their un-
ceasing persecutors.

Besides the gnat, the gadfly is a common pest to
the Rein-Deer. In the autumn, this insect deposits
its eggs in their skin, where the worms burrow, and
often prove fatal to them. The moment a single fly
is seen, the whole herd is in motion: they know
their enemy, and endeavour to avoid it, by tossing
up their heads, and running among each other:
but all this too often proves ineffectual.

Every morning and evening during the summer,
the herdsman returns to his cottage with the Deer
to be milked, where a large fire of moss is prepared,
for the purpose of filling the place with smoke, to
drive off the gnats, and keep the Deer quiet whilst
milking. The quantity of milk given by one
female in a day, is about a pint. It is thinner than
that of a Cow, but sweeter and more nourishing.

The female begins to breed at the age of two
years, is in season the latter end of September, goes
with young eight months, and generally brings

forth two at a time. The fondness of the dam for
her young is very remarkable. They follow her
two or three years, but do not acquire their full
strength until four. It is at this age that they are
trained to labour; and they continue servicable
four or five years. They never live above fifteen or
sixteen years. At eight or nine years old, the Lap-
landers kill them for their skins and their flesh.
Of the former they make garments, which are
warm, and cover them from head to foot: they also
serve them for beds; they spread them on each side
of the fire upon the leaves of trees, and in this
manner lie both soft and warm. The latter affords
a constant supply of good and wholesome food,
which, in the winter, when other kinds of provisions
fail, is their chief subsistence. The tongue of the
Rein-Deer is considered as a great delicacy; and
when dried, great numbers of them are sold into
other countries. The sinews serve for thread, with
which the Laplanders make their cloaths, shoes,
and other necessaries; and when covered with the
hair, serve them for ropes.

Innumerable are the uses, the comforts, and
advantages, which the poor inhabitants of this
dreary climate derive from this animal. We can-
not sum them up better than in the beautiful
language of the poet:—

 " Their Rein-Deer form their riches. These their tents,
 " Their robes, their beds, and all their homely wealth
 " Supply; their wholesome fare, and chearful cups:
 " Obsequious at their call, the docile tribe
 " Yield to the sled their necks, and whirl them swift
 " O'er hill and dale, heap'd into one expanse
 " Of marbled snow, as far as eye can sweep,
 " With a blue crust of ice unbounded glaz'd."

The horns of the Rein-Deer are large and slender, bending forward, with brow antlers, which are broad and palmated. A pair in our possession are in length two feet eight inches, and from tip to tip two feet five; they weigh nine pounds: the projecting brow antler is fourteen inches long, one foot broad, and serrated at the end: it should seem, both from its situation and form, an excellent instrument to remove the snow, under which their favourite moss lies. Both sexes have horns: those of the female are less, and have fewer branches.

We are happy in being able to give an accurate representation of this singular creature. The drawing was taken from one in the possession of Sir H. G. Liddell, Bart., which he brought over from Lapland, with four others, in 1786. The height at the shoulder was three feet three inches. The hair on the body was of a dark brown colour; and on the neck brown, mixed with white: a large tuft of hair, of a dirty white colour, hung down from the throat, near its breast; and it had a large white spot on the inside of each hind leg, close by the joint: its head was long and fine; and round each eye was a large black space: its horns were covered with a fine down, like velvet. The hoofs of this animal are large, broad, and deeply cloven: they spread out to a great breadth on the ground; and when the animal is in motion, make a crackling noise, by being drawn up forcibly together.

Not many attempts have been made to draw the Rein-Deer from its native mountains, and transport it to milder climates; and of these few have succeeded. Naturalists from thence have concluded, that it cannot exist but amidst ice and snow. M. Buffon regrets the impossibility of pro-

curing the animal alive; and says, that when transported to another climate, it soon dies. M. Regnard mentions some that were brought to Dantzick; where, being unable to endure the heat of the climate, they all perished. Queen Christina, of Sweden, procured five and twenty, which she purposed sending to Oliver Cromwell: they were brought as far as Stockholm; but the Laplanders who attended them refusing to come to England, fifteen of the number were killed by the Wolves, and the remaining ten did not long survive, the climate being considered as too warm.

To those brought over by Sir H. G. Liddell, five more were added the year following. They produced young ones, and gave promising hopes of thriving in this country: but, unfortunately, some of them were killed; and the others died, in consequence of a disorder similar to that called the *rot* in Sheep, which was attributed to the richness of the grass whereon they fed. Nor can we wonder at the failure of this spirited enterprize, when we consider, that it is the sole employment of the Laplander to tend and herd his Rein-Deer, to drive them in the summer time to the summits of the mountains, to the sides of clear lakes and streams, and to lead them where they can find the most proper food. Want of knowledge or attention to minute particulars, is sufficient to overturn the best-laid plans.

There is, however, little doubt but this animal will live without the Lapland *lichen;* to which, perhaps, it only hath recourse, because there is in those latitudes no other sustenance during the winter. It is also, in England, free from its mortal enemy—the gadfly. But as the desire of possessing

this animal has hitherto been excited only by curiosity, it is not likely that much attention will be paid to it in a country like this, abounding with such a variety of useful quadrupeds.

The Rein-Deer is wild in America, where it is called the *Caribou*. It is found in Spitzbergen and Greenland, and is very common in the most northern parts of Europe, and in Asia, as far as Kamschatka, where some of the richest of the natives keep herds of ten or twenty thousand in number.

In the neighbourhood of Hudson's Bay, there are great herds of wild Rein-Deer: columns of many thousands annually pass from North to South in the months of March and April. In that season the muskatoes are very troublesome, and oblige them to quit the woods, and seek refreshment on the shore and open country. Great numbers of beasts of prey follow the herds. The Wolves single out the stragglers, detach them from the flock, and hunt them down: the Foxes attend at a distance, to pick up the offals left by the former. In autumn, the Deer, with the Fawns bred during the summer, re-migrate northward.

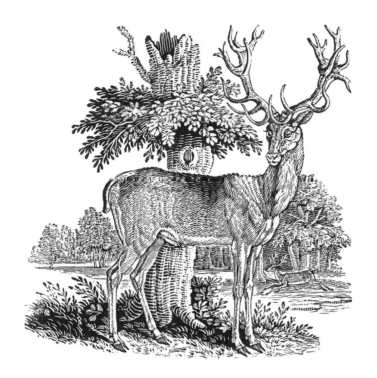

THE STAG, OR RED-DEER.

(Cervus Elephas, Linn.—*Le Cerf*, Buff.)

THIS is the most beautiful animal of the Deer kind. The elegance of his form, the lightness of his motions, the flexibility of his limbs, his bold, branching horns, which are annually renewed, his grandeur, strength, and swiftness, give him a decided pre-eminence over every other inhabitant of the forest.

The age of the Stag is known by its horns. The first year exhibits only a short protuberance, which is covered with a hairy skin; the next year the

horns are straight and single; the third year pro-
duces two antlers, the fourth three, the fifth four;
and when arrived at the sixth year, the antlers
amount to six or seven on each side; but the num-
ber is not always certain.

The Stag begins to shed his horns the latter end
of February, or the beginning of March. Soon
after the old horn has fallen off, a soft tumour
begins to appear, which is soon covered with a
down like velvet: this tumour every day buds forth,
like the graft of a tree; and, rising by degrees,
shoots out the antlers on each side: the skin con-
tinues to cover it for some time, and is furnished
with blood-vessels, which supply the growing horns
with nourishment, and occasion the furrows obser-
vable in them when that covering is stript off: the
impression is deeper at the bottom, where the ves-
sels are larger, and diminishes towards the point,
where they are smooth. When the horns are at
their full growth, they acquire strength and solidity;
and the velvet covering or skin, with its blood-
vessels, dries up and begins to fall off; which the
animal endeavours to hasten, by rubbing them
against the trees; and, in this manner, the whole
head gradually acquires its complete hardness, ex-
pansion and beauty.

Soon after the Stags have polished their horns,
which is not completed till July or August, they
quit the thickets, and return to the forests; they
cry with a loud and tremulous note, and fly from
place to place, in search of the females, with ex-
treme ardour; their necks swell; they strike with
their horns against trees, and other obstacles, and
become extremely furious. At this season, when
two Stags meet, their contests are often desperate,

and terminate in the defeat or flight of one of them; while the other remains in possession of his mistress and the field, till another rival approaches, that he is also obliged to attack and repel. During this time which usually lasts about three weeks, the Stag is frequently seen by the sides of rivers and pools of water, where he can quench his thirst, as well as cool his ardour. He swims with great ease and strength; and, it is said, will even venture out to sea, allured by the Hinds, and swim from one Island to another, though at a considerable distance.

The Hinds go with young eight months and a few days, and seldom produce more than one, called a *Fawn*. They bring forth in May, or the beginning of June, and conceal their young with great care in the most obscure retreats. They will even expose themselves to the fury of the hounds, and suffer all the terrors of the chase, in order to draw off the Dogs from their hiding-place. The Hind is also very bold in the protection of her offspring, and defends it with great courage against her numerous and rapacious enemies: the Wild Cat, the Dog, and even the Wolf, are frequently obliged to give way to her upon these occasions. But what appears to be strangely unnatural, the Stag himself is often one of her most dangerous foes, and would destroy the Fawn, if not prevented by the maternal care of the Hind, which carefully conceals the place of its retreat.

The Fawn never quits the dam during the whole summer; and in winter, the Stags and Hinds of all ages keep together in herds, which are more or less numerous, according to the mildness or rigour of the season. They separate in the spring: the Hinds retire to bring forth ; while none but the young ones remain together.

Stags are gregarious, and fond of grazing in company: it is danger or necessity alone that separates them.

The Stag, in England, is usually of a reddish colour; in other countries it is generally brown or yellow. His eye is peculiarly beautiful, soft, and sparkling: his hearing is quick; and his sense of smelling acute. When listening, he raises his head, erects his ears, and seems attentive to every noise, which he can hear at a great distance. When he approaches a thicket, he stops to look around him on all sides, and attentively surveys every object near him: if the wary animal perceive nothing to alarm him, he moves slowly forward; but on the least appearance of danger, he flies off with the rapidity of the wind. He appears to listen with great tranquility and delight to the sound of the shepherd's pipe, which is sometimes made use of to allure the poor animal to its destruction.

The Stag eats slowly, and is nice in the choice of his pasture. When his stomach is full, he lies down to chew the cud at leisure. This, however, seems to be attended with greater exertions than in the Ox or the Sheep; for the grass is not returned from the first stomach without violent straining, owing to the great length of his neck, and the narrowness of the passage. This effort is made by a kind of hiccup, which continues during the time of his ruminating.

The voice of the Stag is stronger and more quivering as he advances in age: in the rutting season, it is even terrible. That of the Hind is not so loud; and is seldom heard, but when excited by apprehension for herself or her young.

The Stag has been said to be an uncommonly long-lived animal; but later observations have fully confuted this unfounded opinion. It is a generally received maxim, that animals live seven times the number of years that bring them to perfection: thus the Stag, being five or six years in arriving at maturity, lives seven times that number, or from thirty-five to forty years.

The following fact, recorded in history, will serve to show that the Stag is possessed of an extraordinary share of courage, when his personal safety is concerned:—Some years ago, William, Duke of Cumberland, caused a Tiger and a Stag to be inclosed in the same area; and the Stag made so bold a defence, that the Tiger was at length obliged to give up.

The hunting of the Stag has been held, in all ages, a diversion of the noblest kind; and former times bear witness of the great exploits performed on these occasions. In our island, large tracts of land were set apart for this purpose; villages and sacred edifices were wantonly thrown down, and converted into one wide waste, that the tyrant of the day might have room to pursue his favourite diversion. In the time of William Rufus and Henry the First, it was less criminal to destroy one of the human species than a beast of chase. Happily for us, these wide extended scenes of desolation and oppression have been gradually contracted; useful arts, agriculture, and commerce, have extensively spread themselves over the naked land; and these superior beasts of the chase have given way to other animals more useful to the community.

In the present cultivated state of this country, therefore, the Stag is almost unknown in its wild

state. The few that remain are kept in parks among the Fallow-Deer, and are distinguished by the name of *Red-Deer*. Its visciousness during the rutting season, and the badness of its flesh, which is poor and ill-flavoured, have occasioned almost the extinction of the species. Some few are yet to be found in the forests that border on Cornwall and Devonshire, on most of the large mountains of Ireland, and in the Highlands of Scotland, where Dr. Johnson describes them as not exceeding the Fallow-Deer in size, and their flesh of equal flavour.

The Red-Deer of this kingdom are nearly of the same size and colour, without much variety: in other parts of the world, they differ in form and size, as well as in their horns and the colour of their bodies.

THE CORSICAN STAG.

Is very small, not exceeding half the height of ours; his body is short and thick, his hair of a dark-brown colour, and his legs short.

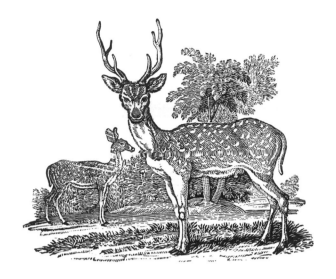

THE AXIS, OR GANGES STAG.

(L'Axis, Buff.)

THIS animal is an inhabitant of those immense plains of India watered by the river Ganges. M. Buffon considers it as a variety or shade between the Stag and the Fallow-Deer. It is of the size of the latter; but its horns are round, like those of the Stag; and it has no brow antlers. Its whole body is marked with white spots, elegantly disposed, and distinct from each other: the belly, inside of the thighs, and legs, are white; along the back there are two rows of spots, parallel to each other; those on the other parts of the body are irregular; the head and neck are grey; and the tail, which is red above and white beneath, is as long as that of the Fallow-Deer.

The continent of America abounds with *Stags*, and other animals of the Deer kind, in great variety. In some parts of that vast country, the inhabitants have domesticated them, and live chiefly upon the milk and cheese with which they supply them.

Thus we find, that the same animal, which, in some parts, contributes only to the amusement of man, may, in others, be brought to supply his necessities. The stores of Nature are various and abundant: it is necessity alone that draws them out to supply our wants, and contribute to our comforts.

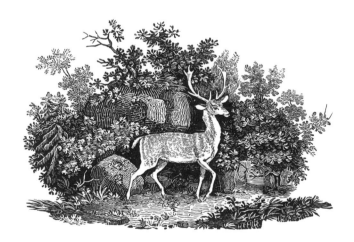

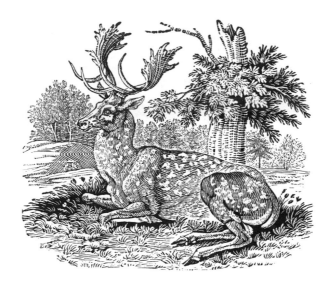

THE FALLOW-DEER.

(*Cervus Dama*, Linn.—*Le Dain*, Buff.)

THE principal difference between the Stag and the Fallow-Deer, seems to be in their size and in the form of their horns; the latter is much smaller than the former, and its horns, instead of being round, like those of the Stag, are broad, palmated at the ends, and better garnished with antlers: the tail is also much longer than that of the Stag, and its hair is brighter; in other respects they nearly resemble each other.

The horns of the Fallow-Deer are shed annually, like those of the Stag; but they fall off later, and are renewed nearly at the same time. Their rutting season arrives fifteen days or three weeks after that of the Stag. The males then bellow frequently,

but with a low and interrupted voice. They are
not so furious at this season as the Stag, nor
exhaust themselves by any uncommon ardour.
They never leave their pasture in quest of the
females, but generally fight with each other, till
one Buck becomes master of the field.

They associate in herds, which sometimes divide
into two parties, and maintain obstinate battles for
the possession of some favourite part of the park:
each party has its leader, which is always the
oldest and strongest of the flock. They attack in
regular order of battle; they fight with courage
and mutually support each other; they retire, they
rally, and seldom give up after one defeat: the
combat is frequently renewed for several days to-
gether; till after many defeats, the weaker party is
obliged to give way, and leave the conquerors in
possession of the object of their contention.

The Fallow-Deer is easily tamed, feeds upon a
variety of things which the Stag refuses, and pre-
serves its condition nearly the same through the
whole year, although its flesh is esteemed much
finer at particular seasons.

They are capable of procreation in their second
year; and, like the Stag, are fond of variety. The
female goes with young eight months; and pro-
duces one, sometimes two, and rarely three, at a
time. They arrive at perfection at the age of three
years, and live till about twenty.

We have in England two varieties of the Fallow-
Deer, which are said to be of foreign origin: the
beautiful spotted kind, supposed to have been
brought from Bengal; and the deep-brown sort,
now common in this country. These last were
introduced by King James the First, out of Norway;

where having observed their hardiness in bearing the cold of that severe climate, he brought some of them into Scotland, and from thence transported them into his chases of Enfield and Epping. Since that time they have multiplied exceedingly in many parts of this kingdom, which is now become famous for venison of superior fatness and flavour to that of any other country in the world.

The Fallow-Deer, with some variation, is found in almost every country of Europe. Those of Spain are as large as Stags, but darker; their necks are also more slender; and their tails, which are longer than those of ours, are black above, and white beneath.

In Guiana (a country of South America), according to Labat, there are *Deer* without horns, smaller than those of Europe, but resembling them in every other particular. They are very lively, light, and excessively timid; of a reddish colour; with sharp, piercing eyes, and short tails. When pursued, they fly into places of difficult access. The natives frequently stand and watch for them in narrow paths; and, as soon as the Game appears within reach, shoot them unperceived. Their flesh is considered as a great delicacy.

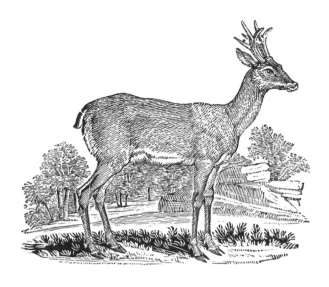

THE ROE-BUCK.

(Cervus Capreolus, Linn.—*La Chevreuil,* Buff.)

THE Roe was formerly common in many parts of England and Wales; but at present it is to be found only in the Highlands of Scotland. It is the smallest of all the Deer kind, being only three feet four inches long, and somewhat more than two feet in height: the horns are from eight to nine inches long, upright, round, and divided into three branches; the body is covered with long hair; the lower part of each hair is ash colour; near the end is a narrow bar of black, and the point is yellow; the hairs on the face are black, tipped with ash colour; the ears are long, their insides of a pale yellow, and covered with long hair; the chest, belly, legs, and the inside of the thighs, are of a yellowish white; the rump is of a pure white, and the tail very short.

The form of the Roe-Buck is elegant, and its motions light and easy. It bounds seemingly without effort, and runs with great swiftness. When hunted, it endeavours to elude its pursuers by the most subtle artifices: it repeatedly returns upon its former steps, till, by various windings, it has entirely confounded the scent. The cunning animal then, by a sudden spring, bounds to one side; and, lying close down upon its belly, permits the hounds to pass by, without offering to stir.

They do not keep together in herds, like other Deer, but live in separate families. The sire, the dam, and the young ones, associate together, and seldom mix with others.

The rutting season continues but fifteen days,— from the latter end of October till about the middle of November. During this period they will not suffer the Fawns to remain with them: the buck obliges them to retire, in order that the dam and her succeeding progeny may remain undisturbed.

The female goes with young five months and a half, and brings forth about the end of April, or beginning of May. On these occasions, she separates from the male, and conceals herself in the thickest and most retired part of the woods. She generally produces two Fawns at a time, sometimes three. In ten or twelve days, these are able to follow their dam. When threatened with danger she hides them in a thicket; and, to preserve them, offers herself to be chased: but, notwithstanding her care, she is frequently robbed of her young. Numbers of Fawns are found out and taken alive by the peasants: and many more are worried by Dogs, Foxes, and other carnivorous animals. By these continual depredations, this beautiful creature is

daily becoming more scarce; and in many coun-
tries, where it once was common, the race is now
wholly extinct.

When about eight or nine months old, their
horns begin to appear in the form of two knobs:
the first year they are without antlers. They shed
their horns in the latter end of autumn, and renew
them in the winter; in which they differ from the
Stag, whose horns fall off in the spring, and are
renewed in summer.

The life of the Roe-Buck seldom exceeds twelve
or fifteen years.

They are very delicate in the choice of their food,
and require a large tract of country, suited to the
wildness of their nature, which can never be
thoroughly subdued. No arts can teach them to
be familiar with their keeper, nor in any degree
attached to him. They are easily terrified; and in
their attempts to escape, will run with such force
against the walls of their inclosure, as sometimes
to disable themselves: they are also subject to
capricious fits of fierceness; and, on these occa-
sions, will strike furiously with their horns and feet
at the object of their dislike.

Some years ago, one of these animals, after being
hunted out of Scotland, through Cumberland, and
various parts of the North of England, at last took
refuge in the woody recesses bordering upon the
banks of the Tyne, between Prudhoe Castle and
Wylam. It was repeatedly seen and hunted, but
no Dogs were equal to its speed: it frequently
crossed the river; and, either by swiftness or artifice,
eluded all its pursuers. It happened during the
rigour of a severe winter, that, being pursued, it
crossed the river upon the ice with some difficulty;

and being much strained by its violent exertions, was taken alive. It was kept for some weeks in the house, and was then again turned out; but all its cunning and activity were gone; it seemed to have forgotten the places of its former retreat; and, after running some time, it laid down in the midst of a brook, where it was killed by the Dogs.

The flesh of the Roe-Buck is fine and well-tasted: that of the male, after the age of two years, is hard; the flesh of the females, though further advanced in years, is more tender: when very young, it is loose and soft; but at the age of eighteen months, is in its highest state of perfection.

In America, the Roe-Buck is much more common than in Europe. In Louisiana, it is very large. The inhabitants live chiefly upon its flesh, which is good and well-flavoured.

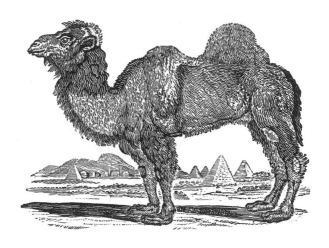

THE CAMEL.

(Camelus Bactrianus, Linn.—*Le Chameau*, Buff.)

POSSESSES the various qualities of the Horse, the Cow, and the Sheep; and is to the Arabian, in a great measure, what those useful creatures are to us. Its milk is rich and nourishing; and being mixed with water, makes a wholesome and refreshing beverage, much used by the Arabs in their journies: the flesh of young Camels is also an excellent and wholesome food. Their hair or fleece, which falls off entirely in the spring, is superior to that of any other domestic animal, and is made into very fine stuffs, for cloaths, coverings, tents, and other furniture.

Possessed of his Camel, the Arabian has nothing either to want or to fear: in one day he can perform a journey of fifty leagues into the desert, where he is safe from every enemy; for without the aid of

this useful animal, no person could pursue him amidst sandy deserts, where nothing presents itself to the eye but one uniform void, naked and solitary.

The Arabian regards the Camel as the most precious gift of Heaven; by the assistance of which he is enabled to subsist in those frightful intervals of Nature, which serve him for an asylum, and secure his independence.

But it is not to the plundering Arab alone that the services of this useful quadruped are confined: in Turkey, Persia, Barbary, and Egypt, every article of merchandise is carried by Camels. Merchants and travellers unite together, and form themselves into numerous bodies, called *caravans*, to prevent the insults of the Arabs. One of these caravans frequently consists of many thousands: the Camels are always more numerous than the men. Each Camel is loaded in proportion to its strength. At the command of their conductor, they lie down on their belly, with their legs folded under them, and in this posture receive their burdens. As soon as they are loaded, they rise of their own accord, and will not suffer any greater weight to be imposed upon them than they can bear with ease; when overloaded, they set up the most pitious cries, till part of the burden be taken off. The common load of the Camel is from three to four hundred weight; and the medium of the expence of the conveyance for each hundred appears to be about one farthing per mile. The usual rate of travelling is three miles in the hour; and the number of hours that are actually employed on the route, exclusive of those allotted to refreshment is seldom more than seven or eight in a day. Of the number of days which are consumed in a long journey, many are

devoted to the purposes of occasional trade, re-
cruiting the strength of the Camels, and procuring
additional stores of provisions and water. A par-
ticular mode of easy conveyance is provided for
women and children, and for persons oppressed
with infirmity or illness: six or eight Camels are
yoked together in a row; and a number of tent
poles are placed in parallel lines upon their backs:
these are covered with carpets: and bags of corn
are superadded to bring the floor to a level, as well
as to soften the harshness of the Camels move-
ments: other carpets are then spread, and the
travellers sit or lie down with the most perfect ease.
The general food of the Camels is such only as
their nightly pasture affords; and is frequently
confined to the hard and thorny shrubs of the
desert, where a sullen kind of vegetation is created
by the rains of the winter, and sustained by the
dew that descends in copious abundance through
all the remainder of the year.

But the peculiar and distinguishing characteristic
of the Camel, is its faculty of abstaining from water
for a greater length of time than any other animal;
for which Nature has made a wonderful provision,
in giving it, besides the four stomachs which it has
in common with other ruminating animals, a fifth
bag, serving as a reservoir for water, where it
remains without corrupting or mixing with the
other aliments. When the Camel is pressed with
thirst, and has occasion for water to macerate its
food while ruminating, it makes part of it pass into
its stomach, by a simple contraction of certain
muscles. By this singular structure, it can take a
prodigious quantity of water at one draught, and is
enabled to pass several days without drinking; Leo

Africanus says fifteen. Camels can discover water by their smell at half a league's distance; and, after a long abstinence, will hasten towards it, some time before their drivers perceive where it lies.

The feet of the Camel are peculiarly adapted to the soil on which it treads. On moist or slippery ground he cannot well support himself; and his broad and tender feet are liable to be injured by the resistance of stones: but he is observed to tread with perfect ease and security on the dry and yielding sand; and whilst, from its peculiar structure, his hoof is incapable of fastening with any degree of security on the ground of a steep ascent or shelving declivity, his movements on a smooth and level surface are singularly firm and safe.

Many attempts have been made to introduce this serviceable animal into other countries; but, as yet, none have succeeded. The race seems to be confined to certain districts, where its utility has been known for ages.

Though a native of warm climates, the Camel dreads those which are excessively hot: it can neither subsist in the burning heat of the torrid zone, nor in the milder air of the temperate. It seems to be an original native of Arabia; for in that country, it is not only more numerous, but thrives better than in any other part of the world.

There are two varieties of this animal, which have been distinguished previous to all historical record: that which is called the *Bactrian Camel* has two hunches on its back, and is found chiefly in Turkey and the countries of the Levant: whilst the *Arabian Camel* has only one hunch.

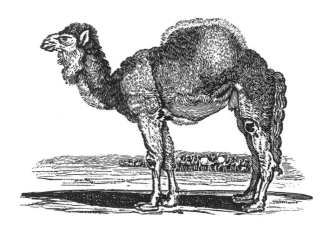

THE ARABIAN CAMEL, OR DROMEDARY.

(Camelus Dromedarius, Linn.—*Le Dromedaire,*
Buff.)

Is common in Arabia and all the northern parts
of Africa, from the Mediterranean sea to the river
Niger; and is infinitely more numerous, and more
generally diffused than the Camel: it is also much·
swifter, and is therefore chiefly employed on busi-
ness which requires dispatch.

In Arabia, they are trained for running matches;
and in many places for carrying couriers, who can
go above a hundred miles a day on them, and that
for nine or ten days together, over burning and
uninhabitable deserts. They require neither whip
nor spur to quicken their pace, but go freely, if
gently treated; and are much enlivened by singing
or the sound of the pipe, which gives them spirits
to pursue their journey.

They are mild and gentle at all times, except when they are in heat: at that period they are seized with a sort of madness; they eat little, and will sometimes attempt to bite their masters; so that it is not safe to approach them.

The Camel arrives at its full strength at the age of six years, and lives forty or fifty.

The females are not usually put to hard labour, but are allowed to pasture and breed at full liberty. Their time of gestation is nearly twelve months; and they generally bring forth one at a birth.

THE LAMA.

(Camelus Glama, Linn.—*Le Lama*, Buff.)

Is the Camel of Peru and Chili; and before the conquest of those countries by the Spaniards, was the only beast of burden known to the Indians. Its disposition is mild, gentle, and tractable.

Before the introduction of Mules, these animals were used by the natives to plough the land, and now serve to carry burdens. They march slowly, and seldom accomplish journies of more than four or five leagues a day; but what they want in speed is made up by perseverance and industry. They travel long journies in countries impassable to most other animals; are very sure-footed; and are much employed in transporting the rich ores, dug out of the mines of Potosi, over the rugged hills and narrow paths of the Andes: Bolivar remarks, that, in his time, three hundred thousand of them were constantly employed in this work. They lie down to be loaded, and, when weary, no blows can excite them to quicken their pace. They neither defend

themselves with their feet nor their teeth. When angry, they have no other method of revenging injuries, but by spitting. They can throw out their saliva to the distance of ten paces; and if it fall on the skin it raises an itching, accompanied with a slight inflammation. Their flesh is eaten, and said to be as good as mutton.

Like the Camel, they have the faculty of abstaining long from water (sometimes four or five days); and, like that animal, their food is coarse and trifling. They are neither allowed corn nor hay; green herbage, of which they eat very moderately, is sufficient for their nourishment.

The wild Lamas, called *Guanacos*, are stronger and more active than the domestic kind. They live in herds, and inhabit the highest regions of the Cordelieres. They run with great swiftness in places of difficult access, where Dogs cannot easily follow them. The most usual way of killing them is with the gun. They are hunted for the sake of their flesh and their hair: of the latter the Indians make cloth.

The Lama resembles the Camel in the form of its body, but is without the dorsal hunch: its head is small and well shaped; its neck long, and very protuberant near its junction with the body: in its domestic state, its hair is short and smooth; when wild, it is coarse and long, of a yellowish colour: a black line runs along the top of the back, from the head to the tail. The tame ones vary in colour: some of them are white, others black, others of a mixed colour—white, grey, and russet, dispersed in spots. Its tail is short: its ears are four inches long: its feet are cloven, like those of the Ox, and are armed behind with a spur, by which the animal is enabled

to support itself on rugged and difficult ground. The height of the Lama is about four feet; and its length, from the neck to the tail, six feet.

THE PACOS.

(Camelus Pacos, Linn.—Le Paco, Buff.)

GREATLY resembles the Lama in figure, but is much smaller. Its body is covered with very fine long wool of the colour of dried roses, or a dull purple: the belly is white. They live in vast herds, and inhabit the most elevated parts of the highest mountains, where they endure the utmost rigour of frost and snow. They are exceedingly swift; and so timid, that it is very difficult to come near them.

The manner of taking them is singular. The Indians tie cords, with small pieces of wool or cloth hanging from them, across the narrow passes of the mountains, about three or four feet from the ground: they then drive a herd of these animals towards them, and they are so terrified by the flutter of the rags, that they dare not pass, but huddle together, and suffer themselves to be killed in great numbers.

Their wool is a valuable article of commerce, and is made into gloves, stockings, bed-cloaths, carpets, &c.

The Pacos is domesticated; and, like the Lama, is employed in carrying burdens, but cannot bear more than from fifty to seventy-five pounds; and is still more subject to capricious fits of obstinacy. When once they lie down with their load, no blows can provoke them to rise.

The great advantages derived from the wool of
these creatures, induced the Spaniards to attempt
their introduction into Europe. Some of them were
brought over to Spain; but, by not sufficiently
attending to the necessity of placing them in situa-
tions similar to those which they had always been
accustomed to, the experiment proved unsuccess-
ful.

THE HOG KIND.

ANIMALS of the Hog kind seem to possess a middle nature, between those that live upon grass and such as are carnivorous, and unite in themselves most of those distinctions which are peculiar to each class. Like the one, they will feed on animal substances, and do not ruminate; like the other, they are cloven-hoofed, live chiefly on vegetables, and seldom seek after animal food, except when urged by necesssity.

The most numerous breed of Hogs in this island is that generally known by the name of the *Berkshire Pigs*, now spread through almost every part of England, and some parts of Scotland. They are in general of a reddish brown colour, with black spots upon them; have large ears hanging over their eyes; are short-legged, small-boned, and are readily made fat. Some of these have been fed to an almost incredible size. Mr. Culley, in his Treatise on Live Stock, gives an account of one that was killed at Congleton, in Cheshire, which measured, from the nose to the end of the tail, three yards eight inches; in height it was four feet and a half; and weighed, after it was killed, eighty-six stones eleven pounds avoirdupoise.

The Hog species, though very numerous, and diffused over Europe, Asia, and Africa, did not exist in America, till transported thither by the Spaniards. In many places they have multiplied exceedingly, and become wild. They resemble the domestic Hog; but their bodies are shorter, and their snout and skin thicker.

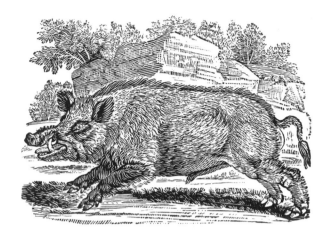

THE WILD-BOAR.

(Sus Aper, Linn.—*Le Sanglier*, Buff.)

WHICH is the original of all the varieties to be
found in this creature, is much smaller than those
of the domestic kind, and does not, like them,
vary in colour, but is uniformly of a brindled
or dark grey, inclining to black. His snout is
longer than that of the tame Hog; and his ears are
short, round, and black. He is armed with for-
midable tusks in each jaw, which serve him for the
double purpose of annoying his enemy, or procur-
ing his food, which is chiefly roots and vegetables:
some of these tusks are almost a foot long: those
in the upper jaw bend upwards in a circular form,
and are exceedingly sharp at the points; those of
the under jaw are always most to be dreaded, for
with them the animal defends himself, and fre-
quently gives mortal wounds.

Wild-Boars are not gregarious; but while young, they live together in families, and frequently unite their forces against the Wolves, or other beasts of prey. When likely to be attacked, they call to each other with a very loud and fierce note: the strongest face the danger and form themselves into a ring, the weakest falling into the centre. In this position few beasts dare venture to engage them, but leave them to pursue a less dangerous chase. When the Wild-Boar is arrived at a state of maturity, he walks the forest alone and fearless. At that time he dreads no single foe; nor will he turn out of his way even for man himself. He offends no animal; at the same time he is furnished with arms which render him a terror to the fiercest.

The hunting of the Wild-Boar is a dangerous but common amusement of the great, in those countries where it is to be found. The Dogs chiefly used for this sport are of a slow and heavy kind. When the Boar is roused, he goes slowly forward, not much afraid, nor very far before his pursuers. He frequently turns round, stops till the hounds come up, and offers to attack them: after keeping each other at bay for a while, the Boar again goes slowly forward, and the Dogs renew the pursuit. In this manner the chase is continued till the Boar becomes quite tired, and refuses to go any farther: the Dogs then attempt to close in upon him from behind; and in this attack the young ones, being generally the most forward, frequently lose their lives: the old seasoned Dogs keep the animal at bay until the hunters come up, who kill him with their spears.

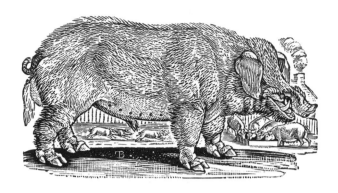

THE COMMON BOAR.

(Sus Scrofa, Linn.—*Le Cochon*, Buff.)

Is, of all other domestic quadrupeds, the most
filthy and impure. Its form is clumsy and disgust-
ing, and its appetite gluttonous and excessive. In
no instance has nature more conspicuously shewn
her economy than in this race of animals, whose
stomachs are fitted to receive nutriment from a
variety of things that would be otherwise wasted:
the refuse of the field, the garden, the barn, or the
kitchen, affords them a luxuriant repast.

Useless during life, and only valuable when
deprived of it, this animal has been sometimes
compared to a miser, whose hoarded treasures are
of little value till death has deprived them of their
rapacious owner.

The parts of this anmial are finely adapted to its
mode of living. Nature has given it a form more
prone than that of other animals. Its neck is
strong and brawny; its snout is long and callous,
well calculated for the purpose of turning up the

earth for roots of various kinds, of which it is
extremely fond; and it has a quick sense of smell-
ing, by which it is enabled to trace out its food. It
is naturally stupid, inactive, and drowsy; much in-
clined to increase in fat, which is disposed in a dif-
ferent manner from that of other animals, and forms
a thick and regular coat between the flesh and the
skin. It is restless at a change of weather; and
during certain high winds, is so agitated, as to run
violently, screaming horribly at the same time. It
appears to forsee the approach of bad weather, as it
previously carries straw in its mouth to its sty, pre-
pares a bed, and seems endeavouring to hide itself
from the impending storm.

Linnæus observes, that the flesh of the Hog is a
wholesome food for those that use much exercise,
but bad for such as lead a sedentary life. It is of
universal use, and makes, in various ways, a con-
stant article in the elegancies of the table. It is of
great importance to this country, as a commercial
nation, for it takes salt better than any other kind,
and consequently is capable of being preserved
longer: it is therefore in great use in ships, and
makes a principal part of the provisions of the
British navy.

The domestic Sow generally brings forth twice a
year, and produces from ten to twenty at a litter:
she goes four months with young, and brings forth
in the fifth. At that time she must be carefully
watched, to prevent her from devouring her young:
still greater attention is necessary to keep off the
male, as he would destroy the whole litter.

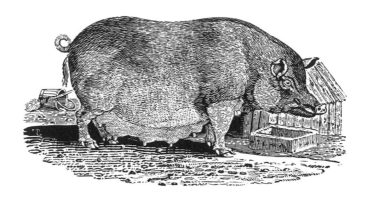

SOW OF THE IMPROVED BREED.

BY a mixture of the Chinese black Swine with others of the larger British breed, a kind has been produced which possesses many qualities superior to either of the original stocks. They are very prolific, are sooner made fat than the larger kind, upon less provisions, and cut up, when killed, to more useful and convenient portions.

Our figure was taken from a Sow of this kind, in the possession of Arthur Mowbray, Esq., of Sherburn, in the county of Durham. She had a litter of nineteen pigs to support at the time, which was the third within ten months: the whole amounted, in that time, to fifty pigs.

The Chinese or black breed is now very common in England. They are smaller, have shorter legs, and their flesh is whiter and sweeter than the common kind.

A kind similar to this were those found in New Guinea, which proved so seasonable a relief to our circumnavigators, when that country was first

visited by them. There are likewise great numbers of them in the Friendly and Society Isles, the Marquesas, and many other of the newly-discovered islands in the South Seas. These are fed with plantains, bread-fruit, and yams, and are exceedingly fat. They are frequently seen by the natives in their canoes, swimming from one island to another, and killed by them with lances and arrows.

Another breed of Swine has lately been introduced into this kingdom, which is expected to rival or excel all the others: the original stock was produced from a Wild Boar brought from America, and a Sow of the improved Chinese breed. The Sows are extremely prolific, and the colour of the pigs in general is most fancifully diversified; some are striped longitudinally, with brown and black; others brown and blue; and others, with black and white. The colour of the Boar was a rusty brown.

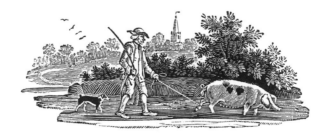

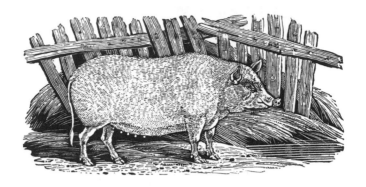

THE CHINESE KIND.

An unceasing attention to improvement has produced or new-modelled the Chinese breed in this country to what is deemed to be nearer perfection. The delicacy of appearance, the thin transparent ears, small head, short small legs, and even the colour of the hair, are all considered as requisite qualities which ought to be attended to in this kind. They are seldom fed for the same purposes as the larger kind of Swine, being accounted too small for being dried into bacon; but they are preferred as the best and most delicate for pork and roasting pigs.

Our figure was taken from one of this description, in the possession of Geo. Baker, Esq., of Elemore, in the county of Durham.

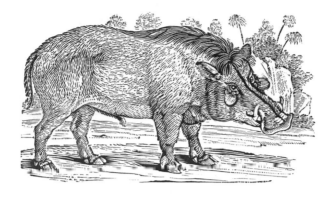

THE AFRICAN WILD-BOAR, OR WOOD SWINE.

(Sus Æthiopicus, Linn.—*Sanglier du Cap Verd,*
Buff.)

LIVES in a wild, uncultivated state, in the hottest
parts of Africa. It is a very vicious animal, and
quick in all its motions. It is as dangerous to
attack one of them as a Lion: for, though much
smaller, it rushes upon a man as swift as an arrow;
and throwing him down before he has time to
strike with his javelin, breaks his legs, and almost
at the same instant, rips up his belly.

It has four tusks: two very large ones proceed
from the upper jaw, and turn upwards like a horn;
they are nine inches long, and full five inches round
at the base; the other two tusks, which come from
the lower jaw, project but three inches from the
mouth. These tusks the animal makes use of as
the dreadful instruments of his vengeance. He
will attack a man on horseback, if he should

venture to come too near him; and, first breaking the Horse's legs, kills both him and the rider.

Sparrman describes this species as of a bright yellow colour, like the domestic kind. Its nose is broad, flat, and of a horny hardness; its head is very large in proportion to the size of its body; underneath each eye it has a great lobe or wattle, lying almost horizontally, broad, flat, rounded at the end, and placed so as to intercept the view of any thing immediately beneath it; the ears are large and sharp-pointed, lined on the inside with long whitish hairs; its tail is slender and flat, and when the animal is pursued it always holds it quite erect.

They live in holes under ground, the avenues to which are exceedingly narrow. The natives seldom dare attack them in their retreats, as there is always danger of their rushing out unawares. When pursued with their young ones, it is no uncommon thing to see them take them up in their mouths, and run with them in that manner at a great rate.

From the shortness of their necks, they frequently fall on their knees to feed; and change this posture to that of standing with the greatest ease.

The flesh of this animal is good, and very much resembles that of the common Hog.

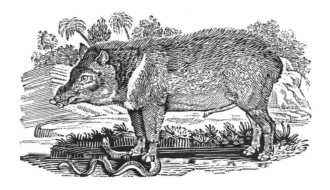

THE PECCARY, OR MEXICAN HOG.

(Sus Tajacu, Linn.)

INHABITS the hottest parts of South America, where the species is very numerous: herds, consisting of two or three hundred, are sometimes to be seen together. It is very fierce, and will fight stoutly with beasts of prey, when attacked by them. The Jaguar, or American Leopard, is its mortal enemy, and frequently loses its life in engaging a number of these animals. They assist each other, surround their enemies, and often come off victorious.

They live chiefly in mountainous places, and are not fond of wallowing in the mire, like the common Hog. They feed on fruits, roots, and seeds; they likewise eat serpents, toads, and lizards; and are very dexterous in first taking off the skins with their fore feet and teeth.

The Peccary in appearance resembles the Hog, though somewhat smaller: its body is covered with strong bristles, which, when the creature is irritated,

VOL. III. Y

rise up like the prickles of a Hedgehog, and are
very strong; they are of a dusky colour, with alter-
nate rings of white; across the shoulders to the
breast, there is a band of white; its head is short
and thick: it has two tusks in each jaw; its ears
are small and erect; and instead of a tail, it has a
small fleshy protuberance, which does not cover its
posteriors. It differs most essentially from the
Hog, in having a small orifice on the lower part of
the back, from which a thin watery humour, of a
most disagreeable smell, flows very copiously. In
the Philosophical Transactions, Dr. Tyson has
described this orifice very minutely, as well as
some other peculiarities in the conformation of its
stomach and intestines.

Like the Hog, the Peccary is very prolific. The
young ones, if taken at first, are easily tamed, and
soon lose all their natural ferocity; but can never
be brought to discover any signs of attachment to
those that feed them. They do no mischief, and
may be allowed to run about at pleasure. They
seldom stray far from home, and return of their
own accord. When angry, they grunt like the
Hog, but much stronger and harsher; and when
suddenly alarmed, make a sharp noise with their
breath, and erect their bristles.

The flesh of the Peccary, though drier and leaner
than that of our Hog, is by no means disagreeable,
and may be greatly improved by castration. When
killed, the dorsal gland must be immediately cut
off. If this operation be deferred for the space of
half an hour, the flesh becomes utterly unfit to be
eaten.

Although the European Hog is common in Ame-
rica, and in many parts has become wild, the

Peccary has never been known to breed with it. They frequently go together, and feed in the same woods; but hitherto no intermediate breed has been known to arise from their intercourse.

M. de la Borde describes two kinds of this animal, —one smaller than the other. He relates, that being one day engaged with some others in hunting a drove of Peccaries, they were surrounded by them, and obliged to take refuge upon a piece of rock; and notwithstanding they kept up a constant fire among them, the creatures did not retire till a great number of them were shot.

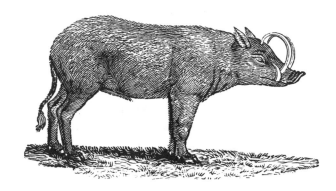

THE BABIROUSSA.

(Sus Babyroussa, Linn.—*Le Babiroussa*, Buff.)

THOUGH classed by naturalists with the Hog
kind, differs from animals of that species in a num-
ber of particulars: its legs are longer, and its body
more slender; it is covered with short hair as soft
as wool, and of a dark grey colour, mixed with red;
its ears are short and pointed; its tail is long, tufted
at the end, and twisted. Its most distinguishing
characteristic consists in four large tusks, the two
stoutest of which proceed, like those of the Wild-
Boar, from the under jaw, pointing upwards, and
standing near eight inches out of the sockets; the
two others rise up like horns on the outside of the
upper jaw, just above the nose, and extend in a
curve above the eyes, almost touching the forehead,
and are twelve inches in length. These tusks are
of the most beautiful ivory, but not so hard as those
of the Elephant.

The Babiroussa abounds in several of the islands
of the East Indies, particularly Buero, a small isle
near Amboyna.

It is easily tamed; and its flesh is well tasted.
It lives on leaves of trees and other vegetables. Its
scent is exquisite: it can discover the approach of
Dogs at a distance. When closely pursued, it
plunges into the sea, swims and dives with great
facility from one island to another, and by that
means frequently escapes from its pursuers.

They live in herds; and when any number of
them are together, their odour is so strong, that the
Dogs can scent them at a considerable distance.
When attacked, they growl frightfully, and defend
themselves with their under tusks: the upper ones
are serviceable to them in taking their repose, by
hooking them on the branches of trees.

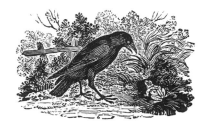

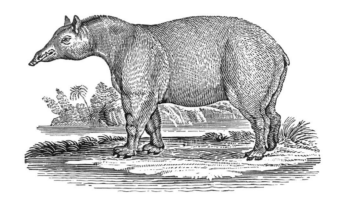

THE LONG-NOSED TAPIIR.

(Hippopotamus Terrestris, Linn.—*Le Tapir*, Buff.)

Is the *Hippopotamus* of the new world, and has
by some authors been mistaken for that animal. It
inhabits the woods and rivers on the eastern side
of South America, from the isthmus of Darien to
the river of the Amazons. It is a solitary animal,
sleeps during the day, and goes out in the night in
search of food; lives on grass, sugar-canes, and
fruits. If disturbed, it takes to the water, swims
with great ease, or plunges to the bottom; and like
the Hippopotamus, walks there as on dry ground.

It is about the size of a small Cow: its nose is
long and slender, and extends far beyond the lower
jaw, forming a kind of proboscis, which it can con-
tract or extend at pleasure: each jaw is furnished
with ten cutting teeth, and as many grinders; its
ears are small and erect; its body formed like that
of a Hog; its back arched; legs short; and hoofs,
of which it has four upon each foot, small, black,

and hollow; its tail is very small; its hair short, and of a dusky brown colour.

The Tapiir is mild and inoffensive, avoids all hostilities with other animals, and flies from every appearance of danger. Its skin, of which the Indians make bucklers, is very thick; and when dried, is so hard as to resist the impression of an arrow. The natives eat its flesh, which is said to be very good.

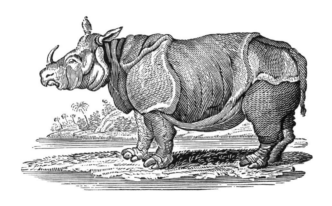

THE RHINOCEROS.

(Rhinoceros Unicornis, Linn.—*Rhinoceros*, Buff.)

WE are indebted to the labours of many learned and ingenious naturalists for accurate descriptions of this wonderful creature, which in size is exceeded only by the Elephant, and in strength and power is inferior to no other animal. Bontius says, that in the bulk of its body it equals the Elephant, but is lower only on account of the shortness of its legs.

The length of the Rhinoceros, from the extremity
of the muzzle to the insertion of the tail, is usually
twelve feet; and the circumference of its body
nearly equal to its length. Its nose is armed with
a formidable weapon, peculiar to this creature,
being a very hard and solid horn, with which it
defends itself from every adversary. The Tiger,
would rather attack the Elephant, whose trunk it
can lay hold of, than the Rhinoceros, which it can-
not face, without danger of having its bowels torn
out.

The body and limbs of the Rhinoceros are cover-
ed with a skin so hard and impenetrable, that he
fears neither the claws of the Tiger, nor the more
formidable proboscis of the Elephant: it will turn
the edge of a scimitar, and even resist the force of
a musket-ball. The skin, which is of a blackish
colour, forms itself into large folds at the neck, the
shoulders, and the crupper, by which the motion of
the head and limbs is facilitated; round the neck,
which is very short, are two large folds; there is
also a fold from the shoulders, which hangs down
upon the fore legs; and another from the hinder
part of the back to the thighs. The body is every
where covered with small tuberosities or knots,
which are small on the neck and back, but larger
on the sides: the thighs, legs, and even the feet, are
full of these incrustations, which have been mis-
taken for scales by some authors: they are, however,
only simple indurations of the skin, without any
uniformity in their figure, or regularity in their
position. Between the folds, the skin is penetrable
and delicate, as soft to the touch as silk, and of a
light flesh colour: the skin of the belly is nearly of
the same colour and consistency.

The body of the Rhinoceros is long and thick: its belly is large, and hangs near the ground; its legs are short, round, and very strong; and its hoofs divided into three parts, each pointing forward. The head of this animal is large; its ears long and erect; and its eyes small, sunk, and without vivacity: the upper lip is long, overhangs the lower, and is capable of great extension: it is so pliable, that the Rhinoceros can move it from side to side, twist it round a stick, collect its food, or seize with it any thing it would carry to its mouth.

The Rhinoceros, without being ferocious, carnivorous, or even extremely wild, is, however, totally untractable and rude. It seems to be subject to paroxysms of fury, which nothing can appease. That which Emanuel, king of Portugal, sent to the Pope in the year 1513, destroyed the vessel in which they were transporting it.

Like the Hog, the Rhinoceros is fond of wallowing in the mire. It is a solitary animal, loves moist and marshy grounds, and seldom quits the banks of rivers. It is found in Bengal, Siam, China, and other countries of Asia; in the isles of Java, Sumatra, Ceylon, &c.; in Ethiopia, and the country as low as the Cape of Good Hope: but in general, the species is not numerous, and is much less diffused than that of the Elephant.

The female produces but one at a time, and at considerable intervals. During the first month, the young Rhinoceros exceeds not the size of a large Dog. At the age of two years, the horn is not more than an inch long; at six years old, it is nine or ten inches long; and grows to the length of three feet and a half, and sometimes four feet. The horn is much esteemed by the natives as an anti-

dote against poison, as well as a remedy for particular diseases.

The Rhinoceros feeds on the grossest herbs, and prefers thistles and shrubs to soft and delicate pasturage. It is fond of the sugar-cane, and eats all kinds of grain.

Dr. Parsons remarks, that this animal has an acute and very attentive ear. It will listen, with a deep and long-continued attention, to any kind of noise; and though it be eating, lying down, or obeying any pressing demands of Nature, it will raise its head, and listen till the noise cease.

From the peculiar construction of his eyes, the Rhinoceros can only see what is immediately before him. When he pursues any object, he proceeds always in a direct line, overturning every obstruction. With the horn on his nose, he tears up trees, raises stones, and throws them behind him to a considerable distance. His sense of smelling is so exquisite, that the hunters are obliged to avoid being to windward of him. They follow him at a distance, and watch till he lies down to sleep: they then approach with great precaution, and discharge their muskets all at once into the lower part of the belly.

The Rhinoceros is supposed to be the *Unicorn* of holy writ, and possesses all the properties ascribed to that animal,—rage, untameableness, great swiftness, and immense strength. It was known to the Romans in very early times, and is handed down to us in some of the works of that celebrated people. Augustus introduced one into the shows, on his triumph over Cleopatra.

Its flesh is eaten and much relished by the natives of India and Africa.

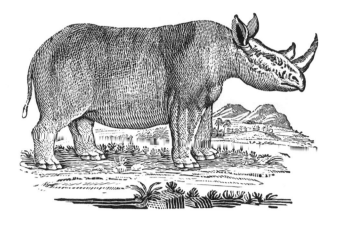

THE TWO-HORNED RHINOCEROS.

(Rhinoceros Bicornis, Linn.)

WE have given the figure of this hitherto un-
described animal, from Mr. Sparrman, whose
authenticity there is every reason to depend upon,
and who has given a most exact anatomical descrip-
tion of it. Of two that were shot, he mentions only
the size of the smaller of them; which was eleven
feet and a half long, seven feet high, and twelve in
circumference. Its skin was without any folds, and
of an ash colour ; excepting about the groin, where
it was flesh-coloured : the surface was scabrous and
knotty, of a close texture, and when dry, extremely
hard. There were no hairs on any part of the body,
except the edges of the ears and the tip of the tail,
on which were a few dark bristly hairs, about an
inch long.

The horns are placed one behind the other, in a
line with the nose : the foremost of them measures

about eighteen inches in length, and is always the larger of the two. They are of a conical shape, and the tips incline a little backward; the lower parts are rough, and seem as if composed of thorny fibres; the upper parts are smooth and plain, like those of an Ox. It is remarkable, that the Rhinoceros makes use of the shorter horn only, for the purpose of digging up roots, of which its food chiefly consists, being endued with the power of turning the larger horn on one side out of the way. The feet are round, and do not spread much; there are three hoofs on each of them, which project but little; the middle one is the longest.

The eyes of this animal are small, and sunk into its head; in consequence of which it sees indistinctly. But its organs of hearing and smelling are very acute: at the least noise, the creature takes the alarm, pricks up its ears, and listens with great attention: if it happen to catch the scent of any person within a small distance, it rushes out with astonishing rapidity; and it is difficult to avoid the impetuous attack of this powerful animal.

It has been generally said of the Rhinoceros, that its tongue is so hard and rough, as to take away the skin and flesh wherever it licks any person that has unfortunately fallen a victim to its fury. Mr. Sparrman says, however, that he thrust his hand into the mouth of one that had just been shot, and found the tongue perfectly soft and smooth. From the account of its intestines, given us by the same ingenious author, we shall just mention the following, which will enable our readers to form a more perfect idea of its enormous bulk: the stomach was four feet in length, and two in diameter; to which was annexed a tube or canal,

twenty-eight feet long, and six inches in diameter; the kidnies were a foot and a half in breadth: the heart was a foot and a half long, and nearly the same in breadth; the liver, when measured from right to left, was found to be three feet and a half in breadth, and two feet and a half deep, as it hangs in the animal's body when in a standing position: it had no gall-bladder, in which it resembles the Horse. Upon opening the stomach, the contents of it were found to consist of roots and small branches of trees masticated, some of which were as big as the end of a man's finger; in the mass there appeared a great quantity of succulent plants, as well as some that were harsh and prickly: the effluvium arising from this mass was so far from being offensive, that it diffused around a very strong and not disagreeable aromatic odour. We shall conclude this account by observing, that the cavity which contained the brains was small, being only six inches long, and four high, and of an oval shape: being filled with pease, it was found to contain barely one quart; a human skull, measured at the same time, did not require much less than three pints to fill it.

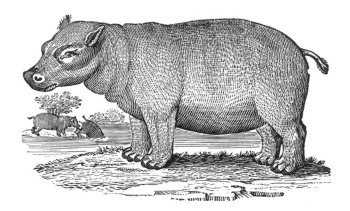

THE HIPPOPOTAMUS.

(Hippopotamus Amphibius, Linn.—*L' Hippopotame,*
Buff.)

THE great difficulties that have always attended
a complete investigation of this huge animal, have
arisen as well from the remoteness of its situation,
as from its peculiar habits and disposition.

Though the Hippopotamus has been celebrated
from the remotest antiquity; though the sacred
writings mention him under the name of *Behemoth;*
and though his figure is to be seen engraven on
Egyptian obelisks and on Roman medals, yet his
history was very imperfectly known to the ancients.
Aristotle says, that he has a mane like a Horse,
and hoofs like an Ox; tusks and tail like a Boar;
that he is of the size of an Ass, and has the voice of
a Horse; with other things equally absurd; all
which Pliny has copied; and, instead of correcting,
has added to the number of his errors. Of the
accounts of later writers, it is much to be lamented

that suitable delineations have not accompanied
their accurate descriptions,—a general defect, by
which the study of nature has been much retarded,
the laborious researches of many learned and ingeni-
ous naturalists greatly frustrated, and the errors of
former times repeatedly copied, and multiplied
without number.

The size of the Hippopotamus is nearly equal to
that of the Elephant. M. Vaillant says, that one
which he killed, measured, from the tip of the nose
to the insertion of the tail, ten feet seven inches,
and was eight feet eleven inches in circumference;
but, from the smallness of its tusks, he supposed it
to be a young one. In its stomach were found
leaves and reeds, grossly chewed: likewise small
branches of trees, a little bruised.

It inhabits all the larger rivers of Africa, from
the Niger to the Cape of Good Hope; but it is
found in none of the African rivers that run into
the Mediterranean, except the Nile, and in that
part of it only which runs through the Upper
Egypt, and in the fens and lakes of Ethiopia.

The head of this animal is enormously large: its
mouth vastly wide. Ray says, that the upper man-
dible is moveable, like that of a Crocodile. In each
jaw there are four cutting teeth; those in the lower
jaw point straight forward: it has four large tusks;
the largest, which are always in the lower jaw, are
sometimes above two feet long: it is said that the
canine teeth are so hard, as to emit fire on being
struck with steel; they are perfectly white, and
preferable to ivory for making artificial teeth: the
grinders are square or oblong like those of a man;
and so large that a single tooth weighs above three
pounds; the skin is of a dusky colour, bears a

resemblance to that of the Rhinoceros, but is
thicker, and is made into whips: the tail is nearly
a foot long, taper, and flatted at the end, which is
thinly furnished with hairs like bristles: its legs
are so short, that its belly almost touches the
ground; the hoofs are divided into four parts, un-
connected by membranes.

When alarmed or pursued, it takes to the water,
plunges in, and sinks to the bottom; where it walks
at full ease. It often rises to the surface, and re-
mains with its head out of the water, making a
bellowing noise, which may be heard at a great
distance. It feeds during the night, on the banks
of the rivers, and sometimes does great damage
in the adjacent plantations of rice and other
grain.*

The Hippopotamus is naturally mild and gentle,
very slow, and heavy in its movements upon land,
but in the water bold and active; and when pro-
voked or wounded will rise and attack boats or
canoes with great fury. Dampier says, he has
known one of these animals sink a boat full of
people, by biting a hole in the bottom with its tusks.
The method of taking it is by digging pits in the
sand, in those parts through which the animal
passes in its way to the river after it has been feed-
ing.

* The Arabic name of the Hippopotamus is Barnik, the Nubians
call it Ird. It is a dreadful plague, on account of its voracity, and
the want of means in the inhabitants to destroy it. They never rise
above water in the day time, but come on shore in the night, when
they destroy as much by the treading of their enormous feet, as by
their voracity. It is generally said that no musket ball can bring
them to the ground, unless they are hit in the vulnerable spot, which
is over the ear. *Burckhardt's Travels.*

The flesh of the Hippopotamus is tender and good: the fat is fine and well-tasted, and much in request with the colonists at the Cape, who look upon it as the most wholesome meat that can be eaten: the gelatinous part of the feet in particular is accounted a great delicacy: the tongue, when dried, is also considered at the Cape as a rare and excellent dish.

Sparrman has given an engraving of this animal, taken from a young one which he caught at the Cape, and from which ours is copied. The subjoined cut, representing the head of the male, is taken from Vaillant's Travels in Africa. The female brings forth one young at a time.

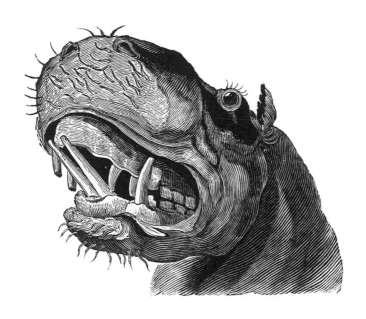

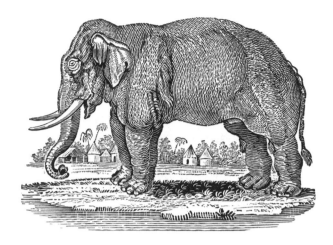

THE ELEPHANT.

(Elephas Maximus, Linn.—*L'Elephant,* Buff.)

OF all the creatures that have hitherto been taken into the service of man, the Elephant is pre-eminent in the size and strength of his body, and inferior to none in sagacity and obedience.

From time immemorial this animal has been employed either for the purposes of labour, of war, or of ostentatious parade; to increase the grandeur of eastern princes, extend their power, or enlarge their dominions.

The Elephant is a native of Asia and Africa, and is not to be found in its natural state either in Europe or America. From the river Senegal to the Cape of Good Hope, they are met with in great numbers. In this extensive region, as they are more numerous than in any other part of the world, so

are they less fearful of man. The savage inhabitants of this dreary country, instead of attempting to subdue this powerful animal, and render it subservient to their necessities, seem desirous only of avoiding its fury.

Sparrman says, that in the country near the Cape, they are sometimes seen in large herds, consisting of many hundreds; and he thinks it probable, that in the more remote and unfrequented parts of that vast country, they are still more numerous.

They are frequently hunted by the colonists at the Cape, who are very expert in shooting them, and make great advantage of their teeth. The largest teeth weigh an hundred and fifty Dutch pounds, and are sold to the governor for as many guilders; so that a man may earn three hundred guilders at one shot. It is not therefore to be wondered at, that a traffic so lucrative should tempt the hunter to run great risks. In approaching this animal, great care must be taken to steal upon him unperceived. If the Elephant discover his enemy near, he rushes out, and endeavours to kill him. One of these hunters being out upon a plain, under the shelter of a few scattered thorn trees, thought he could be able to advance near enough to shoot an Elephant that was at a little distance from him; but he was discovered, pursued, and overtaken by the animal, which laid hold of him with his trunk, and beat him instantly to death.

The height of the Elephant at the Cape is from twelve to fifteen feet. The female is less than the male, and her tusks do not grow to such a size.

In proportion to the size of the Elephant his eyes are very small; but they are lively, brilliant, and

capable of great expression. He turns them slowly, and with gentleness, towards his master. When he speaks, the animal regards him with an eye of mildness and attention. His ears are very large, and much longer, in proportion to his body, than those of the Ass: they lie flat on the head, and are commonly pendulous; but he can raise and move them with great facility, and frequently uses them as a fan to cool himself, or defend his eyes from dust and insects. His hearing is likewise remarkably fine; for he delights in the sound of musical instruments, and moves in cadence to the trumpet and tabor. Their are four grinders in each jaw, closely united together, forming with the jaw-bone, one hard and compact body. One of these grinders sometimes measures nine inches broad, and weighs four pounds and a half. The texture of the skin is uneven, wrinkled and knotty; full of deep fissures, nearly resembling the bark of an oak tree, which run in all directions over its surface. It is of a tawny colour, inclining to citron. In the fissures there are some bristly hairs, which are also thinly scattered over the body. The legs resemble massy columns, of fifteen or eighteen inches diameter, and from five to six feet high. The foot is short, and divided into five toes, covered by the skin, so as not to be visible. To each toe there is affixed a nail or hoof, of a horny substance.

The most remarkable feature of the Elephant is his trunk or proboscis, which is composed of membranes, nerves, and muscles. It is an organ both of feeling and of motion. The animal can not only move and bend it, but can contract, lengthen, and turn it in every direction. The extremity of the trunk terminates in a protuberance, which stretches

out on the upper side in the form of a finger, and possesses in a great degree the niceness and dexterity of that usful member. It is equally flexible, and as capable of laying hold of objects as the fingers of a man. He lifts from the ground the smallest piece of money; he selects herbs and flowers, and picks them up one by one; he unties the knots of ropes, opens and shuts gates, &c. With his trunk he grasps any body which it is applied to, so firmly, that no force can tear it from his gripe.

Of all the instruments which Nature has so liberally bestowed on her most favourite productions, the trunk of the Elephant is perhaps the most complete and admirable. Ray says, it is divided into three partitions or chambers, two of which run in spiral directions, and the other in a right line. It is eight feet long in an Elephant of fourteen feet high, and five feet in circumference at the thickest part. The nostrils are situated at the extremity, through which it draws in water by a strong suction, either for the purpose of quenching its thirst, or of washing and cooling itself, which it frequently does, by taking up a large quantity, part of which it carries to its mouth, and drinks; and by elevating the trunk, allows the remainder to run over every part of its body.

Roots, herbs, leaves, and tender wood, are the ordinary food of the Elephant. It does not ruminate, and has but one stomach: this want, however, is amply supplied by the magnitude and length of his intestines, and particularly of the colon, which is from fifteen to twenty feet in length, and two or three in diameter. When one of them discovers a plentiful pasture, he calls to the others and invites

them to partake. As they require a great quantity
of forage, they frequently change their pasture, and
do considerable damage whenever they happen to
stray into cultivated ground. From the weight of
their bodies and the size of their feet, they destroy
much more than they use for food. The Indians
and negroes use every artifice to prevent the ap-
proach of these unwelcome visitants, by making
loud noises, and kindling fires round their habita-
tions; but in spite of all their precautions, the
Elephants often break through their fences, destroy
their whole harvest, and overturn their huts. It is
not easy to separate them: they generally act in
concert, whether they attack, march, or fly.

The ordinary walk of the Elephant is not quicker
than that of a Horse; but when pushed, he assumes
a kind of ambling pace, which in fleetness is equal
to a gallop. He goes forward with ease and
celerity; but it is with great difficulty that he turns
himself round, and that not without taking a pretty
large circuit. It is generally in narrow and hollow
places that the negroes attack him, and cut off his
tail, which they value above every other part of his
body. He swims well, and is of much use in carry-
ing great quantities of baggage over large rivers.
When swimming, he raises his long trunk above
the surface of the water for the sake of respiration,
every other part of his body being below: in this
manner several of these animals swim together, and
steer their course without danger of running foul of
each other.

The Elephant, when tamed, is gentle, obedient,
and docile: patient of labour, he submits to the
most toilsome drudgery; and is so attentive to the
commands of his governor, that a word or a look is

sufficient to stimulate him to the most violent exertions. His attachment to his keeper is so great, that he caresses him with his trunk, and frequently will obey no other master: he knows his voice, and can distinguish the tone of command, of anger, or of approbation, and regulates his actions accordingly: he receives his orders with attention, and executes them with eagerness, but without precipitation. All his motions are orderly, and seem to correspond with the dignity of his appearance, being grave, majestic, and cautious. He kneels down for the accommodation of those who would mount upon his back, and with his pliant trunk even assists them to ascend. He suffers himself to be harnessed, and seems to have a pleasure in the finery of his trappings. He is used in drawing chariots, waggons, and various kinds of machines. One of them will perform with ease the work of many Horses.

The conductor of the Elephant is usually mounted on its neck, and makes use of a rod of iron, sharp at the end, and hooked; with which he urges the animal forward, by pricking its head, ears, or muzzle: but in general, a word from the keeper is sufficient to encourage this intelligent creature to proceed on its way, or perform the task assigned to it. In India, where they were once employed in launching ships, one of them was directed to force a large vessel into the water, which proving superior to its strength, the master, in an angry tone, cried out, "Take away that lazy beast, and bring another in its place." The poor animal instantly redoubled its efforts, fractured its skull, and died upon the spot.

The Indians, from very early periods, have em-

ployed Elephants in their wars: Porus opposed the passage of Alexander, over the Hydaspes, with eighty-five of them. M. de Buffon imagines, that it was some of the Elephants taken by that monarch, and afterwards transported into Greece, which were employed by Pyrrhus against the Romans. Since the invention of fire-arms, the Elephant has been of little use in deciding the contests of hostile nations; for being terrified with the flash of the powder and the report that immediately succeeds, they are soon thrown into confusion, and then become dangerous to their employers. They are now chiefly used for the purposes of labour, or magnificent parade.

The Indian princes, in their travels, are attended by hundreds of these animals: some are employed to convey the ladies who compose the seraglio, in latticed cages made for that purpose, and covered with branches of trees; whilst others transport immense quantities of baggage, with which the sovereigns of the East are always accompanied in their marches from one place to another. They are likewise made use of as the dreadful instruments of executing condemned criminals—a task which they perform with great dexterity. At the word of command, they break the limbs of the criminal with their trunks; they sometimes trample him to death, or impale him on their enormous tusks, just as they are directed by their more barbarous keeper.

It is a singular circumstance in the history of this extraordinary animal, that in a state of subjection, it is unalterably barren; and though it has been reduced under the dominion of man for ages, it has never been known to breed; as if it had a proper sense of its degraded condition, and ob-

stinately refused to increase the pride and power of its conquerors by propagating a race of slaves. It therefore follows, that of all the numerous bands of Elephants that are trained to service, there is not one that has not been originally wild, nor one that has not been forced into a state of subjection. To recruit, therefore, the numbers that are unavoidably consumed by disease, accident, or age, the eastern princes are obliged every year to send into the forests, and use various methods to procure fresh supplies.

The manner of taking, taming, and rendering these animals submissive, is curious, and well deserves a place in the history of the Elephant. In the midst of a forest abounding with Elephants, a large piece of ground is marked out, and surrounded with strong palisades, interwoven with branches of trees: one end of the inclosure is narrow; from which it widens gradually, so as to take in a great extent of country. Several thousand men are employed upon the occasion, who place themselves in such a manner as to prevent the wild Elephants from making their escape: they kindle large fires at certain distances, and make a dreadful noise with drums and various kinds of discordant instruments, calculated for the purpose of stunning and terrifying the poor animals; whilst another party, consisting of some thousands, with the assistance of tame female Elephants, trained for the purpose, drive the wild Elephants slowly towards the great opening of the inclosure, the whole train of hunters closing in after them, shouting, and making a great noise, till they are driven by insensible degrees into the narrow part of the inclosure, through which there is an opening into a smaller space, strongly fenced in,

and guarded on all sides. As soon as one of the
Elephants enters this strait, a strong bar closes the
passage from behind, and he finds himself com-
pletely environed. On the top of this narrow pas-
sage, some of the huntsmen stand with goads in
their hands, urging the creature forward to the end
of the passage, where there is an opening just wide
enough to let him pass. He is now received into
the custody of two females, who stand on each side
of him, and press him into the service: if he be
likely to prove refractory, they begin to discipline
him with their trunks, till he is reduced to obedi-
ence, and suffers himself to be led to a tree, where
he is bound by the leg with stout thongs, made of
untanned Elk or Buck skin. The tame Elephants
are then led back to the inclosure, and the others
are made to submit in the same manner. They are
all suffered to remain fast to the trees for several
days. Attendants are placed by the side of each
animal, who supply him with food by little and
little, till he is brought by degrees to be sensible of
kindness and caresses, and allows himself to be led
to the stable. In the space of fourteen days, his
absolute submission is completed. During that
time, he is fed daily with cocoa-nut leaves, and led
once a day to the water by the tame ones. He be-
comes accustomed to the voice of his keeper, and
at last quietly resigns his prodigious powers to the
dominion and service of man.

The time of gestation of the Elephant is hitherto
but imperfectly known: Aristotle says, it goes two
years with young; which is the more likely, as the
season of desire in the male returns but once in
three years. The female produces one young at a
time. The young Elephants are said to suck with

their trunk, the teats of the female being situated between her fore legs.*

The Elephant is thirty years in arriving at its full growth; and is said to live, though in a state of captivity, to the age of an hundred and twenty or an hundred and thirty years: in a state of unrestrained freedom, it is supposed to live much longer.

The Elephant will drink wine, and is fond of spiritous liquors. By shewing him a vessel filled with arrack, he is induced to exert the greatest efforts, and perform the most painful tasks, in hopes of receiving it as the reward of his labour. To disappoint him is dangerous, as he seldom fails to be revenged. The following instance is given as a fact, and deserves to be recorded:—An Elephant, disappointed of his reward, out of revenge killed his cornac or governor. The poor man's wife, who beheld the dreadful scene, took her two infants, and threw them at the feet of the enraged animal, saying, "Since you have slain my husband, take my life also, as well as that of my children." The Elephant instantly stopped, relented, and, as if stung with remorse, took the eldest boy in its trunk, placed him on its neck, adopted him for its cornac, and would never allow any other person to mount it.

We might quote many other facts equally curious and interesting: those we have already recited are sufficient to shew that the Elephant is possessed of instinctive faculties superior to those of any other animal. We must at the same time admire the

* The nipples of the Elephant are near the breast, and the old one is forced to suck herself, and by the help of her trunk conveys the milk into the mouth of her young. *See Philosophical Transactions, No. 336.*

providential order of that dispensation, which, to an animal of such unequalled powers, has added a disposition so mild and tractable. What ravages might we not expect from the prodigious strength of the Elephant, combined with the fierceness and rapacity of the Tiger!

We cannot close our account of the Elephant, without taking some notice of the teeth of that animal, which have been so frequently found in a fossil state in various parts of the world. Some years ago, two great grinding teeth, and part of the tusk of an Elephant, were discovered at the depth of forty-two yards, in a lead mine, in Flintshire, lying in a bed of gravel: the grinders were almost as perfect as if they had been just taken from the living animal; the tusk was much decayed and very soft. Near the banks of many rivers in Siberia, large tusks and teeth have been frequently dug up, which were formerly attributed to a creature called the *Mammoth ;* but they are now universally believed to have belonged to the Elephant. The molares or grinders are perfectly the same with those of the present race; but both they and the tusks are much larger: some of the latter have been known to weigh four hundred pounds; and grinders of the weight of twenty-four pounds have not unfrequently been discovered. One of these was taken from a skeleton of the same head in which the tusks were found: and as the ivory of the latter was in every respect the same as that generally known, and made use of for the purpose of useful and ornamental works, we cannot deny our assent to the opinion of those who suppose them to have been once parts of the animal we have just described. Tusks of a prodigious size, teeth,

jaw-bones, and vertebræ, have likewise been fre-
quently found on the banks of the river Ohio, in
America, five or six feet beneath the surface.
Some of the tusks are near seven feet long, one foot
nine inches in circumference at the base, and one
foot near the point. They differ from those of the
Elephant in having a large twist or spiral curve
towards the small end. There is a still greater
difference in the form of the grinders, which are
made like those of a carnivorous animal, not flat
and ribbed transversely on their surface, like those
of an Elephant, but furnished with a double row of
high and conic projections, as if intended to
masticate, not grind their food. Specimens of
these teeth and bones are deposited in the British
Museum, that of the Royal Society, and in the cab-
inet of the late ingenious Dr. Hunter. These fos-
sil bones are also found in Peru and in the Brazils.
As yet, the living animal has evaded the search of
the curious naturalist; but it is not improbable,
that it may exist in some of those remote parts of
that vast continent, yet unpenetrated by Europeans.

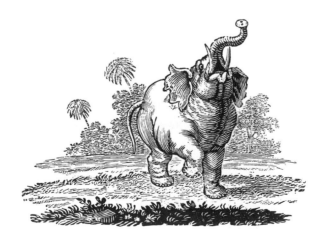

ANIMALS OF THE CAT KIND.

WE have hitherto been employed in the pleasing task of describing most of those numerous tribes of animals that are more nearly connected with the interests of mankind; that serve as the instruments of man's happiness, or at least that do not openly oppose him; that depend upon his care for their subsistence; and in their turn contribute largely to his comfort and support. We have taken an ample range among the wilder inhabitants of the forest, which, though in a more remote degree dependant on man, are nevertheless objects of his attention and pursuit. We have followed Nature to her most retired recesses, and have seen and admired her works under a variety of the most beautiful living forms; but our progress has hitherto been unstained with blood.

The attention of our readers will now be engaged in a different pursuit. The scene must be diversified.

We come now to a sanguinary and unrelenting tribe, the bold and intrepid enemies of man, that disdain to own his power, and carry on unceasing hostilities against him.

This numerous and ferocious tribe is chiefly distinguished by their sharp and formidable claws, which are lodged in a sheath, and are capable of being extended or drawn in at pleasure. They lead a solitary and a ravenous life, and never unite for mutual defence or support, like those of the herbivorous kinds. They seek their food alone, and are frequently enemies to each other. Though differing greatly in size and in colour, they are nearly allied to each other in form and disposition, being equally fierce, rapacious, and artful.

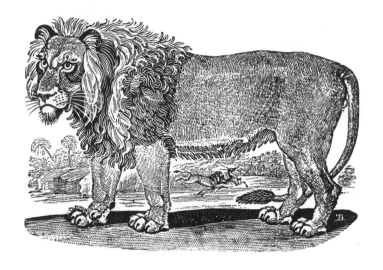

THE LION.

(*Felis Leo*, Linn.—*Le Lion*, Buff.)

Is eminently distinguished from the rest, as well in size and strength, as by his large and flowing mane.

This animal is produced in Africa, and the hottest parts of Asia. It is found in the greatest numbers in the scorched and desolate regions of the torrid zone, in the deserts of Zaara and Biledulgerid, and in all the interior parts of the vast continent of Africa. In these desert regions, whence mankind are driven by the rigorous heat of the climate, this animal reigns sole master: its disposition seems to partake of the ardour of its native soil: inflamed by the influence of a burning sun, its rage is most tremendous, and its courage undaunted. Happily, indeed, the species is not numerous, and is said to

be greatly diminished; for, if we may credit the testimony of those who have traversed these vast deserts, the number of Lions is not nearly so great as formerly. Mr. Shaw observes, that the Romans carried more Lions from Lybia in one year, for their public spectacles, than could be found in all that country at this time. It is likewise remarked that in Turkey, Persia, and the Indies, Lions are not now so frequently met with as in former times.

It is observed of this animal, that its courage diminishes, and its caution and timidity are greater, in proportion as it approaches the habitations of the human race. Being acquainted with man, and the power of his arms, it loses its natural fortitude to such a degree, as to be terrified at the sound of his voice. It has been known to fly before women, and even children, and suffer itself to be driven away by them from its lurking places in the neighbourhood of their villages.

This alteration in the Lion's disposition sufficiently shews, that it will admit of a certain degree of education: and it is a well-known fact, that the keepers of wild beasts frequently play with him, pull out his tongue, hold him by the teeth, and even chastise him without cause. The animal seems to bear all with a sullen kind of composure, and rarely retaliates this unmerited treatment. It is dangerous, however, to provoke him too far, or to depend upon his temper with too great security. Labat tells us of a gentleman who kept a Lion in his chamber, and employed a servant to attend it; who, as is usual, mixed his blows with caresses. This ill-judged association continued for some time. One morning the gentleman was awakened by an unusual noise in his room, and drawing his curtains,

he perceived it to proceed from the Lion, which was growling over the body of the unhappy man, whom it had just killed, and had separated his head from his body. The terror and confusion of the gentleman may be easily conceived: he flew out of the room, and, with the assistance of some people, had the animal secured from doing further mischief.

As the passions of this animal are strong, and its appetites vehement, we ought not to presume that the impressions of education will always be sufficiently powerful. It must be dangerous, therefore, to suffer it to remain too long without food, or to persist in irritating or abusing it.

However, numberless accounts assure us, that the anger of the Lion is noble, its courage magnanimous, and its temper susceptible of grateful impressions. It has been often seen to despise weak and contemptible enemies, and even to pardon their insults, when it was in its power to punish them: it has been known to spare the life of an animal that was thrown to be devoured by it, to live in habits of perfect cordiality with it, to share its subsistence, and even to give it a preference when its portion of food was scanty.

The form of the Lion is strikingly bold and majestic: his large and shaggy mane, which he can erect at pleasure, surrounding his awful front; his huge eye-brows; his round and fiery eye-balls, which, upon the least irritation, seem to glow with peculiar lustre; together with the formidable appearance of his teeth,—exhibit a picture of terrific grandeur, which no words can describe.

The length of the largest Lion is between eight and nine feet, the tail about four, and its height

about four feet and a half. The female is about one-fourth part less, and without the mane.

As the Lion advances in years, his mane grows longer and thicker. The hair on the rest of his body is short and smooth, of a tawny colour, but whitish on the belly. The roaring of the Lion is loud and dreadful: when heard in the night, it resembles distant thunder. Its cry of anger is much louder and shorter.

The Lion seldom attacks any animal openly, except when compelled by extreme hunger: in that case no danger deters him; but as most animals endeavour to avoid him, he is obliged to have recourse to artifice, and take his prey by surprise. For this purpose, he crouches on his belly in some thicket, where he waits till his prey approaches; and then, with one prodigious spring he leaps upon it at the distance of fifteen or twenty feet, and generally seizes it at the first bound. If he miss his object, he gives up the pursuit; and turning back towards the place of his ambush, he measures the ground step by step, and again lies in wait for another opportunity. The lurking place of the Lion is generally chosen near a spring, or by the side of a river; where he frequently has an opportunity of catching such animals as come to quench their thirst.

There are, however, instances where the Lion deviates from his usual method of taking his prey, of which the following, related by Sparrman, is remarkable:—A Hottentot, perceiving that he was followed by a Lion, and concluding that the animal only waited the approach of night to make him his prey, began to consider of the best method of providing for his safety, which he at length effected in

the following singular manner : observing a piece of broken ground, with a precipitate descent on one side, he sat down by the edge of it ; and found, to his great joy, that the Lion also made a halt, and kept at the same distance as before. As soon as it grew dark, the Hottentot, sliding gently forward, let himself down a little below the edge of the hill, and held up his cloak and hat upon his stick, making at the same time a gentle motion with it : the Lion, in the mean while, came creeping softly towards him, like a Cat; and mistaking the skin cloak for the man himself, made a spring, and fell headlong down the precipice : by which means the poor Hottentot was safely delivered from his insidious enemy.

That the Lion does not always kill whatever animal happens to be in his power, has already been observed; and this peculiarity in its temper is remarkably obvious, with regard to the human species. Of this there have been many instances. At St. Catherine Cree's church, Leadenhall-street, London, provision is made, under the will of Sir John Gager, who was lord-mayor in the year 1646, for a sermon to be annually preached on the 16th of November, in commemoration of his happy deliverance from a Lion, which he met in a desert, as he was travelling in the Turkish dominions, and which suffered him to pass unmolested. The minister is to have 20s. for the sermon, the clerk 2s. 6d., and the sexton 1s. The sum of 8l. 16s. 6d. is likewise to be distributed among the necessitous inhabitants, pursuant to the will of Sir John. Sparrman, among several instances of the same nature, mentions a person who, though he was thrown down by a Lion, and wounded by it in

several places, was after all generously left with
life.

The strength of this animal is great: one of them
was observed to seize a heifer, which it carried off
in its mouth with ease, and leaped over a ditch
without much apparent difficulty.

At the Cape of Good Hope, the Lion is frequently
hunted by the colonists. In the day time, and
upon an open plain, twelve or sixteen Dogs will
easily get the better of a large Lion. As the Lion
is not remarkably swift, the Dogs soon come pretty
near him; when, with a sullen kind of magnanimity,
he turns round, and waits for the attack, shaking
his mane, and roaring with a short and sharp tone.
The hounds surround him; and rushing upon him
all at once, soon tear him to pieces. It is said that
he has seldom time to make more than two or three
strokes with his paws; each of which is attended
with the death of one of his assailants.

The Lioness goes with young five months, and
brings forth three or four at a time. The young
ones are about the size of a large Pug-Dog, harm-
less, pretty, and playful. They continue at the teat
twelve months, and are about five years in coming
to perfection.

The attachment of the Lioness to her young is
remarkably strong: for their support, she is more
ferocious than the Lion himself, makes her incur-
sions with greater boldness, destroys, without
distinction, every animal that falls in her way, and
carries it reeking to her cubs. She usually brings
forth in the most retired and inaccessible places;
and when afraid of her retreat being discovered,
endeavours, it is said, to hide her track by brushing
the ground with her tail. When much disturbed

or alarmed, she will sometimes transport her young from one place to another in her mouth ; and if obstructed in her course, will defend them to the last extremity.

The Lion is a long-lived animal, although naturalists have differed greatly as to the precise period of its existence. Buffon limits it to twenty, or twenty-two years at most. It is however certain, that it lives much beyond that time. The great Lion called Pompey, which died in the year 1760, was known to have been in the Tower above seventy years; and one, brought from the river Gambia, died there not long ago, at the age of sixty-three. Several of these animals have been bred in the Tower: so that the time of their gestation, the number they produce, and the time of their arriving at perfection, are all pretty well known.

The flesh of the Lion is said to have a strong disagreeable flavour; yet it is frequently eaten by the negroes. The skin, which was formerly a robe of distinction for heroes, is now made use of by those people as a mantle or a bed. They also preserve the grease, which is of a penetrating nature, and is used in medicine.

The representation we have given was drawn from a remarkably fine one, exhibited at Newcastle in the year 1788. It was then young, extremely healthful, active, and in full condition.

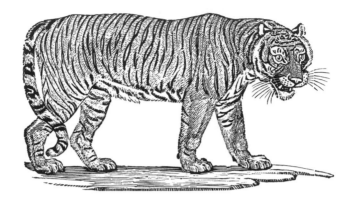

THE TIGER.

(Felis Tigris, Linn.—*Le Tigre*, Buff.)

IS the most rapacious and destructive of all carnivorous animals. Fierce without provocation, and cruel without necessity, its thirst for blood is insatiable: though glutted with slaughter, it continues its carnage, nor ever gives up so long as a single object remains in its sight: flocks and herds fall indiscriminate victims to its fury: it fears neither the sight nor the opposition of man, whom it frequently makes its prey, and it is even said to prefer human flesh to that of any other animal.

The Tiger is peculiar to Asia, and is found as far North as China and Chinese Tartary: it inhabits Mount Ararat and Hyrcani, of old famous for its wild beasts. The greatest numbers are met with in India and its islands. They are the scourge of the country: they lurk among the bushes, by the sides of rivers, and almost depopulate many places. They seldom pursue their prey, but bound upon it

from the place of their ambush, with an elasticity, and from a distance scarcely credible. It is highly probable that, from this circumstance, the Tiger may derive its name, which, in the Armenian language, signifies an arrow; to the flight of which this creature may very properly be compared, in the quickness and agility of its bounds.

The strength of this animal is so great, that when it has killed a Deer or other animal, it carries it off with such ease, that it seems no impediment to its flight. If it be undisturbed, it plunges its head into the body of the animal, up to its very eyes, as if to satiate itself with blood.

The Tiger is one of the few animals whose ferocity can never be wholly subdued. Neither gentleness nor constraint has any effect in softening its temper. It does not seem sensible of the attention of its keeper; and would equally tear the hand that feeds, with that by which it is chastised.

A beautiful young male Tiger, lately brought over from China, in the Pitt East Indiaman, at the age of ten months, was so far domesticated, as to admit every kind of familiarity from the people on board. It seemed to be quite harmless, and was as playful as a kitten. It frequently slept with the sailors in their hammocks, and would suffer two or three of them to repose their heads upon its back, as upon a pillow, whilst it lay stretched out upon the deck. In return for this, it would, however, now and then steal their meat. Having one day taken a piece of beef from the carpenter, he followed the animal, took the meat out of its mouth, and beat it severely for the theft; which punishment it suffered with all the patience of a Dog. It would frequently run out on the bowsprit, climb

about the ship like a Cat, and perform a number of tricks, with an agility that was truly astonishing. There was a Dog on board the ship with which it would often play in the most diverting manner. From these circumstances, one might be led to suppose, that the disposition of the Tiger, like that of many other animals, was capable of some degree of culture. But it ought to be remembered, that at the time this one was taken on board the ship, it was only a month or six weeks old; and when arrived in this country, it had not quite completed a year. How much longer its good humour might have continued, it is impossible to say: but it is much to be doubted, whether the same innocent playfulness would have formed a part of its character when arrived at its full state of maturity.

Notwithstanding the cruelty of this creature's disposition, a sudden check has sometimes had a good effect in preventing its meditated attack. Some ladies and gentlemen being on a party of pleasure, under a shade of trees, on the banks of a river in Bengal, were suddenly surprised at seeing a Tiger ready to make its fatal spring: one of the ladies, with amazing presence of mind, laid hold of an umbrella, and unfurling it directly in the animal's face, it instantly retired. Another party had not the same good fortune. A Tiger darted among them while they were at dinner, seized on a gentleman, and carried him off in the sight of his disconsolate companions.

They attack all kinds of animals, even the Lion; and furious combats have frequently been maintained between them, in which both have perished.

Father Tachard gives an account of a battle between a Tiger and two Elephants, at Siam; of

which he was an eye-witness. The heads, and part
of the trunks of the Elephants, were defended from
the claws of the Tiger by a covering made for the
purpose. They were placed in the midst of a large
enclosure. One of them were suffered to approach
the Tiger, which was confined by cords, and re-
ceived two or three heavy blows from the trunk of
the Elephant upon its back, which beat it to the
ground, where it lay for some time as if it were
dead : but, though this attack had a good deal
abated its fury, it was no sooner untied, than with
a horrible roar, it mode a spring at the Elephant's
trunk, which that animal dexterously avoided by
drawing it up; and receiving the Tiger on its
tusks, threw it up into the air. The two Elephants
were then allowed to come up ; and, after giving it
several heavy blows, would undoubtedly have killed
it, if an end had not been put to the combat.—
Under such restraints and disadvantages, we can-
not wonder that the issue was unfavourable to the
Tiger. We may, however, by this, judge of its
great strength and fierceness,—that, after being
disabled by the first attack of the Elephant, whilst
it was held by its cords, it would venture to continue
such an unequal engagement.

We are happy in being able to present our
curious readers with an engraving of this rare
anmial, drawn from the life, from a Tiger that was
exhibited at Newcastle in 1787, and was generally
allowed to be one of the finest creatures of its kind
ever seen in England. The beautiful bars of black
with which every part of its body was streaked, are
accurately copied : the colour of the ground was
yellow, deeper on the back, and softening by
degrees towards the belly, where it was white ; as

were also the throat and insides of the legs: a
white space, spotted with black, surrounded each
eye; and on each cheek, a stripe of the same colour
extended from the ears to the throat. It was nearly
the same height as the Lion, and was of the largest
species of the Tiger, which is called the *Royal
Tiger*. The smallest of them is not above two feet
high, said to be extremely cunning, and delights in
human flesh. The second kind is about three feet
high, and is fond of Deer, Wild Hogs, &c., which it
frequently takes by the sides of rivers, as they come
down to quench their thirst.

The skin of this animal is much esteemed all over
the East, particularly in China. The Mandarins
cover their seats of justice with it; and during the
winter, use it for cushions and pillows.

———

We have now described the two great heads of
this mischievous family, which are eminently dis-
tinguished from the rest in size, strength, and
colour.

The three succeeding species have been fre-
quently confounded with each other; and although
there is some difference in their size, and in the
disposition of their spots, yet these have been so
indiscriminately defined, as to make it difficult to
form a true criterion, so as accurately to distinguish
each species. Strikingly similar in the form of
their bodies, in the beauty of their skins, as well
as in their dispositions and habits, which seem to
be equally formed for rapine and cruelty,—there is
much room to conjecture, that commixture may be
one great cause of producing the slight differences
observable in them. If we regard the figure and
diversity of the spots, we shall find many varieties

not taken notice of by naturalists; if we be led to
judge by the size, we shall find an almost imper-
ceptible gradation from the Cat to the Tiger. It
would be vain, therefore, to make as many varieties
in these animals, as we see differences in spots or
stature: it will be sufficient to point out the most
general distinctions.

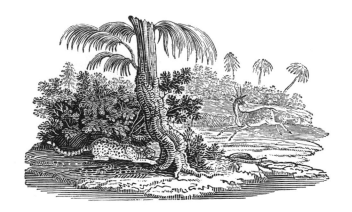

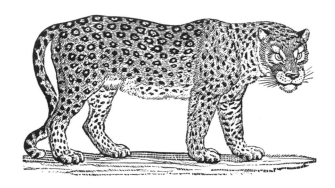

THE PANTHER.

(Felis Pardus, Linn.—*La Panthere,* Buff.)

Is next in size to the Tiger, and has, by many
naturalists, been mistaken for that animal. Its
hair is short, and smooth; and instead of being
streaked like the Tiger, is beautifully marked on
the back, sides, and flanks, with black spots, dis-
posed in circles, from four to five in each, with a
single spot in the centre; on the face, breast, and
legs, the spots are single: the colour of the body
on the back and sides is yellow, deep on the back,
and paler towards the belly, which is white: its
ears are short and pointed; its eye is restless; and
its whole aspect fierce and cruel.

It is an untameable animal, and inhabits Africa,
from Barbary to the remotest parts of Guinea.

Its manner of taking its prey is the same with
that of the Tiger,—always by surprize, either lurk-
ing in thickets, or creeping on its belly till it comes
within reach. When pressed with hunger, it

attacks every living creature without distinction, but happily prefers the flesh of brutes to that of mankind: it will even climb up trees in pursuit of Monkies and lesser animals; so that nothing is secure from its attacks.

The Panther is about the height of a large Mastiff Dog, but its legs are not quite so long. Its voice is strong and hoarse, and it growls continually.

The ancients were well acquainted with these animals. The Romans drew prodigious numbers from the deserts of Africa, for their public shows: sufficient, one might suppose, to have entirely exhausted them. Scaurus exhibited an hundred and fifty of them at one time; Pompey four hundred and ten; and Augustus four hundred and twenty. They probably thinned the coasts of Mauritania of these animals; but they still swarm in the southern parts of Guinea.

In China, there is a most beautiful animal of this kind, called *Louchu*, the skin of which sells for six pounds sterling.

An animal of this species is likewise found in Asiatic Tartary, called there the *Babr*. It is seven feet long, extremely rapacious, and very destructive of Horses and Camels. Its skin is very fine, and valued in Russia at one pound sterling.

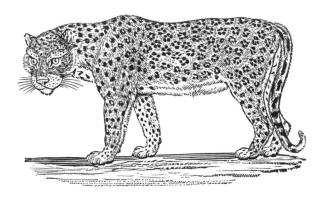

THE LEOPARD.

(Le Leopard, Buff.)

THE very trifling difference between this and the last-mentioned animal, gives reason to suppose, that it consists chiefly in the name. It inhabits the same countries; and in some places goes by the same name, being called the *Panther of Senegal;* and is chiefly found there. It is mentioned by Ray as the *female Panther,* but is rather smaller than that animal. Its length from nose to tail, is about four feet: the colour of the body is a more lively yellow; and the spots with which it is diversified, are smaller and closer than those of the Panther.

The interior parts of Africa abound with these animals; whence they come down in great numbers, and make dreadful havock among the numerous herds that cover the plains of the Lower Guinea. When beasts of chase fail, they spare no living creature.

The negroes take them in pitfalls, slightly cover-
ed at the top, and baited with flesh. Their chief
inducement for pursuing them is their flesh, which
they eat; and it is said to be as white as veal, and
well-tasted. The negresses make collars of their
teeth, and wear them as charms.

The skins of these animals are brought to
Europe, where they are greatly esteemed.

In India, there is a species of *Leopard* about the
size of a large Greyhound, with a small head, and
short ears: its face, chin, and throat, are of a pale-
brown colour, inclining to yellow; the body is of a
light twany-brown, marked with small round black
spots, scattered over the back, sides, head, and legs;
the hair on the top of the neck is longer than the
rest; the belly is white; the tail very long, marked
on the upper side with large black spots.

This is the animal, mentioned in our account of
the Antelope, which is made use of in India for
hunting that and other beasts of the chase. It is
carried in a small kind of waggon, chained and
hoodwinked till it approaches the herd; when it is
unchained, and suffered to pursue the game. It
begins by creeping along, with its belly close to
the ground, stopping and concealing itself till it
gets an advantageous situation; it then darts on its
prey with great agility, frequently making five or
six amazing bounds. If it should not succeed in its
first effort, it gives up the point for that time, and
readily returns to its master.

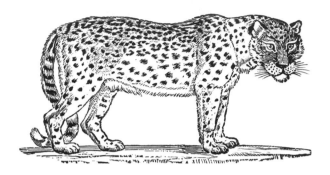

THE OUNCE.

(L'Once, Buff.)

Is smaller than the Leopard, being three feet
and a half long from the nose to the tail, very
strong, long-backed, and short legged. The hair
is long, and of a light grey colour, tinged with
yellow; lighter on the breast and belly: the head is
marked with small round spots: behind each ear
there is a large black spot: the back is beautifully
varied with a number of oval figures, formed by
small spots almost touching each other; the spots
on the side are more irregular; those on the legs
and thighs small, and thinly dispersed: the tail is
full of hair, irregularly marked with large black
spots, and upwards of three feet long.

It is common in Barbary, Persia, and China; is
much more gentle than the Leopard; and, like the
Hunting Leopard, is sometimes trained to the
chase. Instead of being conveyed in a waggon, it
is carried on the crupper of the Horse, is as much
under command as a Setting-Dog, returns at a call,
and jumps up behind its master.

The scent of the Ounce is not so fine as that of the Dog. It neither follows animals by their foot, nor is it able to overtake them in a continued chase: it hunts solely by the eye, and makes only a few springs at its prey. It is so nimble, as to clear a ditch or a wall of many feet. It often climbs trees to watch animals that are passing, and suddenly darts upon them.

It is supposed to be the *Lesser Panther* of Oppian, and the *Panthera* of Pliny.

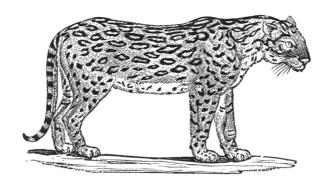

THE JAGUAR.

(Felis Onca, Linn.—*Le Jaguar*, Buff.)

Is the most formidable animal of the new continent, rather larger than the Panther, with hair of a bright tawny colour. The top of the back is marked with long stripes of black; the sides beautifully variegated with irregular oblong spots, open in the middle: the tail is not so long as that of the Ounce, and irregularly marked with large black spots.

It is found in the hottest parts of South America; is very fierce; and when pressed with hunger, will sometimes venture to seize a man.

The Indians are much afraid of it, and think it prefers them to the white inhabitants, who, perhaps, are better prepared to repel its attacks. In travelling through the deserts of Guiana, they light great fires in the night, of which these animals are much afraid.

They howl dreadfully; their cry, which is expressive of the two monosyllables—*hou*, *hou*, is somewhat plaintive, grave, and strong, like that of an Ox.

The Ant-eater, though it has no teeth to defend itself with, is the most cruel enemy the Jaguar has to encounter. As soon as the Jaguar attacks this little animal, it lies down on its back, and with its long claws, seizes and suffocates him.

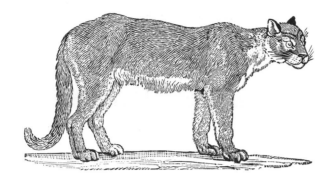

THE COUGUAR.

(Felis Concolor, Linn.—*Le Couguar*, Buff.)

INHABITS the continent of America, and is called
by some the *Puma*, or *American Lion;* but differs
so much from that noble animal, as not to admit of
any comparison. Its head is small; it has no
mane; its length, from nose to tail, is five feet three
inches; the tail two feet: the predominant colour is
a lively red, mixed with black, especially on the
back, where it is darkest: its chin, throat, and all
the inferior parts of the body, are whitish: its legs
are long; claws white; and the outer claw of the
fore feet much longer than the others.

Is is found in many parts of North America, from
Canada to Florida: it is also common in Guiana,
Brazil, and Mexico.

It is fierce and ravenous in the extreme, and will
swim rivers to attack cattle even in their inclosures.
In North America, its fury seems to be subdued by
the rigour of the climate, for it will fly from a Dog

in company with its master, and take shelter by running up a tree.

It is very destructive to domestic animals, particularly to Hogs. It preys also upon the Moose and other Deer; lies lurking upon the branch of a tree till some of these animals pass underneath, when it drops down upon one of them, and never quits its hold till it has drunk its blood. It will even attack beasts of prey. In the museum of the Royal Society is preserved the skin of one of these animals, which was shot just as it had seized a Wolf. When satisfied with eating, it conceals the rest of the carcase, covering it carefully with leaves. It purs like a Cat, and sometimes howls dreadfully.

The fur is soft, and is used by the Indians for a winter habit; when dressed, it is made into gloves and shoes. The flesh is white, and by the natives reckoned excellent food.

The Couguar, when brought into captivity, is almost as gentle as the Domestic Cat, allows itself to be caressed, and will permit boys to mount on its back. It is sometimes called the *Poltron Tiger*.

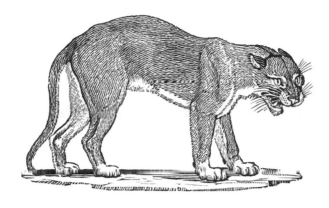

THE BLACK TIGER, OR BLACK LEOPARD.

(Le Couguar noir, Buff.)

DIFFERS from the former chiefly in the colour, which is dusky, sometimes spotted with black, but generally plain. The throat, belly, and inside of the legs, are of a pale ash colour; the upper lip white, furnished with long whiskers: above each eye it has very long hairs; and at the corner of the mouth a black spot: its paws are white; and its ears sharp and pointed.

It grows, it is said, to the size of a Heifer of a year old, and has great strength in its limbs.

It inhabits Brazil and Guiana, is a cruel and fierce animal, much dreaded by the Indians; but fortunately the species is not numerous.

M. de la Borde, in his description of these animals, says, that they frequent the sea-shore, and eat the eggs deposited there by the Turtles. They likewise eat Caimans or Alligators, Lizards, and

Fishes, and sometimes the buds and tender leaves of the Indian fig. They are excellent swimmers. In order to catch the Alligator, they lie down on their belly at the edge of the river, strike the water to make a noise, and as soon as the alligator raises its head above the water, dart their claws into its eyes, and drag it on shore.

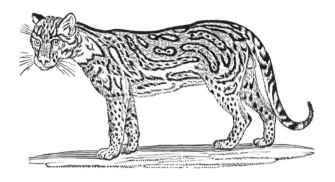

THE OCELOT.

(Felis Pardalis, Linn.—*L'Ocelot*, Buff.)

THE skin of the male Ocelot is extremely beautiful, and most elegantly variegated. Its general colour is that of a bright tawny; a black stripe extends along the top of the back from head to tail; its forehead is spotted with black, as are also its legs; its shoulders, sides, and rump, are beautifully marbled with long stripes of black, forming oval figures, filled in the middle with small black spots; its tail is irregularly marked with large spots, and black at the end. The colours of the female are not so vivid as those of the male; neither is she so beautifully marked.

The Ocelot very much resembles the common Cat in the form of its body, although it is a great deal larger. Buffon makes its height two feet and a half, and its length about four feet.

It is a native of South America, inhabits Mexico and Brazil, is very voracious, but timid, and seldom attacks men. It is afraid of Dogs; and when pursued, flies to the woods.

It lives chiefly in the mountains, and conceals itself amongst the leaves of trees; from whence it darts upon such animals as come within its reach. It sometimes extends itself along the boughs, as if it were dead, till the Monkies, tempted by their natural curiosity, approach within its reach. It is said to prefer the blood of animals to their flesh.

The Ocelot cannot easily be tamed, and retains its original wildness in a state of captivity. Nothing can soften the natural ferocity of its disposition, nor calm the restlessness of its motions. For this reason, it is always kept in a cage. One of these animals, shewn in Newcastle in 1788, although extremely old, exhibited great marks of ferocity. It was kept closely confined, and would not admit of being caressed by its keeper in the same manner as the Lion; but growled constantly, and always appeared in motion. A male and female Ocelot were brought to France some years ago, which had been taken when very young. At the age of three months, they became so strong and fierce, as to kill a bitch that was given them for a nurse. When a live Cat was thrown to them, they sucked its blood, but would not taste its flesh. The male seemed to have a great superiority over the female, as he never allowed her to partake till his own appetite was satisfied.

The female Ocelot, like all the larger animals of
the Cat kind, produces a small number at a time.
The two above-mentioned were the only young
ones found with the mother, which was killed at
the time they were taken; and this circumstance
makes it probable, that they bring forth only that
number.

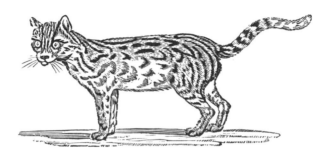

THE MARGAY.

(*Le Margay*, Buff.)

Is another beautiful animal of the spotted tribe,
and known in many places by the name of the
Tiger Cat. The ground colour of the body is
tawny; the face is striped with black; the body is
marked with stripes and large spots of black; the
breast and insides of the legs are white, spotted
with black; the tail is long, marked with alternate
spots of black, tawny, and grey.

The Margay is smaller than the Ocelot, and
about the size of a Wild Cat, which it resembles in
disposition and habits, living on small animals,
birds, &c. It is very wild, and cannot easily be
brought under subjection.

Its colours vary, though they are generally such as have been described.

It is common in Guiana, Brazil, and various parts of South America.

It is called the *Cayenne Cat*, and is not so frequent in temperate as in warm climates.

In taking a survey of this beautiful race of animals, we are unavoidably led to observe, that much remains for the laborious researches of the natural historian, before a complete account can be made out of the various kinds of which it is composed. Several species are frequently found in the East Indies, in the woods near the Cape of Good Hope, and on the continent of America; but in general these have been so negligently or so injudiciously mentioned, as to render it impossible to form a perfect description of them. A good history of these animals is one of the many desiderata of the naturalist; but when we consider the great distance which most of this ferocious tribe observe in their separation from mankind, and the dangers that must be encountered in approaching their solitary habitations, we are obliged to lament that this desirable object is not likely to be soon accomplished.

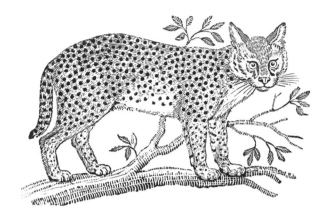

THE SERVAL.

(Le Serval, Buff.)

INHABITS the mountainous parts of India, and is called by the natives of Malabar, the *Marapute.* It is larger than the Wild Cat. Its general colour is a pale yellow; white on the breast and belly; variegated with round spots, which are equally distributed over every part of its body: its eyes are extremely brilliant, and have a wild, piercing look; its whiskers are long and stiff; its tail short; and its feet are armed with long hooked claws.

It is seldom to be seen upon the ground; but lives chiefly in trees, where it makes its bed, and breeds its young. It feeds on young birds, and leaps with great agility from tree to tree. It is extremely fierce; but avoids mankind, unless provoked; when it darts furiously upon the offender, and tears and bites nearly in the same manner as the Panther.

Sparrman mentions an animal of this kind, found at the Cape of Good Hope, which he calls the *Tiger Cat*, and supposes it to be the same with the Serval.

The same author mentions another animal of this kind, called at the Cape the *Wild Red Cat;* the skin of which is supposed by the natives to possess great medicinal powers, and to give ease to persons afflicted with the gout, lumbago, and pains in the joints. The fur is very fine and soft; and probably there are many other skins, which, if applied with an equal degree of good faith, might have the same salutary effects.

The colour of the upper part of this creature is of a very bright red; towards the sides it is mixed with white and grey; the belly is white; the upper part of the ears, which have tufts of hair on their tips, is dark brown, sprinkled with grey. Its body is long, and about two feet in height.

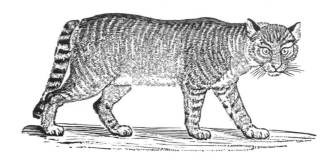

THE WILD CAT.

(Felis Catus, Linn.—*Le Chat sauvage,* Buff.)

THE history of this animal is so intimately con-
nected with that of the common or domestic kind,
that we shall include our account of both under one
general head, and describe them as constituting the
same species.

The Domestic Cat, if suffered to escape into the
woods, becomes wild, and lives on small birds and
such other game as it can find there; it likewise
breeds with the wild one. It is no uncommon
thing for females of the tame species to quit their
homes during the time they are in season, go in
quest of male Wild Cats, and return to the same
habitations impregnated by them. It is from this
connexion that some of our Domestic Cats so per-
fectly resemble those of the wild breed.

The hair of the Wild Cat is soft and fine, of a
pale yellow colour, mixed with grey; a dusky list
runs along the middle of the back, from head to
tail; the sides are streaked with grey, pointing
from the back downwards; the tail is thick, and

marked with alternate bars of black and white. It is larger and stronger than the Tame Cat, and its fur much longer.

It inhabits the most mountainous and woody parts of this island, lives in trees, and hunts for birds and small animals, such as Rabbits, Hares, Rats, Mice, Moles, &c. It frequently makes great havoc among poultry, will even kill young Lambs, Kids, and Fawns, and is the fiercest and most destructive beast of prey in this kingdom.

It is taken either in traps, or by shooting. There is frequently danger in the latter mode; for if it be only slightly wounded, it will attack the person who has injured it, and is not easily repelled.

Wild Cats are found, with very little variety, in almost every climate. They existed in America before its discovery by the Europeans. One of them was brought to Columbus, which was of the ordinary size, of a brownish grey colour, with a long tail. They are common in many places of Asia and Africa. Sparrman gives a description of one which he shot at the Cape, which was in every respect similar to those of this country. It was of a grey colour; and measured from the nose to the tail, nearly twenty-two inches: the tail was thirteen inches long: its height was about a foot and a half. Its intestines were full of Moles and Rats.

Some Wild Cats have been taken in this kingdom, of a most enormous size. We recollect one having been killed in the county of Cumberland, which measured, from its nose to the end of its tail, upwards of five feet.

The province of Chorazan, in Persia, is particularly famous for a most beautiful *Cat*, about the size of the tame one, of a fine grey colour, without

any mixture, and as soft and shining as silk. It is
darker on the back, softening by degrees towards
the breast and belly, where it is almost white. The
tail is long, and covered with hair, five or six inches
in length. The animal frequently turns it upon its
back, like a Squirrel; the point of it resembling a
plume of feathers.

The *Cat of Angora* differs greatly from the Wild
Cat, in having much longer hair, especially about
the neck, where it forms a fine ruff, and gives it a
Lion-like appearance. Some of these are of a
silvery whiteness, and silky texture; others are of a
dun colour, mixed with yellow.

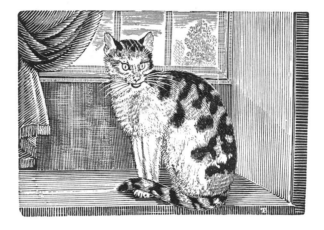

THE DOMESTIC CAT.

DIFFERS from the Wild Cat, in being somewhat less; and instead of being uniformly the same, is distinguished by a great variety of shades and colouring.

To describe an animal so well known, might seem a superfluous task: we shall only, therefore, select such of its peculiarities as are least obvious, and may have escaped the notice of inattentive observers.

It is generally remarked, that Cats can see in the dark; but though this is not absolutely the case, yet it is certain that they can see with much less light than most other animals, owing to the peculiar structure of their eyes, the pupils of which are capable of being contracted or dilated in proportion to the degree of light by which they are affected. The pupil of the Cat, during the day, is perpetually contracted; and it is with difficulty that it can see

by a strong light: but in the twilight, the pupil re-
sumes its natural roundness, the animal enjoys
perfect vision, and takes advantage of this supe-
riority to discover and surprize its prey.

The cry of the Cat is loud, piercing, and clamor-
ous; and whether expressive of anger or of love, is
equally violent and hideous. Its call may be heard
at a great distance, and is so well known to the
whole fraternity, that on some occasions several
hundred Cats have been brought together from dif-
ferent parts. Invited by the piercing cries of dis-
tress from a suffering fellow-creature, they assemble
in crowds; and with loud squalls and yells, express
their horrid sympathies. They frequently tear the
miserable object to pieces; and with the most blind
and furious rage, fall upon each other, killing and
wounding indiscriminately, till there is scarcely one
left. These terrible conflicts happen only in the
night; and though rare, instances of very furious
engagements are well authenticated.

The Cat is particularly averse to water, cold, and
bad smells. It is fond of certain perfumes, but is
more particularly attracted by the smell of valerian,
marum, and cat-mint: it rubs itself against them;
and, if not prevented from coming at them in a
garden where they are planted, would infallibly
destroy them.

The Cat brings forth twice, and sometimes thrice,
a year. The period of her gestation is fifty-five or
fifty-six days, and she generally produces five or
six at one litter. She conceals her kittens from the
male, lest he should devour them, as he is some-
times inclined; and if apprehensive of being dis-
turbed, will take them up in her mouth, and remove
them one by one to a more secure retreat: even the

female herself, contrary to the established law of Nature, which binds the parent to its offspring by an almost indissoluble tie, is sometimes known to eat her own young the moment she has produced them.

Though extremely useful in destroying the vermin that infest our houses, the Cat seems little attached to the persons of those who afford it protection. It appears to be under no subjection, and acts only for itself. All its views are confined to the place where it has been brought up; if carried elsewhere, it seems lost and bewildered: neither caresses nor attention can reconcile it to its new situation, and it frequently takes the first opportunity of escaping to its former haunts. Frequent instances are in our recollection, of Cats having returned to the place from whence they had been carried, though at many miles distance, and even across rivers, when they could not possibly have any knowledge of the road or situation that would apparently lead them to it. This extraordinary faculty is, however, possessed in a much greater degree by Dogs; yet it is in both animals equally wonderful and unaccountable.

In the time of Hoel the Good, King of Wales, who died in the year 948, laws were made as well to preserve, as to fix the different prices of animals; among which the Cat was included, as being at that period of great importance, on account of its scarceness and utility.

The price of a Kitten, before it could see, was fixed at one penny; till proof could be given of its having caught a Mouse, two-pence; after which it was rated at four-pence, which was a great sum in those days, when the value of specie was extremely

high: it was likewise required, that it should be perfect in its senses of hearing and seeing, should be a good mouser, have its claws whole, and if a female, be a careful nurse: if it failed in any of these good qualities, the seller was to forfeit to the buyer the third part of its value. If any one should steal or kill the Cat that guarded the Prince's granary, he was either to forfeit a milk ewe, her fleece and lamb, or as much wheat as, when poured on the Cat suspended by its tail (its head touching the floor), would form a heap high enough to cover the tip of the former. Hence we may conclude that Cats were not originally natives of these islands; and from the great care taken to improve and preserve the breed of this prolific creature, we may suppose, were but little known at that period. Whatever credit we may allow to the circumstances of the well-known story of Whittington and his Cat, it is another proof of the great value set upon this animal in former times.

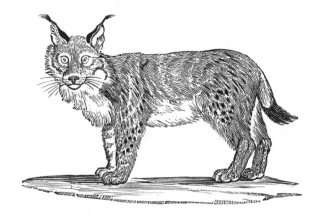

THE LYNX.

(Felis Lynx, Linn.—*Le Lynx, ou Loup Cervier,*
Buff.)

DIFFERS greatly from every animal of the Cat
kind we have hitherto described. Its ears are long
and erect, tufted at the end with long black hairs,
by which this species of animal is peculiarly dis-
tinguished: the hair on the body is long and soft,
of a red ash colour, marked with dusky spots,
which differ according to the age of the creature;
sometimes they are scarcely visible: its legs and
feet are very thick and strong; its tail short, and
black at the extremity: its eyes are of a pale yellow
colour; and its aspect softer and less ferocious than
that of the Panther or the Ounce. The skin of the
male is more spotted than that of the female.

The fur is valuable for its softness and warmth,
and is imported in great quantities from America
and the North of Europe. The farther North they
are taken, the whiter they are, and the spots more
distinct. The most elegant of these is called the
Irbys, and is taken near Lake Balkash, in Usbec

Tartary. It is much larger than the common kind. Its skin sells in that country for one pound sterling. The colour of its hair changes with the climate and the season. The winter furs are richer and more beautiful than those taken in summer.

The Lynx is said to be very long-lived, is a very destructive animal, lives by hunting, and pursues its prey to the tops of the highest trees. It feeds on Weasels, Ermines, Squirrels, &c., which are unable to escape it. It watches the approach of the Fallow Deer, Hare, and other animals, and darts upon them from the branches of trees, where it lies concealed; seizes them by the throat, and drinks their blood; after which, it abandons them, and goes in quest of fresh game. Its sight is remarkably quick, and it sees its prey at a great distance. It often eats no more of a Sheep or Goat than the brain, the liver, and the intestines. It will sometimes dig under the doors to gain admission into the sheepfold. When attacked by a Dog, it lies down on its back, strikes desperately with its claws, and frequently obliges its assailant to retreat.

Although the Lynx has nothing in common with the Wolf, it has been distinguished by the name of *Lupus-Cervarius*, or the *Stag Wolf*. Its manner of howling is similar to that of the Wolf; and when heard at a distance, is not easily distinguished from the cry of that animal. The epithet *Cervarius* has been added, because its skin is variegated with spots like that of a young Stag.

A variety is found in the inner parts of the province of New York, which is called the *Bay Lynx*, and is about twice the size of a large Cat. Its hair is short and smooth; its general colour is a

bright bay, obscurely marked with dusky spots; on its face there are black stripes, pointing downward toward the nose; on each side of the upper lip it has three rows of small black spots, with long whiskers issuing from them; each cheek is marked with long black stripes, of a circular form, proceeding from the corners of the eyes; the under part of the body, and insides of the legs, are white; the inside of each fore leg is marked on the upper part with two black bars; its tail, which is short, is marked with bars of a dusky colour, and at the end with one of a deep black; the tip and under side are white.

The Lynxes of our days must be very different animals from those which have been described by poets as drawing the chariot of Bacchus; for, besides the impracticability of training these animals to the yoke, we find that the Lynx is not an inhabitant of India, nor of any of the warmer countries of Asia, conquered by that hero It prefers cold to even temperate climates, and is common in the forests of the northern parts of Europe, Asia, and America.

The ancients seem to have given the name of *Lynx* to an animal which existed only in imagination, and may be ranked with their other ideal monsters and prodigies—the Sphynx, the Pegasus, and the Unicorn. Its sight was said to penetrate the most opaque bodies, and its urine to be converted into a precious stone.

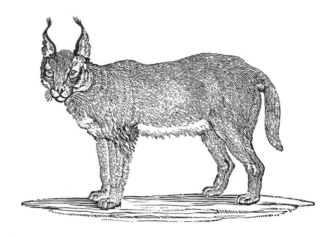

THE CARACAL.

(Le Caracal, Buff.)

RESEMBLES the Lynx in size, figure, and aspect, as well as in having its ears tipt with a pencil of black hairs. It differs from the last-mentioned animal in not being spotted; its hair is rougher, and of a pale reddish brown; its tail is longer, and of a uniform colour; its face is more lengthened, its look more fierce, and its nature and disposition are more savage.

This animal is found only in warm climates, and is common in Persia, India, Barbary, and in all the countries inhabited by the Lion, the Panther, and the Ounce. It is called in Persia the *Syah-Gush;* and in the Turkish language, the *Karrah-Kulak.* Both these names signify the *Cat with black ears.* It is said to follow the Lion, and to feed on the remains which that animal leaves of his prey; for

which reason it is called among the Arabs, the *Lion's Guide*.

The Caracal is about the height of a Fox, but much stronger, and more ferocious. It has been known to attack a Hound, and instantly to tear it to pieces.

This animal is extremely difficult to tame; but when taken young, and reared with great caution, it may be trained to the chace. It is used in taking the smaller sort of animals, in which it is very successful, but it is active only in the pursuit of those that are too feeble for resistance, or too timid to exert their powers. Whenever it meets with one that is superior to it in strength, it loses its courage, and gives up the chace. It is likewise employed in catching birds; such as Cranes, Pelicans, Peacocks, &c., which it surprises with singular address. When it has seized its prey, it holds it fast in its mouth, and lies upon it for some time quite motionless.

There are some varieties in this animal. The face of the *Nubian Caracal* is rounder; the ears black on the outside, interspersed with silver-coloured hairs; on the breast, belly, and insides of the thighs, there are small bright yellow spots; and it has the Mule-cross on the withers, like most of the Barbary Caracals.

In Lybia, there are *Caracals* with white ears, tufted at the end with thin black hairs: they have white tails, the extremities of which are surrounded with four black rings; and on the hind part of each leg there are four black spots. They are small, not exceeding the size of a domestic Cat.

We have now gone through all the principal varieties which constitute this numerous race; in

all of which, as has been already observed, from
the Lion to the common Cat, we may perceive a
striking similitude in disposition, form and man-
ners. This agreement is likewise observable in
their internal conformation, which is still more
exact,—in the shortness of their intestines, the
sharpness and number of their teeth, and in the
structure of their feet and claws. They are all
equally carnivorous, and tear, rather than chew
their meat. They eat slowly, and growl whilst
they feed, as if afraid of losing their prey. They
are all cowardly, and seldom make an attack but
where conquest is certain.

Animals of this race may be considered as the
most formidable enemies of mankind. There are
others more powerful, but their dispositions are
milder, and they seldom offend till they feel them-
selves injured: others are more numerous, but they
are weaker, and find their safety, not in oppos-
ing, but in flying from man. These are the only
quadrupeds that in any degree make good their
ground against him, and maintain a kind of divid-
ed sway over many fair and fertile tracts, that
seem, in other respects, formed for the comfort and
convenience of social life.

ANIMALS OF THE WEASEL KIND.

THESE little, active, and enterprising animals are particularly distinguished from other carnivorous kinds by the length and slenderness of their bodies, which are admirably adapted to their manner of living, and methods of taking their prey. They are so small and flexible, as to wind like worms into very small crevices and openings; whither they easily follow the little animals that serve them for food.

All the animals of this kind are furnished with small glands, placed near the anus, from which an unctuous matter continually exudes: the effluvium of it is extremely offensive in the Polecat, Ferret, Weasel, &c.; but in the Civet Cat, Martin, and Pine Weasel, it is an agreeable perfume. They are all equally marked for rapine and cruelty; they subsist only by theft, and find their chief protection in their minuteness. They are all, from the shortness of their legs, slow in pursuit; and make up that deficiency by patience, assiduity and cunning.

As their prey is precarious, they can live a long time without food. When they fall in with plenty, they immediately kill every thing within their reach, before they begin to satisfy their appetite; and always suck the blood of every animal they kill, before they eat its flesh.

These are the principal peculiarities common to this kind; all the species of which have so striking a resemblance to each other, that having seen one, we may form a very just idea of the rest. The most obvious difference consists in their size. We shall therefore begin with the smallest of this numerous class, and proceed gradually upwards to the largest.

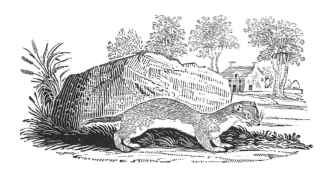

THE WEASEL.

(Mustela Nivalis, Linn.—*La Belette,* Buff.)

THE length of this animal does not exceed seven
inches from the nose to the tail, which is only two
inches and a half long, and ends in a point: its
height is not above two inches and a half; so that
it is nearly four times as long as it is high.

The most prevailing colour of the Weasel is a
pale reddish brown on the back, sides, and legs;
the throat and belly are white; beneath the corners
of the mouth, on each jaw, is a spot of brown. It
has whiskers, like a Cat: its ears are large, and
have a fold at the lower part, that gives them the
appearance of being double; its eyes are small,
round, and black; its teeth are thirty-two in num-
ber, and extremely sharp.

The Weasel is very common, and well known in
most parts of this country; is very destructive to
young birds, poultry, Rabbits, &c.; and is a keen
devourer of eggs, which it sucks with great avidity.
It will follow a Hare,* which is terrified into a state

* They sometimes pursue the Hare in packs.

of absolute imbecility at the sight of this little animal, and gives itself up to it without resistance, making at the same time the most piteous outcries.

The bite of the Weasel is generally fatal. It seizes its prey near the head, and fixes its sharp teeth into a vital part. A Hare, Rabbit, or any other small animal, bitten in this manner, is never known to recover; but lingers for some time and dies. The wound is so small, that the place where the teeth enter can scarcely be perceived.

It is remarkably active, and will run up the sides of a wall with such facility, that no place is secure from it.

The Weasel is very useful to the farmer, and is much encouraged by him. During winter it frequents his barns, out-houses, and granaries; which it effectually clears of Rats and Mice. It is, indeed, a more deadly enemy to them than even the Cat itself; for being more active and slender, it pursues them into their holes, and kills them after a short resistance. It creeps also into Pigeon-holes, and destroys the young ones; catches Sparrows, and all kinds of small birds; and when it has brought forth its young, it hunts with still greater boldness and avidity. In summer, it ventures to a distance from its usual haunts; is frequently found by the side of waters, near corn-mills; and is almost sure to follow wherever a swarm of Rats has taken possession of any place.

The evening is the time when it begins its depredations. Towards the close of the day it may frequently be seen stealing from its hole, and creeping about the farmer's yard in search of its prey. If it enter the place where poultry are kept, it seldom attacks the Cocks or the old Hens, but

always aims at the young ones. It does not eat its prey on the spot where it has killed it; but, when it is not too large, carries it away to its retreat. It also breaks and sucks all the eggs it can meet with; and, not unfrequently, kills the Hen that attempts to defend them.

The Weasel is a .wild and untractable little animal. When kept in a cage, it seems in a continual state of agitation, is terrified at the sight of every person that approaches to look at it, and hides itself in the wool or hay which is given to it for that purpose.

It conveys all its food to its hiding-place, and will not touch it till it begin to putrefy. It passes the greater part of the day in sleeping, and usually employs the night in hunting for its prey.

The female brings forth in the spring, and generally produces four or five at one litter. She prepares a bed for them, of straw, leaves, and moss. The young are brought forth blind, but very soon acquire strength enough to follow their dam, and assist in her excursions. They will attack Serpents, Water-Rats, Moles, Field-Mice, &c.: they overrun the meadows, and frequently kill the Partridges, and suck their eggs.

The motion of the Weasel consists of unequal and precipitant leaps; and in climbing a tree, it makes a considerable spring of some feet from the ground. It jumps in the same manner upon its prey; and being extremely limber, evades the attempts of much stronger animals to seize it.

We are told, that an Eagle having seized a Weasel, mounted into the air with it, and was soon after observed to be in great distress. Its little enemy had extricated itself so far, as to be able to

bite it severely in the throat; which presently brought the Eagle to the ground, and gave the Weasel an opportunity of escaping.

Notwithstanding the wildness of its nature, there are not wanting instances to prove that it is capable of being thoroughly tamed. M. Buffon, who asserted the impossibility of bringing the Weasel into any degree of subjection, is afterwards corrected by a lady, who assures him, that she has tried the experiment upon a young Weasel taken in her garden; which soon learned to recognise and lick the hand from which it received its food, and became as familiar, caressing, and frolicsome as a Dog or a Squirrel. The same author mentions another experiment, made by a gentleman, who trained a young Weasel so completely, that it followed him wherever he went. The method of taming them is to stroke them gently over the back; and to threaten, and even to beat them, when they bite.

These facts may serve to shew the possibility of rendering this animal domestic; and hold out a useful hint to us, that its services might be very great in clearing ships, granaries, and other places, from the vermin with which they are frequently infested: for it is very well known, that one of these animals will kill more Rats and Mice than any Cat, being better able to pursue them into their holes and lurking-places.

The odour of the Weasel is very strong, especially in the summer time, or when it is irritated and pursued; it is then intolerable, and may be smelt at some distance.

The following circumstance, related by Buffon, will shew that this animal has a natural attachment

to every thing that is corrupt:—A Weasel was
taken in his neighbourhood, with three young ones,
out of the carcase of a Wolf that had been hung on
a tree by the hind feet. The Wolf was almost
entirely putrefied; and the Weasel had made a
nest of leaves and herbage for her young in the
thorax of the putrid carcase.

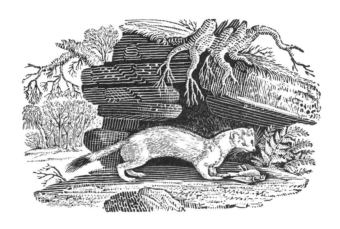

THE STOAT.

(Mustela Erminea, Linn.—*Le Roselet*, Buff.)

THE difference in shape between this animal
and the Weasel is so small, that they have fre-
quently been described under the same denomina-
tion; a small Stoat being sometimes mistaken for
a Weasel.

Its length is about ten inches; the tail five inches
and a half, very hairy, and tipt with black at the
end; the edges of the ears, and ends of the toes, are
of a yellowish white: in other respects, it perfectly
resembles the Weasel in colour as well as form.

In the most northern parts of Europe, it regularly changes its colour in winter, and becomes perfectly white, except the end of the tail, which remains invariably black. It is then called the *Ermine*, and is much sought after for its valuable fur, which makes a considerable article of commerce in Norway, Lapland, Russia, and other cold countries; where it is found in prodigious numbers. It is also very common in Kamschatka and Siberia, and is taken in traps baited with flesh. The skins are sold in this country for from two to three pounds sterling per hundred. In Norway, they are either shot with blunt arrows, or taken in traps made of two flat stones, one being propped up with a stick, to which is fastened a baited string: and as soon as the animal begins to nibble, the stone falls down, and crushes it to death. The Stoat is likewise found white in the winter time in Great Britain, and is then erroneously called a *White Weasel*. Its fur, however, among us, is of little value, having neither the thickness, the closeness, nor the pure whiteness, of those which come from Siberia.

One of them, which we had in our possession, had entirely assumed its winter robe; but with a considerable mixture of yellow, especially on the top of the head and back.

They begin to change from brown to white in November, and resume their summer vesture in March.

The natural history of this animal is much the same with that of the Weasel; its food being young Birds, Rabbits, Mice, &c.; its agility the same; and its scent equally fetid.

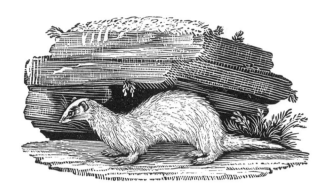

THE FERRET.

(Mustela Furo, Linn.—*Le Furet*, Buff.)

Is known to us only in a kind of domestic state.
It is originally a native of Africa: from whence,
according to Strabo, it was brought into Spain;
and from its known enmity to the Rabbit, was
made use of to reduce the numbers of them with
which that kingdom abounded. It has since been
employed for the same purpose in various parts of
Europe; but as it is not able to bear the severity of
a cold climate, it cannot subsist without great care
and shelter. It is usually kept in a box with wool,
of which it makes itself a warm bed. It sleeps a
great part of the day; and the moment it awakes
seems eager for its food, which is commonly bread
and milk.

It breeds twice a year. The female goes six
weeks with young. Some of them devour their
offspring as soon as they are brought forth; when
they immediately come in season again, and have

three litters, which generally consist of five or six, but sometimes seven or eight, and even nine.

It is apt to degenerate in this country, and lose in some degree its ferocity. Warreners are therefore obliged to procure an intercourse between the female and the Foumart. The produce is a breed of a much darker colour than the Ferret, partaking more of that of the Foumart.

The length of the Ferret is about fourteen inches; that of the tail five: its nose is sharper than that of the Weasel or the Foumart; its ears are round; and its eyes red and fiery: the colour of the whole body is a very pale yellow.

This animal is naturally such an enemy to the Rabbit, that if a dead Rabbit be laid before a young Ferret, it instantly seizes upon it, although it has never seen one before: if a living Rabbit be presented to it, the Ferret is still more eager, seizes it by the neck, winds itself round it, and continues to suck its blood till it be satiated. When employed in the business of the warren, it must be muzzled, that it may not kill the Rabbits in their holes, but only oblige them to come out, that the warrener may catch them in his nets. If the Ferret be suffered to go in without a muzzle, or should disengage itself from it whilst in the hole, there is a great danger of losing it: for, after satisfying itself with blood, it falls asleep, and it is then almost impossible to come at it. The most usual methods of recovering the Ferret are, by digging it out, or smoking the hole. If these do not succeed, it continues during the summer among the Rabbit holes, and lives upon the prey it finds there; but being unable to endure the cold of the winter, is sure to perish.

It is sometimes employed with great success in killing Rats, and is frequently kept in granaries and mills for that purpose. It is extremely vigilant in the pursuit of them, and will not suffer one to live where it is. A young Ferret, after it has seized a Rat, will suffer itself to be dragged by it a considerable way before it has killed it, which it never fails to do in a short time.

If the Ferret could be kept warm enough at sea, it might be extremely serviceable in destroying the Rats, which frequently commit such great depredations on board of ships, and have sometimes been the occasion of their total loss.

The Ferret, though easily tamed, is soon irritated. Its odour is fetid; its nature voracious; it is tame without attachment; and such is its appetite for blood, that it has been known to attack and kill children in the cradle. When angry, it is apt to bite; and the wound is difficult to cure.

The *Madagascar Weasel*, or *Vansire* of M. Buffon, may be referred to this species; to which its size and form are strikingly similar. It is about fourteen inches in length; the hair is of a dark brown colour, mixed with black; it differs from the Ferret in the number of its grinding teeth, which amount to twelve; whereas in the Ferret there are but eight; the tail is longer than that of the Ferret, and better furnished with hair.

The same author mentions another animal of this species under the name of the *Nems*, which is a native of Arabia. It resembles the Ferret in every thing but the colour, being of a dark brown, mixed with white; the belly is of a bright yellow colour, without any mixture; the prevailing colour on the head and round the eyes is a clear yellow; on the

nose, cheeks, and other parts of the face where the
hair is short, a tincture of brown more or less pre-
vails, and terminates gradually above the eyes; the
legs are covered with short hair, of a deep yellow
colour; on each foot there are four toes, and a
small one behind; the claws are small and black;
the tail, which is more than double the length of
that of the Ferret, is very thick at its origin, ter-
minates in a point, and is covered with long hair,
similar to that on the body.

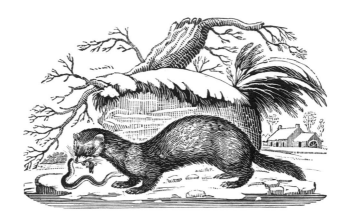

THE FOUMART.

(Mustela Putorius, Linn.—*Le Putois*, Buff.)

So called from its offensive smell, as well as to
distinguish it from the Martin, to which it bears a
strong resemblance. It is likewise called the *Pole-
cat* or *Fitchet.*

Its length is about seventeen inches, exclusive of
the tail, which is six inches; its eyes are small,
very brilliant, and when the animal is irritated or
afraid, shine in the dark with singular lustre; its
ears are short, broad, and tipt with white on their
edges; it is white about the mouth; the rest of the
body is for the most part of a deep chocolate colour;
the sides are covered with hairs of two colours; the
ends being dark like the rest of the body, and the
middle of a full tawny colour.

The shape of the Foumart, like all others of this
genus, is long and slender, the nose sharp-pointed,
and the legs short; the toes are long, and the claws

sharp. It is in every respect admirably formed for
that peculiar mode of life assigned to it by the all-
wise Author of Nature.

It is very active and nimble, runs very fast, and
will creep up the sides of walls with great agility.
In running, its belly seems to touch the ground; in
preparing to jump, it arches its back, and makes
its spring with great force.

It is very destructive to poultry, Pigeons, and
young game of all kinds. It makes great havoc
amongst Rabbits; and its thirst for blood is so
great, that it kills many more than it can eat. One
or two of them will almost destroy a whole warren.

It is never seen abroad in the day-time, unless
forced from its hole; and is seldom hunted but in
the winter, being at that season easily found by
tracing its footsteps in the snow. It generally
resides in woods or thick brakes; where it burrows
under ground, forming a shallow retreat about two
yards in length, commonly ending among the roots
of trees.

In the winter season, it frequents houses, barns,
&c., feeding on poultry, eggs, and sometimes milk.
But it has another mode of procuring subsistence,
which has hitherto escaped the observation of the
naturalist; and which, though singular, we can
vouch for the truth of. During a severe storm, one
of these animals was traced in the snow from the
side of a rivulet to its hole, at some distance from
it: as it was observed to have made frequent trips,
and as other marks were to be seen in the snow
which could not easily be accounted for, it was
thought a matter worthy of great attention: its
hole was accordingly examined, the Foumart taken,
and eleven fine Eels were discovered to be the fruits

of its nocturnal excursions. The marks in the snow were found to have been made by the motion of the Eels in the creature's mouth.

From the above curious circumstance, we have given a representation of this animal (which was drawn from the life) in possession of this singular booty. It may be matter of amusing investigation for some future naturalist, to enquire by what arts this wily animal obtains a booty so apparently difficult for it to lay hold of.

In attending to the instinctive faculties of animals, there is room for deep and diligent enquiry; and though our progress is liable to many interruptions, it is·a delightful task to follow the workings of Nature through all her intricate and curious windings: every step we gain is a sufficient reward for our trouble, and leads us to admire the wisdom and goodness of that dispensation which furnishes every creature with sufficient and ample powers to provide for all its wants, necessities, and comforts.

The female Foumart brings forth in the summer, generally five or six at a time. She suckles them but a short time, and accustoms them early to live upon blood and eggs.

Though the smell of this animal is rank and disagreeable, even to a proverb, yet the skin is drest with the hair on, and used as other furs, without retaining its offensive odour.

The Foumart is very fierce and bold. When attacked by a Dog, it will defend itself with great spirit, attack in its turn, and fasten upon the nose of its enemy with so keen a bite, as frequently to oblige him to desist.

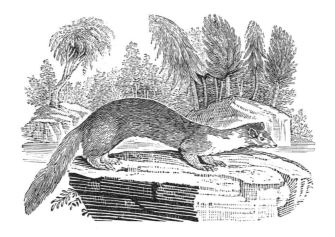

THE PINE-WEASEL, OR YELLOW-BREASTED MARTIN.

(La Marte, Buff.)

INHABITS the North of Europe, Asia, and America: it is likewise found in Great Britain, but is not numerous there. It lives chiefly in large forests, especially where the pine-tree abounds, of the tops of which it is very fond.

North America abounds with these animals. Prodigious numbers of their skins are annually imported from thence: about thirty thousand skins have been brought over from Canada in one year, and from Hudson's Bay nearly fifteen thousand in the same time.

The principal difference between the Pine-Weasel and the Martin is in the colour. The breast of the former is yellow; the colour of the body much darker; and the fur, in general, greatly superior in fineness, beauty, and value.

THE MARTIN.

(Mustela Martes, Linn.—*La Fouine,* Buff.)

Is much more common in this country than the Pine-Weasel. It lives wholly in woods, and breeds in the hollows of trees. It produces from four to six young ones at a time.

This species is the most beautiful of all the Weasel kind. Its head is small, and elegantly formed; its eyes are lively; and its motions quick and graceful.

When taken young, it is easily tamed, and becomes extremely playful and good-humoured. Its attachment, however, is not to be depended upon. It readily takes advantage of the first opportunity to regain its liberty, and retire to the woods, its natural haunts.

The food of the Martin is much the same with other animals of its kind. It makes incessant war upon Rats, Mice, and other vermin; poultry, game, and small birds, are its constant prey: it feeds also on grain, and is extremely fond of honey.

M. Buffon tells us of one of them that he had tamed, which he remarks, drank frequently. It sometimes slept two days successively, and at other times would continue awake as long. In preparing itself for sleep, it folded itself up in a round form, and covered its head with its tail. When awake, its motions were so violent, so constant, and so troublesome, that it was necessary to keep it chained. From the flexibility of its body, it easily eluded its fetters; and, after returning once or twice, at length absented itself entirely.

The Martin is about eighteen inches long; the tail ten, and full of hair, especially towards the end, which is thick and bushy; the ears are broad, rounded, and open, the body is covered with a thick fur, of a dark brown colour; the head brown, mixed with red; the throat and breast are white; the belly is of the same colour with the back, but a little paler; the feet are broad, and covered on the under side with a thick fur; the claws white, large, and sharp, well adapted for climbing trees, which in this country are its constant residence.

The skin and excrements have an agreeable musky scent, and are entirely free from that rankness which is so disgusting in other animals of this kind. Its fur is valuable, and in high estimation.

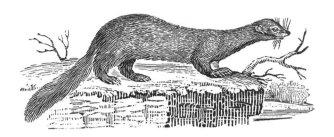

THE SABLE.

(Mustela Zibellina, Linn.—*La Zibeline*, Buff.)

So highly esteemed for its skin, is a native of the snowy regions of the North; it is found chiefly in Siberia, Kamschatka, and some of the islands which lie between that country and Japan. It is also found in Lapland.

The darkest furs are the most valuable. A single skin, though not above four inches broad, is sometimes valued as high as fifteen pounds. The Sable differs from all other furs in this, that the hair turns with equal ease to either side.

The Sable resembles the Martin in form, and is about the same size. It lives in holes in the earth, by the banks of rivers, and under the roots of trees. It makes its nest of moss, small twigs, and grass.

The female brings forth in the spring, and produces from three to five at one time. Sometimes, like the Martin, it forms its nest in the hollow of a tree.

It is very lively and active, and leaps with great agility from tree to tree, in pursuit of small birds,

Woodcocks, Squirrels, &c. It likewise lives upon Rats, fishes, pine tops, and wild fruits.

It is affirmed by naturalists, that the Sable is not averse to the water; and from the fineness and closeness of its fur, there is great reason to suppose that it is much accustomed to that element, from which it also derives a part of its subsistence: and as a further proof that this animal is in some degree amphibious, we are told by travellers,* that it is very numerous in small islands, whither the hunters go in quest of them. It is mentioned by Aristotle as a water animal, and is described by him under the name of *Satherius.*

The hunting of the Sable is chiefly carried on by criminals confined to the desert regions of Siberia, or by soldiers sent thither for that purpose, who generally remain there several years. They are obliged to furnish a certain quantity of furs, and shoot with a single ball, to injure the skin as little as possible. They frequently take them in traps, or kill them with blunt arrows. As an encouragement to the hunters, they are allowed to share among themselves whatever skins they take above the allotted number; and this in a few years, amounts to a considerable premium. The hunters form themselves into small troops, each of which is directed by a leader of their own chusing.

The season of hunting is from November to February; for at that time the Sables are in the highest perfection: those caught at any other time of the year are full of short hairs, and are sold at inferior prices. The best skins are such as have only long hair, which is always black, and of a

* Avril's Travels, p. 140.

glossy brightness. Old furs do not retain their gloss. Both the Russians and Chinese have a method of dyeing their furs; but the dyed Sables are easily discovered, having neither the smoothness nor the brightness of the natural hair.

The bellies of Sables, which are sold in pairs, are about two fingers in breadth, and are tied together in bundles of forty pieces, which are sold at from one to two pounds sterling. The tails are sold by the hundred, from four to eight pounds.

There are instances of Sables being found of a snowy whiteness; but they are rare, and bought only as curiosities.

The hunters of these animals are frequently obliged to endure the utmost extremity of cold and hunger in the pursuit of their booty. They penetrate deep into immense woods, where they have no other method of finding their way back but by marking the trees as they advance: if this should by any means fail them, they are inevitably lost. They sometimes trace the Sables on the new-fallen snow to their holes, place their nets at the entrance, and wait frequently two or three days before the animal comes out. It has happened by the failure of their provisions, that these poor wretches have been reduced to the necessity of tying thin boards tight to their stomachs to prevent the cravings of appetite. Such are the hardships our fellow-creatures undergo to supply the wants of the vain and luxuriant!

An animal, similar to the Sable, is mentioned by Mr. Pennant under the name of the *Fisher*. It is found in North America; and by the number of skins imported, must be very numerous there, nearly six hundred of them having been brought in one

season from New York and Pennsylvania. The hair on the body is mostly black; the sides brown; the ears are broad and round, dusky on their outsides, and edged with white; the face and sides of the neck pale brown, mixed with black; the feet are very broad, and covered with hair, even to their soles; the tail is full and bushy; the length, from nose to tail, is twenty-eight inches; the tail seventeen.

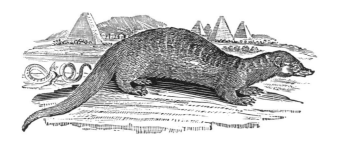

THE ICHNEUMON.

(Viverra Ichneumon, Linn.—*La Mangouste*, Buff.)

THIS animal, in Egypt, is domestic, like the Cat; and is retained by the natives for the same useful purpose of clearing their houses of Rats and Mice. With all the strength and agility of the Cat, it has a more general appetite for carnage. It attacks without dread, the most deadly Serpents, and preys on every noxious reptile of the torrid zone, which it seizes and kills with great avidity. It is said, that when it is wounded by a Serpent, and begins to feel the effect of the poison, it immediately has

recourse to a certain root, which the Indians call
after its name, and assert that it is an antidote for
the bite of any venomous reptile.

The Ichneumon is the most formidable enemy of
the Crocodile: it destroys its eggs, which it digs
out of the sand, where they are laid to hatch by the
heat of the sun; and kills great numbers of young
Crocodiles soon after their production, before they
are able to reach the water. It was for this reason
that the ancient Egyptians worshipped this animal,
and ranked the Ichneumon among those deities
that were most propitious to them.

In its domestic state, it is perfectly tame and
gentle. M. d'Obsonville speaks of one which he
reared from a young one. It became tamer than a
Cat, was obedient to the call of its master, and fol-
lowed him wherever he went. One day he brought
a small water serpent alive, being desirous to know
how far its instinct would carry it against a being
with whom it was hitherto entirely unacquainted.
Its first emotion seemed to be astonishment mixed
with anger: its hair became erect; in an instant it
slipped behind the reptile; and with remarkable
swiftness and agility, leaped upon its head, seized
it, and crushed it with its teeth. This first essay
seemed to have awakened in it its natural appetite
for blood, which till then had given way to the gen-
tleness of its education: it no longer suffered the
poultry, among which it was brought up, to pass
unregarded; but took the first opportunity, when it
was alone, to strangle them: it eat a part of their
flesh, and drank only the blood of others.

These animals are numerous in all the southern
regions of Asia, from Egypt to the island of Java:
they are also found in Africa, in the country about

the Cape of Good Hope. They frequent the banks of rivers, are fond of fish, are said to take the water like an Otter, and will continue in it a considerable time without rising to take breath.

The Ichneumon varies in size. The domestic kind is generally larger than those that are wild, and its colours more variegated. It is in general about the size of a common Cat; somewhat longer in the body, and shorter in the legs. Its fur contains tints of white, brown, fawn colour, and a dirty silver grey, which altogether form a mixture very agreeable to the eye. Its form is like that of the Polecat. Its eyes are small, but inflamed, and sparkle with a singular vivacity; its nose is long and slender; its ears small, rounded, and almost naked; its tail is very thick at the base, and tapers to a point; underneath the tail is an orifice, from which a most fetid humour is secreted; its claws are long. It darts upon its prey like an arrow, and seizes it with inevitable certainty.

It has a small soft voice, somewhat like a murmur; and, unless struck or irritated, never exerts it. When it sleeps, it folds itself up like a ball, and is not easily awaked. It frequently sits up like a Squirrel, and feeds itself with its fore feet; catches any thing that is thrown to it; and will often feign itself dead, till its prey come within its reach.

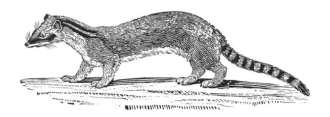

THE FOSSANE.

(La Fossane, Buff.)

Is rather smaller than the Martin. Its body is slender, and covered with hair of an ash colour, mixed with tawny; the sides of the face are black; at the hind part of the head there are four black lines, extending from thence towards the shoulders; the tail is long, and annulated with black; its eye is full, round and black, which gives it a wild and mischievous aspect.

It inhabits the island of Madagascar, Guinea, Cochin-China, and the Philippine Isles. It feeds on flesh and fruits, but prefers the latter, and is peculiarly fond of bananas. It is very fierce, and not easily tamed.

In Guinea, it is called the *Berbe;* and by Europeans, the *Wine-bibber*, being very greedy of palm-wine. When young, its flesh is reckoned very good to eat.

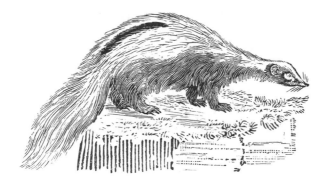

THE SKUNK.

(Viverra Putorius, Linn.—*Le Conepate,* Buff.)

It is called the *Chinche* by the natives of Brazil, and is about the size of a common Cat. Its nose is long and slender, and extends a considerable way beyond the lower jaw: its ears are large, short, and rounded; a white stripe extends from the nose over the forehead and along the back, where it is intersected with a small line of black, commencing at the tail, and extending upwards along the middle of the back; its belly and legs are black; its hair is long, especially on the tail, which is thick and bushy.

It inhabits Peru, Brazil, and other parts of South America; and is likewise found in North America, as far as Canada.

It is remarkable for a most intolerable suffocating, fetid vapour, which it emits from behind, when attacked, pursued, or frightened. The stench of this effluvium is insupportable, and is the creature's best means of defence.

There are three or four varieties, mentioned by M. Buffon under the name of the *Stinking Polecats;*

all of which possess this wonderful faculty of annoy-
ing their enemies from the same quarter.

Some turn their tail to their pursuers, and emit a
most horrible stench, which keeps both Dogs and
men at a considerable distance. Others eject their
urine to the distance of several feet; and it is of so
virulent a quality, as almost to occasion blindness,
if any of it should happen to fall into the eyes.
Clothes infected with it retain the smell for many
days: no washing can make them sweet; but they
must be even buried in fresh soil before they can be
thoroughly cleansed. Dogs that are not properly
bred, turn back as soon as they feel the smell:
those that have been accustomed to it, will kill the
animal; but are obliged to relieve themselves by
thrusting their noses into the ground.

The *Stifling* or *Squash*, which is the second
variety, is nearly of the same size as the Skunk.
Its hair is long, and of a deep brown colour. It
lives in holes and clefts of rocks, where the female
brings forth her young. It is a native of Mexico,
and feeds on Beetles, Worms, and small birds. It
destroys poultry, of which it eats only the brains.
When afraid, or irritated, it voids the same offensive
kind of odour, which no creature dares venture to
approach. Professor Kalm was in danger of being
suffocated by one that was pursued into a house
where he slept; and it affected the cattle so much,
that they bellowed through pain. Another, which
was killed by a maid-servant in a cellar, so affected
her with its stench, that she lay ill for several days:
all the provisions that were in the place were so
tainted by the smell, as to be utterly unfit for use.

Another variety is called the *Conepate*, and is,
perhaps, no more than the female of the last-

mentioned animal. It is somewhat smaller, and differs chiefly from the Squash in being marked with five parallel white lines, which run along its back and sides from head to tail.

It is a native of North America. When attacked, it bristles up its hair, throws itself into a round form, and emits an odour which no creature can support.

The last of this pestiferous family which we shall mention is the *Zorilla*.

This animal is a native of New Spain, where it is called the *Mariputa*. It is found on the banks of the river Oronoque; and although extremely beautiful, it is at the same time the most offensive of all creatures. Its body is beautifully marked with white stripes upon a black ground, running from the head to the middle of the back, from whence they are crossed with other white bands, which cover the lower part of the back and flanks: its tail is long and bushy, black as far as the middle, and white to its extremity. It is an active and mischievous little animal. Its stench is said to extend to a considerable distance, and is so powerful as to overcome even the Panther of America, which is one of its greatest enemies.

Notwithstanding this offensive quality in these animals, they are frequently tamed, and will follow their master. They do not emit their odour, unless when beaten or irritated. They are frequently killed by the native Indians, who immediately cut away the noxious glands; thereby preventing the flesh, which is good eating, from being infected. Its taste is said nearly to resemble the flavour of a young Pig. The savage Indians make purses of their skins.

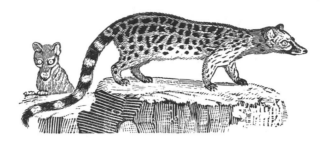

THE GENET.

(Viverra Genetta, Linn —*La Genette,* Buff.)

Is as much distinguished for the agreeable perfume which it yields, as those we have just described are for the rankest and most disagreeable odour in nature.

The body of the Genet is longer than that of the Martin; its head is long and slender, with a sharp muzzle; its ears are a little pointed; its hair soft, smooth, and shining; of a tawny red colour, spotted with black; along the ridge of the back there is a kind of mane of long hair, which forms a black line from head to tail; the spots on the sides are round and distinct, those on the back almost close; its tail is long, and marked with seven or eight rings of black. From an orifice beneath its tail, it yields a kind of perfume, which smells faintly of musk.

It is found in Turkey, Syria, and Spain. We are told by Belon, that he saw Genets in the houses at Constantinople as tame as Cats; and that they were useful to the inhabitants in destroying Rats, Mice, and other vermin.

It is a most beautiful, cleanly, and industrious animal, and very active in pursuing its prey. Its nature is mild and gentle, its colours beautifully variegated, and its fur valuable. Upon the whole, it seems to be one of those animals that, with proper care and attention, might become a useful addition to our stock of domestic quadrupeds.

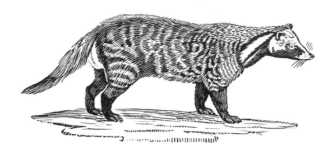

THE CIVET.

(Viverra Zibetha, Linn.—*La Civette,* Buff.)

Is larger than the Genet, and yields a perfume in much greater quantities, and of a stronger quality.

Though originally a native of the warm climates of Africa or Asia, it can live in temperate, and even in cold countries; but it must be fed with nourishing diet, and carefully defended against the severities of the weather.

Numbers of them are kept in Holland, for the purpose of collecting this valuable perfume. The Civet procured at Amsterdam is more esteemed than that which comes from the Levant, or India, being less adulterated. To collect this perfume, the Civet is put into a cage, so narrow, that it cannot turn itself: the cage is opened at one end, and the animal drawn backwards by the tail, and securely held by its hind legs: a small spoon is then introduced into the pouch which contains the perfume, with which it is carefully scraped, and the matter put into a vessel properly secured. This operation is performed two or three times a week.

The quantity of odorous humour depends much on the quality of the nourishment and the appetite of the animal, which always produces more in proportion to the goodness of its food. Boiled flesh, eggs, rice, small animals, birds, and particularly fish, are the kinds of food the Civet mostly delights in; and these ought to be varied, so as to excite its appetite, and preserve its health. It requires very little water; and, though it drinks seldom, it discharges its urine frequently. It is somewhat remarkable, that in this operation the male is not to be distinguished from the female. From this circumstance, it has been supposed that this was the *Hyena* of the ancients; and it is certain, that most of the fables related concerning that monster, are in a certain way applicable to the Civet.

The ancients were well acquainted with the pomatum of the Civet, and ascribed to it certain powers of exciting love; for which purpose it still constitutes one of the luxuries of the East.

What has been fabulously related concerning the uncertainty of sex in the Hyena, applies much more strongly to the Civet; for in the male nothing appears externally but three apertures, so perfectly similar to those of the female, that it is impossible to distinguish the sex otherwise than by dissection.

The perfume of this animal is so strong, that it infects every part of its body: the hair and the skin are so thoroughly penetrated with it, that they retain it long after being taken from the body. If a person be shut up in the same apartment, it is almost insupportable; and when heated with rage, it becomes still more pungent.

The Civet is naturally savage, and somewhat

ferocious; yet it is easily tamed, so as to be handled without danger.

The teeth are strong and sharp; but its claws are weak. It is very active and nimble, leaps like a Cat, and runs with great swiftness. It lives by hunting; surprises small animals and birds; and, like the Weasel, will sometimes steal into the yard, and carry off poultry. Its eyes shine in the dark; and it is probable, that it can see well enough to pursue its prey during the night, and it is known to be most active at that time.

The Civet is very prolific in its native climate; but though it lives and produces its perfume in temperate regions, it is never known to breed there. Its voice is stronger than that of the Cat, and has some resemblance to the cry of an enraged Dog.

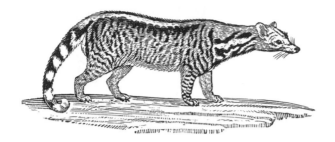

THE ZIBET.

(Le Zibet, Buff.)

Is so similar to the Civet, as to be considered by some authors as only a variety of that animal; and it must be allowed that they have many essential relations, both in their external and internal structure; but they differ from each other by such distinguishing characteristics, as entitle them to be regarded as two distinct species. The ears of the Zibet are larger and more erect; and its muzzle is thinner and flatter; its body is longer than that of the Civet; and its tail, which is also longer, is marked with annular spots, like that of the Genet: it has no mane or long hair on the neck and spine; and its hair is shorter and softer.

The perfume of the Zibet is peculiarly violent and piercing, beyond that of either the Civet or the Genet. This odorous matter is found in a fissure near the organs of generation. It is a thick humour, of the consistence of pomatum; and though very strong, is agreeable, even as it issues from the body of the animal. This matter of the Zibet must not be confounded with musk, which is

a sanguineous humour, derived from a species of the
Roe-Buck, or Goat without Horns;* and has nothing
in common with the Zibet, but its strong perfume.

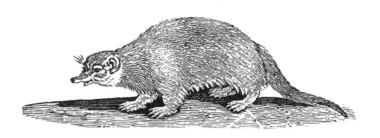

THE SURICATE, OR FOUR-TOED WEASEL.

Is rather less than the Rabbit: it pretty much
resembles the Ichneumon, both in size and in the
colour of its hair; only it is rougher, and its tail is
not quite so long. Its upper jaw is much longer
than the lower, and very pliant and moveable. It
has only four toes on each foot.

One of them, in the possession of M. de Seve,
was observed sometimes to walk on its hind legs,
and frequently to sit upright, with its fore feet
hanging down on its breast.

The Suricate is carnivorous, and preys on small
animals. It is fond of fish, and still more so of
eggs. Like the Squirrel, it makes use of its fore
paws to convey its victuals to its mouth. In drink-
ing, it laps like a dog; but will not drink water,
except when it is warm.

* See page 115.

That kept by M. de Seve was extremely playful and familiar, knew its own name, and would return at a call. What was remarkable, it seemed to have an aversion to particular persons, whom it would always bite on their approaching it: some people were so disagreeable to it, that even when restrained, it would make use of several artifices to come near enough to bite them; and when it could not lay hold of their legs, would fly at their shoes or petticoats. When discontented, it made a noise like the barking of a whelp; and when pleased or caressed, would utter a sound like the shaking of a rattle.

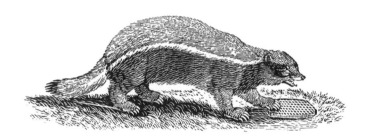

THE RATEL.

DESCRIBED by Mr. Pennant under the name of the *Fizzler*, is a native of the Cape of Good Hope. It lives chiefly upon honey, and is endowed with a wonderful faculty of discovering the secret retreats where the Bees deposit their stores. About sunset, the Ratel is particularly attentive in watching the motions of these industrious insects; and having observed their route, it follows with great care the direction in which they fly. It is frequently

assisted in discovering its delicious booty by a bird
called the Honey Guide *(cuculus indicator)* which is
extremely fond both of honey and the eggs of Bees;
and, in the pursuit of its food, excites the attention
of the Ratel by a loud grating cry of *cherr, cherr,
cherr;* at the same time flying slowly on towards
the place where the swarm of Bees have taken up
their abode. The Ratel follows the sound with
great attention; and having plundered the nest,
leaves sufficient behind it as a reward for the ser-
vices of its faithful guide. The Ratel is well
adapted to this purpose, as the toughness and
thickness of its skin effectually defend it from the
stings of the Bees. On this account, it is not
easily killed; for its skin is so loosely attached to
its body, that when seized by a hound, it gives
way, and the animal has an opportunity of turning
round, and biting its assailant, which it frequently
does so severely, as to oblige him to desist.

The Ratel, according to Mr. Pennant, is two feet
long from the nose to the tail, which is eight
inches; its legs are short; on each foot it has four
toes, armed with long claws; those on the fore feet
are above an inch long, and very sharp; its tongue
is rough; it has no ear-laps; the orifice of the ear
is wide, and surrounded by a callous rim; a broad
stripe, of an ash colour, extends along the back
from the forehead to the tail, which is separated
from the black hair on the sides and belly by a
light grey list running from behind each ear to the
tail. It burrows in holes under ground, is said to
be very fetid, and is called the *Stinking Badger* by
M. de la Caille.

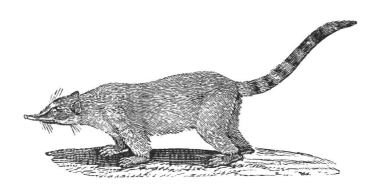

THE COATI, OR BRAZILIAN WEASEL.

(Viverra Nasua, Linn.—*La Coati,* Buff.)

HAS some resemblance to the Bear in the length of its hind legs, in the form of its feet, in the bushiness of its hair, and in the structure of its paws. It is small. Its tail is long, and variegated with different colours; its upper jaw is much longer than the lower, and very pliant; its ears are round; its hair is smooth, soft, and glossy, of a bright bay colour; and its breast is whitish.

Linnæus describes one of them which he kept a considerable time, and in vain attempted to bring into subjection. It was very obstinate and capricious. It killed the poultry, tore off their heads, and sucked their blood. It defended itself with great force whenever any person attempted to lay hold of it contrary to its inclination, and it stuck fast to the legs of those with whom it was familiar; when it wanted to ransack their pockets, and carry off any thing that it found in them. It had an extreme aversion to hog's bristles, and the smallest

brush made it desist. Its mode of living was very
singular: it slept from midnight to noon, kept
awake the rest of the day, and uniformly walked
about from six in the evening till midnight, without
the least regard to the weather. This is probably
the time assigned by nature to this species of ani-
mals for procuring their food, which consists chiefly
of young birds, eggs, and small animals.

It inhabits Brazil and Guiana, runs up trees very
nimbly, eats like a Dog, and holds its food between
its fore legs, like the bear.

The Coati stands with ease on its hind feet. It
is said to gnaw its own tail, which it generally car-
ries erect, and sweeps it about from side to side.

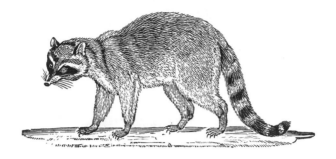

THE RACCOON.

(Ursus Lotor, Linn.—*Le Raton*, Buff.)

Is very common in the warm regions of America. It is found also in the mountains of Jamaica; from whence great numbers of them frequently descend into the plantations, and make sad havoc among the sugar-canes, of which they are particularly fond. The planters consider these animals as their greatest enemies, as they frequently do infinite mischief in one night's excursion. They have contrived various methods of destroying them, yet still they propagate in such numbers, that neither traps nor fire-arms can extirpate them.

The Raccoon is somewhat less than the badger: its head resembles that of a Fox, but its ears are round and much shorter, and its upper jaw very pointed, and longer than the lower: its eyes, which are large, are surrounded with two broad patches of black: its body is thick and short, covered with long hair, black at the points and grey underneath; its tail is long and bushy, and marked with alternate rings of black and white; its feet and toes are black.

The Raccoon is very active and nimble. Its claws, which are extremely sharp, enable it to climb trees with great facility. It moves forward chiefly by bounding; and though it proceeds in an oblique direction, runs very swiftly.

When tamed, it is good-natured and sportive; but is almost constantly in motion, and as unlucky and inquisitive as a Monkey, examining every thing with its paws, which it makes use of as hands to lay hold of any thing that is given to it, and to carry its meat to its mouth. It sits up to eat, is extremely fond of sweet things and strong liquors, with which it will get excessively drunk. It has all the cunning of a Fox, is very destructive of poultry, but will eat all sorts of fruits, grain, and roots. It has a peculiar method of dipping every thing in water it intends to eat, and will seldom taste bread till it be well soaked. It opens oysters with astonishing dexterity, separates the shells, and leaves not a vestige of the fish. It does this without looking at the oyster, but places it under its hind paws, and with its fore feet, searches for the weakest part, where it fixes its claws, forces it open, and snatches out the fish. It likewise devours all kinds of insects, delights in hunting spiders, and when at liberty in a garden, will eat grasshoppers, snails, worms, &c. It is very cleanly, and always retires to obey the calls of nature. It is familiar, and even caressing, leaps upon those it is fond of, plays sportively, and moves about with great agility.

This animal is hunted for its skin, which is next in value to that of the Beaver for making hats.

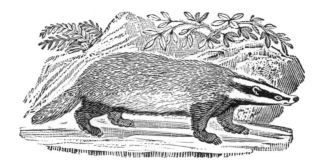

THE BADGER.

(Ursus Meles, Linn.—Le Blaireau, ou Taison, Buff.)

ALTHOUGH nature has furnished this animal with formidable weapons of offence, and has besides given it strength sufficient to use them with great effect, it is notwithstanding very harmless and inoffensive; and, unless attacked, employs them only for its support.

The Badger retires to the most secret recesses, where it digs its hole, and forms its habitation under ground. Its food consists chiefly of roots, fruits, grass, insects, and frogs. It is charged with destroying Lambs and Rabbits, but there seems to be no other reason to consider it as a beast of prey, than the analogy between its teeth and those of carnivorous animals.

Few creatures defend themselves better, or bite with greater keenness, than the Badger. On that account it is frequently baited with Dogs trained for the purpose. This inhuman diversion is chiefly confined to the idle and the vicious, who take a cruel pleasure in seeing this harmless animal sur-

rounded by its enemies, and defending itself from their attacks, which it does with astonishing agility and success. Its motions are so quick, that a Dog is frequently desperately wounded in the first moment of assault, and obliged to fly. The thickness of the Badger's skin, and the length and coarseness of its hair, are an excellent defence against the bites of the Dogs: its skin is so loose, as to resist the impressions of their teeth, and give the animal an opportunity of turning itself round, and wounding its adversaries in their tenderest parts. In this manner this singular creature is able to resist repeated attacks both of men and dogs, from all quarters; till, being overpowered with numbers, and enfeebled by many desperate wounds, it is at last obliged to submit.

The Badger is an indolent animal, and sleeps much. It confines itself to its hole during the whole day, and feeds only in the night. It is so cleanly, as never to defile its habitation with its ordure. It breeds only once in a year, and brings forth four or five at a time.

It is not known to exist in warm countries. It is an original native of the temperate climates of Europe; and is found, without any variety, in Spain, France, Italy, Germany, Britain, Poland, and Sweden.

The usual length of the Badger is somewhat above two feet, exclusive of the tail, which is about six inches long; its eyes are small, and are placed in a black stripe, which begins behind the ears, and runs tapering towards the nose; the throat and legs are black; the back, sides, and tail, are of a dirty grey, mixed with black; the legs and feet are very short, strong, and thick; each foot consists of

five toes; those on the fore feet are armed with strong claws, well adapted for digging its subterranean habitation.

In walking, the Badger treads on its whole heel, like the Bear; which brings its belly very near the ground.

Immediately below the tail, between that and the anus, there is a narrow transverse orifice, whence a white substance, of a very fetid smell, constantly exudes.

The skin, when dressed with the hair on, is used for pistol furniture. Its flesh is eaten: the hind quarters are sometimes made into hams, which, when cured, are not inferior in goodness to the best bacon. The hairs are made into brushes, which are used by painters to soften and harmonise their shades.

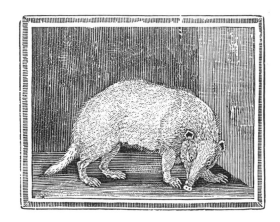

THE SAND-BEAR.

WE have given the figure of this animal, drawn
from one kept in the Tower; of which we have not
been able to obtain any further description, than
its being somewhat less than the Badger, almost
without hair, extremely sensible of cold, and bur-
rows in the ground. From these circumstances, as
well as from the striking similarity of its figure to
that of the Badger, we are inclined to think it is a
variety of that animal, mentioned by naturalists
under the name of the *Sow-Badger*.

Its colour is a yellowish white; its eyes are small;
and its head thicker than that of the common Bad-
ger; its legs are short; and on each foot there are
four toes, armed with sharp white claws.

M. Brisson describes a white Badger, from New
York, so similar to this, that we suspect it to be the
same species.

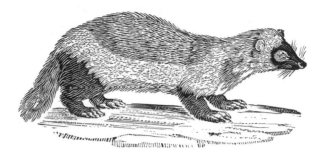

THE WOLVERINE, OR GLUTTON.

(Mustela Gulo, Linn.—*Le Glutton*, Buff.)

THIS voracious animal is found in all the countries bordering on the Northern Ocean, both in Europe and Asia: it is likewise common in Canada, the country about Hudson's Bay, and other parts of North America, where it is known by the name of the *Carcajou*.

It has been variously described by naturalists. We have selected the account given by M. Buffon, which was taken from a living one in his possession. Its length, from the nose to the insertion of the tail, was two feet two inches; the tail eight inches long; the length of the fore legs was eleven inches, and the hind ones twelve; it had five toes on each foot, armed with long sharp claws; the middle claw of the fore foot was one inch and a half long; the muzzle, as far as the eyebrows, was black; its eyes were small and black, and its ears short; its breast and under jaw were spotted with white; the back, legs, belly, and tail, were black. During its confinement, it did not discover symp-

toms of great ferocity. It eat voraciously; and
after a full meal, covered itself in its cage with
straw. It eat no bread, but would devour more
than four pounds of flesh every day, which it swal-
lowed greedily, almost without chewing.

In a state of liberty, it is said to lead a life of
continual rapine. It lurks in the branches of trees,
in order to surprise Deer and other animals that
pass under them. It waits with great patience the
arrival of its prey, and darts from its hiding-place
with unerring certainty. In this manner it indis-
criminately surprises the Horse, the Elk, the Stag,
and the Rein-Deer, and fixes itself between their
shoulders with its teeth and claws.

The wild Rein-Deer, which are numerous both
in Lapland and North America, frequently fall vic-
tims to the Glutton. When seized by this blood-
thirsty animal, it is in vain that the wounded Deer
endeavours to disengage itself from its enemy by
rushing among the branches of the trees: no force
can oblige it to quit its hold: it maintains its posi-
tion, and continues to suck the blood of the flying
animal till it falls down exhausted with pain and
fatigue. It then devours the carcase with insatiable
voracity, and gorges itself with the flesh till it is
almost in danger of bursting.

In Kamschatka, the Glutton makes use of a sin-
gular stratagem for killing the Fallow-Deer. It
climbs up a tree, taking with it a quantity of that
species of moss of which the Deer is very fond
When one of them approaches the tree, the Glutton
throws down the moss; and if the Deer stop to eat,
the Glutton darts upon its back, and fixing itself
firmly between its horns, tears out its eyes, and by
that means secures its prey. It then divides the

flesh of the Deer into a number of portions, which it conceals in the earth, to serve for future provision.

The motions of the Glutton are slow. There are few quadrupeds that cannot escape from it, except the Beaver, which it frequently pursues and overtakes. In America, it is called the *Beaver-eater*. It sometimes lies in wait, and surprises those animals coming out of their burrows, or breaks into their habitations, and kills great numbers of them.

Tho Glutton often defeats the labour of the huntsmen by stealing away the Sables and other animals that have been caught in their traps; and it is sometimes taken in the snares laid for them.

When attacked, it makes a strong resistance. It will tear the stock from the gun with its teeth, or break the trap in pieces in which it is caught. Notwithstanding its fierceness, it is capable of being tamed, and of learning several entertaining tricks.

It is hunted only for its skin, which is very valuable, of a most beautiful glossy black, which shines with a peculiar lustre, and reflects the light like damask silk.

The skins are sold in Siberia at five or six shillings each, at Jakutsk at twelve, and still dearer in Kamschatka. There the women dress their hair with its white paws, which they esteem a great ornament.

The furs of this animal, from the North of Europe and Asia, are infinitely finer, blacker, and more glossy, than those of the American kind.

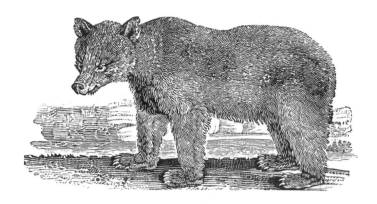

THE BROWN BEAR.

(Ursus cauda abrupta, Linn.—*L'Ours,* Buff.)

THERE are two principal varieties of the Bear,—
the *Brown* and the *Black.* The former is found in
almost every climate, the Black Bear chiefly in the
forests of the northern regions of Europe and
America.

The Brown Bear is sometimes carnivorous; but
its general food is roots, fruits, and vegetables.

It is a savage and solitary animal, lives in desert
and unfrequented places, and chuses its den in the
most dangerous and inaccessible precipices of un-
frequented mountains. It retires alone to its den
about the end of autumn, (at which time it is ex-
ceedingly fat) and lives for several weeks in a state
of total inactivity and abstinence from food. Dur-
ing this time, the female brings forth her young,
and suckles them. She chuses her retreat for that
purpose, in the most retired places, apart from the

male, lest he should devour them. She makes a warm bed for her young, and attends them with unremitting care during four months, and in all that time scarcely allows herself any nourishment. She brings forth two, and sometimes three young at a time. The cubs are round and shapeless, with pointed muzzles; but they are not licked into form by the female, as Pliny and other ancient naturalists supposed. At first they do not exceed eight inches in length. They are blind during the first four weeks, are of a pale yellow colour, and have scarcely any resemblance of the creature when arrived at maturity. The time of gestation in these animals is about six months, and they bring forth in the beginning of January.

In the spring, the old Bears, attended by their young, come out from their retreats, lean, and almost famished by their long confinement. They then ransack every quarter in search of food. They frequently climb trees, and devour the fruit in great quantities, particularly the date-plum tree, of which they are exceedingly fond. They ascend these trees with surprising agility, keep themselves firm on the branches with the hinder paws, and with the other collect the fruit.

The Bear is remarkably fond of honey, which it will encounter great difficulties to obtain, and seeks for with great cunning and avidity.

It enjoys, in a superior degree, the senses of hearing, smelling, and touching. Its ears are short and rounded; and its eyes small, but lively and penetrating, and defended by a nictating membrane: from the peculiar formation of the internal parts of its nose, its sense of smelling is exceedingly exquisite: the legs and thighs are strong and

muscular: it has five toes on each foot, and uses its
fore feet as hands, although the toes are not
separated as in most animals that do so; the largest
finger is on the outside.

The voice of the Bear is a deep and surly kind of
growl, which it frequently exerts without the least
cause. It is very easily irritated, and at that time
its resentment is furious, and often capriciously
exerted.

When tamed, it appears mild and obedient to its
master; but is not to be trusted without the utmost
caution. It may be taught to walk upright, to
dance, to lay hold of a pole with its paws, and
perform various tricks to entertain the multitude,
who are highly pleased to see the awkward move-
ments of this rugged creature, which it seems to
suit to the sound of an instrument, or to the voice
of its leader. But to give the Bear this kind of
education, it must be taken when young, and
accustomed early to restraint and discipline: an
old Bear will suffer neither, without discovering the
most furious resentment: neither the voice nor the
menaces of his keeper have any effect upon him;
he equally growls at the hand that is held out to
feed, as at that which is raised to correct him.

The excessive cruelties practised upon this poor
animal, in teaching it to walk erect, and regulate
its motions to the sound of the flagelet, are such as
make sensibility shudder. Its eyes are put out, and
an iron ring being put through the cartilage of the
nose to lead it by, it is kept from food, and beaten,
till it yield obedience to the will of its savage tutors.
Some of them are taught to perform by setting
their feet upon hot iron plates, and then playing to
them whilst in this uneasy situation. It is truly

shocking to every feeling mind to reflect, that such cruelties should be exercised upon any part of the brute creation by our fellow men. That they should be rewarded by numbers of unthinking people, who crowd around them to see the animal's rude attempts to imitate human actions, is not to be wondered at: but it is much to be wished, that the timely interference of the magistrate would prevent every exhibition of this kind, that, in Britain, at least, we might not be reproached with tolerating practices so disgraceful to humanity.

One of these animals presented to the Prince of Wales, a few years ago, was kept in the Tower. By the carelessness of the servant, the door of his den was left open; and the keeper's wife happening to go across the court at the same time, the animal flew out, seized the woman, threw her down, and fastened upon her neck, which he bit, and without offering any further violence, lay upon her, sucking the blood out of the wound. Resistance was in vain, as it only served to irritate the brute; and she must inevitably have perished, had not her husband luckily discovered her situation. By a sudden blow, he obliged the Bear to quit his hold, and retire to his den, which he did with great reluctance, and not without making a second attempt to come at the woman, who was almost dead through fear and loss of blood. It is somewhat remarkable, that whenever it happened to see her afterwards, it growled, and made most violent struggles to get out to her. The Prince, upon hearing of the circumstance, ordered the Bear to be killed.

The flesh of the young Bear is reckoned a great delicacy; and the paws of an old one are esteemed a most exquisite morsel. The fat is white, and

very sweet; and the oil is said to be of great use in softening swellings proceeding from sprains.

Great numbers are killed annually in America for the sake of their skins, which form a considerable article of commerce.

The Bear was once an inhabitant of this island, and was included in the ancient laws and regulations respecting beasts of chase. Long after their extirpation, they were imported for the cruel purpose of baiting them, which at that time was a favourite amusement of our ancestors. We find it, in Queen Elizabeth's days, among the various entertainments prepared for her Majesty on her visit at Kenilworth.

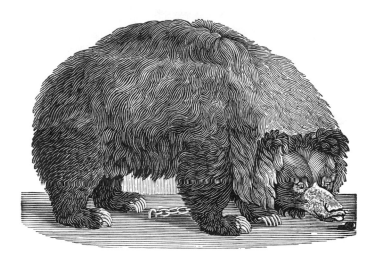

WE have here given a faithful representation, drawn from the life, of an animal which has hitherto escaped the observation of naturalists. Its features and leading characters seem to be so strong, as to leave no room for doubt with respect to its rank in the animal creation: and from the striking correspondence of parts observable between it and the common Bear, we are induced to dispose of them in the same class. We are the more confirmed in this opinion, from an attentive examination of its disposition and manners; notwithstanding it seems to differ in some of those characteristics which have been pointed out by naturalists as the guides to a regular and systematic arrangement.

Its body is covered with a long, rough, and shaggy coat of hair, which gives it, when lying down, the appearance of a rude and shapeless mass; on the top of its back, the hair, which is twelve inches long, rises up like a hunch, separates

in the middle, and falls down in different directions; its head is large, very broad at the forehead, and is the only part on which the hair is short; its snout is long, and ends in a thin, broad cartilage, over-hanging the nostrils about an inch and a half; its lips are thin and very long, and seem to be furnished with muscles, by which the animal can protrude them in a most singular manner, which it never fails to do when its attention is directed to any particular object, or when food is held out to it; its eyes are small, black, and heavy, and its aspect louring; its ears and tail are short, and hid in the hair; its legs and thighs are remarkably thick and strong; it treads on its heel like a Bear, and its toes are not divided; it has five long crooked white claws on each foot, which it uses with great dexterity, either separately or together, like fingers, to break its food into smaller portions, or to convey it to its mouth. Its colour is a deep, shining black; excepting the snout and a spot above each eye, which are of a yellowish white colour; there is likewise a crescent of white underneath the throat: it has no cutting teeth, but two very strong canine teeth, and six grinders, in each jaw.

It appears to be a gentle, good-natured animal; but when irritated or disturbed, utters a short abrupt roar, like a Bear, ending in a whining tone, expressive of impatience. It feeds on bread, fruit, and nuts; is fond of honey; and will eat marrow, or the fat of meat, either raw or dressed; but refuses roots of all kinds, and the lean or muscular parts of flesh.

This rare animal is said to have been brought from the interior parts of Bengal; and that it burrows in the ground.

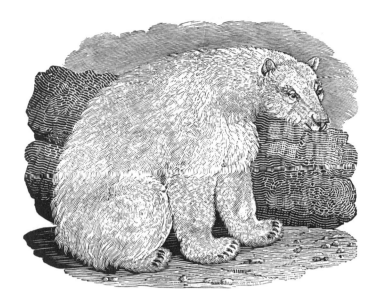

THE POLAR OR GREAT WHITE BEAR.

(Ursus Albus, Linn.—*L'Ours Blanc*, Buff.)

DIFFERS greatly from the common Bear in the length of its head and neck, and grows to above twice the size. Some of them are thirteen feet long. Its limbs are of great size and strength; its hair long, harsh and disagreeable to the touch, and of a yellowish white colour; its ears are short and round; and its teeth large.

It inhabits only the coldest parts of the globe, and has been found above latitude 80, as far as navigators have penetrated northwards. These inhospitable regions seem adapted to its sullen nature.

——————————————" There the shapeless Bear,
" With dangling ice all horrid, stalks forlorn :
" Slow pac'd, and sourer as the storms increase,
" He makes his bed beneath th' inclement drift ;
" And, with stern patience, scorning weak complaint,
" Hardens his heart against assailing want."

It has seldom been seen farther south than New-
foundland, but abounds chiefly on the shores of
Hudson's Bay, Greenland, and Spitzbergen on one
side, and those of Nova-Zembla on the other. It
has been sometimes found in the intermediate
countries of Norway and Iceland; but such as
have appeared in those parts have always been
driven thither upon floating sheets of ice; so that
those countries are only acquainted with them by
accident.

During summer, they take up their residence on
large islands of ice, and frequently pass from one to
another. They swim well, and can go to the
distance of six or seven leagues; they likewise dive,
but do not continue long under water. When the
pieces of ice are detached by strong winds or
currents, the Bears allow themselves to be carried
along with them; and as they cannot regain the
land, or abandon the ice on which they are em-
barked, they often perish in the open sea. Those
which arrive with the ice on the coasts of Iceland
and Norway, are almost famished with hunger from
the length of their voyage, and are extremely vora-
cious As soon as the natives discover one of them,
they arm themselves, and presently dispatch him.

The ferocity of the Bear is as remarkable as its
attachment to its young. A few years since, the
crew of a boat belonging to a ship in the Whale
fishery, shot at a Bear at a short distance, and

wounded it. The animal immediately set up the most dreadful yells, and ran along the ice towards the boat. Before it reached it, a second shot was fired, and hit it. This served to increase its fury. It presently swam to the boat; and in attempting to get on board, reached its fore foot upon the gunwale; but one of the crew having a hatchet, cut it off. The animal still, however, continued to swim after them till they arrived at the ship; and several shots were fired at it, which also took effect: but on reaching the ship, it immediately ascended the deck; and the crew having fled into the shrouds, it was pursuing them thither, when a shot from one of them laid it dead upon the deck.

Its flesh is white, and is said to taste like mutton. The fat is melted for train oil; and that of the feet is used in medicine.

The White Bear brings forth two young at a time. Their fondness for their offspring is so great that they will die rather than desert them: wounds serve only to make the attachment more violent: they embrace their cubs to the last, and bemoan them with the most piteous cries.

They feed on fish, Seals, and the carcases of Whales. Allured by the scent of Seal's flesh, they often break into the huts of the Greenlanders. They sometimes attack the Morse, with which they have terrible conflicts; but the large teeth of that animal give it a decided superiority over the Bear, which is generally worsted.

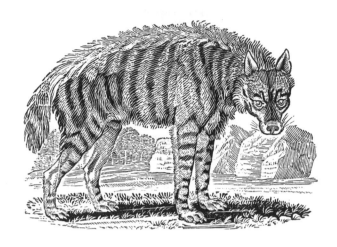

THE STRIPED HYENA.

(Canis Hyæna, Linn.—L'Hyæne, Buff.)

ALTHOUGH naturalists, both ancient and modern, have described the Hyena under different denominations, and have ascribed to it properties which it is now known not to possess, yet its characters are so singular, that it is impossible to mistake them, and so peculiar, as to distinguish it from every other class of animals. In many respects it resembles those of the Dog kind, has some similitude to the Wolf in form and disposition, and is about the same size.

The Hyena has only four toes on each foot; its head is broad and flat, and its muzzle shorter than that of the Wolf; its fore legs are longer than the hind ones; its ears are long, pointed, and bare; and its eyes are remarkably wild, sullen, and ferocious.

There are two varieties,—the one striped, and the other spotted. The hair of the former is of an ash colour, marked with long black stripes, disposed in waves, from the back downward; there are others across the legs; the hair in general is coarse and rough; its tail is short and bushy, with pretty long hair, sometimes plain, and sometimes barred with black; immediately underneath the tail, and above the anus, there is an orifice like that of the Badger, which opens into a kind of pouch, and contains a substance of the consistence of civet, but of a rank, disagreeable odour. This opening may probably have given rise to the error of the ancients, who asserted, that the Hyena was every alternate year male and female. Its manner of holding its head is somewhat like a Dog pursuing a scent with its nose near the ground. This position of the head makes the shoulders appear more elevated. A bristly mane runs along the top of the back from head to tail, which gives it an appearance somewhat like a Hog; from which probably it may have derived its name; the word *huaina* being a Greek word derived from *hus*, which signifies a Sow. Such are the most striking distinctions of the Hyena, which has been pictured by ignorance and timidity under every form that can strike terror into the imagination. Wonderful powers were ascribed to it by the ancients; who believed that it changed its sex; that it imitated the human voice, and by that means attracted unwary travellers, and destroyed them; that it had the power of charming the shepherds, and as it were riveting them to the place where they stood. Many other things, equally absurd, have been told of this animal: but these are sufficient to shew, that objects of terror and super-

stition are nearly allied; and when once they have taken possession of the human mind, the most improbable stories are easily received and credited.

It resides in the caverns of mountains, in the clefts of rocks, or in holes and dens, which it digs in the earth. Its disposition is extremely ferocious; and though taken young, it never can be tamed. It lives by depredations, like the Wolf, but is stronger, and more daring and rapacious. It follows the flocks, ravages the sheepfold, and destroys every thing within its reach with the most insatiable voracity. Its eyes shine in the dark; and it is asserted, with some appearance of probability, that it can see nearly as well by night as by day. When destitute of other provisions, it ransacks the graves, and devours putrid human bodies that have been long buried.

The voice of the Hyena is very peculiar; its beginning seems to be somewhat like the moaning of a human voice, and the ending like one making a violent effort to vomit.

It inhabits Asiatic Turkey, Syria, Persia, and Barbary. The superstitious Arabs, when they kill one of them, carefully bury the head, lest it should be applied to magical purposes.

The courage of the Hyena is equal to its rapacity. It will defend itself with great obstinacy against much larger quadrupeds: it is not afraid of the Lion nor the Panther, will sometimes attack the Ounce, and seldom fails to conquer.

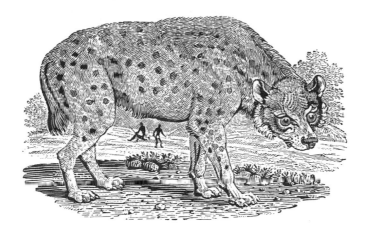

THE SPOTTED HYENA.

Is called, at the Cape of Good Hope, the *Tiger-Wolf*, and is very common in that part of the world. Sparrman describes it as a cruel, mischievous, and formidable animal. Its horrid yells are to be heard every night, whilst it prowls about for its prey, and lurks near farm yards, where cattle are kept. These are well defended by Dogs, of which the Hyena, though larger and stronger, is much afraid; and will not venture an attack, unless pressed by the most urgent necessity: neither will it dare to seize upon any of the larger animals, such as Oxen, Cows, Horses, &c., whilst they make the least appearance of defending themselves, or even if they do not betray any symptoms of fear. It sometimes endeavours to disperse the cattle by its hideous roaring; after which it selects and pursues one of them, which it soon disables by a deadly bite, and then devours.

These animals were formerly so bold as to molest the Hottentots in their huts, and sometimes carry off their children; but since the introduction of fire-arms, these and other wild beasts keep at a greater distance from the habitations of mankind. It is a fact, however, that numbers of them attend almost every night about the shambles at the Cape, where they meet with bones, skin, and other offals, which are left there by the inhabitants, who suffer these animals to come unmolested, and carry off their refuse; and it is somewhat remarkable that they have seldom been known to do any mischief there, though fed in the very heart of the town.

The howlings of the Hyena are dreadful beyond all conception, and spread a general alarm: they are almost incessant, and seem to be the natural consequence of its craving appetite. Perhaps it may not be going too far to say, that Nature has kindly impressed this involuntary disposition to yelling upon this animal, that every living creature may be upon its guard, and secure itself from the attacks of so cruel an enemy.

The general colour is a reddish brown, marked with roundish dark spots; the hind legs, in some, with transverse black bars,—in others with spots; its head is large and flat; above each eye, as well as on the lips, it has whiskers; a short shagged kind of mane runs along from the middle of the back to its head, the hair pointing forward; its ears are short and rounded; the hair on its face and the upper part of its head is short; the skin on its brow is wrinkled.

Our figure was drawn from a male Hyena exhibited in Newcastle in the spring and summer of 1799.

THE FOX.

(Canis Vulpes, Linn.—*Le Renard*, Buff.)

THIS lively and crafty animal is common to every part of Great Britain, and is so well known as not to require a particular description.

M. Buffon has taken great pains to prove, that the Dog and the Fox will not breed together. For this purpose he kept two males and a female for a considerable time, and tried to make the males copulate with bitches, which they uniformly refused; and from thence he concludes, that no mixture can take place between the two species. But it should be remembered, that the Foxes were in a state of confinement; and of course, many circumstances might concur to disgust them, and render the experiment abortive. In confirmation of this, we need only observe, that the same Foxes, which, when at liberty, darted on the poultry with their usual eagerness, never attempted to touch a single fowl after they were chained: and we are told further, " that a living hen was generally fixed near them for a whole night; and though food was kept from them for many hours, yet, in spite of hunger and opportunity, they never forgot that they were chained, and disturbed not the hen." Now if any one should be so hardy as to assert from this, that Foxes have a natural aversion to poultry, one may easily conceive how little credit would be given to the conclusion, and how much laughter it would excite. We just mention this to shew, that experi-

ments of this kind, where Nature is thwarted in her
process, or restrained in any of her operations, are
not always to be depended upon. That the Fox
and the Dog will breed together, is a fact too well
known in several parts of the North of England, to
admit of the smallest doubt. It is a common practice
in many places to tie up a bitch that is in season,
where she may be visited by a Fox, and be im-
pregnated by him. The fruits of the connection are
sufficiently obvious: most, if not all the puppies,
have a strong resemblance to the Fox: the sharp
nose, prick ears, long body, and short legs of the
Fox, evidently point out their origin. These Dogs
are highly esteemed by farmers and graziers, as
the most useful kind for driving cattle; they bite
keenly, are extremely active and playful, and are
very expert at destroying Weasels, Rats, and other
vermin.

The Fox sleeps much during the day; but the
night is its season of activity, and the time when it
roams about in search of prey. It will eat flesh of
any kind, but prefers that of Hares, Rabbits, poul-
try, and all kinds of birds. Those that reside near
the sea-coast will, for want of other food, eat crabs,
shrimps, mussels, and other shell-fish.

In France and Italy, the Fox does great damage
among the vineyards, by feeding on the grapes, of
which it is extremely fond. It boldly attacks the
wild bees, and frequently robs them of their stores;
but not with impunity: the whole swarm flies out,
and fastens upon the invader; but he retires only for
a few minutes, and rids himself of the bees by roll-
ing upon the ground; by which means he crushes
such as stick to him, and then returns to his charge,
and devours both wax and honey.

The cunning of the Fox, in surprising and se-
curing its prey, is equally remarkable. When it
has acquired more than it can devour, its first care
is to secure what it has killed, which is generally all
within its reach. It digs holes in different places,
where it conceals its booty, by carefully covering it
with earth to prevent a discovery. If a flock of
poultry have unfortunately fallen victims to its
stratagems, it will bring them, one by one, to these
hiding places, where it leaves them till hunger de-
mands frosh supplies.

The chase of the Fox is a very favourite diversion
in this kingdom, and is no where pursued with such
ardour and intrepidity. Both our Dogs and Horses
are confessedly superior to those of any other coun-
try. The instant the Fox finds he is pursued, he
flies towards his hole; and finding it stopped, which
is always carefully done before the chase begins, he
has recourse to his speed and his cunning for safety.
He does not double and measure his ground back
like the Hare, but continues his course straight for-
ward before the Hounds, with great strength and per-
severance. Both Dogs and Horses, particularly the
latter, have frequently fallen victims to the ardour of
the pursuit, which has sometimes continued for up-
wards of fifty miles without the smallest intermis-
sion, and almost at full speed.* As the scent of the
Fox is very strong, the Dogs follow with great

* Mr. CHARLES TURNER's Hounds hunted at Ayreyholm, near
Hurworth, in the county of Durham, and found the noted old Fox
CÆSAR, which made an extraordinary chase. After a round of
four miles, he led to Smeaton, through Hornby and Appleton; then
back again to Hornby, Worset Moor, Piersburgh, Lympton, Cray-
thorn, Middleton, Hilton, Seamer, Newby, Marton, Ormsby; then
upon Hambleton, through Kirkleatham Park, Upleatham, Skelton,

alacrity and eagerness, and have been known to keep up a constant chase for eight or ten hours together; and it is hard to say, whether the spirited eagerness of the Hounds, the ardour of the Horses, or the enthusiasm of the Hunters, is most to be admired. The Fox is the only one of the party which has the plea of necessity on his side; and it operates so strongly, that he often escapes the utmost efforts of his pursuers, and returns to his hole in safety. The smell of his urine is so offensive to the Dogs, that it sometimes proves the means of his escape from them. When all his shifts have failed him, and he is at last overtaken, he then defends himself with great obstinacy, and fights in silence till he is torn in pieces by the Dogs.

There are three varieties of Foxes in this island, which differ from each other more in form than in colour.

and Kelton. Mr. Turner tired three Horses : and only three Hounds were in pursuit, when he thought proper to call them off, it being near five in the evening. The chase was upwards of fifty miles.

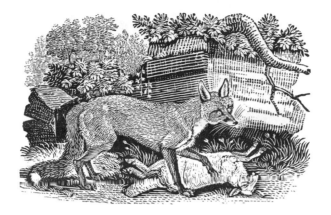

THE GREYHOUND FOX.

Is the largest, and is chiefly found in the mountainous parts of England and Scotland: he is likewise the boldest, and will attack a well-grown Sheep. His ears are long and erect, and his aspect wild.

THE MASTIFF FOX.

Is rather less; but his limbs are more strongly formed.

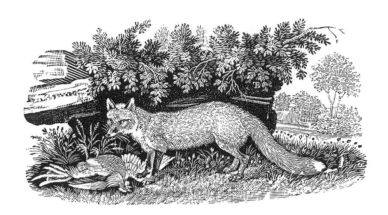

THE CUR FOX.

Is the least, but the most common, and approaches nearest to the habitations of mankind. It lurks about the out-houses of the farmer, and carries off all the poultry within its reach. It is remarkably playful and familiar when tamed; but, like all wild animals half reclaimed, will, on the least offence, bite those it is most familiar with.

The eye of the Fox is of a lively hazel colour, very significant and expressive; and discovers very sensibly the different emotions of love, fear, or anger, by which it may be affected. The Fox seems greatly to admire its bushy tail, and frequently amuses itself by endeavouring to catch it as it runs round. In cold weather, when it lies down, it folds it about its head.

The Fox sleeps soundly; and like the Dog, lies in a round form. When he is only reposing himself, he stretches out his hind legs, and lies on his belly. In this position, he spies the birds as they

alight on the hedges or places near him, and is
ready to spring upon such as are within his reach.
He rarely lies exposed, but chuses the cover of
some thick brake, where he is pretty secure from
being surprised. Crows, Magpies, and other birds,
which consider the Fox as a common enemy, will
often give notice of his retreat by the most clamor-
ous notes, and frequently follow him a considerable
way from tree to tree, repeating their outcries.

Foxes produce but once a year, from three to six
young ones at a time. When the female is preg-
nant she retires, and seldom goes out of her hole,
where she prepares a bed for her young. She
comes in season in the winter; and young Foxes
are found in the month of April. If she perceive
that her habitation is discovered, she carries them
off, one by one, to a more secure retreat. The
young are brought forth blind, like puppies. They
grow eighteen months or two years, and live thir-
teen or fourteen years.

The Fox is frequently taken in traps; but great
caution must be used to deceive this wily animal.
The trap must be placed in the midst of a field,
where there is neither hedge nor path near it, and
so nicely covered with mould, that not the least
vestige can be seen where it lies: about the trap,
and at a small distance from it, in different places,
a few pieces of cheese, or other strongly-scented
food, must be carelessly scattered: then with a
sheep's paunch, or some other animal substance, a
trail is made, of about a mile in length, to the
different places where the bait is laid, and from
thence to the trap: the shoes of the person who
carries the trail must be likewise well rubbed with
the paunch, that the Fox may not discover his

scent. He then approaches with more confidence, and if the design be well conducted, seldom fails of being caught.

There are many varieties of this animal, apparently produced by the influence of climate. Those of this country are mostly of a tawny red, mixed with ash colour; the fore part of the legs is black, and the tail tipt with white. In colder countries, Foxes are of various colours.

THE BLACK FOX.

Is most valuable for its fur, which is esteemed in Russia superior to that of the finest sable. A single skin will sell for four hundred rubles.

THE CROSS FOX.

(*Le Renard Croisé*, Buff)

Inhabits the coldest parts of Europe, Asia, and North America. Its fur is very valuable, being thicker and softer than the common sort. Great numbers of skins are imported from Canada.

It derives its name from a black mark which passes over its back across the shoulders, and another along the back to the tail.

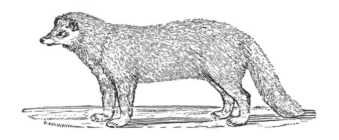

THE ARCTIC FOX.

(Canis Lapogus, Linn.—*Isatis,* Buff.)

INHABITS the countries bordering on the Frozen Sea. It is found in Greenland, Iceland, Spitzbergen, Nova-Zembla, and Lapland; in Kamschatka, and the opposite parts of America. It burrows, and makes holes in the ground, several feet in length; at the end of which it forms a nest of moss. In Greenland and Spitzbergen, it lives in the clefts of rocks, being unable to burrow, on account of the frost. Two or three of them inhabit the same hole.

It is endowed with all the cunning of the common Fox, preys on young Geese, Ducks, and other water-fowl, before they are able to fly; likewise on Hares, wild-birds and eggs: and in Greenland, for want of other food, it feeds on berries and shell-fish. In Lapland and the North of Asia, its principal food is the Leming, or Lapland Marmot; immense numbers of which sometimes cover the face of the country. The Foxes follow them in their migrations from one place to another; and as the return of the Marmot is very uncertain, and frequently

after great intervals of time, they are sometimes absent three or four years in pursuit of their favourite prey.

The hair of the Arctic Fox is of an ash colour, but changes to white in the winter, when it is long, soft, and somewhat woolly: its tail is shorter than that of the common Fox, and more bushy; and its toes are covered with fur on the under part, like those of a Hare: it is smaller and more slender than the European Fox: its nose is sharp and black; and its ears short, and almost hid in the fur. It is sometimes taken in traps, but its skin is of little value.

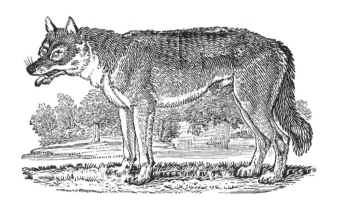

THE WOLF.

(Canis Lupus, Linn.—*Le Loup*, Buff.)

ALL naturalists agree in placing the Wolf and the Dog in the same class; and from the slightest inspection of its external form only, it would seem that the Wolf was in every respect a Dog in its state of natural freedom. The shape of its head is different; and its eyes, being fixed in a more oblique position, give it a look of more savage fierceness: its ears are sharp and erect; its tail long, bushy, and bending inwards between its hind legs; its body is stronger than that of almost any species of Dog, its jaws and teeth larger, and its hair coarser and thicker. The internal structure of these animals is perfectly similar. The Wolf couples in the same manner as the Dog; and its immediate separation is prevented from the same cause; the time of gestation is also nearly the same; and from a variety of successful experiments

related by the celebrated Dr. Hunter, there is no longer any room to doubt, that the Wolf and the Dog will copulate together, and produce an intermediate species, capable of subsequent propagation.

The appetite of the Wolf, for every kind of animal food, is excessively voracious; and although Nature has furnished it with every requisite for pursuing and conquering its prey, it is frequently reduced to the last extremity, and sometimes perishes for want of food. So great is the general detestation of this destructive creature, that all the wild animals endeavour to avoid it, and most commonly escape by their superior swiftness.

When pressed with hunger from repeated disappointments, the Wolf becomes courageous from necessity. It then braves every danger, and even attacks those animals that are under the protection of man. Sometimes whole droves of them join in the cruel work of general devastation, roam through the villages, and attack the sheepfolds: they dig the earth under the doors, enter with dreadful ferocity, and put every living creature to death before they depart. The Horse is the only tame animal that can defend itself against them: all the weaker animals become their prey: even man himself, upon these occasions, frequently falls a victim to their rapacity; and it is said, that when once they have tasted human blood, they always give it the preference. Hence many superstitious stories have been told of the Wolf. The old Saxons believed that it was possessed by some evil spirit, and called it the *Were-Wulf;* and the French peasants, from the same reason, called it the *Loup-garou.*

The language of the poet is beautifully descriptive of this creature's insatiable fury:—

" By wintry famine rous'd from all the tract
" Of horrid mountains, which the shining Alps,
" And wavy Appenine, and Pyrenees,
" Branch out, stupendous, into distant lands,
" Cruel as death! and hungry as the grave!
" Burning for blood! bony, and ghaunt, and grim!
" Assembling Wolves, in raging troops, descend;
" And, pouring o'er the country, bear along,
" Keen as the north wind sweeps the glossy snow,
" All is their prize."

The Wolf has great strength, especially in the
muscles of his neck and jaws: he can carry a Sheep
in his mouth, and easily run off with it in that man-
ner. His bite is cruel and deadly, and keener as it
meets with less resistance; but when opposed, he
is cautious and circumspect, and seldom fights but
from necessity. He is harder and more robust, but
not so sensible as the Dog. He almost incessantly
prowls about for prey; and of all animals is the
most difficult to conquer in the chase. His sense
of smelling is peculiarly strong; he scents the track
of animals, and follows it with great perseverance:
the odour of carrion strikes him at the distance of
near a league.

Wolves are capable of bearing want of food for a
long time. To allay their hunger, they will some-
times fill their stomachs with mud. They have
been known to follow armies, and assemble in
troops upon the field of battle; tear up such
bodies as have been carelessly interred, and de-
vour them with insatiable avidity.

In all ages the Wolf has been considered as the
most savage enemy of mankind, and rewards were
given for its head. Various methods have been
taken to rid the world of this rapacious invader:
pitfalls, traps, and poison, have all been employed

against him; and happily for these islands, the whole race has long been extirpated here. King Edgar attempted to effect it in England, by remitting the punishment of certain crimes on producing a number of Wolves' tongues; and in Wales, the tax of gold and silver was commuted for an annual tribute of Wolves' heads. Some centuries after that, they increased to such a degree, as to become an object of royal attention; and great rewards were given for destroying them. Camden informs us, that certain persons held their lands on condition of hunting and destroying the Wolves that infested the country; whence they were called the *Wolve-hunt*. In the reign of Athelstan, Wolves abounded so much in Yorkshire, that a retreat was built at Flixton, to defend passengers from their attacks. As the ravages of these animals were greatest during winter, particularly in January, when the cold was severest, our Saxon ancestors distinguished that month by the title of *Wolf-moneth*. They also called an outlaw *Wolfshed*, as being out of the protection of the law, and as liable to be killed as that destructive beast. They infested Ireland many centuries after their extinction in England: the last presentment for killing Wolves was made in the county of Cork, about the year 1710.

These animals abound in the immense forests of Germany, where the following methods are taken to destroy them:—In some very sequestered part of the forest, they hang up a large piece of carrion on the branch of a tree, having previously made a train of some miles long, leaving small pieces of putrid flesh here and there to allure the Wolves to the spot: they then wait till it is dark, and approach

the place with great circumspection; where they
sometimes find two or three Wolves assembled,
leaping up, and straining themselves to catch the
bait, which is placed just within their reach; and
while the animals are busily employed in this way,
the hunters being provided with fire-arms, seldom
fail to dispatch them. In a convenient place at the
foot of a declivity, they make a small inclosure of
strong pales, so high, that the Wolf, having once
entered, cannot return again. An opening is left
at the top of the bank; and a Sheep that has been
long dead, is the bait; to which he is allured by
long trains, made from different places where he is
known to haunt. As soon as he arrives at the spot,
he examines every part of the inclosure; and find-
ing no other way to come at the booty, he precipi-
tates himself to the bottom; and having made a
plentiful meal, endeavours in vain to re-ascend.
His disappointment at not being able to get back
is productive of the most dreadful howlings, which
alarm his enemies; and they either take him alive,
or dispatch him with bludgeons. It is remarkable,
that when this animal finds there is no possibility
of escaping, his courage entirely forsakes him, and
he is for some time so stupefied with fear, that he
may be killed without offering to resist, or taken
alive without much danger. Wolves are sometimes
taken in strong nets, into which they are driven by
the hunters, who surround a large tract of land, and
with drums, horns, and other instruments, accom-
panied with loud cries from a large company as-
sembled upon the occasion, drive the animals
towards the entrance of the nets, where they are
entangled, and killed with clubs and hatchets.
Great care must be taken to secure them at first:

if they recover from their consternation, they easily escape by tearing the net to pieces.

Wolves are found, with some variety, in almost every country of the world. Those of Senegal are larger and fiercer than those of Europe. In North America they are small, of a dark colour, and may be easily tamed. Before the introduction of Dogs, the Indians made use of them in hunting the wild animals of the country; and they are still employed for the same purpose in the more remote parts of that vast continent. They are said to hunt in packs, and run down the Deer by their scent. The appearance of these animals near the habitations of the Indians, sometimes indicates that the Bison or the Deer is at no great distance; and when any of those are taken, the Wolves are rewarded with the offal. Catesby affirms, that the Wolves of that country have mixed with the Dogs carried thither by the Europeans, and produced an intermediate race. In the northern regions there are Wolves entirely white, and others of a deep black. In Mexico there is a variety of the Wolf, with a very large head, strong jaws, and great teeth: on the upper lip it has strong bristles, not unlike the softer spines of the Porcupine, of a grey and white colour; its ears are large and erect; its body is ash coloured, spotted with black; on its sides there are black stripes from the back downward; its neck is fat and thick, covered with a loose skin, marked with a long tawny stroke; on the breast is another of the same kind; the tail is long, and tinged in the middle with tawny; the legs and feet are striped with black. It inhabits the hot parts of Mexico or New Spain, is equally voracious with the European Wolf, attacks cattle, and sometimes men. There are no Wolves further south on the new continent.

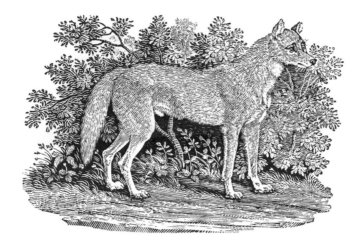

THE NEW SOUTH WALES WOLF.

HAS been called a Dog; but its wild and savage nature seems strongly to point out its affinity to the Wolf; to which, in other respects, it bears a great resemblance. It neither barks nor growls; but when vexed, erects the hairs of its whole body like bristles, and appears extremely furious. It is fond of Rabbits and poultry, which it eagerly devours raw; but will not touch dressed meat.

One of them sent to this country from Botany Bay, was extremely nimble; and so fierce, as to seize on every animal it saw. If not restrained, it would have run down Deer and Sheep: an Ass had also nearly fallen a victim to its fury.

Its height is rather less than two feet; the length two feet and a half: it is formed much like a Wolf; its ears short and erect, and its tail long and bushy: the general colour is a pale brown, lighter on the belly: the feet and inside of the legs are white.

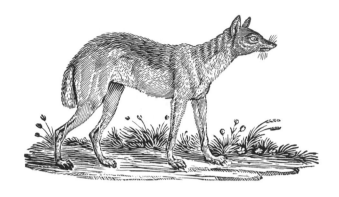

THE JACKAL.

(Canis Aureus, Linn.—*Le Chacal*, Buff.)

WE beg leave to make our acknowledgments to
Mr. Pennant for the drawing of this animal, which
he assures us was drawn from the life; and we
doubt not, therefore, its being a faithful repre-
sentation.

The species of the Jackal is diffused, with some
variety, through almost every part of Asia: and is
found in Barbary, and other parts of Africa, as far
as the Cape of Good Hope.

Although it is one of the most numerous of all
the wild animals of the East, there is scarcely any
one less known in Europe, or more confusedly
described by natural historians.

They vary in size. Those of the warmest climates
are said to be the largest. They are of a reddish
brown colour. The smaller Jackal is about the size
of a Fox, and its colour is a bright yellow.

That the Jackal is nearly allied to the Dog, has been clearly proved from a circumstance related by Mr. Hunter, of a female Jackal taken on board an East-Indiaman at Bombay whilst a cub, and being impregnated by a Dog during the voyage, brought forth six puppies; one of which afterwards produced young ones, from an intercourse with a Dog. From these and other recent facts, it appears, that the Fox, the Wolf, the Jackal, and the Dog, may be considered as different species of the same genus; and that the Jackal makes nearer approaches to the Dog than either the Fox or the Wolf.

Jackals go in packs of forty or fifty, and hunt like hounds in full cry from evening till morning. They destroy the poultry, and attack the flocks: they roam through the villages and gardens, and carry off every thing they can eat: they enter stables, yards, and outhouses, and devour skins, and every thing that is made of leather; such as harnessing, boots, shoes, &c. Nothing can escape their rapacity. They will ransack the repositories of the dead, and greedily devour the most putrid bodies; for which reason, in those countries where they abound, the inhabitants are obliged to make the graves of a great depth, and secure them with spines, to prevent the Jackals from raking up the earth with their feet. They are said to attend caravans, and follow armies, in hopes of being furnished with a banquet by disease or battle. They may be considered as the vulture among quadrupeds; and like that voracious bird, devour every thing indiscriminately that has once had animal life. They hide themselves in holes and dens by day, and seldom appear abroad till the evening, when they fill the air with the most horrid howlings, and

begin the chase. The Lion, the Panther, and other
beasts of prey that do not follow by the scent, take
advantge of the general consternation, and follow
in silence till the Jackals have hunted down their
prey: they then devour the fruits of their labours,
and leave them only the remains of the spoil;
whence the Jackal has been vulgarly called the
Lion's Provider, as if those two animals acted in
concert, and had formed a plan for their mutual
support.

The Jackal frequently pursues the Gazelle; and
is so bold as to follow it even into the midst of a
town or village, whither that timid animal fre-
quently flies for protection, and by that means
sometimes escapes.

Sparrman's description of those he saw at the
Cape differs materially from the accounts we have
been able to collect from other authors. He says
they are about three feet in length, and their tails
little more than a foot long: the predominant
colour is a reddish yellow; the legs are of a pale
gold colour; under the belly, and on the inside of
the legs, the colour inclines to white; the nose and
ears are of a bright red; the head, neck, and back
are grey; the tail is partly grey, and partly of an
umber colour, and black at the tip. He says it
resembles the European Fox in form, manners, and
disposition; and is not known to assemble in packs
for the purpose of hunting; neither is its voracity
equal to that ascribed to it by other naturalists. It
is probable it may have been confounded with the
Wild Dog, which is common at the Cape, and
hunts its prey in packs. It is very fierce and mis-
chievous, and very destructive to the flocks of
Sheep and Goats in those parts. There are two

kinds of these Dogs,—the one large, and of a reddish colour; the other less, and browner. They are very bold, and wander about night and day in search of prey. They make a noise somewhat like the cry of our common Hounds, and hunt with great sagacity, acting perfectly in concert with each other till the game falls a prey to the pack. They are said to be always extremely lean, and very ugly.

M. Buffon mentions an animal of the Jackal kind by the name of the *Adive;* of which he gives a drawing, somewhat resembling a small Fox. It is less than the common Jackal, and is sometimes tamed, and kept in a domestic state.

THE DOG.

THE services of this truly valuable creature have
been so eminently useful to the domestic interests
of man, in all ages, that to give the history of the
Dog would be little less than to trace mankind back
to their original state of simplicity and freedom, to
mark the progress of civilization through the vari-
ous changes of the world, and to follow attentively
the gradual advancement of that order which placed
man at the head of the animal world, and gave him
a manifest superiority over every part of the brute
creation.

Let us consider for a moment the state of man
without the aid of this useful domestic : with what
arts shall he oppose the numerous host of foes that
surround him on all sides, seeking every opportunity
to encroach upon his possessions, to destroy his
labours, or endanger his personal safety; or how
shall he bring into subjection such as are necessary
for his well-being ? His utmost vigilance will not
be sufficient to secure him from the rapacity of one,
nor his greatest exertions enable him to overcome
the speed of another. To maintain his indepen-
dence, to insure his safety, and to provide for his
support, it was necessary that some one among the
animals should be brought over to his assistance,
whose zeal and fidelity might be depended on: and
where, amidst all the various orders of animated
being, could one be found so entirely adapted to
this purpose ? where could one be found so bold, so
tractable, and so obedient as the Dog ? To confirm
the truth of these observations, we need only turn

our attention to the present condition of those na-
tions not yet emerged from a state of barbarism,
where the uses of the Dog are but little known or
attended to, and we shall find that they lead a pre-
carious and wretched life of perpetual warfare with
the still more savage inhabitants of the forest, with
which they are obliged to dispute the possession of
their uncultivated fields, and not unfrequently to
divide with them the fruits of their labours. Hence
we may conclude, that the attention of mankind, in
the earliest ages, would be engaged in training and
rendering this animal subservient to the important
purposes of domestic utility; and the result of this
art has been the conquest and peaceable possession
of the earth.

Of all animals, the Dog seems most susceptible
of change, and most easily modified by difference of
climate, food, and education ; not only the figure of
his body, but his faculties, habits, and dispositions,
vary in a surprising manner: nothing appears con-
stant in them but their internal conformation, which
is alike in all; in every other respect they are very
dissimilar: they vary in size, in figure, in the length
of the nose and the shape of the head, in the length
and direction of the ears and tail, in the colour,
quality, and quantity of the hair, &c. To enumerate
the different kinds, or mark the discriminations by
which each is distinguished, would be a task as
fruitless as it would be impossible ; to account for
this wonderful variety, or investigate the character
of the primitive stock from which they have sprung,
would be equally vain. Of this only we are certain,
that, in every age, Dogs have been found possessed
of qualities most admirably adapted for the various
purposes to which they have been from time to time

applied. We have seen, in the history of the Cow
and the Sheep, that those animals which have been
long under the management of man, never preserve
the stamp of Nature in its original purity. In wild
animals, which still enjoy their natural freedom
from restraint, and have the independent choice
of food and climate, this impression is still faith-
fully preserved; but those which man has subdued,
transported from climate to climate, and changed
their food, habits, and manner of living, must neces-
sarily have suffered the greatest alterations in their
form; and as the Dog, of all other domestic animals,
is most accustomed to this influence, is endowed
with dispositions the most docile and obedient, is
susceptible of every impression, and submissive to
every restraint, we need not wonder that he should
be subject to the greatest variety. To an attentive
observer of the canine race, it is truly wonderful and
curious to observe the rapid changes and singular
combinations of forms, arising from promiscuous in-
tercourse, which every where present themselves:
they appear in endless succession, and seem more
like the effect of whimsical caprice than the regular
and uniform production of Nature, rendering every
idea of a systematic arrangement dubious and pro-
blematical: but in whatever light we consider the
various mixtures which at present abound, we may
fairly presume, that the services of the Shepherd's
Dog would be first required in maintaining and pre-
serving the superiority of man over those animals
which were destined for his support.

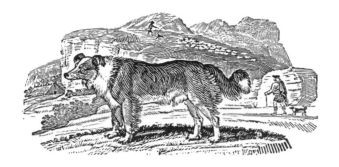

THE SHEPHERD'S DOG.

(Canis domesticus, Linn.—*Le Chien de Berger*, Buff.)

THIS useful animal, ever faithful to his charge, reigns at the head of the flock; where he is better heard, and more attended to, than even the voice of the shepherd. Safety, order, and discipline, are the fruits of his vigilance and activity.

In those large tracts of land which, in many parts of our island, are solely appropriated to the feeding of Sheep and other cattle, this sagacious animal is of the utmost importance. Immense flocks may be seen continually ranging over these extensive wilds, as far as the eye can reach, seemingly without control: their only guide is the shepherd, attended by his Dog, the constant companion of his toils: it receives his commands, and is always prompt to execute them; it is the watchful guardian of the flock, prevents them from straggling, keeps them together, and conducts them from one part of their pasture to another: it will not suffer any strangers to mix with them, but carefully keeps

off every intruder. In driving a number of Sheep
to any distant part, a well trained Dog never fails
to confine them to the road; he watches every
avenue that leads from it, where he takes his stand,
threatening every delinquent, and pursues the
stragglers, if any should escape, and forces them
into order, without doing them the least injury. If
the herdsman be at any time absent from the flock,
he depends upon his Dog to keep them together;
and as soon as he gives the well-known signal, this
faithful creature conducts them to his master,
though at a considerable distance.

There is a very remarkable singularity in the feet
of the Shepherd's Dog, which we have likewise
sometimes observed in those of the Cur and the
Spaniel. They have one, and sometimes two extra
toes on the hind feet, though they seem not to be
of much use. They appear to be destitute of
muscles, and hang dangling at the hind part of
the leg, more like an unnatural excrescence than a
necessary part of the animal. But the adage, that
"Nature has made nothing in vain," ought to cor-
rect our decision on their utility, which probably
may exist unknown to us.

This breed of Dogs, at present, appears to be
preserved in the greatest purity, in the northern
parts of England and Scotland; where its aid is
highly necessary in managing the numerous herds
of Sheep bred in those extensive wilds and fells.

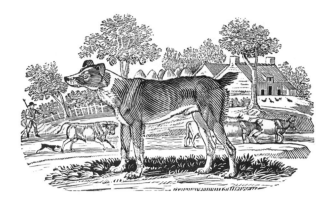

THE CUR DOG.

Is a trusty and useful servant to the farmer and grazier; and although it is not taken notice of by naturalists as a distinct race, yet it is now so generally used, especially in the North of England, and such great attention is paid in breeding it, that we cannot help considering it as a permanent kind. In the North of England, this and the foregoing are called *Coally* Dogs.

These are chiefly employed in driving cattle; in which way they are extremely useful. They are larger, stronger, and fiercer than the Shepherd's Dog; and their hair is smoother and shorter. They are mostly of a black and white colour; their ears are half-pricked; and many of them are whelped with short tails, which seem as if they had been cut: these are called *Self-tailed Dogs*. They bite very keenly; and as they always make their attack at the heels, the cattle have no defence against them: in this way, they are more than a match for a Bull, which they will compel to run. Their

sagacity is uncommonly great: they know their master's fields, and are singularly attentive to the cattle that are in them. A good Dog watches, goes his rounds, and if any strange cattle should happen to appear among the herd, although unbidden, he quickly flies at them, and with keen bites obliges them to depart.

Similar to the Cur, is that which is commonly used in driving cattle to the slaughter: and as these Dogs have frequently to go long journies, great strength, as well as swiftness, is required for that purpose. They are therefore generally of a mixed kind, and unite in them the several qualities of the Shepherd's Dog, the Cur, the Mastiff, and the Greyhound. Thus, by a judicious mixture of different kinds, the services of the Dog are rendered still more various and extensive, and the great purposes of domestic utility more fully answered.

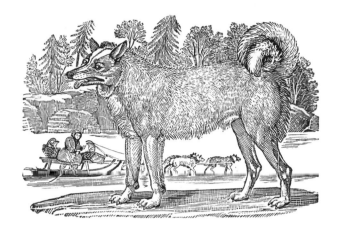

THE GREENLAND DOG.

(Le Chien de Sibirie, Buff.)

THE savage aspect and disposition of this Dog seem to bear some affinity to the rigours of the climate it inhabits.

The Pomeranian or Wolf Dog of M. Buffon, the Siberian, Lapland, and Iceland Dogs are somewhat similar to it in the sharpness of their muzzles, in their long shaggy hair, and bushy curling tails. The principal difference is in their size. Though much larger, they all of them have some resemblance to the Shepherd's Dog.

Most of the Greenland Dogs are white; but some are spotted, and some black. They may rather be said to howl than bark. The Greenlanders sometimes eat their flesh: they make garments of their skins, and use them in drawing sledges; to which they yoke them, four, five, and sometimes six

together.* The Dogs of Kamschatka are commonly black or white. They are strong, nimble, and active, and are very useful in drawing sledges, the only method of travelling in that dreary country during the winter. They travel with great expedition. Captain King relates, that during his stay there, a courier, with dispatches, drawn by them, performed a journey of 270 miles in less than four days.

The sledges are usually drawn by five Dogs, four of them yoked two and two abreast: the foremost acts as a leader to the rest. The reins being fastened to a collar round the leading Dog's neck, are of little use in directing the pack; the driver depending chiefly upon their obedience to his voice, with which he animates them to proceed. Great care and attention are consequently used in training up those for leaders, which are more valuable according to their steadiness and docility, the sum of forty roubles, or nine pounds, being no unusual price for one of them. The rider has a crooked stick, answering the purpose of both whip and reins; with which, by striking on the snow, he regulates the speed of the Dogs, or stops them at his pleasure. When they are inattentive to their duty, he often chastises them by throwing it at them. He discovers great dexterity in regaining his stick, which is the greatest difficulty attending his situation; for if he should happen to lose it, the Dogs immediately discover the circumstance, and never fail to set off at full speed, and continue to run till their strength is exhausted, or till the car-

* Five of these Dogs, that had escaped with their trappings, were found in Greenland, and brought to this country, a few years ago, by one of our ships in the fishery.

riage is overturned and dashed to pieces, or hurried down a precipice.

In December, 1784, a Dog was left by a smuggling vessel, near Boomer, on the coast of Northumberland. Finding himself deserted, he began to worry Sheep; and did so much damage, that he became the terror of the country within a circuit of about twenty miles. We are assured, that when he caught a Sheep, he bit a hole in its right side, and after eating the tallow about the kidnies, left it: several of them, thus lacerated, were found alive by the shepherds; and being taken proper care of, some of them recovered, and afterwards had lambs. From his delicacy in this respect, the destruction he made may in some measure be conceived; as it may be supposed, that the fat of one Sheep in a day would hardly satisfy his hunger. The farmers were so much alarmed by his depredations, that various means were used for his destruction. They frequently pursued him with Hounds, Greyhounds, &c.; but when the Dogs came up with him, he laid down on his back, as if supplicating for mercy; and in this position they never hurt him: he therefore laid quietly, taking his rest till the hunters approached, when he made off without being followed by the Hounds, till they were again excited to the pursuit, which always terminated unsuccessfully. It is worthy of notice, that he was one day pursued from Howick to upwards of thirty miles distance: but returned thither and killed Sheep the same evening. His constant residence, during the day, was upon a rock on the Heugh Hill, near Howick, where he had a view of four roads that approached it; and in March, 1785, after many fruitless attempts, he was at last shot there.

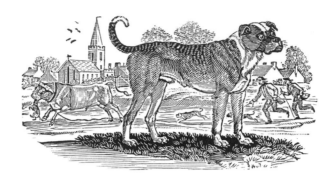

THE BULL-DOG.

Is the fiercest of all the Dog kind, and is prob-
ably the most courageous creature in the world. It
is low in stature, but very strong and muscular. Its
nose is short; and the under jaw projects beyond
the upper, which gives it a fierce and unpleasing
aspect. Its courage in attacking the Bull is well
known: its fury in seizing, and its invincible ob-
stinacy in maintaining its hold, are truly astonish-
ing. It always aims at the front; and generally
fastens upon the lip, the tongue, the eye, or some
part of the face; where it hangs, in spite of every
effort of the Bull to disengage himself.

The uncommon ardour of these Dogs in fighting
will be best illustrated by the following fact, related
by an eye-witness; which at the same time cor-
roborates, in some degree, that wonderful account
of the Dogs of Epirus, given by Elian, and quoted
by Dr. Goldsmith in the History of the Dog:—
Some years ago, at a Bull-baiting in the North
of England, when that barbarous custom was very
common, a young man, confident of the courage of

his Dog, laid some trifling wager, that he would, at separate times, cut off all the four feet of his Dog; and that after every amputation, it would attack the Bull. The cruel experiment was tried, and the Dog continued to seize the Bull as eagerly as if he had been perfectly whole.

Of late years this inhuman custom of baiting the Bull has been almost entirely laid aside in the North of England; and consequently there are now few of this kind of Dogs to be seen.

As the Bull-Dog always makes his attack without barking, it is very dangerous to approach him alone, without the greatest precaution.

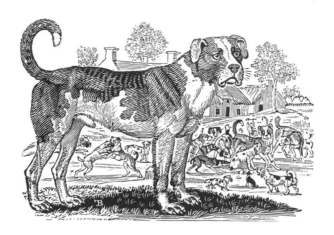

THE MASTIFF.

(*Canis Molossus*, Linn.—*Le Dogue*, Buff.)

Is much larger and stronger than the Bull-Dog;
its ears are more pendulous; its lips are large and
loose; its aspect is sullen and grave, and its bark
loud and terrific. He seems every way formed for
the important trust of guarding and securing the
valuable property committed to his care. Houses,
gardens, yards, &c., are safe from depredations
whilst in his custody. Confined during the day, as
soon as the gates are locked, he is left to range
at full liberty: he then goes round the premises,
examines every part of them, and by loud bark-
ings gives notice that he is ready to defend his
charge.

Dr. Caius, in his curious treatise on British Dogs,
tells us, that three of these animals were reckoned
a match for a Bear, and four for a Lion.

We have a curious account, recorded in Stow's Annals, of an engagement between three Mastiffs and a Lion, in the presence of James the First. "One of the Dogs being put into the den, was soon disabled by the Lion, which took it by the head and neck, and dragged it about: another Dog was then let loose, and served in the same manner: but the third being put in, immediately seized the Lion by the lip, and held him for a considerable time; till being severely torn by his claws, the Dog was obliged to quit its hold: and the Lion, greatly exhausted in the conflict, refused to renew the engagement: but taking a sudden leap over the Dogs, fled into the interior part of his den. Two of the Dogs soon died of their wounds: the last survived, and was taken great care of by the king's son; who said, 'he that had fought with the king of beasts, should never after fight with any inferior creature.'"

The Mastiffs of Great Britain were noted in the time of the Roman Emperors, who appointed an officer, whose sole business it was to breed and send from hence such as would prove equal to the combats of the amphitheatre.

The following anecdote will shew, that the Mastiff, conscious of its superior strength, knows how to chastise the impertinence of an inferior:—A large Dog of this kind, belonging to the late M. Ridley, Esq., of Heaton, near Newcastle, being frequently molested by a Mongrel, and teazed by its continual barking, at last took it up in his mouth by the back, and with great composure dropped it over the quay into the river, without doing any further injury to an enemy so much his inferior.

The Mastiff, in its pure and unmixed state, is now seldom to be met with. The generality of Dogs distinguished by that name seem to be compounded of the Bull-Dog, Danish Mastiff, and the Ban-Dog.

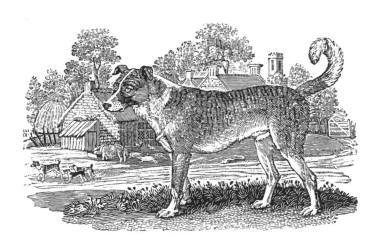

THE BAN-DOG.

Is a variety of this fierce tribe, not often to be seen at present. It is lighter, smaller, more active and vigilant than the Mastiff, but not so powerful; its nose is smaller, and possesses in some degree, the scent of the Hound; its hair is rougher, and generally of a yellowish grey, streaked with shades of a black or brown colour. It does not invariably, like the preceding kinds, attack its adversary in front, but frequently seizes cattle by the flank. It attacks with eagerness, and its bite is keen and dangerous.

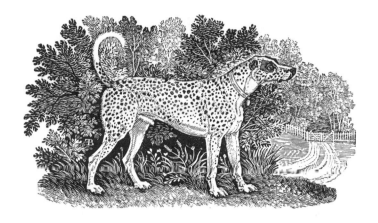

THE DALMATIAN, OR COACH DOG.

(Le Braque de Bengal, Buff.)

HAS been erroneously called the *Danish Dog;* and by M. Buffon, the *Harrier of Bengal;* but for what reason it is difficult to ascertain, as its incapacity of scenting is sufficient to destroy all affinity to any Dog employed in the pursuit of the Hare.

It is common in this country at present, and is frequently kept in genteel houses, as an elegant attendant on a carriage. We do not, however, admire the cruel practice of depriving the poor animal of its ears, in order to increase its beauty; a practice so general, that we do not remember ever to have seen one of these Dogs unmutilated in that way.

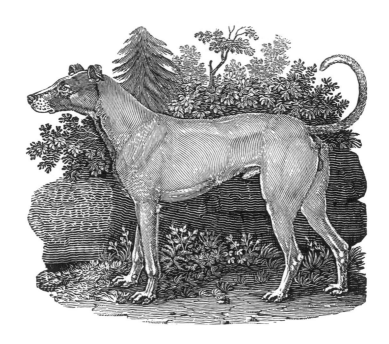

THE IRISH GREYHOUND.

(Canis Graius Hibernicus, Ray.—*Le Matin*, Buff.)

Is the largest of the Dog kind, and its appear-
ance the most beautiful and majestic. It is only to
be found in Ireland, where it was formerly of great
use in clearing the country from Wolves. It is
now extremely rare, and is kept rather for show
than use, being equally unserviceable for hunting
either the Stag, the Fox, or the Hare.

These Dogs are about three feet high, generally
of a white or cinnamon colour, and made somewhat
like a Greyhound, but more robust; their aspect is
mild, and their disposition gentle and peaceable:

their strength is so great, that in combat the Mastiff or Bull-Dog is far from being equal to them. They mostly seize their antagonists by the back, and shake them to death, which their great size generally enables them to do with ease.

M. Buffon supposes the *Great Danish Dog* to be only a variety of the Irish Greyhound. Next to this, in size and strength, is

THE SCOTTISH HIGHLAND GREYHOUND, OR WOLF-DOG,

WHICH was formerly used by the chieftains of that country in their *grand hunting parties*. One of them, which we saw some years ago, was a large, powerful, fierce-looking Dog; its ears were pendulous, and its eyes half hid in the hair; its body was strong and muscular, and covered with harsh, wiry, reddish hair, mixed with white.

THE GAZEHOUND

WAS somewhat similar to the Greyhound; and, like that animal, hunted only by the eye. It was formerly in great repute, but is now unknown to us. It was used in hunting either the Fox, the Hare, or the Stag. It would select from the rest the fattest Deer, pursue it by the eye, and though it should rejoin the herd, would infallibly fix upon the same, and pursue it till taken.

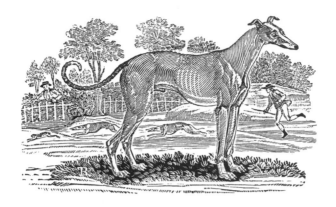

THE GREYHOUND.

(Canis Graius, Linn.—*Le Levrier*, Buff.)

M. BUFFON supposes to be the Irish Greyhound, rendered thinner and more delicate by the difference of climate and culture: and whatever errors there may be in the fanciful arrangements of that ingenious author, there is an evident similarity of form in all of those just mentioned; particularly in the depth of the chest, in the length of the legs, and in the smallness of the muzzle.

The Greyhound is the fleetest of all Dogs, and can outrun every animal of the chase; but as it wants the faculty of scenting, it follows only by the eye. It was formerly held in such estimation, as to be considered the peculiar companion of gentlemen; and by the forest laws of King Canute, it was enacted, that no person under that degree should presume to keep a Greyhound.

The *Small Italian Greyhound* is not above half the size, but perfectly similar in form. Its shape is exquisitely beautiful and delicate. It is not common in this country, the climate being too rigorous for the extreme delicacy of its constitution.

THE LYEMMER.

So called from its being led in a thong, and slipped at the game. Dr. Caius informs us, that it hunted both by the scent and sight; and, in its form, was between the Hound and the Greyhound. It is now unknown to us.

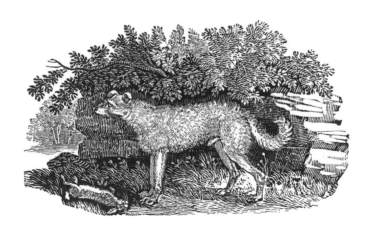

THE LURCHER.

Is less and shorter than the Greyhound, and its limbs stronger: its body is covered with a rough coat of hair, most commonly of a pale yellow colour; its aspect is sullen, and its habits, whence it derives its name, are dark and cunning.

As this Dog possesses the advantage of a fine scent, it is often employed in killing Hares and Rabbits in the night time. When taken to the warren, it steals out with the utmost precaution, watches and scents the Rabbits while they are feeding, and darts upon them without barking or making the least noise. One of them will singly make incredible havoc in a short time; and is so trained as to bring its booty to its master, who waits in some convenient place to receive it.* They are so destructive, and have been so often employed in illicit practices, that they are now, with great propriety, proscribed, and the breed is almost extinct.

Another Dog of this family, formerly in use, but now only known to us by its name, is

THE TUMBLER;

WHICH was so called from its cunning manner of taking Rabbits and other game. It did not run directly at them, but, in a careless and inattentive manner, tumbled itself about till it came within reach of its prey, which it always seized by a sudden spring.

* We have seen a Dog and Bitch of this kind in the possession of a man who had formerly used them for the purpose above described. He declared, that he could at that time procure in an evening as many Rabbits with them as he could carry home.

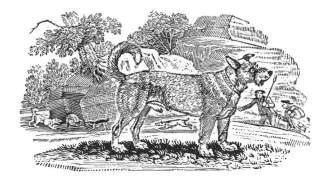

THE TERRIER.

HAS a most acute smell, is generally an attendant on every pack of Hounds, and is very expert in forcing Foxes or other game out of their coverts. It is the determined enemy of all the vermin kind; such as Weasels, Foumarts, Badgers, Rats, Mice, &c. It is fierce, keen, and hardy; and in its encounters with the Badger, sometimes meets with very severe treatment, which it sustains with great courage and fortitude. A well-trained veteran Dog frequently proves more than a match for that hard-biting animal.

There are two kinds of Terriers,—the one rough, short-legged, long-backed, very strong, and most commonly of a yellowish colour, or mixed with black and white, the other is smooth, sleek, and beautifully formed, having a shorter body, and more sprightly appearance: it is generally of a reddish brown colour, or black, with tanned legs; and is similar to the rough Terrier in disposition and faculties, but inferior in size, strength, and hardiness.

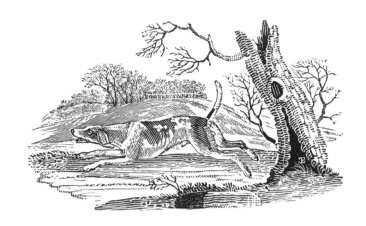

THE BEAGLE.

OF those Dogs that are kept for the business of the chase in this country, the Beagle is the smallest, and is used only in hunting the Hare. Although far inferior in point of speed to that animal, it follows by the exquisiteness of its scent, and traces her footsteps through all her various windings, with great exactness and perseverance. Its tones are soft and musical, and add greatly to the pleasures of the chase.

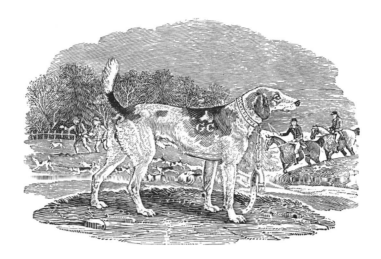

THE HARRIER.

(Le Braque, Buff.)

WHICH chiefly differs from the Beagle in being somewhat larger, is very nimble and vigorous. It pursues the Hare with the most impetuous eagerness, and gives her no time to breath or double. The most eager sportsmen generally find it sufficient exercise to keep in with their speed. They exert their voices with great cheerfulness, and make delightful harmony.

A mixed breed, between this and the large Terrier, forms a strong, active, and hardy Hound, used in hunting the Otter. It is rough, wire-haired, thick-quartered, long-eared, and thin-shouldered.

There is reason to suppose, that the Beagle and the Harrier must have been introduced into Great Britain after the Romans became masters of the

island; as, before that period, the Britons were occupied in clearing their extensive forests of the various wild beasts, such as Wild-Boars, Bears, Wolves, &c., with which they abounded; and for that purpose larger and stronger Dogs than the Harrier or the Beagle would be required.

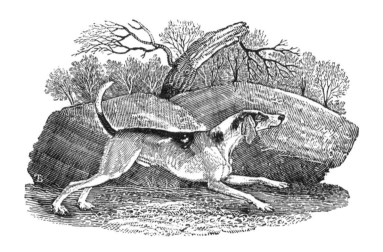

THE FOX-HOUND.

No country in Europe can boast of Fox-Hounds equal in swiftness, strength, or agility, to those of Britain; where the utmost attention is paid to their breeding, education, and maintenance. The climate also seems congenial to their nature; for it has been said, that when Hounds of the English breed have been sent into France, or other countries, they quickly degenerate, and in some degree lose those qualities for which they were originally so admirable.

In England, the attachment to the chase is in some measure considered as a trait in the national character; consequently it is not to be wondered at that our Dogs and Horses should excel all others in that noble diversion. This propensity appears to be increasing in the nation; and no price seems now thought too great for Hounds of known excellence.*

The Fox-Hounds generally preferred, are tall, light made, but strong, and possessed of great courage, speed, and activity.

The habits and faculties of these Dogs are so generally known, as to render any description unnecessary.

Dogs of the same kind are also trained to the hunting of the Stag and other Deer.

The following anecdote affords a proof of their wonderful spirit in supporting a continuity of exertion :—

"Many years since, a very large Stag was turned out of Whinfield Park, in the county of Westmorland, and pursued by the Hounds till, by fatigue or accident, the whole pack were thrown out, except two staunch and favourite Dogs, which continued the chase the greater part of the day. The Stag returned to the park from whence he set out; and, as his last effort, leaped the wall, and expired as soon as he had accomplished it. One of the Hounds pursued to the wall; but being unable to get over it, laid down, and almost immediately expired: the other was also found dead at a small distance.

* In 1788, Mr. Noel's pack was sold to Sir Wm. Lowther, Bart., for 1000 guineas.

" The length of the chase is uncertain : but as they were seen at Redkirks, near Annan, in Scotland, distant by the post-road, about forty-six miles, it is conjectured that the circuitous and uneven course they might be supposed to take would not be less than one hundred and twenty miles.

" To commemorate this fact, the horns of the Stag, which were the largest ever seen in that part of the country, were placed on a tree of a most enormous size, in the park (afterwards called the Hart-horn tree), accompanied with this inscription :—

" Hercules kill'd Hart o' Greece ;
" And Hart o' Greece kill'd Hercules."

" The horns have been since removed, and are now at Julian's Bower, in the same county."

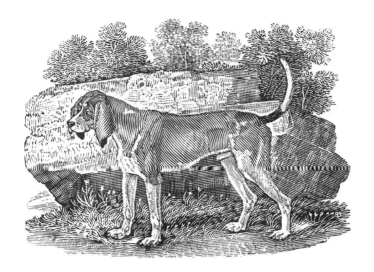

THE OLD ENGLISH HOUND.

(Canis Sagax, Linn.—*Le Chien courant,* Buff.)

Is described by Whitaker, in his History of Manchester, as the original breed of this island, used by the ancient Britons in the chase of the larger kinds of game, with which their country abounded.

This valuable Hound is distinguished by its great size and strength. Its body is long, its chest deep, its ears long and sweeping, and the tone of its voice is peculiarly deep and mellow. From the particular formation of its organs, or from the extraordinary moisture that always adheres to its nose and lips, or perhaps from some other unknown cause, it is endued with the most exquisite sense of smelling, and can often distinguish the scent an

hour after the lighter Beagles have given it up.
Their slowness also disposes them to receive the
directions of the huntsman: but as they are able to
hunt a cold scent, they are too apt to make it so,
by their want of speed, and tedious exactness.

These Dogs were once common in every part of
this island, and were formerly much larger than at
present.

The breed, which has been gradually declining,
and its size studiously diminished by a mixture of
other kinds, in order to increase its speed, is now
almost extinct.

It seems to have been accurately described by
Shakespeare in the following lines:—

> " My Hounds are bred out of the Spartan kind,
> " So flew'd, so sanded; and their heads are hung
> " With ears that sweep away the morning dew;
> " Crook-knee'd and dew-lapp'd, like Thessalian bulls;
> " Slow in pursuit; but match'd in mouth like bells,
> " Each under each

Besides these, there is a variety called the *Kibble-
Hound*, produced by a mixture of the Beagle and
the Old English Hound.

THE BLOOD-HOUND.

WAS in great request with our ancestors; and as
it was remarkable for the fineness of its scent, it
was frequently employed in recovering game that
had escaped wounded from the hunter. It could
follow, with great certainty, the footsteps of a man
to a considerable distance: and in barbarous and
uncivilized times, when the thief or murderer had
fled, this useful creature would trace him through

the thickest and most secret coverts; nor would it cease its pursuit till it had taken the felon. For this reason, there was a law in Scotland, that whoever denied entrance to one of these Dogs, in pursuit of stolen goods, should be deemed an accessary.

Blood-Hounds were formerly used in certain districts, lying between England and Scotland, which were much infested by robbers and murderers; and a tax was laid upon the inhabitants for keeping and maintaining a certain number of them. But as the arm of justice is now extended over every part of the country, and there are no secret recesses where villainy may lie concealed, these services are no longer necessary.

In Scotland it was distinguished by the name of the *Sleuth-Hound*.

Some few of these Dogs are still kept in the southern part of the kingdom, and are used in pursuit of Deer that have been previously wounded by a shot to draw blood, the scent of which enables them to pursue with most unerring steadiness. They are sometimes employed in discovering Deer-stealers, whom they infallibly trace by the blood that issues from the wounds of their victims. They are also said to be kept in convents, situated in the lonely and mountainous countries of Switzerland, both as a guard to the sacred mansion, as well as to find out the bodies of men who have been unfortunately lost in crossing those wild and dreary tracts.

The Blood-Hound is taller than the Old English Hound, most beautifully formed, and superior to every other kind in activity, speed, and sagacity. They seldom bark, except in the chase: they are commonly of a reddish or brown colour.

A Hound bitch, belonging to the Rivington hunt, near Bolton, pupped four whelps during a hard chase, which she carefully covered in a rush isle, and immediately after joined the pack. Shortly after, she pupped another, which she carried in her mouth during the remainder of a chase of many miles: after which, she returned to the place where she had dropped the four.

Somerville thus beautifully describes their mode of pursuing the nightly spoiler:—

> " Soon the sagacious brute, his curling tail
> " Flourish'd in air, low bending, plies around
> " His busy nose, the steaming vapour snuffs
> " Inquisitive, nor leaves one turf untry'd.
> " Till, conscious of the recent stains, his heart
> " Beats quick; his snuffling nose, his active tail,
> " Attest his joy: then with deep-op'ning mouth,
> " That makes the welkin tremble, he proclaims
> " Th' audacious felon: foot by foot he marks
> " His winding way, while all the list'ning crowd
> " Applaud his reas'nings: o'er the wat'ry ford,
> " Dry sandy heaths, and stony barren hills:
> " O'er beaten paths, with men and beasts distain'd,
> " Unerring he pursues, till at the cot
> " Arriv'd, and seizing by his guilty throat
> " The caitiff vile, redeems the captive prey:
> " So exquisitely delicate his sense!"

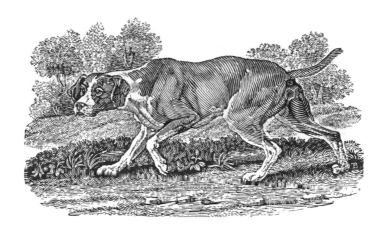

THE SPANISH POINTER.

(Canis Avicularis, Linn.)

Is of foreign origin, as its name seems to imply; but it is now naturalized in this country, which has long been famous for Dogs of this kind; the greatest attention being paid to preserve the breed in its utmost purity.

This Dog is remarkable for the aptness and facility with which it receives instruction. It may be said to be almost self-taught; whilst the English Pointer requires the greatest care and attention in breaking and training to the sport. The Spanish Pointer, however, is not so durable and hardy, nor so able to undergo the fatigues of an extensive range. It is chiefly employed in finding Partridges, Pheasants, &c., either for the gun or the net.

It is said, that an English nobleman (Robert Dudley, Duke of Northumberland) was the first who broke a Setting-Dog to the net.

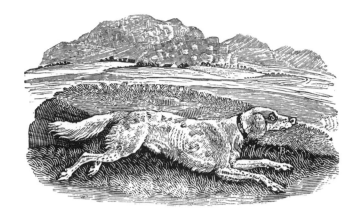

THE ENGLISH SETTER.

Is a hardy, active, handsome Dog. Its scent is
exquisite; and it ranges with great speed and won-
derful perseverance. Its sagacity in discovering the
various kinds of game, and its caution in approach-
ing them, are truly astonishing. But as the uses of
this valuable Dog are so well known, we will con-
clude with the following beautiful quotation from
Somerville :—

> " When Autumn smiles, all-beauteous in decay,
> " And paints each chequer'd grove with various hues,
> " My Setter ranges in the new-shorn fields,
> " His nose in air erect ; from ridge to ridge
> " Panting he bounds, his quarter'd ground divides
> " In equal intervals, nor careless leaves
> " One inch untry'd : at length the tainted gales
> " His nostrils wide inhale ; quick joy elates
> " His beating heart, which, aw'd by discipline
> " Severe, he dares not own, but cautious creeps,
> " Low-cow'ring, step by step ; at last attains
> " His proper distance ; there he stops at once,
> " And points with his instructive nose upon
> " The trembling prey."

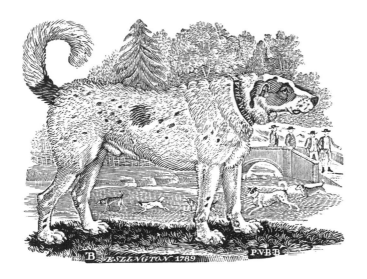

THE NEWFOUNDLAND DOG.

THE drawing of this Dog was taken from a very fine one at Eslington, in the county of Northumberland. Its dimensions were as follow :—

From its nose to the end of its tail, it measured six feet two inches; the length of its tail, one foot ten inches: from one fore foot right over its shoulders to the other, five feet seven inches; girt behind the shoulder, three feet two inches; round its head over its ears, two feet; round the upper part of its fore leg, nine inches and a half. It was web-footed, could swim extremely fast, dive with great ease, and bring up any thing from the bottom of the water. It was naturally fond of fish; and ate raw trouts, or other small fish, out of the nets.

This breed of Dogs was originally brought from the country of which they bear the name, where their great strength and docility render them extremely useful to the settlers on those coasts, who use them in bringing down wood from the interior parts of the country to the sea side: three or four of them yoked to a sledge will draw two or three hundred weight of wood piled upon it, for several miles, with great ease: they are not attended by a driver, nor any person to guide them; but after having delivered their loading, they return immediately to the woods, where they are accustomed to be fed with dried fish, &c.

The extraordinary sagacity of these Dogs, and their attachment to their masters, render them highly valuable in particular situations.

During a severe storm, in the winter of 1789, a ship, belonging to Newcastle, was lost near Yarmouth; and a Newfoundland Dog alone escaped to shore, bringing in his mouth the captain's pocketbook. He landed amidst a number of people, several of whom in vain endeavoured to take it from him. The sagacious animal, as if sensible of the importance of the charge, which in all probability was delivered to him by his perishing master, at length leapt fawningly against the breast of a man, who had attracted his notice among the crowd, and delivered the book to him. The Dog immediately returned to the place where he had landed, and watched with great attention for every thing that came from the wrecked vessel, seizing them, and endeavouring to bring them to land.

The following is another instance of their great docility and strength of observation:—A gentleman walking by the side of the river Tyne, and observ-

ing, on the opposite side, a child fall into the water, gave notice to his Dog, which immediately jumped in, swam over, and catching hold of the child with its mouth, brought it safe to land.

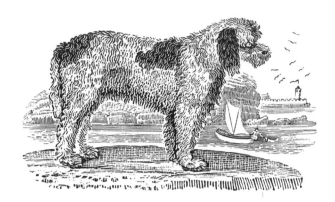

THE LARGE ROUGH WATER DOG.

(Canis Aviarius Aquaticus, Linn.—*Le Grand
Barbet,* Buff.)

Is web-footed, swims with great ease, and is used
in hunting Ducks and other aquatic birds. From
its aptness to fetch and carry, it is frequently kept
on board of ships, for the purpose of recovering
any thing that has fallen overboard; and is like-
wise useful in taking up birds that are shot, and
drop into the sea.

There is a variety much smaller. They are both
remarkable for their long and shaggy coat, which
frequently incommodes them by growing over their
eyes.

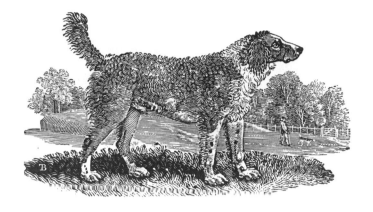

THE LARGE WATER-SPANIEL.

THE drawing of this beautiful animal was made from one of the finest of its kind, in the possession of J. E. Blackett, Esq., of Newcastle-upon-Tyne.

This kind of Dog is valuable for its great docility and attachment to its master. It receives instructions with readiness, and obeys with uncommon alacrity. Its form is elegant, its hair beautifully curled or crisped, its ears long, and its aspect mild and sagacious. It is fond of the water, and swims well. It is chiefly used in discovering the haunts of Wild-Ducks and other water fowl, and also in finding birds that have been shot or disabled. It is probably the *Finder*, described by Caius.

THE SMALL WATER-SPANIEL.

Is similar to the other in form, habits, and dis-
position; and its capacity for receiving instruction
is equally good. With looks of extreme attention
and sensibility, it observes the motions of its mas-
ter, and catches the well-known signal with amazing
promptitude.

The various tricks which these Dogs are some-
times taught to perform, seem more like the effect
of reasoning powers, than of undiscerning instinct.

THE SPRINGER, OR COCKER.

Is lively, active, and pleasant; an unwearied pursuer of its game; and very expert in raising Woodcocks and Snipes from their haunts in woods and marshes, through which it ranges with amazing perseverance.

Of the same kind is that beautiful little Dog, which, in this country, is well known under the appellation of *King Charles's Dog;* the favourite and constant companion of that monarch, who was generally attended by several of them. It is still preserved as an idle but innocent companion. Its long ears, curled hair, and web-feet, evidently point out its alliance with the more useful and active kind last mentioned.

Similar to this, but smaller, is the *Pyrame-Dog.* It is generally black, with reddish legs; and above each eye is a spot of the same colour.

Still farther removed, we have the *Shock-Dog;* a diminutive creature, almost hid in the great quantity of its hair, which covers it from head to foot.

Another variety is the *Lion-Dog;* so called from
the shaggy hair which covers the head and all the
fore part of the body; whilst the hinder part is quite
smooth, saving a tuft of hair at the end of the tail.
This species is become extremely rare.

THE COMFORTER.

Is a most elegant little animal, and is generally
kept by the ladies as an attendant of the toilette
or the drawing-room. It is very snappish, ill-
natured, and noisy; and does not readily admit
the familiarity of strangers.

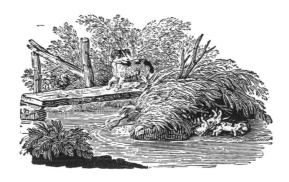

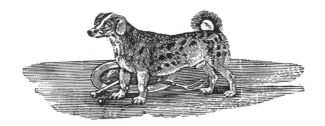

THE TURNSPIT.

Is generally long-bodied, has short crooked legs, its tail curled upon its back, and is frequently spotted with black upon a blue-grey ground. It is peculiar in the colour of its eyes; the same Dog often having the iris of one eye black, and the other white.

It is a bold, vigilant, and spirited little Dog. At present, however, its services seem but little attended to; a more certain method of doing the business of the spit having superseded the labours of this industrious animal.

THE PUG-DOG.

In outward appearance, is every way formed like the Bull-Dog; but much smaller, and its tail is curled upon its back. It was formerly very common in many parts of England; however, at present, it is rarely to be met with. Although it has no longer its admirers here, Mrs. Piozzi informs us, that she saw great numbers at Padua, in Italy, and that it still maintains its place in the favour of the fair ones of that country.

From these, and a mixture of others, proceeds a numberless variety of Messets, Lap-Dogs, Dancers, Waps, Mongrels, and compounds without end.

That all these, however divided, compose one general family, is apparent, from the facility with which they intermix, produce, and re-produce. In all of them the same attachment to mankind, the same pliant and humble disposition, submitting with patience to the various indignities to which they are exposed by their dependent situation, is eminently observable. Even those that, by accident or neglect, have been abandoned, and become wild, when taken home, are easily reclaimed by kindness and attention: they quickly become familiar, and continue faithfully attached to their masters. Multitudes of these are to be found in South America, which have sprung from those taken thither by the Europeans. They breed in holes in the ground, are formed somewhat like a Greyhound, have erect ears, are very vigilant, and excellent in the chase.

To mention some of the more common instances of this creature's sagacity, by way of elucidating its general character, may not be amiss; and amongst these, its care in directing the steps of the blind man is not the least worthy of notice. There are few who have not seen an unfortunate object of this description, led by his Dog, through the various passages of a populous town, to the accustomed place where he sits to supplicate the contributions of passengers. It may sometimes be seen to stop at particular houses, to receive the morsel from the hand of charity, or pick from the ground the money thrown out to relieve its miserable owner. When the day is passed, it conducts him home again; and gratefully receives as the reward of its services, the

scanty pittance which poverty and wretchedness can bestow.

Dogs will sometimes imitate the actions of their masters, will open a door that is fastened with a latch, or pull a bell, where they are desirous of gaining admittance. Faber mentions one belonging to a nobleman of the Medici family, which always attended at its master's table, took from him his plates, and brought him others; and if he wanted wine, would carry it to him, in a glass placed upon a silver plate, which it held in its mouth, without spilling the smallest drop. The same Dog would also hold the stirrups in its teeth, whilst its master was mounting his Horse.

That Dogs are capable of mutual attachment is evident from the well-known story of the Dog at St. Alban's; which, being left by its master at an inn there till he returned from London, and being ill-treated by a large Dog belonging to the house, stole privately off. It soon returned with a friend, that was much larger and stronger than itself; and both fell upon the aggressor, and punished him severely for his cruelty to a stranger.

There are several peculiarities common to all animals of the Dog kind, briefly mentioned by Linnæus, with which we shall conclude its history; the principal of which are as follow:—The Dog is carnivorous; its stomach digests bones; it eats grass for a vomit; voids its urine sideways, and commonly where other Dogs have done so before; smells at a stranger; scarcely ever sweats, but lolls out its tongue when hot; remembers injuries done to it; is subject to the hydrophobia; its sense of hearing very quick; when asleep, is supposed to dream; goes with young sixty-three days, and

brings forth from four to eight at one time. It
barks at strange Dogs, snaps at a stone thrown at
it, howls at certain musical notes; when about to
lie down, frequently goes round the place; fawns at
the approach of its master, and will not patiently
suffer any one to strike him; runs before him on a
journey, often going over the same ground; on
coming to cross ways, stops, looks back, and waits
to observe which of them he takes; sits up and
begs; and when it has committed a theft, slinks
away with its tail between its legs; is an enemy to
beggars and ill-looking people, and attacks them
without the least provocation; is also said to be
sick at the approach of bad weather. We cannot,
however, agree with the learned naturalist when he
asserts, that the male puppies resemble the Dog,
and the female the Bitch; or that it is a character
common to the whole species, that the tail always
bends to the left side. To these we may add, as
equally void of foundation, a remark of M. Buffon,
that a female Hound, covered with a Dog of her
own kind, has been known to produce a mixed
race, consisting of Hounds and Terriers. We
barely mention these to show, that too much cau-
tion cannot be used in forming general characters
or systematic arrangements; and we leave it to the
experience of the most inattentive observer to de-
tect such palpable absurdities.

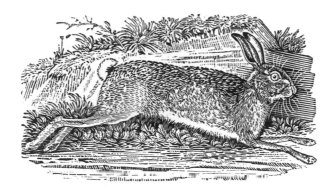

THE HARE.

(Lepus timidus, Linn.—*Le Lievre*, Buff.)

THIS harmless and inoffensive animal, destitute of every means of defence, and surrounded on all sides by its enemies, would soon be utterly extirpated, if Nature, ever kind and provident, had not endowed it with faculties, by which it is frequently enabled to elude their pursuit.

Fearful of every danger, and attentive to every alarm, the Hare is continually upon the watch; and being provided with very long ears, moveable at pleasure, and easily directed to every quarter, is warned of the most distant approaches of danger. Its eyes are large and prominent, adapted to receive the rays of light on every side, and give notice of more immediate alarms. To these may be added its great swiftness, by which it soon leaves most of its pursuers far behind. The hind are much longer than the fore legs, and are furnished with strong muscles, which give the Hare a

singular advantage in running up a hill: sensible
of its powers in this respect, it is always observed
to fly towards rising ground when first started.

Thus formed for escape, the Hare might be sup-
posed to enjoy a state of tolerable security; but as
every rapacious creature is its enemy, it is seldom
permitted to live out its natural term. Dogs and
Foxes pursue it by instinct; Wild-Cats, and
Weasels of all kinds, catch and devour it; birds of
prey are still more dangerous enemies; whilst man,
far more powerful than all, makes use of every
artifice to obtain an animal which constitutes one
of the numerous delicacies of his table. If we were
to enumerate the various stratagems which in-
genuity has suggested to circumvent this persecuted
creature, we would willingly omit the notable
achievements and gallant exploits of the chase;
which, to a cool and dispassionate observer, seem
to demand a nobler game.

" Poor is the triumph o'er the timid Hare."

Another remarkable means of safety to the Hare
is its colour, which, being similar to the ground
where it sits, secures it from the sight of its enemies;
and as a further instance of the care of Providence
in the preservation of its creatures, these, as well as
some other animals in more northern regions, are
observed to change their colour, and become per-
fectly white during winter, which renders them less
conspicuous in the snow. Some rare instances oc-
cur, of white Hares being met with in Great Britain.

The Hare is very prolific, and breeds three or four
times in the year. The female goes with young
thirty days, and generally brings forth three or four
at a litter. The rutting season begins in February.

During the day, Hares sleep or repose in their
seats, and seldom remove from them : the night is
the season when they go about in search of food ;
and they are sure to return to their forms or seats
by the same paths which they took in leaving
them.

> " 'Tis instinct that directs the jealous Hare
> " To chuse her soft abode. With step revers'd,
> " She forms the doubling maze; then, ere the morn
> " Peeps through the clouds, leaps to her close recess."

The following instances of the sagacity of the
Hare in endeavouring to escape from its enemies
are worthy of notice :—Fouilloux says he has seen
a Hare start from its form at the sound of the
hunter's horn, run towards a pool of water at a
considerable distance, plunge itself in, and swim
to some rushes in the middle, where it lay down,
and concealed itself from the pursuit of the Dogs.
He mentions another, which, after running two
hours before the Dogs, pushed a Hare from its
seat and took possession of it. Others he has seen
run into a Sheep-fold, and lie down among the
Sheep; and some have effected their escape by
mounting an old wall, and clapping themselves
down in the midst of the ivy which covered it.

The fur of the Hare is of great use in making
hats, for which purpose many thousands of their
skins are annually imported from Russia.

The Hare was reckoned a great delicacy among
the Romans, but was forbidden to the Jews, and
held sacred among the ancient Britons, who re-
ligiously abstained from eating it. We are told,
that Boadicea, immediately before her last conflict
with the Romans, let loose a Hare she had con-

cealed in her bosom ; which taking what was
deemed a fortunate course, was looked upon as a
good omen. It is to this day deemed unclean by
the Mahometans.

The Hare is found in most parts of the world,
with very little variety. Those of North America
are rather less than the European. They frequent
marshes and meadows, and when pursued take
refuge in hollow trees.

THE ALPINE HARE.

Is grey in summer, with a slight mixture of
black and tawny. Its hair is soft, its ears shorter,
and its legs more slender than the common Hare's.
In winter, the whole body changes to a snowy
whiteness, except the tips and edges of the ears,
which remain black.

This animal lives on the highest hills in Scot-
land, Norway, Lapland, Russia, and Siberia ; never
descends from the mountains, nor mixes with the
common Hare, although they abound in the same
parts. It does not run fast; and when pursued,
often takes shelter in clefts of rocks. It is easily
tamed, is very frolicsome, and fond of honey and
other sweets. It changes its colour in September,
and resumes its grey coat in April. Troops of five
or six hundred are sometimes seen, which migrate
towards the south in spring, and return in autumn.

A variety is found in those mountains of Tartary
which extend as far as the lake Baikal. It inhabits
the middle regions of the hills, among thick woods,
and in moist places abounding with grass and herb-

age. It lives in the crevices of rocks, and sometimes burrows in the earth lodged between the clefts. Its voice is a sharp whistle, not unlike the chirping of a Sparrow.

In the autumn, great numbers of them assemble together, and collect vast quantities of the finest herbs, which, when dried, they form into pointed ricks of various sizes; some of them four or five feet in height, and of proportionable bulk. These they place under the shelter of an overhanging rock, or pile round the trunks of trees. By this method, these industrious little animals lay up a stock of winter food, and wisely provide against the rigours of those stormy regions: otherwise, being prevented by the depth of snow from quitting their retreats in quest of food, they must all inevitably perish.

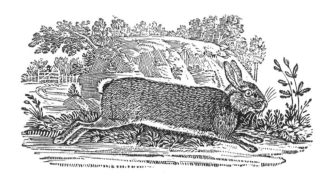

THE RABBIT.

(Lepus Cuniculus, Linn.—*Le Lapin,* Buff.)

NOTWITHSTANDING the great similarity between
the Hare and the Rabbit, Nature has placed an in-
separable bar between them, in not allowing them
to intermix, to which they mutually discover the
most extreme aversion. Besides this, their is a
wide difference in their habits and propensities:
the Rabbit lives in holes in the earth, where it
brings forth its young, and retires from the ap-
proach of danger; whilst the Hare prefers the
open fields, and trusts to its speed for safety.

The fecundity of the Rabbit is truly astonishing.
It breeds seven times in the year, and generally
produces eight young at a time; from which it is
calculated, that one pair may increase, in the course
of four years, to the amazing number of 1,274,840:
so that, if frequent reductions were not made in
various ways, there is reason to apprehend they
would soon exceed the means of their support, and

over-run the face of the country. But as their in-
crease is great, so is the number of their enemies;
for, besides those that are taken for the use of man,
great numbers are devoured by Foxes, Weasels,
Foumarts, and other beasts of prey. In Spain they
formerly increased to such a degree, as to become
so noxious, that the inhabitants were obliged to
procure Ferrets from Africa to destroy them.

The Rabbit is capable of procreating at the age
of five or six months. The female goes with young
about thirty days. Previous to her bringing forth,
she makes a bed with down, which she pulls off her
own coat. She never leaves her young but when
pressed with hunger, and returns as soon as that is
allayed, which she effects with surprising quickness.
During the time she tends and suckles her young,
she carefully conceals them from the male, lest he
should devour them; and frequently covers up the
mouth of the hole, that her retreat may not be dis-
covered.

It lives to the age of eight or nine years, and pre-
fers warm and temperate climates. Pliny and
Aristotle mention it as being anciently known only
in Greece and Spain: it is now, however, common
in various parts of Europe; but in Sweden and
other cold countries it can be reared only in houses.

It abounds in Great Britain, where its skin forms
a very considerable article in the manufacture of
hats. Lincolnshire, Norfolk, and Cambridgeshire,
are most noted for the production of them.

The flesh of the Rabbit, as well as the Hare, was
forbidden to the Jews and the Mahometans.

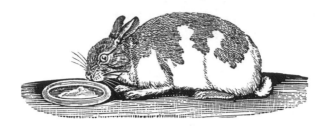

THE DOMESTIC RABBIT.

Is of various colours—white, brown, black, and variegated. It is somewhat larger than the wild Rabbit; but its flesh is not so good, being softer and more insipid. Its food is generally cabbage leaves, colewort, blades of corn, sour-dock, and other succulent plants; but sweet short hay, and a little clean oats, make the best diet.

The RABBIT of ANGORA, like the Goat and Sheep of that country, is covered with long hair, which falls down its side in wavy curls, and is of a silky fineness.

Mr. Pennant describes a remarkable variety under the name of the *Hooded Rabbit*, which has a double skin over its back, into which it can withdraw its head: it likewise conceals its fore legs in a part which falls down under its throat. There are small holes in this loose skin, which admit light to the eyes. The colour of the body is cinereous; that of the head and ears is brown.

A manuscript account of this animal, with a drawing by Mr. G. Edwards, is preserved in the British Museum.

The Rabbit is not a native of America. There are great numbers of them in many of the West Indian islands, which have originated from a stock carried thither from Europe.

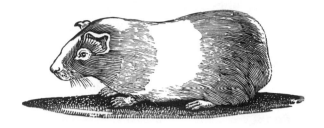

THE GUINEA-PIG, OR RESTLESS CAVY.

(Mus Porcellus, Linn.—*Le Cochon d'Inde,* Buff.)

THIS little animal, though a native of Brazil, lives and propagates in temperate, and even in cold climates, when protected from the inclemency of the seasons. Great numbers are kept in a domestic state, but for what purpose can hardly be determined. They have neither beauty nor utility to recommend them; their skins are of little value: and their flesh, though eatable, is far from being good. Their habits and dispositions are equally unpleasant and disgusting: void of attachment even to their own offspring, they suffer them to be devoured the moment they are brought forth, without making the smallest attempt to defend them. The males frequently destroy their own young; and are so stupid as to allow themselves to be killed by Cats without resistance. They pass their whole lives in sleeping, eating, and in the propagation of their species. They are by nature gentle and tame; they do no mischief, but seem to be equally incapable of good. Rats are said to avoid the places where they reside.

The Guinea-Pig is considerably less than the
Rabbit; its upper lip is only half divided; it has
two cutting teeth in each jaw; large and broad
ears; its hair is of different colours, white, varied
with orange and black, in irregular patches; it has
no tail; is a restless animal; feeds on bread, grain,
and vegetables; and makes a noise like the grunt-
ing of a pig.

It is capable of breeding at the age of two months,
and produces from four to twelve at one time.

The species would be innumerable, if many of
them were not taken off by various means: some
are killed by Cats, others by the males, and more,
both young and old, perish by the severity of the
climate, and want of proper care.

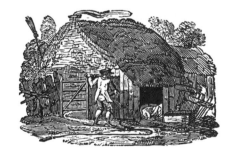

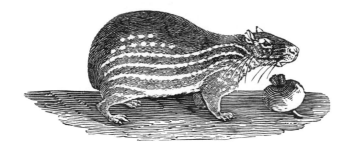

THE SPOTTED CAVY.

(Mus Paca, Linn.—*Le Paca,* Buff.)

Is about the size of a Hare, but its body is much
thicker, plumper, and fatter. The colour of the hair
on the back is dark brown, or liver-coloured; it is
lighter on the sides, which are beautifully marked
with lines of white spots, running in parallel direc-
tions from its throat to its rump; those on the upper
part of the body are perfectly distinct; the belly is
white. Its head is large; its ears short and naked;
its eyes full, and placed high in its head, near the
ears; in the lower part of each jaw, immediately
under the eye, it has a remarkably deep slit or fur-
row, which seems like the termination of the jaw,
and has the appearance of an opening of the mouth;
its upper jaw projects beyond the under; it has two
strong yellow cutting teeth in each jaw; its mouth
is small, and its upper lip is divided; it has long
whiskers on its lips, and on each side of its head,
under the ears; its legs are short; it has four toes
on the fore, and three on the hind foot; it has no
tail.

The Spotted Cavy is a native of South America, and lives on the banks of rivers, in warm and moist places. It digs holes in the ground, secretes itself during the day, and goes out at night in quest of food.

Its motions are heavy and ungraceful. It runs seldom, and with extreme awkwardness; sits frequently upon its posteriors; and in that situation, smooths and dresses itself with its paws, drawing them over its body with the utmost nicety.

It is a cleanly animal, and will not bear the smallest degree of dirtiness in its apartment.

In a domestic state, it is gentle and tractable, fond of attention, and licks the hand of any one that caresses it. When irritated, it is apt to bite. Its anger is expressed by chattering its teeth, and is always preceded by a kind of grunting. It feeds on grain, roots, fruits, and almost every kind of vegetable.

When pursued, it takes to the water, and escapes by diving. If attacked by Dogs, it makes a vigorous defence.

Its flesh is esteemed a great delicacy by the natives of Brazil.

We have been minute in our description of this curious little animal, which was drawn from the life, and think there is good reason to conclude that the species might be easily naturalized in this country, and added to our stock of useful animals. It is not much afraid of cold; and being accustomed to burrow, it would by that means defend itself against the rigours of our winter.

There are several varieties of them; some of which weigh from fourteen to twenty, and even thirty pounds.

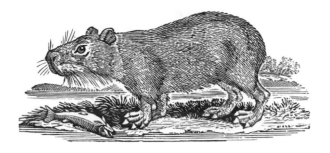

THE CAPIBARA.

(Sus Hydrochærus, Linn.—*Le Cabiai,* Buff.)

Is a native of South America, and lives on the
banks of great rivers, such as the Oronoque, Ama-
zons, and Rio de la Plata; swims and dives re-
markably well, and is very dexterous in catching
fish, upon which it chiefly subsists: it likewise eats
grain, fruits, and sugar-canes, feeds mostly in the
night, and commits great ravages in the gardens.
They generally keep in large herds, and make a
noise not much unlike the braying of an Ass.

Its flesh is fat and tender; but, like that of the
Otter, has an oily and fishy taste.

It is about the size of a small Hog; and, by
some naturalists, has been classed with that ani-
mal.

Its fore hoofs are divided into four, the hind ones
into three; its head is large and thick, and on the
nose there are long whiskers; its ears are small
and rounded, and its eyes large and black; there
are two large cutting-teeth and eight grinders in
each jaw, and each of these grinders forms on its
surface what appears to be three teeth, flat at their

ends; the legs are short; the toes long, and con-
nected at the bottom with a small web; the end of
each toe is guarded by a small hoof; it has no tail;
the hair on the body is short, rough, and of a brown
colour.

It is a gentle animal, easily tamed, and will fol-
low those who feed it and treat it kindly.

As it runs badly, on account of the peculiar con-
struction of its feet, its safety consists not in flight:
Nature has provided it with other means of pre-
servation: when in danger, it plunges into the
water, and dives to a great distance.

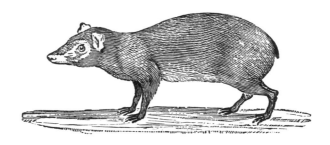

THE AGOUTI, OR LONG-NOSED CAVY.

(*Cavia Aguti*, Linn.—*L'Agouti*, Buff.)

Is about the size of a Hare; its nose is long,
upper lip divided; skin sleek and shining, of a
brown colour mixed with red; tail short; legs·
slender and almost naked; has four toes on the
fore, and three on the hind foot; grunts like a
Pig; sits on its hind legs, and feeds itself with
its paws; and when satiated with food, it· con-
ceals the remainder. It eats fruits, roots, nuts,
and almost every kind of vegetable; is hunted

with Dogs; runs fast, and its motions are like those of the Hare. Its flesh, which resembles that of a Rabbit, is eaten by the inhabitants of South America.

Great numbers of them are found in Guiana and Brazil. They live in woods, hedges, and hollow trees.

The female brings forth at all times of the year, and produces three, four, and sometimes five, at a time.

If taken when young, the Agouti is easily tamed, and will go out and return of its own accord. It delights in cutting or gnawing every thing with its teeth. When irritated, the hair of its back rises, it strikes the ground with its hind feet, and at the same time makes a noise like the grunting of a Pig.

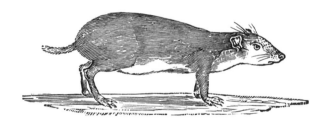

THE AKOUCHI.

SEEMS to be a variety of the Agouti; and though somewhat less, is nearly of the same form, but its tail is longer. It inhabits the same countries, is of an olive colour; its flesh is white, delicate, and has the flavour of a young Rabbit; is much esteemed by the natives, who hunt it with Dogs, and reckon it among the finest game of South America.

THE ROCK CAVY.

(*L'Aperea*, Buff.)

Is likewise found in Brazil; is about twelve inches in length; the colour of the upper part of its body resembles that of the Hare; its belly is white; the upper lip divided; the ears short and rounded like those of a Rat, and it has no tail. It moves like the Hare, its fore legs being shorter than the hind. It has four toes on the fore feet, and only three on the hind. Its flesh is like that of the Rabbit; and its manner of living is also very similar.

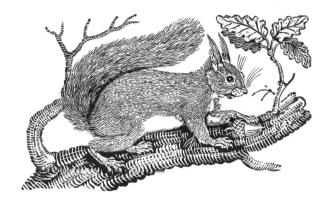

THE SQUIRREL.

(Sciurus Vulgaris, Linn.—L'Ecureuil, Buff.)

THIS beautiful little animal is equally admirable for the neatness and elegance of its formation, as for its liveliness and activity. Its disposition is gentle and harmless. Though naturally wild, it is soon familiarized to confinement and restraint; and though excessively timid, it is easily taught to receive with freedom the most familiar caresses from the hand that feeds it.

It usually lives in woods, and makes its nest of moss or dry leaves in the hollows of trees. It seldom descends upon the ground, but leaps from tree to tree with great agility.

Its food consists of fruits, almonds, nuts, acorns, &c.; of which it accumulates great stores for winter provision, and secures them carefully near its nest. In the summer it feeds on buds and young shoots, and is particularly fond of the cones of the fir and pine trees.

The spring is the season of love with Squirrels. At that time the males pursue the females, and exhibit wonderful proofs of agility; whilst the latter, as if to make trial of the constancy of their lovers, seem to avoid them by a variety of entertaining sallies; and like true coquets, feign an escape, by way of enhancing the value of the conquest. They bring forth four or five young at a time.

The Squirrel is of a bright brown colour, inclining to red; the breast and belly are white; the ears are ornamented with long tufts of hair; the eyes are large, black, and lively; the fore teeth strong and sharp; the fore legs are curiously furnished with long stiff hairs, which project on each side like whiskers. When it eats, it sits erect, and uses its fore feet as hands to convey food to its mouth.

The tail of the Squirrel is its greatest ornament, and serves as a defence from the cold, being large enough to cover the whole body; it likewise assists it in taking leaps from one tree to another; and we may add a third application of it, which would seem altogether improbable, were we not assured of it by Linnæus and other naturalists:—In attempting to cross a lake or river, the Squirrel places itself upon a piece of bark; and erecting its tail to catch the wind, boldly commits itself to the mercy of the waves. The smallest gust of wind is sufficient to overset a whole navy of these little adventurers; and in such perilous voyages many hundreds of them are said to perish.

Of the Squirrel there are several varieties; some of which are to be found in almost every country; but they abound chiefly in northern and temperate climates.

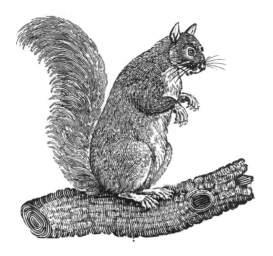

THE GREY SQUIRREL.

(Sciurus Cinereus, Linn.*—Le Petit Gris,* Buff.)

Is about the size of a young Rabbit: its ears are short, and not tufted at the ends; its hair is grey, mixed with black; on each side there is a red streak, which runs lengthwise; its tail is long and bushy, of a grey colour, variegated with black and white. It is common to both continents. In Sweden and other northern countries, it changes its colour in the winter.

It is very numerous in North America, and does incredible damage to the plantations. Great flocks of them descend from the mountains, and lay waste the fields of maize, by eating the young ears. A reward of three-pence per head was given for every one that was killed; and such numbers were destroyed in one year, that Pennsylvania alone paid in rewards the sum of 8000*l.* of its currency.

It makes its nest in hollow trees, with moss, straw, wool, &c. It lays up stores of provisions in holes made in the ground, for its winter sustenance. These hoards are often destroyed by Swine; they are sometimes so long covered with snow, that the Squirrels perish for want of food.

The fur is very valuable, and is imported under the name of *petit-gris*.

THE BLACK SQUIRREL.

(Sciurus Niger, Linn.—L'Ecureuil noir, Buff.)

Is about the same size and form with the last; but its tail is not so long. It is generally black, with white on the nose, ears, and end of the tail.

Its dispositions and habits are so similar to the Grey Squirrel, that it might be taken for a variety of that kind; but it is said to associate in separate troops, and is equally numerous.

It is found in the northern parts of Asia, North America, and Mexico.

In the latter country, there is a variety with plain round ears, the upper part of the body variegated with black, white, and brown. It is twice the size of the common Squirrel, lives under ground, where it brings forth its young, and lays in its stock of provisions. It feeds on maize, and is extremely lively, gentle and docile. It is the *Coquallin* of M. Buffon.

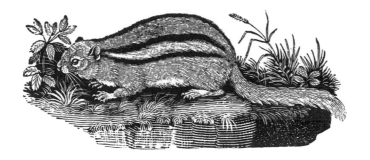

THE DORMOUSE, OR GROUND SQUIRREL.

(Sciurus Striatus, Linn.—*Le Suisse*, Buff.)

Is very numerous in the forests of North America, as well as the North of Asia. It burrows in the ground, and makes two entrances to its habitation, that if one should be stopped up, it may have access by the other. Its hole is formed with great skill, having several branches from the principal passage, each of which is terminated by a store-house, in which its winter food is deposited: in one is contained acorns, in another nuts, in a third maize, and in another chesnuts, which are its favourite food.

These animals seldom stir out during winter, nor so long as their provisions last: when those fail, they sometimes work their way into places where apples are laid up, or in barns where maize is stored, and make great havock. During harvest, they fill their mouths so full with corn, that their cheeks are quite distended; and in this manner carry it to their concealed store. They give great

preference to certain kinds of food; and if, after filling their mouths with rye, they chance to meet with wheat, they discharge the one, that they may secure the other.

The Ground Squirrel is marked with a stripe of black which runs along the ridge of the back; and on each side a yellow stripe, bordered with black; its head, body, and tail, are of a reddish brown; breast and belly white; its nose and feet of a pale red colour; its eyes full and lively.

It is very wild, bites severely, and is tamed with difficulty. Its skin is of little value.

THE HUDSON'S BAY SQUIRREL.

Is smaller than the European. It is marked along the middle of the back with a dusky line, from head to tail; the belly is of a pale ash colour, mottled with black; and the tail, which is dusky and barred with black, is not so long, nor so full of hair, as that of the common kind.

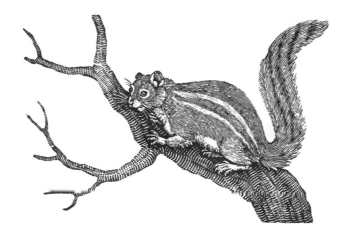

THE BARBARY SQUIRREL.

(Sciurus Getulus, Linn.—*Le Barbaresque,* Buff.)

Is of an ash colour, inclining to red; each side is beautifully marked with two white stripes, running lengthwise; its belly is white; its tail bushy, and variegated with regular shades of black, one beneath the other; its eyes are full and black, with white orbits. It is about the size of the common Squirrel.

THE PALM SQUIRREL.

(Sciurus Palmarum, Linn.—*Le Palmiste,* Buff.)

Is similar to the last, having a pale yellow stripe on the middle of the back, and two on each side parallel to it; the belly is of the same colour; the rest of the body black and red closely mixed; its tail is long, does not lie on its back like that of the Squirrel, but is carried erect.

Both these Squirrels inhabit Barbary and other hot countries. They live chiefly in palm trees, from whence the latter has its name.

THE FAT SQUIRREL.

(Sciurus Glis, Linn.—*Le Loir*, Buff.)

Is found in France and the southern parts of Europe. Its body is covered with soft hair, of an ash colour; its belly whitish; its ears thin and naked. It is about six inches long, and thicker than the common Squirrel. It dwells chiefly in trees, leaps from bough to bough, feeds on fruits and acorns, and lodges in hollows of trees. It remains in a torpid state during the winter, and grows very fat.

It was considered as a great delicacy among the Romans, who had places constructed on purpose to keep and feed them in, which they called *gliraria*.

THE GREATER DORMOUSE, OR GARDEN SQUIRREL.

(Mus Quercinus, Linn.—*Le Lerot*, Buff.)

Is rather less than the last-mentioned. Its eyes are surrounded with a large black spot, which reaches to the ears; its body is of a tawny colour; its throat and belly white, tinged with yellow: its tail is long and bushy at the end.

It is common in the South of Europe, infests gardens, is particularly fond of peaches, and very destructive of all kinds of fruit. It lodges in holes in the walls, and brings forth five or six young at a time.

It has a strong odour, like a Rat; and, like the Fat Squirrel, remains torpid during the winter.

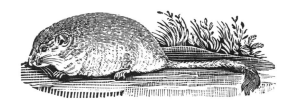

THE LESSER DORMOUSE.

(Mus Avellanarius, Linn.—*Le Muscardin*, Buff.)

Is rather larger than the Mouse, of a tawny red colour, with a white throat, and full black eyes. It lives in woods or thick hedges; makes its nest with grass, dried leaves, or moss, in the hollow of a tree, or the bottom of a thick bush, and brings forth three or four young at a time.

It lays up stores of nuts, acorns, and beans; and retires at the approach of cold weather to its retreat; where it rolls itself up in a warm nest, made of soft moss, &c., and remains in a torpid state during the continuance of winter. The warmth of a sunny day, or a temporary change from cold to heat, will sometimes revive it; but after taking a little food, it soon relapses into its former state.

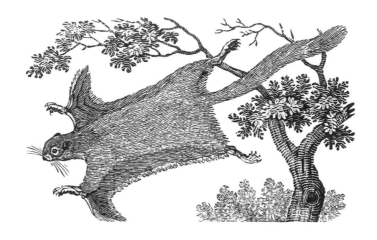

THE FLYING SQUIRREL.

(Sciurus Volans, Linn.—*Le Poulatouche*, Buff.)

Is peculiarly distinguished by a membraneous
continuation of the skin of the sides and belly,
which extends from the fore to the hind feet, and
assists it greatly in making leaps from one tree to
another, frequently at the distance of twenty or
thirty yards. Its head is small and round; its eyes
are full, round, and black; and its ears small and
naked.

It is found in all the northern regions, both of the
old and new continents. It is more numerous in
America than in Europe, is less than the common
Squirrel, lives in trees, and sleeps in the day, but
is extremely active during the night.

In the act of leaping, the loose skin is stretched
out by the feet; whereby the surface of the body is
augmented, the animal becomes lighter in propor-

tion to its bulk, the acceleration of its fall is retarded, and it appears to sail or fly from one place to another. Where numbers of them are seen at a time leaping, they appear like leaves blown off by the wind.

There are several kinds, differing much in size. In the islands of the East Indies, there is a variety as large as a Hare, called the TAGUAN, or GREAT FLYING SQUIRREL, which perfectly resembles the other in figure, and in the form of its lateral membrane. The head is smaller in proportion to the size of the body; the colour of the skin is dark brown, mixed with white; the upper part of the body whitish; the tail is brown, and grows gradually deeper towards the end, where it is black; the claws are long, thin, and hooked, like those of a Cat, and enable it to keep hold where it happens to fall; it also catches hold with its tail, which is long and muscular.

It is a wild and timid animal. Its bite is so strong, that it can make its escape from a wooden cage with great facility.

A variety is found in Virginia, called, by Mr. Pennant, the HOODED SQUIRREL; the lateral membrane begins at the chin and ears, where it forms a kind of hood, and extends, like that of the former, from the fore to the hind legs; its body is of a reddish colour above, and of a yellowish ash beneath. It is a rare species, not much noticed by naturalists.

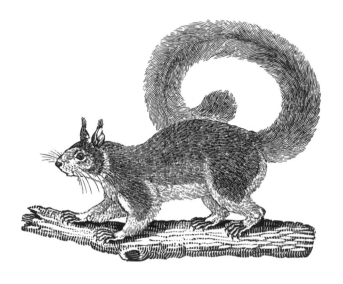

THE LONG-TAILED SQUIRREL.

THIS species is found in Ceylon and Malabar. In the Cingalese tongue, it is called *Dandoelana;* and from the noise it makes, *Roekea.*

It is about three times the size of the European Squirrel: the ears are tufted with black hairs; the end of the nose is pink-coloured; the cheeks, legs, and belly are of a dull yellow; between the ears there is a yellow spot; the crown of the head and the back are black; from each ear is a bifurcated line of the same colour, pointing down the cheeks; the upper part of the feet is covered with black hairs, the lower part naked and red: the tail is nearly twice the length of the body, of a light ash colour, and extremely bushy.

We are indebted to Mr. Pennant for the drawing of this curious animal.

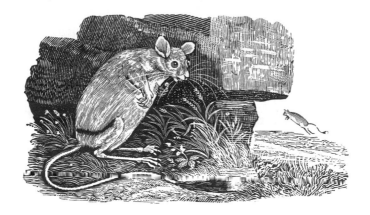

THE JERBOA.

(Mus Jaculus, Linn.—*Le Jerbo,* Buff.)

THIS animal, remarkable for the singular con-
struction of its legs, is found in Egypt, Barbary,
and Palestine. It is somewhat less than a Rat:
its head has a great resemblance to that of a Rab-
bit; its eyes are large and full; the fore legs only
one inch in length, and are used as hands to con-
vey victuals to its mouth; the hind legs are naked,
and very much resemble those of a bird, having
only three toes on each, the middle one longest; its
tail is much longer than its body, and terminated
with a black tuft, the tip of which is white; its hair
is long and soft, of a reddish colour on the back;
the under parts of the body are white; across the
thighs there is a large black band, in the form of a
crescent.

The motions of the Jerboa are similar to those of
the Kanguroo. It goes forward very nimbly on its

hind feet, taking leaps of five or six feet from the ground.

It is a lively harmless animal, lives entirely on vegetables, and burrows in the ground like a Rabbit.

It is the *Daman Israel* of the Arabs, or *Lamb of Israel;* and is supposed to be the *Coney* of holy writ, our Rabbit being unknown in Palestine. It is also the *Mouse* mentioned in Isaiah;* *Achbar*, in the original, signifying a Jerboa.

The Jerboa is easily tamed, is fond of warmth, and seems to be sensible of the approach of bad weather, by wrapping itself up close in hay.

Among the Mongol Tartars, this animal is called the *Alaghtaaga*. It is supposed to be the *Two-footed Mouse*, and the *Egyptian Mouse* of the ancients, which were said to walk on their hind legs.

It makes its nest of the finest and most delicate herbage; rolls itself up, with its head between its thighs; and sleeps during the winter, without taking any nutriment.

When pursued, it springs so nimbly, that its feet scarcely seem to touch the ground. It does not go straight forward, but turns here and there till it gains a burrow, where it quickly secretes itself. In leaping, it carries its tail stretched out; but in standing or walking carries it in the form of an S, the lower part touching the ground.

* Chap. lxvi. ver. 17.

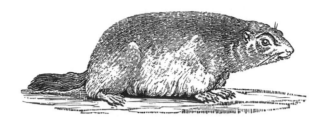

THE MARMOT.

(Mus Marmota Linn.—*Le Marmotte,* Buff.)

HAS been placed by naturalists in the same class
with the Hare and the Rat; and on examining its
parts, we find a partial agreement with both those
animals. In its nose and lips, as well as in the
general form of its head, it resembles the Hare; its
ears are like those of the Rat, with which it like-
wise agrees in the number and form of its teeth and
claws: in other respects, it is no way similar to
either of those kinds; and is still farther separated
from them by habitudes which seem peculiar to
itself, and distinguish it from almost every other
species of quadruped.

The Marmot inhabits the highest regions of the
Alps; and is likewise found in Poland, Ukraine,
and Chinese Tartary.

It is somewhat less than a Hare: its ears are
round, and so short, that they are almost hid in the
fur; its tail is short and bushy; the hair on the
back is of a brownish ash colour; and that on the
belly reddish, soft, and bushy. Its voice resembles
the murmuring of a young puppy; when irritated,

or frightened, it makes a whistling noise, very loud and piercing.

It feeds on insects, roots, and vegetables; but when tamed, is remarkably fond of milk and butter. It lives in holes, formed with great art in the side of a mountain. There are two entrances to each; and the chamber to which they lead is deep and spacious: the bottom is lined with moss and hay, of which these provident animals lay in a store during summer: and at the approach of winter, shut themselves up in their holes by stopping the entrances with earth, so effectually, that no discovery can be made of the place of their retreat. The chamber in which they lodge is large enough to contain a family of from five to a dozen Marmots. They roll themselves up, and being well covered with hay, remain in a torpid state, insensible to the rigours of the season, and perfectly secure from the storm that rages without; till the cheering influence of the sun again calls them out to renew their exhausted strength, to propagate their kind, and provide for their future retreat. The torpid state lasts from about Michaelmas till April. They go in extremely fat, but gradually waste; and at the end of their long sleep, they appear lean and extremely emaciated.

The Marmot produces once a year, and the litter generally consists of three or four.

When a number of them are feeding together, they place one as a centinel, which makes a whistling noise on the least appearance of interruption; and the party immediately betake themselves to their holes, the centinel driving up the rear.

The Marmot is very playful, and easily tamed. It learns to hold a stick, to dance, and to exhibit

various gestures: it will obey the voice of its master. Like the Cat, it has an antipathy to Dogs, which it attacks fiercely upon the least irritation. It is very apt to gnaw linen or woollen stuffs, often sits upright, and walks with ease on its hind feet. It eats in the manner of a Squirrel, and carries its food to its mouth with its fore paws.

Its flesh is sometimes eaten, but is always attended with a disagreeable odour.

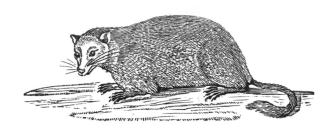

THE MONAX.

(Mus Monax, Linn.—*Glis Marmota,* Buff.)

Is found in various parts of North America, and
seems to be the same with the Marmot of Canada,
described by M. Buffon.

It is larger than a Rabbit; its tail is short and
rough; its ribs are so flexible, that it can easily
pass through a hole of not more than two inches in
width; its eyes are black and prominent; its back
is of a deep brown colour, lighter on the sides and
belly; and its feet and legs are black.

It sleeps during winter, in holes under the roots
of trees, and lives on fruits and other vegetables.
Its flesh is good and well tasted.

An animal of the same kind is found in the
Bahama isles; but whether it retires to sleep, in a
climate so mild, is not well known.

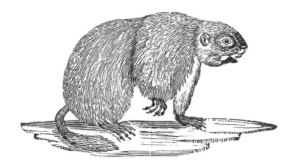

THE QUEBEC MARMOT.

Is rather larger than a Rabbit: its ears are short, and its whole head round; its cheeks are of a grey colour, and its nose black; its back is variegated, each hair being grey at the bottom, black in the middle, and white at the tips; its belly and legs are of an orange colour; its toes black and naked, and its tail short and rather bushy. It inhabits Hudson's Bay and Canada.

One of them, exhibited in London some years ago, was perfectly tame.

Mr. Pennant supposes it to be the species called the SIFFLEUR by the French of Canada.

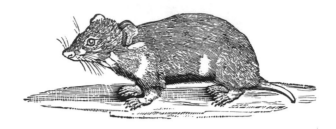

THE HAMSTER.

(Mus Cricetus, Linn.—*Le Hamster,* Buff.)

ALTHOUGH the qualities of this animal are sufficiently noxious to render it an object of universal detestation in those countries where it abounds; yet, when considered with regard to those instincts which conduce to its own preservation and support, it well deserves our highest admiration.

Its habitation is curious, and constructed with great art. It consists of a variety of apartments, adapted to various purposes, and extremely well fitted both for the comfort and convenience of the inhabitants. The first entrance is formed in an oblique direction, at the end of which the male sinks a perpendicular hole, which he reserves for his own use. The female makes several, for the accommodation of herself and family, that her young, during the short time they are allowed to stay with her, may have a free passage to the general stores. One of the holes is lined with straw, and serves as a lodging; the others contain provisions, of which great quantities are always accumulated during the time of harvest. They begin to lay in their stores in August. To

facilitate the transportation of their food, Nature
has furnished them with two pouches in each
cheek, which they fill with corn, beans, or pease,
till they seem ready to burst; and on their return
to their holes, empty them, by pressing their two
fore feet against their cheeks. The quantity of pro-
vision found in these magazines, depends on the
age or sex of the inhabitants. The old Hamsters
often amass an hundred pounds weight of grain;
but the young and the females are satisfied with
much less.

At the approach of winter, the Hamsters retire
into their subterraneous abodes, the entrance to
which they shut up with great care: there they
remain in perfect tranquillity, and feed on their
provisions till the frost becomes severe, when they
sink into a torpid state, in which they continue till
the return of spring. During this period, if any
of the holes be opened, the Hamster is always
found lying upon a bed of soft straw, with its head
turned under its belly between the two fore legs,
and the muzzle resting upon the hind ones: its eyes
are shut, every member perfectly stiff, and sensa-
tion so totally suspended, that neither respiration
nor any other sign of life can be perceived. When
dissected in this situation, the heart may be seen
alternately contracting and dilating very slowly;
the fat appears to be coagulated; and the intestines
are quite cold. During this operation, the animal
seems to feel very little: it sometimes opens its
mouth, as if it wanted to respire; but the·lethargy
is too strong to admit of its entirely awaking.

They copulate about the end of April, when the
males enter the apartments of the females, but re-
main only a few days. If two males happen to

meet in the same hole, a furious combat ensues,
which generally terminates in the death of the
weaker.

The females bring forth twice or thrice every
year; each litter consisting of six or eight. In
about three weeks the young are driven from their
holes, and left to provide for themselves. Their
increase is so rapid in some years, as to be almost
sufficient to occasion a dearth; but the ferocity with
which they upon all occasions attack and devour
each other, is so great, as to be the happy means of
preventing the ill effects of their fecundity.

It is not only its own species to which the fury of
the Hamster is directed: he attacks and devours
every animal, without distinction, that he is able to
conquer: and frequently opposes himself to enemies
much superior to himself in strength. Rather than
fly, he allows himself to be beaten to death. If
he seize a man's hand, he must be killed before he
can be made to quit his hold. A Horse or a Dog
are equally objects of his rage; and wherever he
seizes, it is with difficulty he can be disengaged.

The Hamster is about the size of a large Water-
Rat; has a short tail, almost naked; its head and
back are of a reddish brown colour, not unlike that
of a Hare; its throat is white, and it has three white
spots on each side; its breast and belly are black.

It is found in various parts of Germany, Poland,
and Ukraine.

The Polecat is its greatest enemy. It pursues the
Hamster into its hole, and destroys great numbers.

Mr. Ray observes, that the hair of this animal is
so closely united to the skin, that it cannot be
pulled off without great difficulty; on which ac-
count it is held in high estimation.

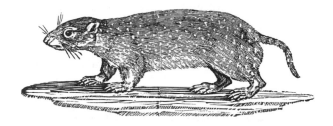

THE SOUSLIK.

(*Mus Citellus*, Linn.—*Le Souslik*, Buff.)

IS about the size of a large Rat. Its skin is beautifully marked with small white spots upon a yellowish ground.

It is found upon the banks of the Wolga, and in the adjoining provinces as far as Austria. It burrows in the ground like a Rabbit, and lays in store of provisions, consisting of grain, herbs, and roots: it also feeds on young Mice, is very fond of salt, and is frequently taken on board the barges laden with that commodity. The female brings forth from two to five at one time.

THE EARLESS MARMOT.

(*Le Zisel*, Buff.)

INSTEAD of ears, has only a small orifice on each side of its head. It is of a dark grey colour. Its body is long and slender, and its tail short.

It is found in Bohemia, Austria, Hungary, and Siberia. It forms its hole in the ground, with a

double entrance; and sleeps during the winter in
the centre of its lodge. It lays in a store of corn,
nuts, &c.; and sits up like a Squirrel when it eats.
It is easily provoked, and bites hard.

Its fur is of little value; but its flesh is reckoned
good eating.

In Poland and Russia, there is an animal of this
kind, called the ZEMNI; and by Mr. Pennant, the
Podolian Marmot.

Its habits are similar to those of the Souslik; but
it is larger, stronger, and more mischievous.

The head is thick, the body slender, and the ears
short and round: it has two cutting teeth in each
jaw; those of the under jaw are much longer than
the upper: the eyes are small, and concealed in the
fur like those of the Mole: its tail is short, and of
an ash colour.

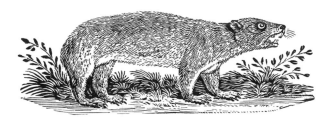

THE TAILLESS MARMOT.

We are favoured by Mr. Pennant with the draw-
ing of this animal, which has hitherto been un-
described. In the form of its body, it seems to
agree with the description given of the Zisel, and
probably may be a variety of that animal.

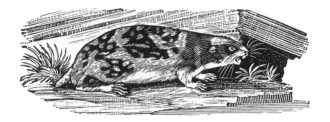

THE LAPLAND MARMOT.

(Mus Lemmus, Linn.—*Le Leming,* Buff.)

THIS wonderful little animal is found only in the
northern parts of Europe and Asia; and is some-
times seen in immense numbers, overspreading
large tracts of country, in Norway, Sweden, and
Lapland. But as its appearance is at very uncer-
tain periods, and the source from whence it is
derived has not been hitherto explored by any
naturalist, its existence has been seriously attri-
buted, by superstitious ignorance, to the generation
of the clouds; from whence, it has been supposed,
it was poured down in showers of rain. Myriads
of them march together; and, like a torrent, which
nothing can resist, their course is marked with ruin
and desolation. Neither fire nor water prevents
their progress. They go straight forward, in regu-
lar lines, about three feet asunder, and generally in
a south-east direction: they swim across lakes and
rivers: no opposition impedes them. If thousands
are destroyed, thousands supply their places: the
void is quickly filled up; and their number does
not appear diminished. They persist in their
course, in spite of every obstacle; and if prevented
from proceeding, they either by assiduity surmount
it, or die in the attempt. Their march is mostly in

the night. They rest during the day, and devour every root and vegetable they meet with. They infect the very herbage; and cattle are said to perish that feed upon the grass they have touched.

An enemy so numerous and destructive would soon render the countries they pass through utterly uninhabitable, did it not fortunately happen, that the same rapacity which excites them to lay waste the productions of the earth, at last impels them to destroy each other. Having nothing more to subsist on, they are said to separate into two armies, which engage with the most deadly hatred, and continue fighting and devouring each other till they are all entirely destroyed. Thousands of them have been found dead; and the air, infected by their putrid carcases, has sometimes been the occasion of malignant distempers. Great numbers of them are likewise destroyed by Foxes, Lynxes, Weasels, and other beasts of prey, which follow them during their march.

The Leming runs swiftly, although its legs are short and slender. It is somewhat less than the Rat: its head is pointed; and in each jaw are two very long cutting-teeth, with which it bites keenly: its ears are short, eyes small, fore legs shorter than the hind: the colour of the head and body black and tawny, disposed in irregular patches: the belly white, tinged with yellow.

Though perfectly disgusting to every other people, its flesh is said to be eaten by the Laplanders.

Where these emigrants are collected, as was before observed, is not certainly known. Linnæus says they are produced among the Norwegian and Lapland Alps; and Pontoppidan supposes, that Kolen's Rock, which divides Nordland from Sweden, is their native place.

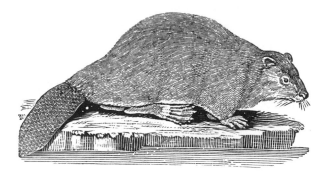

THE BEAVER.

(Castor Fiber, Linn.—*Le Castor, ou Le Bievre,* Buff.)

THE Beaver is amphibious, and is remarkable for its sagacity and foresight in building houses to shelter and protect itself in winter, and dams to supply them with water. The great size and strength of its cutting teeth, of which it has two in each jaw, enable it to cut or gnaw down trees of considerable magnitude, with ease. Its ears are short and almost hid in the fur; its nose is blunt; tail broad and flat, nearly of an oval form, and covered with scales; it serves as a rudder to guide its motions in the water; and by flapping it on the surface, as well as on the ground, serves as a signal to apprise the community of danger. Its fore feet are small, not unlike those of a Rat; the hinder feet are large and strong, with membranes between each toe; it has five toes on each foot. Its length from nose to tail is about two feet: the tail, which they cannot raise upwards over their backs, is eleven inches long, and three broad. The Beavers vary in colour. The most valuable

skins are black, but the general colour is a chesnut-
brown, more or less dark; some have been found
entirely white, others spotted; but both these kinds
are very rare. They breed once a year, and bring
forth from two to six at a birth.

Beavers are found chiefly in the northern parts of
Europe, Asia, and America; particularly the latter,
from whence many thousands of their skins are an-
nually brought into Europe,* where the fur is used
as an important and valuable article in the manu-
facture of hats.

The Beaver is one of the most industrious and
sagacious of quadrupeds; their labours seem the
result of a social compact, formed for mutual con-
venience, preservation, and support; and as in all
well regulated societies, a due subordination is
necessary for the ordering and conducting each in-
dividual effort to the advantage of the whole; so
amongst these curious animals, it would appear,
according to the accounts of some authors, that in
forming their habitations, in which their sagacity
and foresight are indeed remarkable, all have their
proper part assigned to them, that by dividing their
labour, safety, stability, and expedition may be the
general effect. For this purpose, after assembling
in certain numbers, a convenient place is chosen for
the erection of their buildings, which is generally†
a level piece of ground with a rivulet running
through it: they begin early in the summer, to pre-
pare for the completion of their works, by cutting

* The Hudson's Bay Company in the year 1763, sold 54,670
Beaver skins at one sale.

† Those which build their houses by the sides of lakes and deep
waters, do not build dams.

down with their teeth, such trees and branches as
suit them; these consist chiefly of green willows,
birch, and poplars, which, together with such drift
wood as they can meet with, their foresight directs
them to drag to the water with their teeth, and float
the whole down the stream to the place where it is
wanted: having thus provided a stock of materials,
the next operation, where an apprehended want of
water makes it necessary, is building the dam; but
they do not fall to work upon this until about the
middle or latter end of August, when the timbers
are then laid in and bedded together across the
stream, with stones, earth, clay, and mud, which
they collect during the night, and carry between
their fore feet and their throat, with surprising
labour and perseverance. The dam or mound is
always made in an arched shape, of greater or
lesser convexity, according to the rapidity of the
stream; it is of great strength and thickness, being
eight or ten feet at the base, gradually tapering
upwards to near the top, of a height sufficient to
secure to them an abundance of water below the
reach of the frost, and is capable of sustaining a
great weight or pressure of that element. Having
completed the mole, their next care is, for each
family to erect their own habitations; these are
made of the same kind of materials, and are built at
a convenient distance above the dam, and are more
or less of a circular, or of an oblong form, both on
the sides and on the top, and are at first about two
feet in thickness, but strengthened on the sides, and
heightened on the top by different plasterings,
every season, to about eight feet high, and the last
plastering is not put on until the frost sets in with
severity, by which it is rendered impenetrable to

their mortal enemy the Quiquehatch or Wolverine, which voracious animal, without these precautions, would not leave one of them alive. The house consists of one apartment, with only one entrance, (which always leads to the water) and is made of a size to accommodate one family, which in number commonly amounts to about four old and six young ones, seldom to fewer, but often to more. It is a common plan with the society to have their houses built one at the end of each other, under one roof, but kept quite separate by the walls or partitions between each. In them, after laying in a stock of provisions, they lodge and sleep warmly and comfortably upon their mossy beds, during the long winter months, and live upon the bark of trees and branches, laid in store for that purpose; they also eat a root something like a cabbage stalk, as well as other kinds, which they seek under the ice, on the sides and bottom of the river. Besides their houses they have a number of holes, or vaults, in the bank of the river, which serve them as places of retreat, when any injury is offered to their houses, and, in general, it is in these holes or vaults that they are taken by the hunters, on account of their skins, and by whom, in the winter, when they are fat, they are esteemed delicious eating. The castor produced by these animals is found in a liquid state, in bags near the anus, about the size of an egg; when taken off, the matter dries, and is reducible to a powder, which is oily, of a sharp bitter taste, and a strong disagreeable smell. These bags are found indifferently in males and females, and were formerly supposed to be the animal's testicles; which, when pursued, it was said to bite off, and by that means escape with its life. In winter they

never go farther than their provisions and stores; but in summer they wander abroad, and live upon berries, fruits, leaves, &c., and though not carnivorous, they will from necessity sometimes eat Crayfish, and such other kinds of fish as they can fall in with. Mr. Hearne,* from a long residence at Hudson's Bay, in the service of the company, had abundant opportunities of observing the economy of these interesting animals, and from his work we have corrected our former account.

He contradicts many things said of them by naturalists, but allows they have great sagacity and foresight in building their houses and dams. He says they do not drive stakes into the ground, nor use their large flat tails to carry burthens upon, neither do they use them as a trowel in plastering their houses, or building their dams, both of which are a rude mass of wood and stones. He treats as a fable the accounts given by authors of their assembling in large bodies, for the purpose of conjointly erecting large towns and cities, and commonwealths, and of their finishing their houses in different stories and apartments, in the neat manner ascribed to them. They merely cut off the projecting branches on the inside, and round and make even the habitation within.

* See Hearne's journey from Prince of Wales's Fort, to the mouth of the Copper Mine River, where it empties itself into the northern ocean.

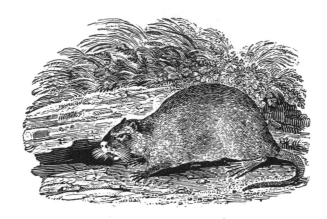

THE MUSQUASH, MUSK BEAVER, OR LITTLE BEAVER.

Is about the size of a Rabbit, the head and nose nearly resembling those of the Beaver, with strong white whiskers, and very large cutting teeth, of a red colour; the eyes small, the ears also small, and a good deal hidden in the fur. The hairs on the body, which nearly hide the dark coloured fur underneath them, are of a ferruginous brown. The legs and toes black, the hinder ones larger and stronger than the fore ones, with five toes, bare, and webbed together; the fore legs are short, with four toes unwebbed, and a very short one on the inside of the foot. The tail is flattish, the upper side covered with scales, and the under with coarse hair. Pennant's description of the Musk Beaver differs from this animal: He says the eyes are large, toes on each foot separated, those behind fringed on each side with strong hairs, closely set together. The figure of Buffon's Musk Rat of Canada, also differs greatly from this, but whether

it may be from defect in the drawing, or from being taken from a different species, we cannot determine. Hearne, in his journey of discovery to the north-western ocean, describes the various animals he met with in those dreary regions, and has given an account of one which he calls the Musquash, Musk Rat, or Musk Beaver, and which we think can be no other than this. He says their manner of life resembles that of the Beaver; like that animal they are provident, and build houses with mud and grass, to shelter themselves from the inclemency of the cold in winter: these, however, they do not build on the banks of rivulets, like the Beaver, but generally on the ice, at a considerable distance from the shore, as soon as the water is skinned over, always taking care to keep a hole open in it to admit them to dive for their food, which chiefly consists of the roots of water plants: and in the southern parts of the country, they feed much on the root called calamus aromaticus. When the water happens, from the long severity of the frost, to freeze to the bottom, and their stores of provisions fail, they prey upon each other, so that only one entire animal is left dead, surrounded by the skeletons of those which have been devoured. Though they generally build their winter habitations in such places as are just described, yet this is not invariably the case, for they also raise mounds or small islands in the midst of deep swamps over-run with rushes and long grass, and upon these, in clumps together, form their sheltered retreats. The Musk Beaver is very cleanly, and when fat, is good eating. It is easily tamed, and soon becomes playful and familiar, and smells pleasantly of musk.

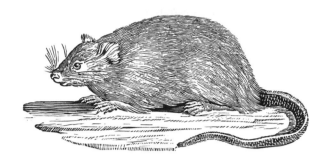

THE MUSK RAT OF CANADA.

(Castor Zibethicus, Linn.—*L'Ondatra*, Buff.)

Is about the size of a young Rabbit: its head is thick and short, resembling that of a Water Rat; its hair soft and glossy; beneath the outward hair there is a thick fine down, very useful in the manufacture of hats; it is of a reddish brown colour; its breast and belly ash, tinged with red; its tail is long and flat, covered with scales; its eyes are large; its ears short and hairy; it has two strong cutting teeth in each jaw; those of the under jaw are about an inch long, but the upper ones are shorter.

This animal is a native of Canada, where it is called the *Ondatra.*

In many respects it very much resembles the Beaver, both in form and manners. It is fond of the water, and swims well. At the approach of winter, several families associate together. They build little huts, about two feet in diameter, composed of herbs and rushes, cemented with clay, forming a dome-like covering: from these are several passages, in different directions, by which

they go out in quest of roots and other food. The hunters take them in the spring, by opening their holes, and letting the light suddenly in upon them. At that time their flesh is tolerably good, and is frequently eaten; but in the summer it acquires a scent of musk, so strong as to render it perfectly unpalatable.

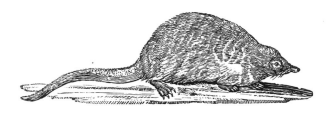

THE MUSCOVY MUSK RAT.

(Castor Moschatus, Linn.—*Dæsman,* Buff.

Is about the size of the common Rat: its nose is long and slender, like that of the Shrew Mouse; it has no external ears, and its eyes are very small; the tail is compressed sideways, and its hind feet are webbed; it is of a dusky colour; the belly of a light ash.

It is a native of Lapland and Russia, frequents the banks of rivers, and feeds on small fishes. It is often devoured by Pikes and other fishes; to which it communicates so strong a flavour of musk, as renders them very unpleasant to the taste.

From its tail is extracted a kind of musk, very much resembling the genuine sort. Their skins are frequently laid among clothes to preserve them from moths. In Lapland it is called the *Desman.*

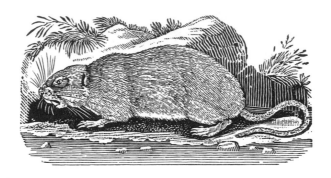

THE WATER RAT.

(Mus Amphibius, Linn.—*Le Rat d'eau,* Buff.)

Is much about the size of the Land Rat; its head
and nose are thicker; its eyes are small; its ears
short, scarcely appearing through the hair; its
teeth are large, strong, and yellow. In an old one
which we examined, the lower incisors measured
somewhat more than half an inch in length. The
hair on its head and body is thicker and longer
than that of the common Rat, and chiefly of a dark
brown colour, mixed with red; the belly is grey;
the tail five inches long, covered with short black
hairs, and the tip with white.

The Water Rat generally frequents the sides of
rivers, ponds, and ditches, where it burrows, and
forms its nest. It feeds on frogs, small fish, and
spawn; swims and dives remarkably fast; and can
continue a long time under water.

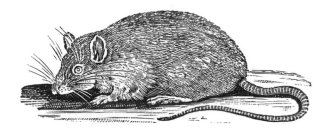

THE RAT.

(Mus Rattus, Linn.—Le Rat, Buff.)

THOUGH small, weak, and contemptible in its appearance, possesses properties which render it a more formidable enemy to mankind, and more injurious to the interests of society, than even those animals that are endued with the greatest strength and most rapacious dispositions. To the one we can oppose united powers and superior arts; with regard to the other, experience has convinced us, that no art can counteract the effects of its amazing fecundity, and that force is ineffectually opposed to an enemy possessed of such variety of means to elude it.

There are two kinds known in this country—the *Black Rat*, which was formerly universal here, but is now very rarely seen, having been almost extirpated by the large brown kind, generally distinguished by the name of the NORWAY RAT. This formidable invader is now universally diffused through the whole country; from whence every method has been tried in vain to exterminate it. It is about nine inches long; of a light brown

colour, mixed with tawny and ash; the throat and
belly are of a dirty white, inclining to grey; its feet
are naked, and of a pale flesh colour; the tail is as
long as the body, covered with minute dusky scales,
thinly interspersed with short hairs.

In summer, it frequents the banks of rivers,
ponds, and ditches, where it lives on frogs, fishes,
and small animals. But its rapacity is not confined
entirely to these: it destroys Rabbits, poultry,
young Pigeons, &c.: it infests the granary, the
barn, and the storehouse; does infinite mischief
among corn and fruit of all kinds; and not con-
tent with satisfying its hunger, frequently carries
off large quantities to its hiding-place.

It is a bold and fierce little animal, and when
closely pursued, will turn and fasten on its assail-
ant. Its bite is keen, and the wound it inflicts
is painful, and difficult to heal, owing to the form
of its teeth, which are long, sharp, and of an
irregular form.

The Rat is amazingly prolific, usually producing
from twelve to eighteen at one time. Their num-
bers would soon increase beyond all power of re-
straint, were it not for an insatiable appetite, that
impels them to destroy and devour each other. The
weaker always fall a prey to the stronger; and the
large male Rat, which usually lives by itself, is
dreaded by those of its own species as their most
formidable enemy.

It is a singular fact in the history of these ani-
mals, that the skins of such of them as have been
devoured in their holes, have frequently been found
curiously turned inside out; every part being com-
pletely inverted, even to the ends of the toes. How
the operation is performed, it would be difficult to

ascertain; but it appears to be effected in some peculiar mode of eating out the contents.

Besides the numbers that perish in these unnatural conflicts, they have many fierce and inveterate enemies, that take every occasion to destroy them. Several kinds of Dogs pursue them with great alacrity, and eagerly kill them, though they invariably refuse to eat their flesh: the Cat is also a very formidable enemy, but generally finds greater difficulty in the contest: the Rat makes a vigorous resistance, and sometimes effects its escape. The Weasel is the most determined enemy of the Rat kind; it hunts them with unceasing avidity, pursues them into their holes, where it soon kills them, and sucks their blood: and in particular situations, the Ferret is a still more deadly adversary. Mankind have likewise contrived various methods of destroying these bold intruders. For that purpose traps are often found ineffectual; such being their extreme sagacity, that when any are drawn into the snare, the others by that means learn to avoid the dangerous allurement, notwithstanding the utmost caution may have been used to conceal the design. The surest method of killing them is by poison: nux vomica, ground, and mixed with oatmeal, with a small proportion of oil of rhodium and musk, has been found from experience to be very effectual.

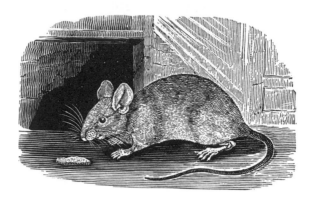

THE MOUSE.

(Mus Musculus, Linn.—*Le Souris*, Buff.)

THIS well-known little animal is diffused in great numbers over almost every part of the world. It seems a constant attendant on man, and is to be found only near his dwelling. Its enemies are numerous and powerful, and its means of resistance weak and inconsiderable: its minuteness seems to be its best security; and it is saved from utter extinction only by its amazing fecundity.

The Mouse brings forth several times in the year, and generally from six to ten each litter. The young are produced without hair, and in little more than fifteen days are able to subsist by themselves; so that the increase is prodigious. Aristotle tells us, that having shut up in a vessel a Mouse big with young, and provided plenty of grain for her and her offspring, in a short time he found 120 Mice, all sprung from the same stock.

The Mouse, when viewed without the disgust and apprehension which usually accompany the sight of it, is a beautiful little animal: its skin is sleek and soft, its eyes bright and lively, all its limbs are formed with exquisite delicacy, and its motions are smart and active.

Some few of this species are of a pure white colour; but whether they be a permanent kind, or only an accidental variety, cannot well be determined. Its appearance is, however, very beautiful: its fine full eyes, of a red colour, form an agreeable contrast with the snowy whiteness of its fur.

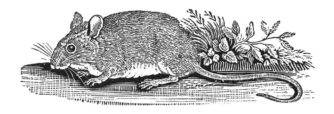

THE LONG-TAILED FIELD MOUSE.

(Mus Sylvaticus, Linn.—*Le Mulot,* Buff.)

Is rather larger than the common Mouse, and very similar to it in form: it is of a yellowish brown colour, its belly white, and its eyes remarkably large and prominent. It is found only in the fields, woods, and gardens; feeds on nuts, corn, and acorns; and lays up great stores for its support during winter. It burrows in the earth, and generally forms its nest near the root of a tree or thick bush. If provisions fail during a storm, they devour each other. They are very prolific, and bring nine or ten young at a time.

Mr. Pennant mentions a species, found in Hampshire, only two inches and a half long from nose to tail, of a fine rust colour above, and white beneath. It appears in great numbers in harvest time among the sheaves and ricks of corn. During winter, it shelters itself under ground, where it makes a warm bed of dry grass and leaves. Its young are brought forth on a nest made between the straws of the standing corn, and are generally about eight in number each time.

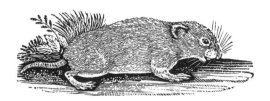

THE SHORT-TAILED FIELD MOUSE.

DIFFERS from the last, in having a thicker head, and shorter tail: its ears are very short, and almost hid in the hair; its body is about three inches long, and the tail one; the upper part of the body is of a reddish brown, and the belly a deep ash colour. Like the last, it frequents the fields and woods, but is seldom troublesome in gardens: it also lives on the same kinds of food, which it hides in holes under ground. It makes its nest in moist meadows, and brings forth seven or eight young at a time.

THE SHREW MOUSE.

(Sorex Araneus, Linn.—*La Musaraigne,* Buff.)

Is smaller than the common Mouse, being only
two inches and a half long from the nose to the
tail: the nose is long and slender; the ears short;
and the eyes, like those of the Mole, almost con-
cealed in the fur. It is of a reddish brown colour;
the belly white. The two upper fore teeth of this
animal are singularly constructed, and deserve par-
ticular notice; having a small barb on each side,
so fine, as to be scarcely visible.

The Shrew Mouse frequents old walls and heaps
of stones; feeds on insects, corn, and putrid sub-
stances; and is sometimes seen on dunghills, where
it roots with its nose like a Hog. It has so strong
and disagreeable a smell, that the Cat, after she has
killed, refuses to eat it. It forms its nest of dry
grass, moss, &c., on the surface of meadows or
pastures; and is said to breed four or five young
at a time.

There seems to be an annual mortality of these
animals in August, numbers of them being found
dead in the fields, highways, &c., about that time.

THE WATER SHREW MOUSE.

(La Musaraigne d'Eau, Buff.)

Is larger than the last. The upper part of its body is black; the throat, breast, and belly of a light ash colour. It is rarely to be seen; frequents e banks of rivulets and marshy places, where it burrows.

It is very numerous in Lincolnshire, but was never observed there till about twenty years ago. It is called, in that county, the *Blind Mouse*.

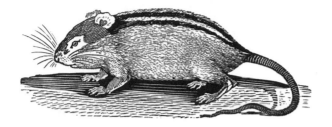

THE DWARF MOUSE.

Is a native of the Cape of Good Hope, where it was discovered, and first described, by Sparrman. It is distinguished from every other species of the genus, by four black lines along its back, from the head to the tail.

It is supposed to be the most diminutive quadruped in the world, being scarcely two inches in length. In the annexed representation, it is drawn the natural size, and forms a striking contrast with those gigantic animals which inhabit that quarter of the world.

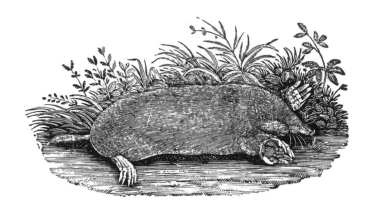

THE MOLE.

(*Talpa Europeus*, Linn.—*La Taupe*, Buff.)

THIS animal, destined to seek its food and provide for its subsistence under the surface of the earth, is wonderfully adapted, by the all-wise Author of Nature, to its peculiar mode of living. It enjoys the senses of hearing and smelling in a very eminent degree: the former gives notice of every approach of danger; whilst the latter enables it to find its prey in the midst of darkness, and compensates in a great measure for an almost total want of sight. To an animal so circumstanced, a larger degree of vision would be attended with manifest inconveniences, as well as liable to continual injuries. We are told by anatomists, that, for their better security, the eyes of the Mole are furnished with muscles, by which it has the power of withdrawing or exerting them at pleasure. Its eyes are extremely small, and perfectly hid in the fur.

The form of this creature's body, and particularly
the construction of its fore feet, are admirably
adapted to the purpose of making its way in the
earth, which it does with wonderful facility: these
are quite naked, very broad, with large palms,
almost like a hand: there are five toes on each,
terminated with strong nails, very concave on the
under side; and in place of a thumb, a strong bone
under the skin. The hind feet are very small, with
five slender toes, and a small thumb on the inside.
Whenever it happens to be surprised on the surface
of the ground, it disappears in an instant; and
every attempt to prevent its subterraneous retreat
would be vain.

The Mole is mostly found in grounds where the
soil is loose and soft, and affords the greatest quan-
tity of worms and insects, on which it feeds.

The female brings forth in the spring, and gener-
ally produces four or five at a time. The young
are quite naked, and continue so till they are grown
to a considerable size. It makes its nest a little
below the surface of the ground, forming a commo-
dious apartment, where it prepares a warm bed of
moss and herbage: from this there are several pas
sages in different directions, to which it can retreat
with its young ones in case of danger; into these
likewise it makes excursions in quest of food. In
the act of forming its tracks or runs, it throws up
large heaps of mould, which are extremely injurious
in meadows, grass lands, and cultivated grounds.
Its destruction is consequently an object of import-
ance to farmers, gardeners, &c.

The skin of the Mole is extremely tough; its fur
short, close set, and softer than the finest velvet, or
perhaps the fur of any other animal.

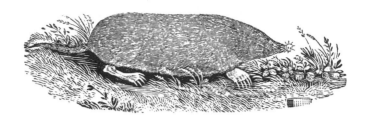

THE RADIATED MOLE.

(Sorex Cristatus, Linn.)

Is less than the common Mole, being not quite
four inches long: its fur is very close, short, and
fine: it is a native of North America, feeds on
roots, and forms subterraneous passages in different
directions.

There is a kind, found in Siberia, with a very
short nose, and no tail. It is of a beautiful green
and gold colour, variable with the light.

There are some other varieties, that differ chiefly
in the colour of the hair; such as the *Yellow Mole*
of North America, which is larger than the Euro-
pean. Its hair is soft, and of a silky gloss.

That which is found in Virginia, resembles the
common Mole. It is of a black colour, mixed with
deep purple.

It is said that hats, peculiarly fine and beautiful,
have been made of the fur of the Mole.

THE OPOSSUM.

(Didelphis, Linn.—*L'Opossum*, Buff.)

THIS animal is found in great numbers in various parts of North and South America, and was supposed by Buffon to belong entirely to the new continent. We are now, however, assured, that it exists in many of the Indian islands. Several varieties of the Opossum kind have been seen also in the newly discovered countries in the South Seas.

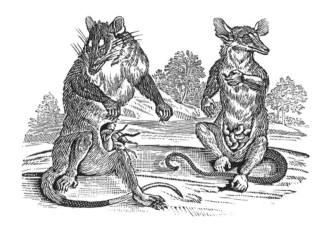

THE SARAGOY. THE MURINE.

THE SARAGOY, or MULUCCA OPOSSUM of Mr. Pennant, is about the size of a Cat: its head is long; nose sharp and pointed; ears large, thin, and naked: eyes small, black, and lively, having a white spot above each of them: its fur is soft, long, and of a dusky ash colour; its belly white; its tail is similar to that of a Rat, naked and scaly, ex-

cepting a small part near the body, which is cover-
ed with hair; its legs are short; and its feet or
hands not unlike those of a Monkey, having five
toes or fingers on each; the thumbs on the hind
feet are destitute of nails. But the peculiar and
distinguishing characteristic of the Opossum is a
pouch or false belly, in which the female deposits
her young immediately after they are brought forth,
and nourishes them in it till they are able to pro-
vide for themselves.

The Chevalier d'Aboville, whilst in America,
during the late war, in order to be satisfied respect-
ing the time of its gestation, manner of bringing
forth, and suckling its young, procured a male and
female Opossum, which he tamed, and kept in his
chamber till they copulated. Ten days after, he
observed a considerable alteration in the size and
form of the pouch; its aperture being wider than it
was before, and its orifice thicker: from that time
it gradually grew closer, leaving only a small
opening in the middle, similar to a navel: on the
fifteenth day he introduced his finger, and found at
the bottom of the bag a small round body, about
the size of a pea: the twenty-fifth day he could feel
a motion under his finger. After the young had
been a month in the pouch, they were plainly to be
seen, on opening it a little. At the end of two
months, on examining the pouch, there appeared to
be six young ones, all of them attached to the
mother by a canal that entered the mouth, which, if
withdrawn, could not be replaced; but when six
weeks old, the young Opossum could resume it by
strong suction, the mouth being then large enough
to receive the pap, which is about two lines in length,
and the size of the second or third string of a violin.

The number of the young varies from five to ten or eleven.

The paps are not disposed in regular order, as in other animals, but seem as if they were formed in those places where the embryos attach themselves to the mother.

The Opossum is a slow, helpless animal, when on the ground; but climbs trees with great ease and quickness; sometimes conceals itself among the branches, and surprises the birds that come within its reach. It frequently hangs suspended by its tail, and in that situation, watches for its prey, which it darts upon with great agility.

By means of this tail, the Opossum flings itself from one tree to another. It feeds on birds, reptiles, insects, roots, leaves, and bark of trees. It is easily tamed, is neither mischievous nor ferocious; but its figure is disagreeable, and the odour that exhales from its skin rank and disgusting.

THE MURINE OPOSSUM.

(Didelphis Murina, Linn.—*La Marmose*, Buff.)

INHABITS the warmest parts of South America. It resembles the former, but is much less. Its food and manner of living are likewise very similar to it.

It brings forth from ten to fourteen young at a time; but, instead of a bag, the female has two longitudinal folds under her belly, within which the young are secured. When first produced, they are not larger than beans, and remain closely attached to the teat till they attain sufficient growth and strength to provide for themselves.

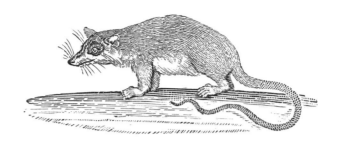

THE MEXICAN OPOSSUM.

DIFFERS little from the preceding, either in size or form. It is found in the mountainous parts of New Spain, and lives in trees. Its tail is useful in twisting round the branches, and securing its hold.

The young attach themselves to their mother by their hands and tails; and upon the least alarm, embrace her closely; whilst she carries them to the shelter of some neighbouring tree.

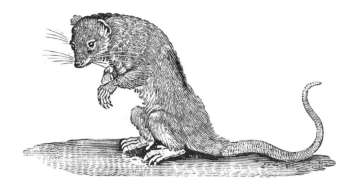

THE PHALANGER.

Is somewhat larger than a Rat: its nose is thick;
ears short and hairy; its fur is of a reddish colour,
variegated with light ash and yellow; the under
part of the body yellowish white; it is distinguished
from all those of the Opossum kind we have hither-
to mentioned, in having the first and second toes of
the hind feet closely united; its claws are large;
tail long, very broad and thick at its junction with
the body, and naked at the end. It inhabits the
East Indies.

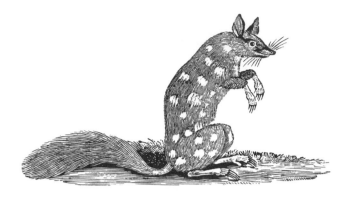

THE SPOTTED OPOSSUM OF NEW SOUTH WALES.

THE general colour of this animal is black; the body spotted with irregular roundish patches of white; the ears are large and erect; muzzle long, pointed, and furnished with long slender whiskers; both fore and hind legs thinly covered with hair of an ash colour; on the fore feet it has five claws, and on the hind four; length, from nose to tail, about twenty-five inches; tail thick and bushy, like that of a Squirrel, except a part near the body, which is small, and covered with short hairs. The female has six teats, placed circularly within the pouch.

THE VULPINE OPOSSUM OF NEW SOUTH WALES.

Is long-nosed and short-legged; from the nose to the insertion of the tail, measures two feet two inches; tail fifteen inches; upper part of the body

grisly, consisting of dusky, reddish, and white hairs; the under parts light tawny; two-thirds of the tail black; a blackish space round each eye; long black whiskers; five toes on the fore feet, and four on the hind, with a thumb of two joints placed at the base of the inner toe; the toes of the fore feet are long, and answer the purpose of a hand; the ears are about an inch and a half in length; in the upper jaw are six cutting teeth, four grinders, and two canine teeth; in the lower jaw, two long cutting tooth, like those of a Squirrel, and four grinders, but no canine teeth.

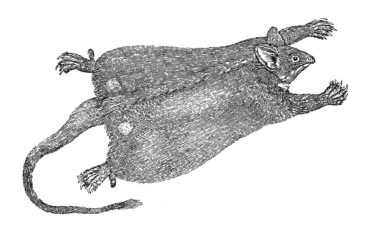

THE FLYING OPOSSUM OF NEW SOUTH WALES.

ITS nose is pointed; its ears large and erect; the fur more delicate, and of a finer texture, than that of the Sea-Otter; is of a beautiful dark colour, and very glossy, mixed with grey; the under parts white; on each hip is a tan-coloured spot; the fur

is continued to the claws; the sailing membrane is
the same as that of the Grey Squirrel, but broader
in proportion; on the fore legs it has five toes, with
a claw on each; on the hind ones, four toes, and a
long thumb, which enables the animal to use it as
a hand; it is remarkable, that the three outside
claws of the hind feet are not separated like the
others.

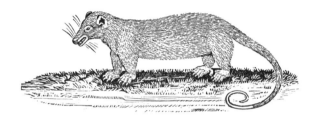

THE OPOSSUM OF VAN DIEMEN'S LAND.

WAS discovered in January, 1777, by Captain
Cook, who describes it as about twice the size of a
large Rat. It is covered with long soft glossy hair,
of a rusty brown colour; its belly is of a dirty
white.

It inhabits Van Diemen's Land, the southern
point of New Holland.

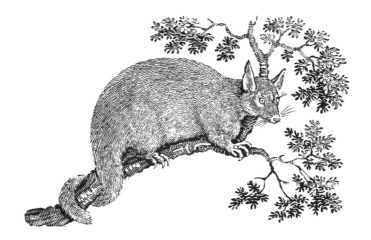

THE SQUIRREL OPOSSUM.

WE are favoured with a drawing of this beautiful animal, taken from a living one in the possession of the reverend Mr. Egerton, prebendary of Durham, by the ingenious Mr. Carfrae.

It is a native of New South Wales; is about eighteen inches long, exclusive of the tail, which is twelve: its head is broad, and pointed at the muzzle, which is furnished with long whiskers; its eyes are full, exceedingly prominent, and of a fiery redness; it has five claws on the fore feet, three on the hind, and a thumb; two cutting teeth on each jaw, the upper projecting beyond the under. Its manners are similar to those of a Squirrel. It sits up, holds its food in its fore paws with great dexterity, and feeds itself. When irritated, it sits still more erect, or throws itself upon its back, making a loud and harsh noise. It feeds on vegetables, small birds, &c.

The fur is long, soft, and very close; of a mixed brown or greyish colour on the back; the under parts of a yellowish white. Its tail is prehensile, very broad at the base, tapers to the end, and is naked on the under side. The female is furnished with a pouch.

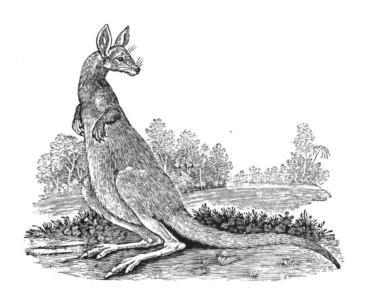

THE KANGUROO.

Is a native of New Holland, where it was first discovered by Sir Joseph Banks. Its head is small and taper, ears large and erect, upper lip divided, the end of the nose black, nostrils wide, lower jaw shorter than the upper, and there are whiskers on both; it likewise has strong hairs above and below the eyes; its head, neck and shoulders, are small; the lower parts of the body increasing in thickness to the rump; its tail is long, very thick near the

rump, and taper; its fore feet are extremely short, and are mostly used in digging or bringing its food to its mouth; it moves altogether on its hind legs, making successive bounds of ten or twelve feet, with such rapidity, as to outstrip the fleetest Grey-hound. In hopping forward, the whole weight of the hinder parts is supported by the tail. It springs from rock to rock, and leaps over bushes seven or eight feet high, with great ease; it has five toes on its fore feet, three on the hind, the middle one very long; the inner claw is divided down the middle into two parts.

The Kanguroo rests on its hind legs, which are hard, black, and naked on the under side. Its fur is short and soft, of a reddish ash colour, lighter on the lower parts.

It is the only quadruped our colonists have yet met with in New South Wales that supplies them with animal food. There are two kinds. The largest that had been shot weighed about 140lbs., and measured, from the point of the nose to the end of the tail, six feet one inch; the tail, two feet one inch; head eight inches; fore legs, one foot; hind legs, two feet eight inches; circumference of the fore part of the body, near the legs, one foot one inch; and of the hind part, three feet. The smaller kind seldom exceed 60lbs.

This animal is furnished with a pouch, similar to that of the Opossum, in which its young are nursed and sheltered.

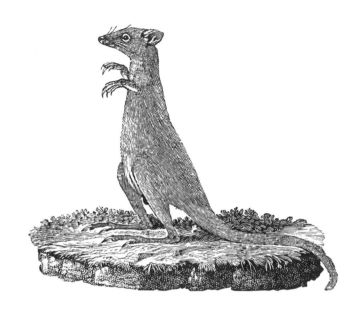

THE KANGUROO RAT OF NEW SOUTH WALES.

Is about the size of a Rabbit, and in shape re-
sembles the Kanguroo, both in respect to the short-
ness of the fore legs, and the peculiar use and
construction of the hind ones; the form of the head
is like that of a Rat, and its body nearly of the
same colour; in the upper jaw it has two long
cutting teeth, with three short ones on each side
of them; in the lower jaw, two long cutting teeth,
and three grinders on each side.

The female, like most of the animals of the
country, has a pouch, like the Opossum.

It feeds on vegetables, burrows in the ground,
and is very tame and inoffensive.

THE YELLOW MACAUCO.

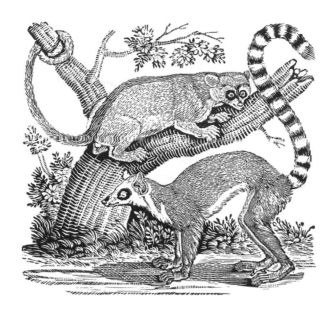

THE RING-TAILED MACAUCO.

(Lemur Catta, Linn.—*Le Mococo*, Buff.)

THE RING-TAILED MACAUCO is a very beautiful animal, about the size of a Cat. Its body and limbs are long and slender; its tail very long and marked with alternate bars of black and white: in the conformation of its paws, it seems to approach the Monkey kind; but its nose is long and sharp, like that of a Fox, and its ears are also large and pointed: its head and throat are white; eyes large, and surrounded with black: its fur is glossy, soft, and delicate, of a reddish ash colour on the back; belly white.

It is found in Madagascar and the neighbouring isles, is very playful, but not mischievous. When in motion, it makes a sort of galloping progress in an oblique direction, and carries it tail almost erect; but when sitting, it is twisted round the body, and brought over its head. Troops of thirty or forty are sometimes seen together.

It is a cleanly animal; and when taken young, may be easily tamed.

THE YELLOW MACAUCO has been classed with the Weasel tribe by Mr. Pennant, in his History of Quadrupeds; and it seems to bear some general resemblance to that species of animals. Its head is flat and broad; its ears are short, eyes small, body long and slender, legs and thighs short and thick, and it has five straight toes on each foot; its fur is short, soft, and glossy, of a black colour, mixed with yellow, on the back; the cheeks, inside of the legs, and belly, yellow; along the back, from head to tail, there is a broad, dusky stripe; and another on the belly, half way from the tail, which is nearly as long as its body, of a bright tawny colour, mixed with black, and has the same prehensile faculty as those of some kinds of Monkies. Its length, from nose to tail, is nineteen inches.

One of this species was shewn in London some years ago, and was said to have been brought from Jamaica, where it is called the *Potto*. It was good-natured and sportive, would catch hold of any thing with its tail, and suspend itself by it.

THE TAILLESS MACAUCO.

(*Lemur Tardigradus*, Linn.)

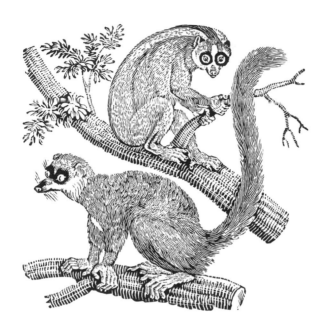

THE MONGOOZ.

(*Lemur Mongooz*, Linn.—*Le Mongooz*, Buff.)

THE TAILLESS MACAUCO is found in Ceylon and Bengal, lives in woods, and feeds on fruits; is fond of eggs and small birds, which it devours greedily.

It is a very inactive animal, and its motions slow; very tenacious of its hold; and makes a plaintive noise.

Its head is small, and nose pointed; each eye is edged with a circle of white, which is also sur-

rounded with another of black; its body is covered with a short silky fur, of a reddish ash colour; the toes naked; nails flat, except those on the inner toes of the hind feet, which are sharp and crooked. Its length, from the nose to the rump, is sixteen inches.

The MONGOOZ is nearly of the same size as the Ring-tailed Macauco.

Its fur is fine, soft, and woolly, of a deep brownish ash colour; the eyes are of a beautiful orange colour, surrounded with black; the ears are short; cheeks white; end of the nose black; the tail very long, and covered with hair of the same sort and colour as the body; its hands and feet are naked, and of a dusky colour; its nails, except one upon the inner toe of each hind foot, are flat.

It inhabits Madagascar and the isles adjacent, sleeps in trees, is very playful and good-natured, feeds on fruits, is extremely tender, and cannot bear any change to a less temperate climate.

THE LORIS.

Is a very slender animal, and differs greatly from the preceding, both in form and manners.

It is not much larger than a Squirrel, but its limbs are longer; the hind legs greatly exceed the fore in length; the thumbs on each foot are more distinct and separate from the toes than those of other Macaucos; its nose is pointed, like that of a Dog; its forehead high; ears round and thin; its fur is short and delicately soft, of a tawny colour on the back, and whitish below: it has no tail.

The Loris is a native of Ceylon, very active, lives in trees, and feeds on fruits. Seba says, the male climbs the trees, and tastes the fruit before he presents it to his mate.

THE BLACK MACAUCO.

(Lemur Niger, Linn.—*Le Vari*, Buff.)

Is larger than the Mongooz. It is a native of Madagascar, is very fierce, and makes a loud noise in the woods; but when tamed, is gentle and good-natured. Its eyes are of a deep orange colour. Round its head, the hair is long, and stands out like a ruff.

The general colour of this animal is black; but some are white, spotted with black. The feet are black and naked.

THE TARSIER.

Is remarkable for the great length of its hind legs, in which it resembles the Jerboa; has four slender toes and a distinct thumb on each foot: its visage is pointed; eyes large and prominent; ears erect, broad, and naked; its hair is soft and woolly, of a deep ash colour, mixed with tawny; its length, from the nose to the rump, is nearly six inches; the tail is nine inches long, round, scaly, almost naked, like that of a Rat, and tufted at the end.

It is found in some of the remote islands of India, especially Amboyna.

VOL. III. 3 L

ANIMALS OF THE MONKEY KIND.

WE now come to the description of a numerous race of animals, consisting of a greater variety of kinds, and making nearer approaches to the human species, both in form and action, than any other class of quadrupeds.

Monkeys are found only in the warmest parts of the world, and chiefly in the torrid zone. They abound in the woods of Africa, from Senegal to the Cape of Good Hope, and from thence to Ethiopia; in all parts of India, and its isles; in the south of China; in Japan; and in South America, from the Isthmus of Darian as far as Paraguay. A species or two are also met with in Arabia and the province of Barbary.

On account of the numbers and different appearances of these animals, they have been divided into three classes, and described under the following denominations; viz.—APES, or such as have no tails; BABOONS, or such as have short tails; MONKIES, or such as have long tails.

In the APE kind, we see the whole external machine strongly impressed with the human likeness, and capable of similar exertions; they walk upright, their posteriors are fleshy, their legs are furnished with calves, and their hands and feet are nearly like the human.

In the BABOON we perceive a more distant resemblance of the human form: he generally goes upon all four, seldom upright, but when constrained to it in a state of servitude. Some of them are as

tall as a man. They have short tails, long faces, sunk eyes, are extremely disgusting, lascivious, and possessed of the most brutal fierceness.

The MONKEY kind are removed still farther, and are much less than the former. Their tails are generally longer than their bodies; and although they sit upon their posteriors, they always move upon all four. They are a lively active race of animals, full of frolic and grimace, greatly addicted to thieving, and extremely fond of imitating human actions, but always with a mischievous intention.

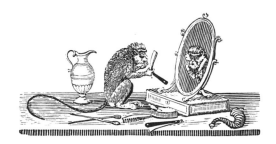

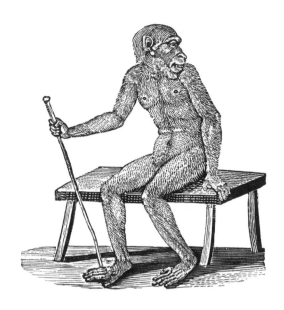

THE ORAN-OUTANG, OR WILD MAN
OF THE WOODS.

(Simia Satyrus, Linn.—*Le Pongo,* Buff.)

Is the largest of all the Ape kind, and makes the nearest approach to the human figure. One of this kind, dissected by Dr. Tyson, has been very accurately described by him. The principal external differences pointed out by that learned physician, consisted in the great length of the arms, and shortness of the thighs; the thumb is also much smaller, and the palm of the hand longer and narrower, than in man; the form of the feet is very dissimilar, the toes being much longer, and the large toe placed at a greater distance from the others; the forehead is

higher, the nose flat, and the eyes much sunk : beside these, that anatomist has enumerated a variety of essential differences in the internal conformation of the Oran-Outang ; all of which sufficiently evince, that, though he has the strongest affinity to the human form of any other quadruped, yet, as Buffon elegantly observes, " the interval which separates the two species is immense ; the resemblance in figure and organization, and the movements of imitation which seem to result from these similarities, neither make him approach the nature of man, nor elevate him above that of the brute."

The Oran-Outang is found in the interior parts of Africa, in Madagascar, Borneo, and some parts of the East Indies.

It is a solitary animal, avoids mankind, and lives only in the most desert places.

The largest of the kind are said to be about six feet high, very active, powerful and intrepid, capable of overcoming the strongest man : they are likewise exceedingly swift, and cannot easily be taken alive. They live entirely on fruits and nuts, will sometimes attack and kill the negroes who wander in the woods, and drive away the Elephants that happen to approach too near the place of their residence. It is said that they sometimes surprise the female negroes, and carry them off into the woods, where they compel them to stay with them.

When taken young, however, the Oran-Outang is capable of being tamed, and rendered extremely docile. One of them shewn in London some years ago, was taught to sit at table, make use of a spoon or fork in eating its victuals, and drink wine or other liquors out of a glass. It was extremely

mild, affectionate, and good-natured; much attach-
ed to its keeper, and obedient to his commands.
Its aspect was grave, and its disposition melan-
choly. It was young, and only two feet four inches
high. Its body was covered with hair of a black
colour, which was much thicker and closer on the
back than on the fore part of the body; the hands
and soles of the feet were naked, and of a dusky
colour.

THE PIGMY APE.

(Simia Sylvanus, Linn.—*Le Pitheque*, Buff.)

A variety, found in Guinea, Ethiopia, and other
parts of Africa, much smaller than the last, being
not more than a foot and a half in length. It is
very tractable, good-natured, and easily tamed; is
supposed to have been the *Pithecos* of the ancients.
It lives in woods, and feeds on fruits and insects.
Troops of them assemble together, and defend
themselves from the attacks of wild beasts in the
desert, by throwing a cloud of sand behind them,
which blinds their pursuers, and facilitates their
escape.

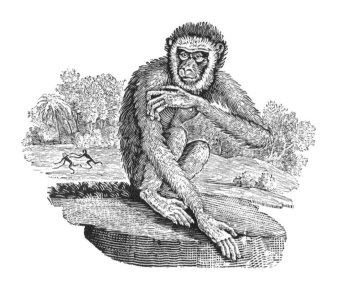

THE LONG-ARMED APE.

(Le Grand Gibbon, Buff.)

Is distinguished by the extraordinary length of its arms, which reach to the ground when its body is upright, and give it a disgusting appearance. Its face is flat, and of a tawny colour, surrounded with a circle of grey hairs, which adds to the singularity of its aspect; its eyes-are large and deep sunk; ears round and naked; body covered on all parts with black rough hair, except its buttocks, which are quite naked.

It is a mild, gentle, and tractable animal; feeds on fruits, leaves, and the bark of trees; is a native of the East Indies, Sumatra, and the Molucca isles; and measures from three to four feet in height.

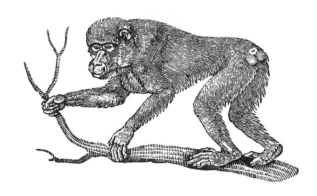

THE BARBARY APE.

(Simia Inuus, Linn.—*Le Magot*, Buff.)

Is wilder and more untractable than the others. His head is large, and his nose prominent: he like-wise differs from the last, in having cheek pouches, which he frequently fills with food before he begins to eat: the canine teeth are large and strong; ears round, and somewhat like those of a man; the body is covered with hair of a brown colour, inclining to green; lighter on the belly. When standing erect upon his hind legs he is generally two feet and a half or three feet high. He walks oftener on four than on two feet; and when resting, supports his body on two prominent callosities, situated on his buttocks.

This is a very common species, and is found in most parts of Africa, from Barbary to the Cape of Good Hope.

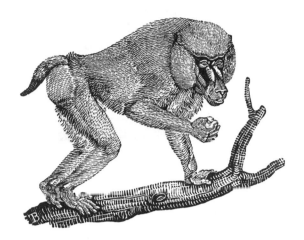

THE BABOON.

(*Simia Sphynx*, Linn.)

DIFFERS from animals of the Ape kind, not only in external appearance, but also in temper and disposition. Fierce, untractable, and libidinous, its disposition seems to partake of the hideous and disgusting deformities of its outward figure. Its body is thick, compact, and nervous, and its strength prodigious. Neither art nor caresses can render it in any degree docile or obedient. It seems to be continually fretting with rage, and seeking every opportunity of shewing its savage and vicious propensities. In a state of captivity, it must be kept closely confined; and even in that state, we have seen one shake the bars of his cage so powerfully with his hands, as to excite the utmost terror in the spectators.

This animal, of which we have given a very
faithful representation from the life, was about four
feet high when standing on its hind legs: its head
was large, shoulders of an amazing strength and
thickness, its muzzle long and thick, eyes small
and deep sunk, its canine teeth very large and for-
midable, and it had pouches in its cheeks: the hair
on its head was long, and formed a very elegant
tupee from its forehead and each side of its face,
which, when angry, it erected; the hair on the body
was uniformly of a light reddish brown; the tail
short, and darker at the end; buttocks red and
naked.

The Baboon inhabits the hottest parts of Africa;
feeds on fruits, roots, and other vegetables. Numer-
ous troops sometimes make their appearance,
plundering gardens and cultivated grounds. They
are extremely dexterous in throwing the fruit from
one to another, and by this means will do in-
credible damage in a very short time.

The female brings forth only one young at a
time, which she carries in her arms, and suckles at
her breast. Notwithstanding its libidinous disposi-
tion, it will not breed in temperate climates.

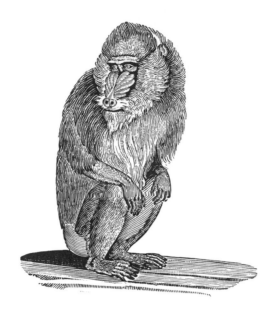

THE RIBBED-NOSE BABOON.

(Simia Maimon, Linn.—*Le Mandrill*, Buff.)

THIS singular creature is no less remarkable for its great size and strength, than for the variety of beautiful colours on different parts of its body. Its nose is marked with broad ribs on each side, of a fine violet-blue colour: a vermilion line begins a little above the eyes; and running down on each side of the nose, which is somewhat similar to that of a Hog, spreads over the tip of it: the insides of the ears are blue, which gradually softens to a purple, and terminates in vermilion; the rump is also of a vermilion colour; and the beautiful colours on the hips are gradations from red to blue; the

hair on the forehead is long, turns back, and forms a kind of pointed crest; its beard is dark at the roots, orange at the middle, and yellow at the end; the back and legs are covered with short hair, of a dark brown colour mixed with yellow; the breast and belly with long whitish hair, speckled with small dark spots; its tail is short and hairy, nails flat, feet and hands black and naked.

One of this kind was exhibited about twelve years ago in the North of England. It was five feet high, extremely fierce, libidinous, and strong. At the sight of women, it discovered marks of the most violent passion: it once caught hold of a lady, who was so incautious as to approach too near it; and she was with some difficulty rescued by the interference of the keeper. Its voice was strong and harsh, not unlike the ordinary growl of the Lion. It generally went upon its four feet, unless obliged by its keeper to stand erect. Its most usual attitude was sitting on its rump, with its arms placed before it.

This creature inhabits the hottest parts of Africa. Schreber says, it lives on succulent fruits and nuts, is fond of eggs, will put eight at once into its pouches, then take them out one by one, break them at the end, and swallow the contents.

Our representation of this animal was done from a drawing in the possession of the Rev. Mr. Egerton, taken from the life by an eminent painter.

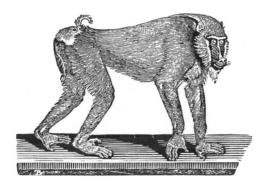

THE SMALL RIBBED-NOSE BABOON.

THE annexed cut was done from the living animal, in the possession of Mr. Rayne, surgeon, in Newcastle.

It is about fifteen inches in height; its face flat, of a fine blue colour; eyes bright hazel; the cheeks marked with small ribs, bounded with fine bushy hair, of a greenish colour, finely speckled with black; the hair on the forehead is very long, and runs up to a point on the top of the shoulders; the muzzle is thick, and furnished with short hair, thinly scattered on each side; it has a short thin beard, ending in a point, which is of an orange colour; the hair on the body is dark brown, mixed with shades of green on the back and sides; the haunches dusky; the ears are small, naked, and pointed; the tail short and hairy; the buttocks bare, and of a red flesh colour; hands and feet naked: it has cheek pouches; feeds on fruits, nuts, roots, and other vegetables. It is lively and playful, walks commonly on all four, is in continual motion, and leaps with astonishing agility. This species is said to come from the coast of Guinea.

THE PIG-TAILED BABOON.

(Simia Nemestrina, Linn.—*Le Maimon,* Buff.)

So termed from its short, naked, Pig-like tail, is the least of all the Baboon kind; a gentle, mild, and tractable animal; very lively and frolicsome, but has none of that impudent petulance so peculiar to most of its species. Its muzzle is large and thick; face and ears naked, and of a flesh colour; the hair on the head and back is of a deep olive, palest on the belly; it has hazel eyes, cheek pouches, callosities on the buttocks, which are naked, and of a red colour. It is a native of Sumatra and Japan.

One of this kind was shewn in the North in 1788, from which this drawing was made.

It is a curious circumstance, that not only this, but every animal of the Baboon and Monkey kind we have yet seen, have shewn a remarkable greediness for tobacco, mustard, and even snuff, which they eat without expressing the smallest inconvenience, and always seem extremely desirous of more.

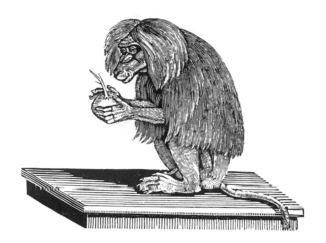

THE DOG-FACED BABOON.

(*Simia Hamadryas*, Linn.)

Is distinguished by a longer tail than the rest of its kind: in this respect it seems to bear some affinity to the Monkey, and has been mentioned under that denomination by several naturalists.

We may observe here, that, in tracing the progress of animated Nature, we are led, by the most imperceptible gradations, from one kind to another: the line of separation seems so faintly drawn, that we are frequently at a loss how to fix the boundaries of one class without encroaching upon those of another; and notwithstanding the regularity and order which every where prevail among the numerous families that inhabit the earth, the best and most improved systems of arrangement fall infinitely short of precision: they serve indeed, to direct us to

the general characters which form the distinguishing features of each genus, but are very inadequate to discriminate the intermingled shades and nice touches by which all are diversified.

The drawing of this animal was taken from one shewn in London under the name of the PERSIAN SAVAGE. Its head was large; muzzle long and thick; eyes small; face naked, and of an olive colour; the hair on its forehead separated in the middle, and hung down on each side of the face; from thence down its back as far as its waist, it was long and shaggy, of a bluish grey colour, freckled with dark spots; the hair on the lower part of the body short; its buttocks bare and red.

That described by Mr. Pennant, which seems to agree with this, is represented as very fierce and untractable.

It inhabits the hottest parts of Africa and Asia, lives in troops, and commits great depredations in gardens and cultivated grounds; is above five feet high, exceedingly strong, vicious, and impudent.

THE URSINE BABOON.

Is not unlike the last, but rather less. Its nose is long; head large; ears short; forehead high and prominent, terminating in a ridge; the body thick and strong, covered with long dusky hair, which gives it the appearance of a young Bear; its tail is half the length of the body; buttocks red.

This animal is very numerous about the Cape of Good Hope. Troops of them assemble together, and make expeditions for the sake of plunder, in

which they observe the utmost precaution. To pre-
vent surprise, they place a centinel, which upon
sight of a man, gives a loud yell; when the whole
troop retreats with the greatest precipitation. It is
highly entertaining to see the females carrying off
their young ones clinging to their backs; whilst
their pouches are crammed so full of fruit, that they
seem ready to burst. They sometimes form a line,
and throw the fruit from one to another, in order to
carry it off the more expeditiously.

THE WANDEROU.

Is a native of Ceylon and the East Indies. Its
head is thick and long, and surrounded with a large
quantity of white hair, which falls down below the
chin, forming a rough, shaggy beard; the rest of
the body is covered with a dark brown coat, almost
black. Like all animals of this kind, it is wild and
vicious; but when taken young, may easily be
tamed; and appears to be more susceptible of
education than other Baboons.

There are several varieties of this species. The
bodies of some are black, with white beards; in
others, the body is whitish, and the beard black:
some are found entirely white; but this species is
extremely rare, and is said to be stronger and more
mischievous than the others.

These bearded Baboons are much esteemed for
the gravity of their appearance; and are used by
the Indians in their ceremonies and shows, in which
they are said to acquit themselves to the admiration
of the spectators.

THE HARE-LIPPED MONKEY.

(Simia Cynomolgus, Linn.—Le Macaque, Buff.)

WE have placed this animal next to the Baboons, because it makes the nearest approach to them in the form of its body, which is short and thick: its head and muzzle are large; its visage ugly, naked, and wrinkled; and its nostrils divided, like those of a Hare: its tail, however, is long, like that of a Monkey: the colour of the hair on the upper part of the body is a greenish ash, lighter on the breast and belly.

There are several varieties, which differ both in size and colour.

This animal is found in Guinea, Congo, and some of the southern parts of Africa. They go in troops, and do infinite mischief to the plantations of millet, which they carry off under their arms and in their mouths. They are extremely nice and delicate in their choice; and by pulling up what does not please them, do more damage than by what they really eat.

THE PATAS, OR RED MONKEY.

Is nearly of the same size as the last, and inhabits the same country; its body is, however, rather longer, its face less hideous, and its hair more beautiful. It is remarkable for the brilliancy of its coat, which is of so bright a red, as to have the appearance of being painted.

There are two varieties of this kind: the one is distinguished by a black line above the eyes, ex-

tending from ear to ear; in the other, the line is
white. Both have long hair under the chin, and
round the cheeks; which in the first is yellow, and
in the second white: the nose is black; the under
part of the body of an ash colour, tinged with
yellow.

These Monkies are very numerous on the banks
of the river Senegal. They are so curious, as
sometimes to descend from the tops of trees to the
extremities of the branches, while boats are pass-
ing, and seem to observe them with great attention.
If not disturbed, their familiarity becomes trouble-
some; they break off branches, throw them at the
passengers, and frequently with so sure an aim,
as to annoy them not a little; but upon being shot
at, they set up most hideous cries, endeavour to
revenge themselves by collecting more offensive
materials, such as stones, dirt, &c., which they
throw at the enemy, and soon retire.

Travellers relate that, in Guinea, Monkies are
frequently seen together in troops of forty or fifty,
plundering gardens and fields of corn with great
boldness. One of them stands on a tree, listens
and looks about on all sides, while the rest are
busy. Upon the least appearance of interruption,
he sets up a loud cry to alarm the party; when
they immediately fly off with the booty they have
collected, leaping from tree to tree with prodigious
agility.

THE CHINESE BONNET MONKEY.

APPEARS to be only a variety of the Malbrouck: the principal difference consists in its having the hair on its head disposed in the form of a flat bonnet, from which its name has been derived. It inhabits the same country, and lives in the same manner.

When fruits and succulent plants fail, these animals are said to eat insects, and sometimes watch by the seaside for Crabs and other shell-fish, which they are very dexterous in catching.

They are never thoroughly tamed, and cannot be trusted without a chain. They do not breed when in a state of confinement, even in their own country; but require to be at perfect freedom in their native woods.

THE MANGABEY.

(Simia Æthiops, Linn.)

Is distinguished from all other Monkies by a very remarkable character. Its eye-lids are naked, of a pure white colour; and round each eye there is a prominent ring: the hair on the head and body is of a yellowish brown colour; that on the belly white. Some of them have a broad collar of white hair surrounding their neck and face.

THE GREEN MONKEY.

(Simia Sabæa, Linn.—*Le Callitriche,* Buff.)

So called from its beautiful hair, which, on the upper part of the body and tail, is of a fine green colour; the throat, belly, and inner side of the limbs are of a silvery whiteness: the tail is eighteen inches long; length of the body thirteen, height eight and a half.

It is common in the Cape de Verd islands and the East Indies, and is also found in Mauritania, and in the territories of ancient Carthage. Hence it is probable, says M. Buffon, that it was known to the Greeks and Romans, and that it was one of those long-tailed Monkies, to which they gave the general name of Callitrix.

It seems to be the same kind as that mentioned by Adanson; who relates, that the woods of Podor, along the river Niger, are full of green Apes, which, from their colour, are scarcely discernible among the branches of the trees where they live.

The animal from which the above was taken was a female, in the possession of William Hargrave, Esq., of Shawdon.

THE MUSTACHE.

(Simia Cephus, Linn.—*Le Moustac,* Buff.)

Is a beautiful little animal, having a tuft of yellow hair on each cheek, and another on the top of the head, which is long and upright: its face is of a bluish colour, body of a greenish ash, breast and belly lighter. Its length is only one foot; that of the tail eighteen inches. It is a native of Guinea.

THE TALAPOIN.

Is a native of the East Indies, where it is suffered to multiply without molestation, owing to the religious tenets of the Bramins, which forbid them to take the life of any kind of animal whatever. They are so tame and familiar, that numbers of them frequently come into their towns, enter the houses, and, if not prevented, help themselves to whatever they meet with that is agreeable to them; such as fruits, sweetmeats, &c.

The Talapoin is about twelve inches long: its head is round; ears black, and shaped like the human; eyes of a bright hazel colour, with black pupils; the hair on the back, upper part of the body, and limbs, of a dusky yellow, tinged with green; the belly lighter; its tail very long, slender, and of an olive colour.

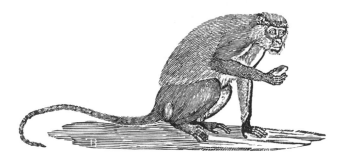

THE VARIED MONKEY, OR MONA.

(*La Mone*, Buff.)

IS the best known of all the Monkey-tribe, being more frequently brought into Europe than any other. It is a native of Barbary and other northern parts of Africa, Arabia, and Persia; where it is called the MONA, from which our general term is derived.

Its nose is short and thick; its face of a dark lead colour; the beard on each side long, and of a greenish yellow; the top of the head is bright yellow, freckled with black; back and sides deep brown, with black freckles; legs, feet, and tail, black; inside of the thighs of a pale blue colour, thinly covered with whitish hairs; and on each side of the rump, close by the tail, is a large white spot.

The drawing and description were taken from the living animal, in the possession of Robert Hedley, Esq., of Newcastle. It was remarkably gentle, tame, and familiar; and seemed to have some attachment to those with whom it was acquainted. Its length was eighteen inches; tail about two feet. It was fed with bread, roasted meat, and fruit of all kinds, of which it was particularly fond.

All the Baboons and Monkies we have yet des-
cribed, are furnished with cheek-pouches, capable
of containing food sufficient to supply them for a
day or two: they also serve as receptacles for what-
ever they obtain more than supplies their present
wants. But we have thought it unnecessary to re-
peat this circumstance in the account of every ani-
mal of those kinds.

THE DOUC.

DIFFERS from other Monkies, in having no cal-
losities on its buttocks, which are entirely covered
with hair; it is also much larger, being nearly four
feet high when erect. Its face is short and rather
flat, furnished on each side with long hairs of a pale
yellow colour; its body is beautifully variegated
with differently coloured hair; round the neck there
is a collar of a bluish purple colour; the top of the
head and body are grey; breast and belly yellow;
arms white below, and black above; tail white;
feet black; face and ears red; lips black; and
round each eye there is a black ring. It is found
in Cochin-China, and in the island of Madagascar;
where it is called the SIFAC.

M. Buffon places the Douc in the last class of
those animals of the Monkey kind that belong to
the old continent, and describes it as forming a
shade between them and the Monkies of America,
which he distinguishes by the generic names of
SAPAJOUS and SAGOINS. They both of them differ
from Monkies, in having neither cheek-pouches nor
callosities on their buttocks; and they are dis-
tinguished from each other by characters peculiar

to each. The Sapajou is furnished with a pre-
hensile tail, the under part of which is generally
covered with a smooth naked skin: the animal can
coil it up or extend it at pleasure, suspend itself by
its extremity on the branches of trees, or use it as
a hand to lay hold of any thing it wants. The
tails of all the Sagoins, on the contrary, are longer
than those of the Sapajous, straight, flaccid, and
entirely covered with hair. This difference alone is
sufficient to distinguish a Sapajou from a Sagoin.

We now proceed to the history and description
of the most remarkable of this numerous race.

THE PREACHER.

(Simia Beelzebub, Linn.—*L'Ouarine*, Buff.)

Is the largest of all the American Monkies, being
about the size of a large Fox. Its body is covered
with long smooth hair, of a shining black colour,
forming a kind of ruff round the animal's neck: its
tail is long, and always twisted at the end.

Great numbers of these Monkies inhabit the
woods of Brazil and Guiana; and from the noise
they make, are called *Howling Monkies*. Several
of them assemble together; and placing themselves
in a kind of regular order, one of them begins first
with a loud tone, which may be heard to a great
distance; the rest soon join in a general chorus,
the most dissonant and hideous that can be con-
ceived: on a sudden they all stop, except the first,
who finishes singly; and the assembly breaks up.

These Monkies are said to be very fierce, and so
wild and mischievous, that they can neither be con-

quered nor tamed. They feed on fruits, grain, herbs, and sometimes insects; live in trees, and leap from bough to bough with wonderful agility, catching hold with their hands and tails as they throw themselves from one branch to another, and maintain themselves so firmly, that even when shot, they remain fixed to the trees where they die.

The flesh of the Preacher is good; and is not only eaten by the natives, but also by Europeans who frequent those parts.

THE COAITA.

Is somewhat less than the Preacher., Its face is naked and red; ears short; its body and limbs are long and slender; hair black and rough; tail long, and naked on the under side.

This animal is found in the neighbourhood of Carthagena, in Guiana, Brazil, and Peru. Great numbers associate together. They seldom appear on the ground, but live mostly in trees, and feed on fruits: when these are not to be had, they are said to eat fishes, worms, and insects; are extremely dexterous in catching their prey, and make great use of their tails in seizing it.

The Coaitas are very lively and active. In passing from one tree to another, they sometimes form a chain, linked to each other by their tails; and swing in that manner till the lowest catches hold of a branch, and draws up the rest. When fruits are ripe, they are generally fat; and their flesh is said to be then excellent.

There are many varieties of the Coaita, which differ chiefly in colour. Some are totally black,

others brown, and some have white hair on the
upper parts of the body. They are called *Spider
Monkies* by Edwards, on account of the length and
slenderness of their legs and tails.

M. Buffon supposes the EXQUIMA to be another
variety of this species. It is nearly of the same
size; but its colour is variegated. The hair on its
back is black and yellow; its throat and belly
white. Its manner of living is the same with that
of the Coaita: and it inhabits the same countries.
Both kinds are remarkable in having only four
fingers on each hand, being quite destitute of the
thumb.

THE SAJOU, OR CAPUCIN.

(Simia Capucina, Linn.—*Le Sai,* Buff.)

THERE are two varieties of this species, the
Brown and the Grey; which, in other respects, are
perfectly similar. Their faces are of a flesh colour,
thinly covered with down; tails long, full of hair
on the upper side, naked below, and prehensile;
hands black and naked; length of the body about
twelve inches.

These animals inhabit Guiana, are extremely
lively and agile, and their constitution seems better
adapted to the temperate climates of Europe than
most of the Sapajou kind. M. Buffon mentions a
few instances of their having produced young ones
in France.

The Sajous are very capricious in their attach-
ments, being fond of particular persons, and dis-
covering the greatest aversion to others.

THE WEEPER.

(Simia Apella, Linn.)

INHABITS Brazil; is very mild, docile, and timid; of a grave and serious aspect; has an appearance of weeping; and when irritated, makes a plaintive noise. It is about fourteen inches long; the tail longer than the body; hair on the back and sides of a deep brown colour, mixed with red on the lower parts. There is a variety with white hair on the throat and breast.

Great numbers of these creatures assemble together, particularly in stormy weather, and make a great chattering. They live much in trees, which bear a podded fruit as large as beans, on which they principally feed.

THE ORANGE MONKEY.

(Simia Sciurea, Linn.—Le Saimiri, Buff.)

IS a most beautiful animal; but so extremely delicate, that it cannot well bear to be brought from its own climate to one less warm.

It is about the size of a Squirrel: its head is round; eyes remarkably lively and brilliant; ears large; hair on the body short and fine, of a shining gold colour; feet orange: its tail is very long: its prehensile faculty is much weaker than the rest of the Sapajous; and on that account, it may be said to form a shade between them and the Sagoins, which have long tails, entirely covered with hair, but of no use in suspending their bodies from the branches of trees.

THE FOX-TAILED MONKEY.

(Simia Pithecia, Linn.—*Le Saki,* Buff.)

THE tail of this animal, like that of the Fox, is covered with long bushy hair. Its body is about seventeen inches in length; hair long, of a dark brown colour on the back, lighter on the under side; its face is tawny, and covered with a fine short whitish down; the forehead and sides of the face are white; its hands and feet are black, with claws instead of nails.

The Saki is a native of Guiana, where it is called the *Saccawinkee.*

THE GREAT-EARED MONKEY.

(Simia Midas, Linn.—*Le Tamarin,* Buff.

Is about the size of a Squirrel: its face is naked, of a swarthy flesh colour; its upper lip somewhat divided; its ears are very large and erect; its hair is soft, shaggy, and of a black colour; hands and feet covered with orange-coloured hair, very fine and smooth; its nails long and crooked; tail black, and twice the length of its body.

It inhabits the hotter parts of South America; is a lively, pleasant animal; easily tamed; but so delicate, that it cannot bear a removal to a colder climate.

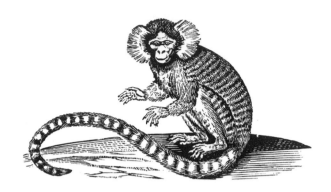

THE STRIATED MONKEY.

(Simia Iacchus, Linn.—*L'Ouistiti*, Buff.)

Is still smaller than the Great-eared Monkey, its head and body not exceeding twelve inches in length: its tail is long, bushy, and like that of the Macauco, marked with alternate rings of black and ash colour; its face is naked, of a swarthy flesh colour; ears large, and like the human; body beautifully marked with dusky, ash-coloured, and reddish bars; its nails are sharp; and its fingers like those of a Squirrel.

It inhabits Brazil; feeds on fruits, vegetables, insects, and snails, and is fond of fish.

Mr. Edwards gives a description of one of these animals, accompanied with an excellent figure. He says, that one day being at liberty, it darted upon a small gold-fish that was in a basin, which it killed and devoured with avidity; and that afterwards small eels were given to it, of which it

seemed at first afraid, from their twisting them-
selves round its neck; but that it soon overcame
and eat them. He likewise says that it produced
young ones in Portugal, which at first were ex-
tremely ugly, having hardly any hair on their
bodies. They adhered closely to the teats of the
mother; and when grown a little larger, fixed
themselves upon her back, from whence she could
not easily disengage them, without rubbing them
off against a wall: upon these occasions, the male
always allowed them to mount upon his back to
relieve the female.

THE SILKY MONKEY.

(Simia Rosalia, Linn.—*Le Marikina*, Buff.)

Is by some called the Lion-Ape, from the quan-
tity of hair which surrounds its face, falling back-
wards like a mane; its tail is also somewhat bushy
at the end; its face is flat, and of a dull purple
colour; its hair long, bright, and silky; it is of a
pale yellow colour on the body; the hair round the
face of a bright bay, inclining to red; its hands and
feet are without hair, and of the same colour as the
face; its body is ten inches long; tail, thirteen.

This creature is a native of Guiana, is very gentle
and lively, and seems to be more hardy than the
other Sagoins. Buffon says, that one of them lived
at Paris several years, with no other precaution
than keeping it in a warm room during winter.

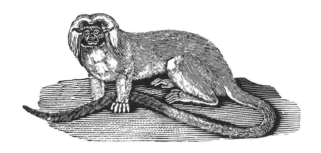

THE RED-TAILED MONKEY.

(Simia Oedipus, Linn.—*Le Pinche*, Buff.)

Is somewhat larger than the Striated Monkey. It is remarkable in having a great quantity of smooth white hair, which falls down from the top of the head on each side, forming a curious contrast with its face, which is black, thinly covered with a fine grey down: its eyes are black and lively; throat black; hair on the back and shoulders of a light reddish brown colour; breast, belly, and legs, white; the tail is long, of a red colour from the rump to the middle; from thence to the end it is black.

It inhabits the woods on the banks of the river Amazon; is a lively, beautiful little animal; has a soft whistling voice, resembling more the chirping of a bird than the cry of a quadruped. It frequently walks with its long tail over its back.

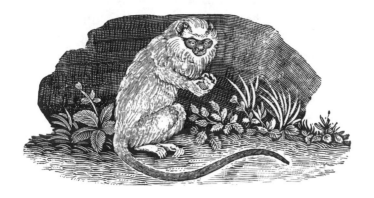

THE MICO, OR FAIR MONKEY.

Is the last that we shall describe of this numer-
ous race, and is the most beautiful of them all. Its
head is small and round; face and ears of so lively
a vermilion colour, as to appear the effect of art;
its body is covered with long hair, of a bright
silvery whiteness, and uncommon elegance; tail
long, and of a shining dark chesnut colour.

It frequents the banks of the river Amazon,
where it was discovered by M. Condamine, who
preserved one alive till almost within sight of the
French coast; but it died before his arrival.

We have now laid before our readers a few of the
most noted varieties of this numerous race; many
others might likewise be added to swell the accounts
but of these little more is known than their names
and places of habitation. There are, probably,
still more, which neither the assiduity of the
naturalist, nor the curiosity of the traveller has
been able to draw from their native woods. In-
deed, there is great room to conjecture, that the
variations of the Monkey kind are somewhat like

those of the Dog, continually increasing; for it is very obvious, that among the smaller kinds of Monkies, the characteristic differences do not appear to be great, however they may vary in size or in colour; and it is certain that the modes of living, faculties, and propensities of these animals are strikingly similar: so that, if we reason from analogy on this subject, we may fairly conclude, that different kinds of Monkies may unite and propagate with the same facility as the Goat and the Sheep, or the almost innumerable kinds of Dogs.*

The greater part of the cuts we have given of the Baboons, Apes, and Monkies, we were fortunate in procuring from living objects, or drawings which might be depended on: and it is to be lamented, that amongst the numbers that have been published, so few should possess that peculiar character so observable in the various members of this imitative tribe, which it is wholly impossible to trace from a stuffed skin, void of every kind of expression; the muscular parts, which should convey the idea of action, being generally ill supplied, or entirely wanting.

* The following fact (communicated by J. Trevelyan, Esq., June 5, 1809,) is well authenticated. The Monkey, belonging to a captain of the navy, is yet alive:

"Pug is a gentleman of excellent humour, and adored by the crew; to make him perfectly happy they got him a wife. For some weeks he showed her every sort of attention. He then grew cool, and jealous of any sort of kindness shewn her by his master, and used her cruelly. As female hearts bear a great deal, this treatment only made her wretched without killing her: he then changed his battery, made up matters by degrees, and appeared as fond of her as ever. One morning when the sea ran very high, he seduced her up aloft, and seemed shewing her some distant object from the yard-arm; when, all of a sudden, her attention being fixed, he applied his paw to her rump, canted her into the sea, (where of course she was immediately drowned) and came down in high spirits!"

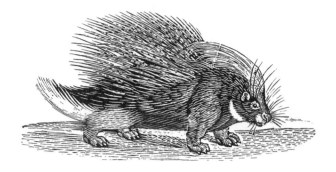

THE PORCUPINE.

(Histrix Cristata, Linn.—Le Porc-epic, Buff.)

THIS animal, so formidable in its appearance, would be much more truly so, if it possessed the power, erroneously ascribed to it, of darting its quills at its enemies, and wounding them· at a distance.

Though denied the privilege of making offensive war, it is sufficiently armed to resist the attacks of animals much more powerful than itself. Upon the smallest irritation, it raises its quills, and shakes them with great violence, directing them to that quarter whence it is in danger of being attacked, and striking at the object of its resentment with its quills at the same time. We have observed on an occasion of this sort, at a time when the animal was moulting or casting its quills, that they would fly out, to the distance of a few yards, with such force, as to bend the points of them against the board where they struck: and it is not improbable, that a circumstance of this kind may have given rise to

an opinion of its power to use them in a more effectual manner.

The largest of the quills are from ten to fifteen inches in length, thick in the middle, and extremely sharp at the end: between the quills, the hair is thin, black, and bristly: the tail is covered with white quills, which are short and transparent: its legs are short; it has four toes before, and five behind.

The Porcupine is found in India, Persia, and Palestine: it is likewise common in all parts of Africa. The Indians hunt it for its quills, of which they make a kind of embroidery: they also eat its flesh.

There are Porcupines in a wild state in Spain and Italy, though they are not originally natives of any part of Europe. Their flesh is sometimes exposed in the markets at Rome, where it is eaten.

The Italian Porcupines have shorter quills and a shorter crest than those of Asia or Africa.

The Porcupine is an inoffensive animal; lives on fruits, roots, and vegetables; sleeps during the day, and feeds by night.

The female goes with young seven months, and brings forth one at a time. The drawing of this animal was made from the life.

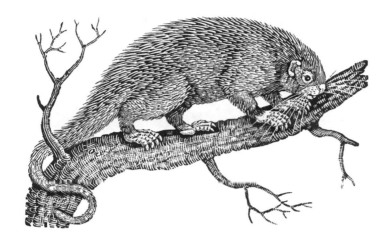

THE BRAZILIAN PORCUPINE.

(Histrix Prehensilis, Linn.)

DIFFERS so greatly from the last, that it can scarcely be said to bear any relation to it, except in its being covered with spines about three inches in length : they are white, very sharp, and have a bar of black near the points. The breast, belly, and lower part of the legs, are covered with strong bristly hairs of a brown colour. Its tail is long and slender, and almost naked at the end : the animal uses it in descending trees, by twisting it round the branches.

It inhabits Mexico and Brazil, lives in woods, and feeds on fruits and small birds. It preys by night, and sleeps in the day. It makes a noise like the grunting of a Swine, and grows very fat. Its flesh is white, and esteemed good to eat.

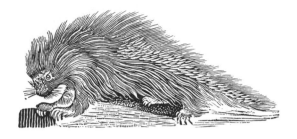

THE CANADA PORCUPINE.

(Histrix Dorsata, Linn.—*L'Urson*, Buff.)

IT is found in Canada, and various parts of North America, as high as Hudson's Bay.

Its ears are short, and hid in the hair; its head, body, and upper part of its tail, are covered with long soft hair, in which are interspersed a number of strong sharp spines; its tail is shorter than that of the preceding species, but it uses it in the same manner in descending trees, frequently suspending itself from the branches.

Many of the trading Indians, during their long excursions, depend on this creature for a supply of food, and esteem it both wholesome and pleasant: they also make use of the quills to trim the edges of their deerskin habits, so as to look like fringe; and stick them in their noses and ears to make holes for their rings.

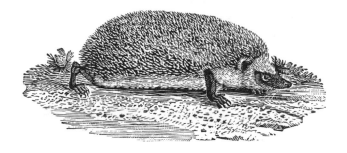

THE HEDGE-HOG, OR URCHIN.

(Erinaceus Europeus, Linn.—*Le Herisson,* Buff.)

THIS animal, destitute of every other means of defence, is provided by nature with a spinous armour, which secures it from the attacks of all the smaller beasts of prey: such as Weasels, Martins, Polecats, &c. When alarmed, it immediately collects itself into the form of a ball, and presents on all sides a surface covered with sharp points, which few animals are hardy enough to engage. The more it is harassed, the closer it rolls itself; till its fears become an additional means of safety, by causing it to void its urine, which, running over its whole body, frequently obliges its enemy to desist, disgusted by the smell.

There are few Dogs that will venture to attack the Hedge-Hog, except such as are trained to the sport, merely to gratify the cruel pleasure of seeing a harmless animal endure, with astonishing patience, the most wanton outrages; whilst the Dogs, becoming more enraged at the wounds they receive from its prickles, at last oblige it to unfold

itself, and it then soon falls a victim to their fury. This little animal has been so far domesticated as to learn to turn a spit by means of a small wheel in which it was placed; it likewise answered to its name.

The Hedge-Hog generally resides in small thickets and hedges; lives on fruits, worms, beetles, and all kinds of insects; conceals itself in the day, and feeds during the night. It is easily taken, for it neither flies nor attempts to defend itself; but when touched, shrinks into a circular form, which it will not easily quit, unless thrown into water.

The Hedge-Hog, in the winter, wraps itself up in a warm nest, made of moss, dried grass, and leaves; and sleeps out the rigours of that season. It is frequently found so completely encircled with herbage on all sides, that it resembles a ball of dried leaves. When taken out and placed before a fire, it soon recovers from its torpid state.

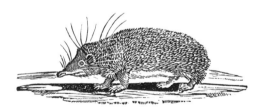

THE TENDRAC.

Is about the size of a Rat. The upper part of its body is covered with spines, shorter and smaller than those of the Hedge-Hog, which it somewhat resembles, but does not roll itself up like that animal; the rest of the body is covered with a kind

of fine hard hair, of a whitish colour; about the head and nose it has several long hairs, like whiskers.

An animal similar to this is mentioned by M. Buffon, under the name of the Tanrec.

THE TANREC.

THIS animal is larger than the last, and has fewer bristles: they occupy only the top of the head, and along the back, as far as the shoulders: the rest of the body is covered with a bristly kind of hair, of a yellowish colour, among which are intermixed some black hairs, much longer than the other. Its nose is long, and its ears more apparent than those of the Tendrac.

Both of them are natives of India. These make a grunting noise, and are fond of wallowing in mud, like Hogs: they frequent the banks of rivers, can live a long time in the water, and are frequently caught in small inlets of the sea: they dig holes in the ground, where they continue in a kind of torpid state for several months. They are generally very fat; and the Indians eat their flesh, though it is reckoned insipid and stringy.

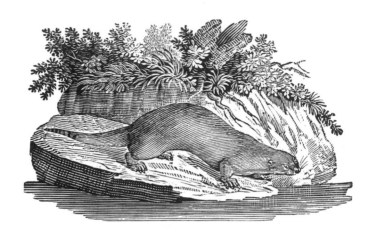

THE OTTER.

(Mustela Lutra, Linn.—*Le Loutre,* Buff.)

ALTHOUGH the Otter is not considered by natural-
ists as wholly amphibious, it is nevertheless capable
of remaining a considerable time under water, and
can pursue and take its prey in that element with
great facility.

Its legs are very short, but remarkably strong,
broad, and muscular; on each foot are five toes,
connected by strong membranes, like those of
water fowl; its head is broad, of an oval form, and
flat on the upper part; the body is long and round,
and the tail tapers to a point; the eyes are bril-
liant, and placed in such a manner that the animal
can see every object that is above it, which gives it
a singular aspect, very much resembling an Eel or
an Asp; the ears are short, and their orifice narrow.

The fur of the Otter is of a deep brown colour, with two small light spots on each side of the nose, and another under the chin.

This animal makes its bed in some retired spot by the side of a lake or river, under a bank, where it has an easy and secure access to the water, to which it immediately flies upon the least alarm; and as it swims with great rapidity, frequently escapes from its pursuers.

It destroys great numbers of fish; and in pursuit of its prey, has been observed commonly to swim against the stream.

As soon as the Otter has caught a fish, it immediately drags it to the shore; devours a part, as far as the vent; and unless pressed by extreme hunger, always leaves the remainder, and takes to the water in quest of more.

Otters are sometimes taken in traps placed near their landing places, where they are carefully concealed in the sand. When hunted with Dogs, the old ones defend themselves with great obstinacy: they bite severely, and do not readily quit their hold where they have once fastened. An old Otter will never give up while it has life; nor make the least complaint, though wounded ever so much by the Dogs, nor even when transfixed with a spear.

There are many instances of Otters being tamed; but in those which have come to our knowledge, they were taken when young: accustomed by degrees to obedience and restraint, they became so far domesticated, as to follow their master, answer to a name, and employ their excellent talents at fishing in his service. Indeed, when taken young, Otters may be easily reared and made tame. We have seen two young ones sucking a Bitch, and

treated by her with as much tenderness as her own offspring.

William Collins, of Kimmerston, near Wooler, had a tame Otter, which followed him wherever he went. He frequently carried it to fish in the river; and when satiated, it never failed returning to its master. One day, in the absence of Collins, being taken out by his son to fish, instead of returning as usual, it refused to come at the accustomed call, and was lost. The father tried every means to recover it; and after several days search, being near the place where his son had lost it, and calling it by its name, to his inexpressible joy, it came creeping to his feet, and showed many genuine marks of affection and firm attachment. Its food, exclusive of fish, consisted chiefly of milk and hasty-pudding.

Some years ago, James Campbell, near Inverness, had a young Otter, which he brought up and tamed. It would follow him wherever he chose; and if called on by its name, would immediately obey. When apprehensive of danger from Dogs, it sought the protection of its master, and would endeavour to fly into his arms for greater security. It was frequently employed in catching fish, and would sometimes take eight or ten salmon in a day. If not prevented, it always made an attempt to break the fish behind the fin next the tail: as soon as one was taken away, it immediately dived in pursuit of more. When tired, it would refuse to fish any longer; and was then rewarded with as much fish as it could devour. Being satisfied with eating, it curled itself round, and fell asleep; in which state it was generally carried home. The same Otter fished as well in the sea as in a river,

and took great numbers of Codlings and other fish. Its food was generally fresh fish, and sometimes milk.

Another person who kept a tame Otter, suffered it to follow him with his Dogs. It was very useful to him in fishing, by going into the water, and driving Trouts and other fish towards the net. It was remarkable, that the Dogs, though accustomed to the sport, were so far from giving it the smallest molestation, that they would not even hunt an Otter whilst it remained with them; on which account the owner was under the necessity of disposing of it.

Notwithstanding the Otter's avidity for fish, it will not eat it, unless it be perfectly fresh. When that cannot be procured, it is fed with milk, or pudding made of oatmeal, &c.

Otters are found in most parts of the world, with no great variation. They are common in Guiana, and frequent the rivers and marshes of that country. They are sometimes seen in great numbers together; and are so fierce, that it is dangerous to come near them. They live in holes, which they make in the banks of the rivers.

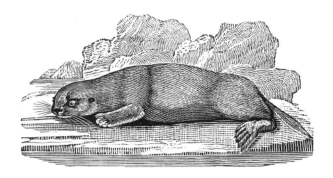

THE SEA-OTTER.

(Mustela Lutris, Linn.)

VAST numbers of these animals inhabit the coasts of Kamschatka, and the numerous islands contiguous to it; as well as the opposite coasts of America: they are also found in some of the larger rivers of South America.

Their skins are of great value, and have long formed a considerable article of export from Russia. They dispose of them to the Chinese at the rate of seventy or a hundred roubles each, and receive in return some of their most valuable commodities.

The fur of the Sea-Otter is thick and long, of a beautiful shining black colour, but sometimes of a silvery hue; the legs are thick and short; the toes joined by a web; the hind feet like those of a Seal; length from nose to tail, four feet two inches; tail thirteen, flat, and pointed at the end. The largest of them weigh from seventy to eighty pounds.

The Sea-Otter is remarkably harmless, and most affectionately fond of its young: it will pine to death for its loss, and die on the very spot where it has been taken away. Before its young can swim, it will carry it in its paws, and support it in the water, lying upon its back. It swims in various positions, —on its back, sides, and even in a perpendicular posture; and in the water is very sportive. Two of them are sometimes seen embracing each other. It frequents shallow places, abounding with sea-weed; and feeds on Lobsters, Crabs, and other shell-fish.

It breeds but once a year, and produces one young at a time, which it suckles and carefully attends almost a year.

The flesh of a young Otter is reckoned delicate eating, and not easily distinguished from that of a Lamb.

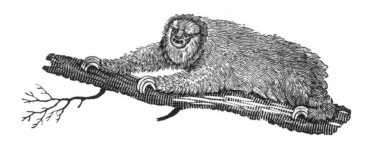

THE SLOTH.

(Bradypus Tridactylus, Linn.—*L'Ai,* Buff.)

OF all animals, is the most sluggish and inactive; and if we were to judge from outward appearance, would seem the most helpless and wretched. All its motions seem to be the effect of the most painful exertion, which hunger alone is capable of exciting.

It lives chiefly in trees; and having ascended one, with infinite labour and difficulty, it remains there till it has entirely stripped it of all its verdure, sparing neither fruit, blossom, nor leaf; after which it is said to devour even the bark. Being unable to descend, it throws itself on the ground, and continues at the bottom of the tree till hunger again compels it to renew its toils in search of subsistence.

Its motions are accompanied with a most piteous and lamentable cry, which terrifies even beasts of prey, and proves its best defence.

Though slow, awkward, and almost incapable of motion, the Sloth is strong, remarkably tenacious of life, and capable of enduring a long abstinence from food.

We are told of one that having fastened itself by its feet to a pole, remained in that situation forty

days without the least sustenance. The strength of its legs and feet is so great, that, having seized any thing, it is almost impossible to oblige it to quit its hold. The same animal laid hold of a Dog that was let loose upon it, and held him fast with his feet till he perished with hunger.

There are two kinds of Sloths, which are principally distinguished by the number of their claws. The one, called the AI, is about the size of a Fox, and has three long claws on each foot; its legs are clumsy, and awkwardly placed; and the fore legs being longer than the hind adds greatly to the difficulty of its progressive motion: its whole body is covered with a rough coat of long hair, of a lightish brown colour, mixed with white, not unlike that of a Badger; and has a black line down the middle of the back: its face is naked, and of a dirty white colour; tail short; eyes small, black, and heavy. It is found only in South America.

THE UNAU has only two claws on each foot: its head is short and round, somewhat like that of a Monkey; its ears are short; and it has no tail. It is found in South America, and also in the Island of Ceylon.

The flesh of both kinds is eaten. They have several stomachs, and are said to belong to the tribe of ruminating animals.

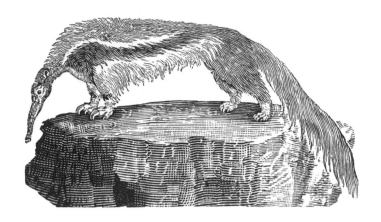

THE ANT-EATER.

(Myrmecophaga Jubata, Linn.—*La Tamanoir,* Buff.)

THERE are several animals distinguished by the common name of Ant-Eaters, which differ greatly in form. They are divided into three classes, viz., the Great, the Middle, and the Lesser Ant-Eater.

The GREAT ANT-EATER is nearly four feet in length, exclusive of its tail, which is two and a half. It is remarkable for the great length of its snout, which is of a cylindrical form, and serves as a sheath to its long and slender tongue, which always lies folded double in its mouth, and is the chief instrument by which it finds subsistence.

This creature is a native of Brazil and Guiana, runs slowly, frequently swims over rivers, lives wholly on Ants, which it collects by thrusting its tongue into their holes, and having penetrated every part of the nest, withdraws it into its mouth loaded with prey.

Its legs are so strong, that few animals can extricate themselves from its gripe. It is said to be formidable even to the Panthers of America; and sometimes fixes itself upon them in such a manner, that both of them fall and perish together; for its obstinacy is so great, that it will not extricate itself from its adversary even after he is dead.

The flesh has a strong disagreeable taste, but is eaten by the Indians.

The MIDDLE ANT-EATER is one foot seven inches from nose to tail. It inhabits the same countries, and procures its food in the same manner, as the last. Its tail is ten inches long, with which it secures its hold in climbing trees by twisting it round the branches.

Both these animals have four strong claws on the fore feet, and five on the hind.

The LESSER ANT-EATER has a sharp-pointed nose, inclining a little downward : its ears are small, and hid in the fur : it has two strong hooked claws on the fore feet, the outward one being much the largest; and four on the hind feet : its fur is long, soft, and silky, of a yellowish brown colour : its length from nose to tail, is seven inches and a half; tail, above eight, thick at the base, and taper to the end. It inhabits Guiana; climbs trees in quest of a species of Ants which build their nests among the branches.

Animals of this kind are found in Ceylon and the Cape of Good Hope. Kolben describes the latter as having long heads and tongues; that they feed on Ants; and are so strong, that if they fasten their claws in the ground, they cannot easily be pulled away. It is called in Ceylon the *Talgoi*, or *Ant-Bear*.

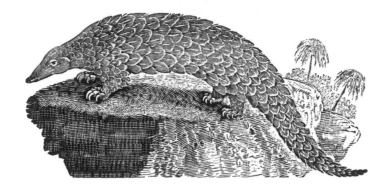

THE GREAT MANIS.

(Manis Pentidactyla, Linn.—*Le Pangolin*, Buff.)

THIS singular creature is defended by a coat of
mail, which protects it from the attacks of the most
powerful animals. All the upper parts of its body
are closely covered with scales of different sizes,
which it can erect at pleasure, opposing to its
adversary a formidable row of offensive weapons.
The Tiger, the Panther, or the Leopard in vain
attempt to force it. The moment it perceives the
approach of an enemy, it rolls itself up like a
Hedge-Hog, and by that means secures all the
weaker parts of its body.

It is a native of the Indian isles, and is said like-
wise to be found in Guinea.

It is slow in its motions; grows to the length of
eight feet, including its tail, which is four.

Its flesh is much esteemed for its delicacy; but it
is difficult to procure, as the animal avoids man-
kind, and lives in obscure retreats, in woods, and
marshy places.

THE LONG-TAILED MANIS.

(Manis Tetradactyla, Linn.—*Le Phatagin*, Buff.)

Is less than the last, being not more than a foot
long from head to tail. Its body is covered with
sharp-pointed scales ; its throat and belly with
hair: its legs are short; and each foot has four
claws. It is remarkable for the great length of its
tail, which in some is above a yard long.

It is a native of Guinea, has been sometimes
called the SCALY LIZARD, and may be said to be
the connecting link in the chain of beings between
quadrupeds and reptiles.

THE ARMADILLO.

Is found only in South America, where there are
several varieties of them. They are all covered
with a strong crust or shell, and are distinguished
from each other by the number of the flexible bands
of which it is composed. It is a harmless, inoffen-
sive animal; feeds on roots, fruits, and other vege-
tables; grows very fat; and is greatly esteemed for
the delicacy of its flesh.

The Indians hunt it with small Dogs, trained for
that purpose. When surprised, it runs to its hole,
or attempts to make a new one, which it does with
great expedition, having strong claws on its fore
feet, with which it adheres so firmly to the ground,
that if it should be caught by the tail whilst making
its way into the earth, its resistance is so great, that
it will sometimes leave it in the hands of its pur-
suers: to avoid this, the hunter has recourse to

artifice; and by tickling it with a stick, it gives up its hold, and suffers itself to be taken alive. If no other means of escape be left, it rolls itself up within its covering by drawing in its head and legs, and bringing its tail round them as a band to connect them more forcibly together: in this situation it sometimes escapes by rolling itself over the edge of a precipice, and generally falls to the bottom unhurt.

The most successful method of catching Armadillos is by snares laid for them by the sides of rivers or other places where they frequent. They all burrow very deep in the ground, and seldom stir out, except during the night, whilst they are in search of food.

To give a minute description of the shells or coverings of the Armadillos would be extremely difficult, as they are all composed of a number of parts, differing greatly from each other in the order and disposition of the figures with which they are distinguished: but it may be necessary to observe, that in general there are two large pieces that cover the shoulders and the rump, between which lie the bands, which are more or less in number in different kinds. These bands are not unlike those in the tail of a Lobster, and being flexible give way to the motions of the animal. The first we shall mention is

THE THREE-BANDED ARMADILLO.

(Dasypus Tricinctus, Linn.—L'Apar, Buff.)

ITS shell is about twelve inches long, with three bands in the middle: the crust on the head, back,

and rump, is divided into a number of elegant
raised figures, with five angles or sides: its tail is
not more than two inches long: it has neither cut-
ting nor canine teeth: and has five toes on each
foot.

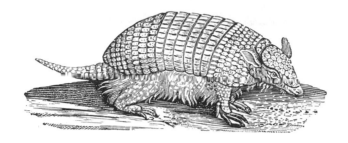

THE SIX-BANDED ARMADILLO.

(Dasypus Sexcinctus, Linn.—*L'Encoubert,* Buff.)

Is about the size of a young Pig. Between the
folds of the bands there are a few scattered hairs:
its tail is long, thick at the base, and tapers to a
point. It is found in Brazil and Guiana.

THE EIGHT-BANDED ARMADILLO.

(Le Tatuette, Buff.)

Is furnished with eight bands. Its ears are long
and upright: eyes small and black: it has four toes
on the fore feet, and five on the hind: its length,
from nose to tail, is about ten inches; the tail nine.
It inhabits Brazil, and is reckoned more delicious
eating than the others.

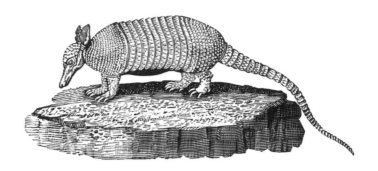

THE NINE-BANDED ARMADILLO.

(Dasypus Novemcinctus, Linn.—*Le Cachichame,*
Buff.)

HAS a tenth band, moveable half way up on each
side: the shell on the shoulders and rump is mark-
ed with hexangular figures; the breast and belly
are covered with long hairs; its tail is long and
taper; and the whole animal three feet in length.

One of this kind was brought to England a few
years ago from the Musquito shore, and lived some
time. It was fed with raw beef and milk, but re-
fused to eat our fruits and grain.

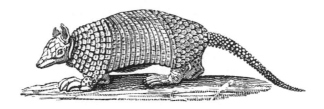

THE KABASSOU.

Is furnished with twelve bands, and is the largest of all the Armadillos, being almost three foot long from nose to tail: the figures on the shoulders are of an oblong form; those on the rump hexangular. It is seldom eaten.

THE WEASEL-HEADED ARMADILLO.

(Dasypus Unicinctus, Linn.—*Le Cirquinçon*, Buff.)

So called from the form of its head, which is slender, has eighteen bands from its shoulder to its tail: the shell is marked with square figures on the shoulders; those on the legs and thighs are round-ish; the body is about fifteen inches long: tail five.

All these animals have the power of drawing themselves up under their shells, either for the pur-pose of repose or safety. They are furnished with strong lateral muscles, consisting of numberless fibres, crossing each other in the form of an X, with which they contract themselves so powerfully, that the strongest man is scarcely able to force them open. The shells of the larger Armadillos are much stronger than those of the smaller kinds: their flesh is likewise harder, and more unfit for the table.

VOL. III. 3 S

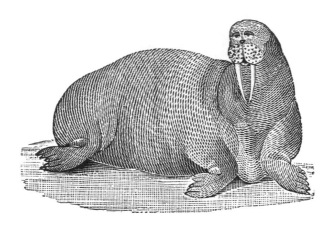

THE WALRUS, OR SEA-HORSE.

(Trichechus Rosmarus, Linn.—*Le Morse,* Buff.)

THERE are several animals whose residence is almost constantly in the water, and which seem to partake greatly of the nature of fishes, that are nevertheless classed by naturalists under the denomination of quadrupeds; and being perfectly amphibious, living with equal ease in the water as on land, may be considered as the last step in the scale of Nature, by which we are conducted from one great division of the animal world to the other. Of these the Walrus is the most considerable for its size, being sometimes found eighteen feet in length, and twelve in circumference at the thickest part: it is likewise remarkable for two large tusks in the upper jaw, which sometimes exceed two feet in length, and weigh from three to twenty pounds each.

The head of the Walrus is round; its lips very

broad, and covered over with thick pellucid bristles; its eyes small and red; instead of ears, it has two small orifices; and above the whiskers, semicircular nostrils, through which it throws out water like the Whale, but with much less noise: its skin is thick and wrinkled, and has a thin covering of short brownish hair: its legs are short: it has five toes on each foot, connected by membranes; and on each toe a small nail: the hind feet are very broad, and extended nearly on a line with the body.

The Walrus is found chiefly in the northern seas Great herds of them are sometimes seen together on the sea shore, or sleeping on an island of ice. When alarmed, they instantly throw themselves into the water with great precipitation. If wounded, they become bold and furious, and unite in the defence of each other: they will attack a boat, and endeavour to sink it by striking their great teeth into its sides, at the same time bellowing in the most hideous manner.

It is hunted for its teeth, which are equal to those of the Elephant for durability and whiteness.

An ordinary Walrus is said to yield half a ton of oil, equal in goodness to that of the Whale.

The female produces one or two young at a time, which she suckles upon land.

In climbing upon the ice, the Walrus makes use of its teeth as hooks to secure its hold, and draw its great unwieldy body after it. It feeds on seaweeds and shell-fish, which it is said to disengage from the rocks to which they adhere, with its tusks.

The White Bear is its greatest enemy. In the combats between these animals, the Walrus is said to be generally victorious, on account of the desperate wounds it inflicts with its teeth.

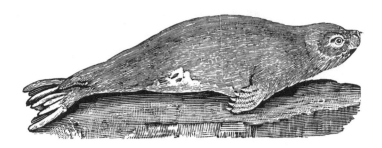

THE SEAL.

(Phoca Vitulina, Linn.—*Le Phoque,* Buff.)

Is found, with some variety, in almost every
quarter of the globe: in the northern seas of Asia,
Europe, and America; as well as the less frequent-
ed regions towards the south pole.

Its usual length is from five to six feet. The
body is closely covered with short hair of various
colours, smooth and shining; its tongue is forked
at the end; it has two canine teeth in each jaw, six
cutting teeth in the upper, and four in the lower; it
has five toes on each foot, furnished with strong
sharp claws, which enable it to climb the rocks, on
which it frequently basks.

It swims with great strength and swiftness, is
very playful, and sports without fear about ships
and boats. It feeds on various kinds of fish, and is
frequently seen near the shore in pursuit of its prey.

Seals are found in great abundance on the coasts
of Great Britain; particularly in the deep recesses
and caverns in the northern parts of the island,
where they resort in the breeding time, and con-
tinue till the young ones are old enough to go to
sea.

The time for taking Seals is in the month of October, or the beginning of November. The hunters, provided with torches and bludgeons, enter the mouths of the caverns about midnight, and row in far as they can : they then land ; and being properly stationed, begin by making a great noise, which alarms the Seals, and brings them down from all parts of the cavern in a confused body, making frightful shrieks and cries. In this hazard-ous employment, great care is necessary on the part of the hunters to avoid the throng, which presses down with great impetuosity, and bears away every thing that opposes its progress ; but when the first crowd has passed, they kill great numbers of young ones, which generally straggle behind, by striking them on the nose.

A young Seal yields above eight gallons of oil. When full grown, their skins are very valuable, and make a beautiful kind of leather, much used in making shoes, &c.

The flesh of the Seal is sometimes eaten ; and that it was formerly admitted to the tables of the great, may be seen in the bill of fare of a sumptuous en-tertainment given by Archbishop Nevil in the reign of Edward the Fourth.

The growth of the Seals is so amazingly rapid, that after nine tides from their birth they are as active as the old ones.

The female brings forth her young on the land, sits on her hind legs while she suckles them, and as soon as they are able carries them to sea, and teaches them to swim and search for food : when they become fatigued, she places them on her back. The young ones know the voice of their mother, and attend to her call.

The voice of the Seal has been compared to the
hoarse barking of a Dog; when young, it is clearer,
and resembles the mewing of the Cat.

Seals are likewise found in the Mediterranean
and Caspian seas, in the lake Baikal, and some of
the larger lakes. These are smaller than the salt-
water Seals ; but so fat, that they seem almost
shapeless.

THE HOODED SEAL.

Is found in the south of Greenland, and is dis-
tinguished by a thick fold on its forehead, with
which it can cover its eyes and nose. Its hair is
white, with a thick coat of black woolly hair under-
neath, which makes it appear of a fine grey colour.
The hunters say that it is not easily killed till the
covering on its head is removed.

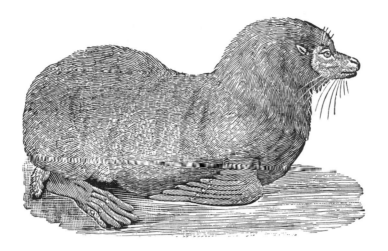

THE URSINE SEAL, OR SEA-BEAR.

(Phoca Ursina, Linn —*L'Ours Marin,* Buff.)

Is much larger than the common Seal, being eight feet in length, and weighing eight hundred pounds.

These animals are found among the islands which lie between Kamschatka and America; also on the coasts of New Zealand, Staten Island, New Georgia, and Falkland's Islands. They lie in thousands on the shore, in separate families, each consisting of above an hundred. One male will sometimes have fifty females, which he guards with extreme jealousy. They are excessively fat and indolent, sometimes even scarcely moving from the place where they lie for the space of three months; during which time the females breed and suckle

their young. If another approach their station, they are roused from their supineness: a battle ensues, which frequently becomes general, and spreads confusion through the whole shore. These conflicts are extremely violent; and the wounds given are very deep, resembling a cut with a sabre.

The attachment of the male to the young is very strong: he defends them with great obstinacy, and frequently revenges their loss upon the female, whom he beats most cruelly; whilst she crawls to his feet, and seems to deprecate his wrath with the most obsequious gestures.

The female generally brings forth one, seldom two, at a time.

They swim with great ease, at the rate of about seven miles in an hour. When wounded, they will seize on a boat, draw it along with them, and sometimes sink it. They can continue a long time under water. In climbing rocks, they fasten their fore paws, and draw themselves up.

These and all the Seal kind, will live a long time after receiving the most dreadful wounds; but the most trifling blow on the snout or forehead instantly kills them.

The general colour of these animals is black. They are covered with a coat of long rough hair, under which is a soft down of a bay colour. On the neck of the old ones, the hair is erect, and a little longer than the rest.

The fat and flesh of the old males are very nauseous; but those of the females and the young, when roasted, are said to be as good as the flesh of a sucking Pig.

THE BAT.

THIS singular animal is distinguished from every other quadruped by being furnished with wings, and seems to possess a middle nature between four-footed animals and birds: it is allied to the one by the faculty of flying only, to the other both by its external and internal structure: in each respect it has the appearance of an imperfect animal. In walking, its feet seem to be entangled with its wings, and it drags its body on the ground with extreme awkwardness. Its motions in the air do not seem to be performed with ease; it raises itself from the ground with difficulty, and its flight is laboured and ill-directed; whence it has very significantly been called the FLITTER-MOUSE. There are several varieties of the Bat kind.

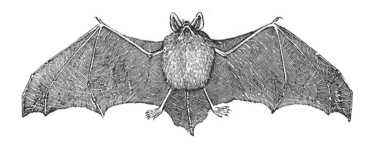

THE SHORT-EARED BAT.

(Vespertilio Murinus, Linn.—*Le Chauve Souris,* Buff.)

Is found in almost every part of Europe, and is most commonly known in Great Britain. Its usual

length is about two inches and a half; the extent of the wings nine inches.

It makes its first appearance early in the summer. It sleeps during the day, and begins its flight in the dusk of the evening. It frequents the sides of woods, glades, and shady walks; and is frequently observed to skim along the surface of the water in quest of gnats and other insects, which are its principal food.

Its membranes or wings are of a dusky colour, and very thin; they extend from the fore feet to the tail: the hind feet are divided into five toes, furnished with claws; the body is covered with a short soft fur, of a mouse-colour, tinged with red; the eyes are very small; and the ears like those of a Mouse; it has four cutting teeth in the upper jaw, and six in the under.

The female produces two young at a time, which she suckles at her breast; and is said to carry them when flying.

Towards the end of summer, the Bat retires into caves, old buildings, or hollow trees, where it remains in a state of inactivity. During winter, some cover themselves with their wings as with a mantle, and suspend themselves by the hind feet; others stick fast to old walls; and some retire into holes.*

* At an ancient mansion of Sir Hugh Owen, near Pembroke, in consequence of a stench in a closet, the wainscot was taken down, and 280 Bats were found and killed. Many of the females had two young ones hanging at their teats: they were a small kind of Bat, with little ears and almost black. The young ones were quite naked, like callow birds.—*Communicated by John Trevelyan, Esq., July, 1808.*

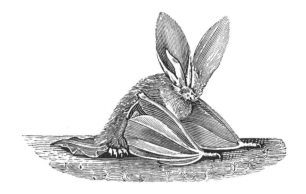

THE LONG-EARED BAT.

(Vespertilio Auritus, Linn.—*L'Oreillar,* Buff,)

Is only an inch and three quarters in length; the extent of its wings is seven inches; its ears are above an inch long, very thin, and almost transparent; within each of them there is a membrane, resembling an ear, which may possibly serve as a valve to defend the organs of hearing during its inactive state.

THE GREAT BAT.

(La Noctule, Buff.)

Is found in Great Britain, but is not so common as the two last-mentioned: It is likewise found in France, and is common in various parts of Russia.

Its length is nearly three inches; that of the tail one and seven-tenths; the extent of the wings thirteen inches; the ears are short, the hair of a reddish ash colour, and on the chin there is a very small wart.

THE PIPISTRELLE.

Is the smallest, and its appearance the least disgusting of all the Bats. Its length is not quite one inch and a quarter; the extent of its wings six and a half; its nose is small, ears broad, and its forehead covered with long hairs; the upper part of the body is of a yellowish brown colour, the lower part dusky, and the lips yellow. It inhabits France, and is common in Russia and Siberia.

THE BARBASTELLE.

Is distinguished by the shortness of its face, almost concealed by its large broad ears, the bases of which touch each other, and cover the forehead and eyes: its cheeks are full, and its lips hairy; its nose is very short, and the end of it flat. Its length is about two inches; the extent of the wings ten and a half. It is found in France.

THE SEROTINE.

Is about the size of the common Bat; its nose is somewhat longer; its ears are short, and broad at the base; the hair on the upper part of the body is of a light brown or rust colour, and the belly paler. It is likewise found in France.

THE HORSE-SHOE BAT.

Is distinguished by a membrane surrounding its nose and upper lip somewhat in the form of a horseshoe, whence it derives its name. Its ears are long, very broad at the base, and are not furnished with

a smaller or internal ear, common to almost all the Bat kind: the upper part of the body is of an ash colour, the belly whitish. They vary in size; the largest are above three inches and a half long from the nose to the end of the tail: the extent of the wings is above fourteen.

This kind is very common in France, and is the last of seven distinct species described by M. Buffon as natives of that country. These are all equally harmless, diminutive, and obscure; shunning the light, and endeavouring to conceal themselves in holes and caverns. They never come out, but during the night, in quest of food; and return at day-break to their dreary habitations. But under the influence of a warmer climate, the Bat assumes a very different character, and possesses powers which render it formidable to mankind, and a scourge to those countries where it is found. Some of them are as large as a well-grown pullet; and so numerous, that they frequently darken the air as they fly. They are fond of blood, and will attack men whom they find asleep; they are said to introduce their sharp pointed tongues into a vein, sucking the blood till they are satiated, without awakening the sufferer.

The ancients had an imperfect knowledge of these animals; and from their aptness to convert every object of terror into an imaginary being, it is probable they had conceived the idea of Harpies, from the cruelty, voracity, and disgusting deformity of these creatures.

These monsters inhabit Madagascar, and all the islands of the Indian Ocean: they likewise have been found in New Holland, the Friendly Isles, the New Hebrides, and New Caledonia.

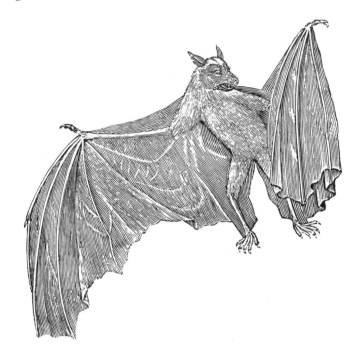

THE TERNATE BAT.

(Vespertilio Vampyrus, Linn.—*La Roussette*, Buff.)

Is above one foot in length, and the extent of its
wings more than four: it has large canine teeth,
four cutting teeth above, and the same below; its
tongue is pointed, and terminated with sharp-
pointed papillæ, or prickles; its nose is sharp, and
its ears large and naked; it has five toes on the
hind feet, furnished with strong hooked claws; it
has no tail; the head is of a dark rust colour; the
back dusky; the neck, shoulders, and under side,
of a lightish brown, inclining to red; the mem-
branes of the wings dusky.

They feed on fruits, and are extremely fond of
the juice of the palm-tree, with which they will

frequently intoxicate themselves, so as to drop on the ground. One hundred and fifty or two hundred of them may sometimes be seen on the same tree, all hanging with their heads down, and their wings folded; and in this manner they repose during great part of the day. They grow very fat at certain times of the year; and when young, they are eaten by the Indians, and considered as excellent food.

THE ROUGETTE, OR LESSER TERNATE BAT.

INHABITS the same countries, and is very similar to the last in the shape of its head and body: the hair is of a cinereous brown colour; and on the neck it has a half-collar, of a lively red, mixed with orange. It is about five inches long; and the extent of its wings little more than two feet.

The Rougettes fly in flocks, and perfectly obscure the air with their numbers. They fly from one island to another, and begin their flight about sunset. During the day, they lodge in the hollow trunks of trees. They live chiefly in trees; and when about to fly, they beat the air with their wings, before they can disengage themselves from the branch to which they are attached. When shot at or suddenly surprised, several of them fall to the ground; and in that situation are incapable of resuming their flight, till they climb upon some elevated object. They move awkwardly on the ground, and use their utmost efforts to quit it as soon as possible. Both these kinds bring forth only one young at a time, once a year.

THE SPECTRE BAT.

(Vespertilio Spectrum, Linn.—*Le Vampire,* Buff.)

ITS nose is long; and at the end there is a membrane, of a conical form, somewhat like a horn, but flexile, which gives it a hideous and disgusting aspect. It has no tail. Its body is covered with long hair, of an ash colour. It is found in Surinam. Stedman, in his account of that colony, particularly describes it, and says that it is fond of human blood.

THE SENEGAL BAT.

HAS two cutting teeth in the upper, and six in the under jaw; and two canine teeth, and eight grinders, in each jaw: its head is long, ears short and pointed; head and body of a tawny brown colour, belly lighter; length rather more than four inches; extent of the wings twenty-one. It is found in Senegal.

THE BULL-DOG BAT.

ITS nose is thick; lips large, and somewhat pendulous; its ears are broad and round, the edges touching each other in the front; the upper part of the body is of a deep ash colour, the lower paler; its tail long; length about two inches; extent of the wings nine and a half: it has twenty-six teeth; two cutting and two canine in each jaw; eight grinders in the upper, and ten in the lower jaw. It inhabits the West Indies.

THE BEARDED BAT.

THE nostrils of this animal are not separated by a

cartilage, as in most animals, but are placed on the side of a small gutter or furrow, which is open from one end to the other; the ears are long and narrow; the upper part of the head and body is of a reddish brown colour, the lower part whitish, tinged with yellow; hair on the forehead and under the chin very long; length of the body about an inch and a half; extent of the wings little more than seven.

THE STRIPED BAT.

(*Vespertilio Spasina*, Linn.)

HAS a small, short nose; ears short, broad, and pointing forward. These Bats vary in colour. The body is generally of a clear brown, the under part whitish: its wings are striped with black, and sometimes with yellow and brown. Length of the body two inches. It is a native of Ceylon, where it is called *Kiriwoula*.

To this we may add a very minute kind, mentioned by Mr. Forster, which was seen and heard in myriads on the island of Tanna, one of the New Hebrides; but every attempt of our voyagers to obtain a nearer inspection of them failed of success.

Bats differ very much in the number and disposition of their teeth, which has occasioned no small confusion in the arrangements of systematic writers; some of them being furnished with two, others with more cutting teeth in each jaw.

We have now given the most distinguished varieties of this curious species. It would be fruitless, if not impossible, to point out all the peculiarities

to be found in the various tribes which abound in every country in the world, and differ from each other more in their habits and dispositions than in their exterior form and appearance, which in all of them seem to be equally deformed and disgusting. But we should not from hence conclude that imperfection and deformity are always in uniform analogy with the notions we have pre-conceived of what is fair and beautiful. Amidst the infinite productions of Creative Power, variety of form, difference of faculties, and degrees of utility, are eminently observable: composing one general plan, in which wisdom, order, and fitness, are displayed through all its parts.

ADDENDA.

WE are favoured, by the Literary and Philosophical Society of Newcastle-upon-Tyne, with the figures and descriptions of two very rare animals, sent to them from New South Wales, by James Hunter, Esq., governor of that settlement, in a letter dated "*Sydney, New South Wales, August* 5, 1798."

The one, like most of the animals found in these new settlements, has a false belly or pouch, for the reception of its young after their protrusion from the uterus; common to every animal of the Opossum kind.

The other seems to be an animal *sui generis;* it appears to possess a three fold nature, that of a fish, a bird, and a quadruped, and is related to nothing that we have hitherto seen: we shall not attempt to arrange it in any of the usual modes of classification, but content ourselves with giving the description of both these curious animals as they have been transmitted to us.

THE WOMBACH.

"THIS animal was found upon an island on the coast of New South Wales, in latitude 40' 36" S.,

where considerable numbers were caught by the company of a ship which had been wrecked there on her voyage from Bengal to Port Jackson.

"I received this animal alive, by a vessel which I had sent to the relief of the sufferers: it was exceedingly weak when it arrived, as it had, during its confinement on board, refused every kind of sustenance, except a small quantity of boiled rice, which was forced down its throat. I had it frequently taken out of a box in which it was kept, that it might receive the benefit of the warmth of the sun, which, however, it did not seem to enjoy; but whenever it could shelter itself under a shrub, there it would continue and sleep. It refused every kind of food on shore as it had done on board, but we could see it sometimes nibble a little of the roots of rushes or grass: it grew weaker every day, was exceedingly harmless, and would allow any person to carry it about. After having lived, with scarcely any kind of food, for six weeks, it died; and its intestines and brain having been taken out, I preserved the body in spirits, for the inspection of the learned members of the Literary and Philosophical Society of Newcastle-upon-Tyne.

"It is about the size of a Badger, a species of which we supposed it to be, from its dexterity of burrowing in the earth, by means of its fore paws; but on watching its general motions, it appeared to have much of the habits and manners of the Bear.

"Its head is large; the forehead, above the eyes, is particularly broad, from which it tapers to the nose,* which is a hard gristly substance, and seems well adapted for removing the earth where it bur-

* Its nose and upper lip resemble those of the Porcupine.

rows: it has two cutting teeth in each jaw, long
and sharp like those of a Kanguroo, with a space
of about an inch between them and the grinders,
which are strong and well set: from the structure
of its teeth, it does not appear to be a carnivorous
animal: its eyes are small and black; its ears short
and pointed; its paws are somewhat like those of a
Bear: its weight appeared to be about forty pounds.
It runs awkwardly, in the manner of a Bear, so
that a man could easily overtake it. There is
something uncommon in the form of its hinder
parts; its posteriors do not round off like those of
most other animals, but fall suddenly down in a
sloping direction, commencing at the hip joint, and
descending to the knee joint of the hind legs; from
this joint to the toe it appears to tread flat upon
the ground; its tail is so short, as hardly to be dis-
covered: its colour is that of a cream-coloured
brown, intermixed with black hairs. This animal
has lately been discovered to be an inhabitant of
the interior of this country also. Its flesh is deli-
cate meat. This one is a female, and has the false
belly for the security of its young. The mountain
natives call it *Wombach*."

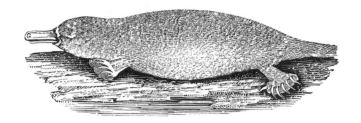

"AN AMPHIBIOUS ANIMAL

Is found in the fresh water lakes, which is about the size of a small Cat; it chiefly frequents the banks of the lakes; its bill is very similar to that of a Duck, and it probably feeds in muddy places in the same way; its eyes are very small; it has four short legs; the fore legs are shorter than those of the hind, and their webs spread considerably beyond the claws, which enables it to swim with great ease; the hind legs are also webbed, and the claws are long and sharp. They are frequently seen on the surface of the water, where they blow like a turtle: their tail is thick, short, and very fat.

"The natives say they sometimes see them of a very large size."